the snows of ... and the future climate of the mountain west

OUR VANISHING GLACIERS

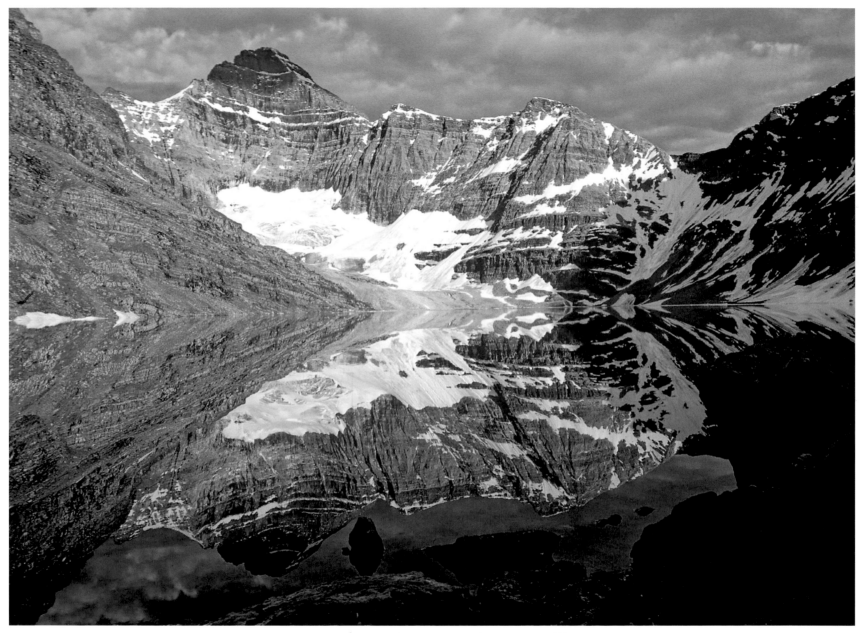

OUR VANISHING GLACIERS

The Snows of Yesteryear and the Future Climate of the Mountain West

Robert William Sandford

EPCOR Chair, Water Security,
United Nations University Institute
for Water, Environment & Health

RMB

RMB | Rocky Mountain Books Ltd.
rmbooks.com
@rmbooks
facebook.com/rmbooks

Cataloguing data available from Library and Archives Canada
ISBN 978-1-77160-202-0 (hardcover)

All photographs are by Robert William Sandford unless oth-erwise noted.

Cover photo: R.W. Sandford, United Nations University Insti-tute for Water, Environment & Health

Printed and bound in Canada by Friesens

Distributed in Canada by Heritage Group Distribution and in the U.S. by Publishers Group West

For information on purchasing bulk quantities of this book, or to obtain media excerpts or invite the author to speak at an event, please visit rmbooks.com and select the "Contact Us" tab.

RMB | Rocky Mountain Books is dedicated to the environment and committed to reducing the destruction of old-growth forests. Our books are produced with respect for the future and consideration for the past.

We acknowledge the financial support of the Government of Canada through the Canada Book Fund and the Canada Council for the Arts, and of the province of British Columbia through the British Columbia Arts Council and the Book Publishing Tax Credit.

In memory of
Reid Robertson Sandford

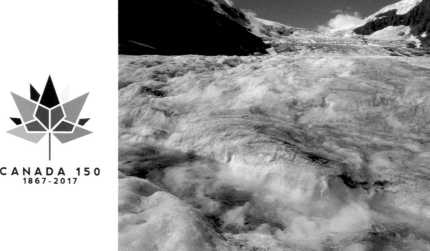

CANADA 150
1867-2017

CANADA'S 150TH ANNIVERSARY:
ICE THAT LASTS THE LIFE OF A NATION

Savage and Paterson (1963) measured the surface velocity of the ice at many places on the glacier and showed that, along the centre line of flow, the velocity decreases from 25 metres per year just below the lowest icefall to less than 15 metres per year near the terminus. At such velocities, ice requires a long time to travel the length of the glacier. The next time you sample the ice at the toe of the glacier, remember that 150–200 years has elapsed since ice exposed here fell as snow in the Columbia Icefield!

— RICHARD E. KUCERA, *EXPLORING THE COLUMBIA ICEFIELD*

TABLE OF CONTENTS

The entire hydrologic cycle from atmosphere to ocean and back is a marathon line of nearly unabridged hydrogen bonds, a continual flow of awareness. To touch water, especially water out of a spring or seep, is to return to each origin, meeting the rains and the snowmelts and the cold interior of the planet, meeting, in fact, the comets machine-gunning against our atmosphere. I am surprised that when a hair dryer falls into a bathtub we are not all electrocuted.

—CRAIG CHILDS, *THE SECRET KNOWLEDGE OF WATER*

ONE: The Wonder of Water

BECAUSE MANY OF US STILL BELIEVE we have unlimited amounts of clean, high quality water, most Canadians don't think much about water as a natural resource. We turn on the tap and expect it to flow. Because water is one of the most familiar of all substances, it doesn't usually occur to us that it is also one of the most amazing. We forget that water is exotic. If you were to outline the characteristics of water without naming the substance you are describing, it would be very difficult for most people to believe that a single substance could exhibit all the remarkable qualities you described. Yet we often let water run out of the tap without giving a thought to how precious it is to us and to the world.

Though we know its chemical composition and many of its obvious qualities, even experts have trouble determining how and why water acts in such an astonishing array of ways. Even though its availability is central to almost every aspect of our lives, we are blissfully content to allow our entire being to revolve around a substance we barely understand. It is as if we live in the midst of a great mystery we have given up trying to solve. The more you know about water, the more astounding the world seems. The more familiar one becomes with this substance, the clearer it becomes that no matter where we live or what we do, our lives are completely circumscribed if not utterly defined by what water is and what water does.

Natural Bridge,
Yoho National Park.

The otherworldly qualities
of liquid star-stuff

Water truly does exhibit amazing qualities. Most of the other substances that exist on Earth possess a narrow range of more or less commonly predictable traits. Most are solid and, except under great extremes of temperature or pressure, don't change. Not water. Water is different. It constantly changes form. It can exist in three states simultaneously within tiny ranges of temperature and pressure. Water is contradictory. In the same moment it can be soft as a cloud and as hard as a glacier. Water gets around, too. It can be in the air at dawn and in the river at dusk. You have to pay attention to water. It can refresh you one minute and drown you the next. In one of its iterations it can be as delicate as a raindrop. In another it can smash you to bits.

With the exception of air, most of the substances we deal with daily on Earth are opaque. But water is ghost-like. You can see right through it. While water does exist in a variety of opaque forms, it can also be transparent in all its forms. We don't often think about how remarkable it is to be able to see completely through a liquid or a solid. It just doesn't happen often in nature. Water is also unique in that it moves between these remarkable states easily. It is the ultimate shape-shifter. You can reach for it only to have it evaporate from your grasp. It can be there and not be there. Simultaneously it can be present and past.

Though water informs almost all of our perceptions about what liquids are supposed to be like, water is a very unlikely liquid indeed. One of the ways it is truly different is in its response to cold. Cooling of other liquids makes them denser. The density of water, however, does not increase uniformly as it gets colder: water is densest not when it is coldest but at a temperature four degrees warmer than its freezing point, which, as every home thermometer indicates, is 0°C, or 32°F. Water doesn't achieve its greatest density until its temperature drops or rises to 4°C, or 39°F. You might not think that would be such a big deal unless, of course, you lived on Earth. It is this anomalous property of water that makes and keeps our planet habitable.

In terms of our planet's capacity to support life, the implications of water's physically expansive response to cold are profound. They are also global. If water didn't expand when it froze, then rivers, lakes and streams would not freeze over in winter. Instead they would turn to ice from the bottom up. One day your favourite lake would be fluid, the next day it would solid as a rock. There would be no life in our northern lakes. No lake trout, no cutthroat, no whitefish, no char. Ice would never disappear from some northern rivers. There would be no place for salmon to spawn. There would be no great annual northward bird migration. Our polar seas too would freeze from the bottom up. Ocean currents would no longer be able to transport the warmth of the tropics to the planet's latitudinal extremes. There would be no temperate zones. We would have to melt water to survive winter, and winter in much of the world might be eternal. All of the world's life would be huddled together on the equatorial bulge of the planet.

Life on Earth has evolved in direct relation to the fact that water responds unlike other liquids to cold. It can be said that water becomes its full self when it freezes. Because frozen water is lighter, it rides atop its heavier liquid form. It can be said that it was water that made the

first bridge. Water also made the first boat. But even as a solid, water never forgets its fluid self. Even the thickest ice flows. That this is so has had astounding consequences for the mountains of North America and for alpine regions on every continent in the world.

In and out of hot water

Water is a key element shaping our weather and our climate. The wholesale effect of ocean circulation on the genesis and maintenance of our contemporary global climate depends on a second anomaly in the nature of water. Water is not only unusual in its response to cold; it is also very unusual in its response to heat. Water acts like a sponge when it comes to heat. It takes more heat to raise the temperature of water than it does to raise the temperature of almost any other substance – whether solid or liquid. Water's great "heat capacity" has profound and universal implications for life on Earth.

The downside of water's high heat capacity is that it takes a lot of energy to warm water up. Of all the hundreds of thousands of solids that are known to exist on Earth, it takes more heat to melt ice than it does to melt anything else. Once the world is frozen, it takes the same great deal of heat the freezing took out of it to thaw it out again.

As anyone who has waited on a kettle will know, it also takes a huge amount of energy to bring water to a boil. The upside of water's amazing heat capacity is that it stays warm for a long time after it has been heated. At a quite quotidian level we see the remarkable benefit of this property in cooking. Hot water is the perfect substance in which to slowly break down starches and other compounds and release their nutrients for easy digestion. Were it not for the amazing heat retention and heat transfer properties of water, there would be a lot of things we wouldn't be able to eat at all and a lot of things that wouldn't taste nearly as good as they do. That water gives up its heat slowly is also why our baths stay pleasantly warm and why large bodies of water can have such an extraordinary influence on local weather. That water gives up its heat only reluctantly is why ocean currents can transfer enough heat from the tropics to the northern and southern temperate regions to make them habitable. This extraordinary process is carried out via global oceanic circulation.

It is hard to comprehend the extent to which heat can be transported by ocean currents. The Gulf Stream, that great mid-Atlantic current which transports heat northward from the tropics of South and Central America, carries twenty-five times as much water as all the Amazons, Congos, Gangeses, Yangtzes, St. Lawrences, Mackenzies and Mississippis on Earth. It also carries with it each day twice as much heat as would be generated by the burning of all the coal mined in the world every year. It keeps Northern Europe warmer than Labrador and permits spring mayflowers to grow on the fogbound coast of Newfoundland.

The currents that circulate through the great big bathtub of the world's oceans warm some places and not others. The distribution of that warmth affects precipitation, the volume of water in rivers and the agricultural and industrial capacity of the areas through which these rivers flow. Ultimately, ocean currents affect patterns of human settlement and the prosperity that is possible in and around these settlements.

From the currents that circulate in our salty seas to the precipitation that falls on the land to fill our freshwater streams, rivers and lakes, our world is saturated with water. Even in the deserts this is true. Squeeze the world and water will come out.

Getting a charge out of water

Besides dramatically influencing the amount of energy it takes to melt ice and the volume of heat that can be absorbed and carried by liquid water, the chemical composition of water also gives it astonishing capacities as a solvent.

Water molecules are held together by a unique force called a covalent bond. In a multitude of compounds that exist in the world, atoms are not held together in the way water's are. They are held together by simple electrical attraction called ionic bonding. These compounds are electrically attracted to water. They get a charge out of water. That so many diverse compounds find water irresistibly attractive makes it an outstanding solvent. It is also water's capacity to form gels that provides structure to the human eye, allowing us to appreciate the blue of our rivers.

Half of all the chemicals that exist on Earth are soluble in water. Water is such a good solvent, in fact, that perfectly pure water is very rare if indeed it occurs at all in nature. Next time you drink some, know that the stuff you're swallowing probably contains, along with many other dissolved substances, a small number of glass molecules that have given in to the magnetic personality of the water in your glass. Even rain, as it falls, dissolves atmospheric gases. And whatever rain lands on, it also dissolves. Every puddle, lake and sea on Earth is an aqueous solution. Wherever there is water, the world gets turned into molecular soup. The soup is good when it is made of natural nutrients, not so good when poisons creep into the broth.

In addition to being an amazing solvent, water has another quality that has huge import for life on Earth. One of the foundations of the evolution of life on this planet resides in the fact that water is selective in terms of the kinds of molecules to which it is chemically attracted.

Rivers within, yearning for rivers without

Though water tends to repel organic compounds, it is strangely attracted to most inorganic substances, including itself. Water likes to be around other water. Its molecules, in fact, cling to one another more tenaciously than those of many metals. You can observe water's remarkable qualities of self-adhesion if you sit by a river. Water sticks together. Water draws water with it. Sit on a riverbank long enough and you might observe that water also likes to sing. The faster it moves the louder it sings. Still water barely whispers; falling water fairly roars.

There is a reason we feel different when we are in the presence of large volumes of water. Water reacts to almost everything and almost everything reacts to water. The feeling you get standing on the edge of river or a lake or beneath a thundering waterfall may be aesthetic but it is physical, too. Your body is aligning itself with the molecular attraction of the water and the water is aligning itself to you. The effect can be even more pronounced when you stand by the sea. Ankle deep in surf, the water in our inner

cellular seas yearns for the salty sea without. The water within us feels the tug of the tide. We know water, but water also knows us.

Go to the kitchen. Turn on your tap. Let the water run. Feel the cool moisture of wind and the wetness of cloud and rain. Feel the cold of snow and the hardness of glacier ice. Hear thunder. Feel the river flow through your hands. Feel the water within you yearn for the water without. Fill a glass. Bring it to your lips. Search with your tongue for water's memory of faraway seas. Taste the limestone of distant mountains. Feel the fissures in ancient ice tingle on your tongue. Hold the glass up to sunlight. See our star burn through the sparkling lens made of the most amazing of all liquids. Drink. Repeat daily until fully and finally restored.

The language of water

In his widely read book *The Habits of Rivers*, fly fisherman Ted Leeson makes a thoughtful and articulate case against attributing human qualities and motives to rivers. He has a valid point. To conceive of landscapes in human terms trivializes them. Making nature knowable and familiar in this way may have been of great service to humans when we were threatened by inexplicable natural uncertainties such as volcanoes and hurricanes, tornadoes and plagues. But the world is different now. The tables have been turned and it is now nature, not us, that is on the run.

But Leeson also knows that words matter, in that they can constrain our vision to see one thing perhaps at the expense of another. And that the loss of words can lead to the loss of the things those words stand for. As the

The Earth from space. Photo courtesy of NASA

LESSONS ANY CHILD CAN TEACH

Close your eyes. Imagine our planet as we have been taught to see it from afar. You can see it suspended in your mind's eye, floating in the darkness of an eternal starlit night. The first thing that comes to mind is a cliché. "Ah, a blue jewel," you say. But you know as soon as the words escape you that the image is an inadequate metaphor for something right in front of your very eyes that you've failed to grasp. You try to explain what is really there to your 8-year-old son. Holding the image before his mind's eye you start with the obvious. "Our world is like no other," you begin. "It is not cold and dry. It is warm and wet. See it in the night. It glows like a bright-blue liquid moon." Examining it closer now, you can see it turning. It is a great rocky sponge soaking in salt water. Unseen at the fiery centre of the sponge is a nuclear furnace, a hot heart that beats in time to the faint residual rhythm of the Big Bang. While flying through space far faster than sound, the rocky sponge waves back and forth on its submerged roots. It sways in time to unseen currents in its silent silver seas.

"Water," you whisper. "Do you see it?"

"Yes," the boy whispers back. "I see it. It's a water-world."

Then suddenly you see what is right there in front of your eyes. This is not an Earth. Everything is floating. A single substance has made our world unique and made it ours. We are where we are and who we are because of water.

American writer William Kittredge has noted, the devaluation of words makes for the devaluation of the things words describe. A vicious circle is created from which there is no escape. With fewer words to describe our rivers, lakes and streams, it becomes harder to justify saving them. As these places vanish from our direct experience, the need for a language to describe them vanishes as well.

Leeson offers that there is a big difference between knowing a river and knowing about a river. He talks about "reading" the surface of the water as if it were text. The act of reading implies a language that can be read. We cannot afford to lose the words that form that language. If you include the language of science there are hundreds of words that describe what water is and what it does. We should learn and use these words so that the things they describe don't disappear from our language and our memory; so they don't disappear from the world. It is not just descriptions of water that are important. The links between what water is and the often defining connection between water and landscape also matter. In 1940, poet Earle Birney observed that the Rocky Mountains of Canada looked like a sea of stone and snow. The great poet also noticed that glacier ice could resemble "frozen salt-green waves." Interestingly, the deepest connections between water and landscape often present themselves not in places where water is most abundant, but it places on Earth with the least of it: deserts.

In *The Secret Knowledge of Water*, Craig Childs explains that right up until the 1930s the general feeling among scientists was that water played no role in the shaping of the remarkable landscape features found in the desert areas of the American Southwest. It was generally held that it was the absence of water that resulted in the classic erosion features so common in these arid lands. Geologists instead pointed to wind, extreme day and nighttime temperatures and constant dryness as the main agents of landscape sculpting. It was widely believed that rock literally exploded under the pressures of extreme daily heating and cooling. Experiments that aimed to validate this hypothesis showed something different, however.

In the laboratory, scientists exposed desert stone to ranges of daily temperature extremes far in excess of what rock would endure even in the most hostile desert environments. The rocks didn't explode as expected. Next, researchers explored how wind might have acted as an agent to chop and channel the desert into canyons and clefts. No dice there either. When they opened up rocks from the Mojave desert, researchers found hidden traces of water. Scientists began to rethink their hypothesis. They began to hike the canyons and observe what happened when it rained. Well trained researchers watched in awe as flash floods rolled boulders as big as houses down canyon floors. Then they got it. It is water, not the absence of it, that creates desert form.

Water and the language of place

After years of studying how water shapes the desert, Craig Childs had an epiphany while watching floodwaters roar down a dry canyon. In an instant of blinding understanding, the sole purpose of the desert was revealed to him. The desert existed to move water. The purpose of water was revealed also. Water existed solely to build a land that will carry it.

The same thing can be said about any Earthly landscape. The sole purpose of the land is to move water. The sole purpose of water is to create landscapes over which it can flow. In creating the landscapes over which it can transport itself, water also makes life on Earth not only possible but worthwhile. Thales of Miletus posited 2500 years ago that the world is afloat on an aqueous bed and

is nourished and sustained by the life-giving properties of water. Considering he arrived at these conclusions through direct observation millennia before the advent of any instrumentation that would prove him fundamentally right, his insight was utterly remarkable.

The flow of water over, through and under the world shapes the landscapes upon which we live. It is water in all its remarkable forms that defines where we live and who we are. In creating a dictionary of the language of water, we create a language of place. It is this language that is the foundation of all the other languages we use to communicate with one another and the world.

The language of the water cycle

When one imagines a cycle one thinks of a wheel. If you think of the circulation of water through the world you will have to get used to the idea that this cycle is going to be hard to ride. Sometimes it appears it's hardly a cycle at all. It is more of a say-it-and-spray stutter in which planetary moisture is spread unevenly over the land and then makes its way haltingly back from a thousand different places to the ocean. Water has many misadventures along the way. It finds its way through the green inner glow of plants, through the soil, through the deep underground and back again into streams and rivers. It is forced through the gills of salmon and is carried aloft on the wings of eagles. It enters the air again as vapour and falls again as rain. It passes through the whole world before again entering the sea. The stop and start of this cycle defines life as we know it on Earth.

Clouds: The "whitewater" of the skies

No matter what words you read in the language of clouds, one meaning underlies all. Clouds tell us that though air usually appears invisible, it is actually saturated with water. Relative to other sources, there isn't much water in the Earth's atmosphere. At any given time, only about 0.04 per cent of all the freshwater on Earth exists in the form of vapour or clouds in our planet's atmosphere. Still, that's a lot of water. According to *National Geographic* magazine, the volume of water in clouds and as vapour in the atmosphere is six times greater than what flows in all the world's rivers. Where and when this water falls determines the patterns of human settlement on Earth. How that water is managed defines the prosperity of the people who live in these settlements.

Clouds appear when atmospheric water materializes, though the phenomenon should be thought of more as a process of fluid dynamics rather than as an act of sudden miraculous materialization. Clouds are more like waterfalls than they resemble anything else. They are water taking on a unique form in order to be transported from one place to another or from one state to the next.

The language of water as expressed by clouds only begins with the names Luke Howard gave to these most important meteorological features during his pioneering studies in the early decades of the nineteenth century. The billowy white fair-weather clouds we so love to watch on a lazy Sunday afternoon are the ones Howard called "cumulus." Cumulus clouds form at low altitudes when warm, moist air is heated by radiation from the sun-hot ground. This air becomes less dense as it warms and thus more buoyant than the cooler air above. Through a process

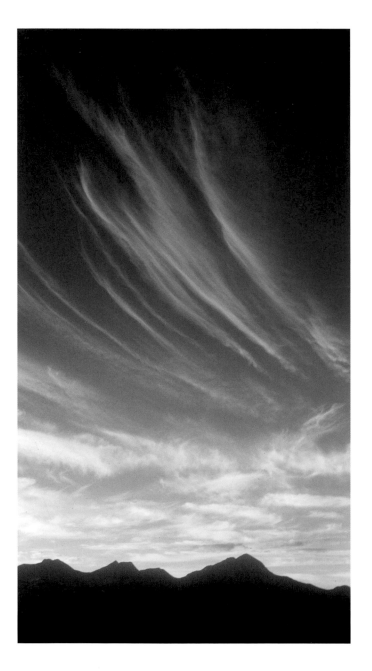

High cirrus over
Pyramid Mountain,
Jasper National Park.

called convection, it begins to rise. As the rising air reaches the condensation level defined by decreasing temperature at altitude, the water vapour condenses into cloud. The clouds assume the "lumpy," bulbous shapes characteristic of all cumulus clouds.

One of the reasons cumulus are considered fair-weather clouds is that their temperature is generally above freezing throughout. This means that all their particles are liquid droplets. No ice is present. Beyond their misty edges the air is measurably drier, so the droplets that stray beyond the billows evaporate very quickly. For this reason the edges of cumulus clouds are sharply defined and whiter than the centre of the cloud, where water droplet concentration is denser. These are the perfect clouds that artists like to paint into landscape scenes – even if such clouds seldom occur in the region they are depicting.

In the Luke Howard categorization of cloud types, "stratus" means layered, and these clouds are not associated with good weather. Stratus clouds form when an updraft of heated air is unable to penetrate a more stable layer of air above, forcing the cloud to spread out laterally. These are the clouds that form overcast skies. Depending on temperature and how much moisture exists in the rising air, these clouds can also bring rain or snow. Low-altitude stratus formations are usually warm, and the water in them is usually liquid. It is interesting to observe that stratus clouds can act as a raw material from which cumulus clouds can be created by updrafts that rise into the higher atmosphere. Clouds formed in this way are called altocumulus and altostratus. These become "mixed clouds" when the temperatures become cold enough to create ice particles in the midst of the water droplets that

compose them. The interior temperature of these clouds is always in the freezing range, usually from 0°c down to -39°c. But something altogether different happens to clouds below this temperature.

The highest-flying of all the clouds are the feathery wraiths created in the upper reaches of our planet's atmosphere, at least six kilometres above the surface. Cirrus clouds don't start forming until the air temperature drops below -39°C. These clouds are composed completely of ice. Unlike fair-weather cumulus, the edges of these high, wispy clouds are not clearly defined. A little like comets, the ice at the edges of cirrus cloud sublimates in sunlight, streaking into invisibility in the extreme cold at the upper limits of where water goes in our atmosphere.

Sundogs: Light rays barking at the glow of upper-atmospheric ice

The unique nature of water is also expressed in the way sunlight passes through ice crystals in the atmosphere. Though sundogs are most common in winter, you can see this expression of water's unique nature any time of year, especially in Canada. Because ice crystals are faceted, they refract light. Plate crystals of ice, sometimes called diamond dust, form in the cold of high cirrus clouds that occur worldwide. As these plate crystals drift and float downward, the rays of the sun are bent by at least 22° as light enters the crystals through one face and exits through another. For this reason, sunlight that passes through clouds of ice cannot reach the eye within a cone of at least 22°. Within this cone at the centre of our line of sight, the sun can appear darker than the bright circle of light that surrounds it. This is how sundogs are formed.

The same phenomenon can sometimes be seen around the full moon on a cold winter's night. Ice crystals in the upper atmosphere can also become aligned in such a way that a halo can be transformed into an arc or a spot. These stunning atmospheric effects are all created by water playing with light.

The next time you stop to marvel at the pink tinge of sunset's fire on lingering cloud, or at a ring burning brightly around a February moon, or maybe the next time you find yourself on your back trying to rearrange summer cumulus into the shapes of sailing ships and exotic animals, remember that in each of these instances you are reading a signature that water has left on the sky.

A language of turbulence scrawled across the sky

There is a limit to how much water as vapour our atmosphere can hold. Warm air holds more than cold air. Clouds, as we have already observed, form when a volume of air rises and cools and condenses into droplets of water or particles of ice. Condensation will not occur, however, unless the air contains tiny airborne particles, such as crystalline sea salts, mineral dust or pollution, around which a raindrop or a crystal of snow can form. For a cloud to produce rain, the droplets have to grow large enough to be able to free-fall through the air. This can be a very slow process. It can take a droplet more than an hour to grow to a mere 20 micrometres in diameter. A droplet of this size would be hard to spot on the head of a pin. Most raindrops acquire sufficient mass to allow them to fall by coalescing with other droplets rather than by swelling in size on their own.

The mass of a raindrop will also determine the speed at which it falls. A fine drizzle is usually composed of droplets that are about 200 micrometres, or about a hundredth of an inch in diameter. Buffeted by the air through which they are attempting to fall, droplets of this size float to Earth at about 10 centimetres, or about four inches, a second, just over a third of a kilometre an hour. You can take a romantic walk through rain falling this slowly. Multiply the diameter of the raindrop by four, however, and you get a completely different kind of experience. Raindrops 800 micrometres across fall at about three metres, 10 feet, a second, or just under 11 kilometres an hour. You can still enjoy that romantic walk but you might want to take an umbrella.

Velocities can really increase if falling raindrops come into contact with ice crystals that are created if subfreezing temperatures exist at mid-levels of a cloud formation. Water droplets freeze instantly when they collide with ice particles. When this happens, the ice particles begin to grow through a process called riming. Under certain conditions riming can lead to ice storms like the one that paralyzed Montreal and area during the winter of 1997–98. More immediately dangerous than ice storms, however, is hail.

Hail is formed through a process of serial riming in tall cumulonimbus clouds, where ice particles can be cycled again and again through mixed ice and water layers. Ice particles created in this way can be huge. Though most hailstones are less than a centimetre across, there have been instances, particularly on the Great Plains, where hailstones of a truly monumental size have rained down on the Earth. Hailstones as large as twelve centimetres, nearly five inches, have been recorded. A hailstone of this size can weigh nearly three hundred grams, more than half a pound. An object of this mass will fall to the Earth like a rock. The terminal velocity of a hailstone of this size would be about 250 kilometres an hour. That, for those who still don't think metrically, is 155 miles an hour. When water starts acting like this it is no longer a wonder. It is a threat to your existence. Forget the umbrella. Forget the walk. Run for your life.

Mountains as water towers

If the sole purpose of the land is to move water and the sole purpose of water is to create landforms over which it can flow, then there is no greater expression of the link between water and our world than the mountains of western Canada. Being sedimentary in nature, the Rocky Mountains are the ultimate expression of the manifold ways in which water mediates our lives. The Canadian Rockies were created in concert with all the qualities water possesses. These mountains are made of marine sediments laid down in ancient inland seas. These sediments are composed of what water in all its remarkable forms tore away from the land and deposited by way of rivers into the sea. These sediments also contain all the dust and debris that fell on the surface of the water and sank into its depths, and from the decomposing bodies of plants and animals that lived for millions of years in those seas. It is not just the rocks that owe their nature to water. Everywhere you look in these mountains, everything you touch there, has been created or shaped by it. Mountains owe even the shapes of their peaks and valleys to water. Carved by rain, rivers and glaciers from these primordial seabeds, the

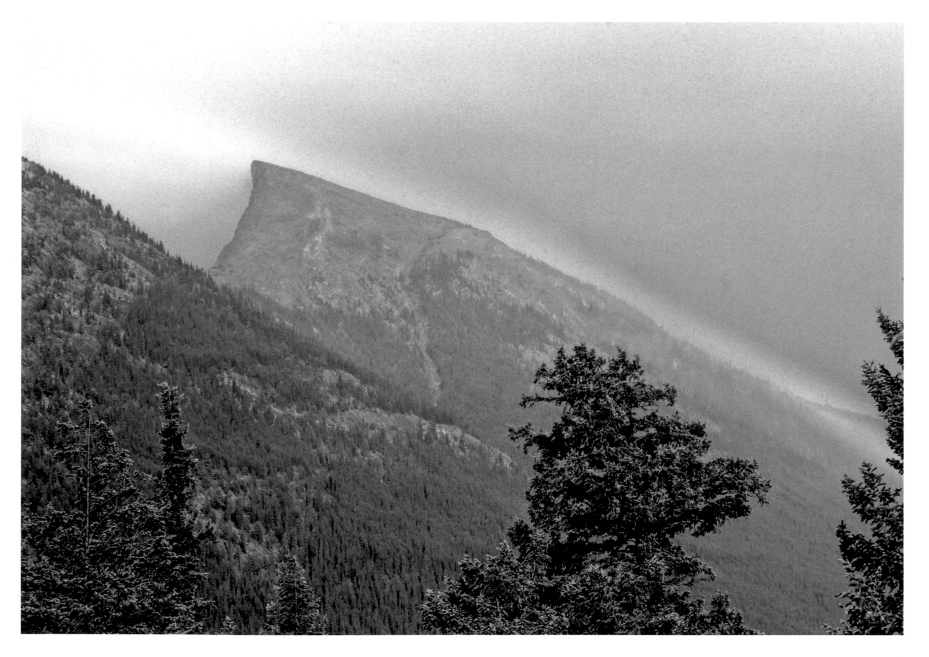

According to the *Arcade Dictionary of Word Origins*, water is an ancient word that goes back ultimately to the prehistoric Indo-European root word *wodōr*. Related words include the Greek *húdōr*, "water" (source of the English prefix *hydro-*), Latin *unda* "wave" (source of the English *redundant, surround, undulate*, etc.), Russian *voda* "water" (source of the English word vodka), Gaelic *uisge* "water" (source of English *whisky*), Lithuanian *vanduō* "water," Latvian *ūdens* "water," Sanskrit *ūdán* "water," and Hittite *watar* "water." In the Germanic languages it has become German *wasser* (which, combined with the Greek ἔλαιον (*elaion* "olive oil"), is the origin of the American brand name *Vaseline*), Dutch and English *water*, Swedish *vatten* and Danish *vand*. *Otter* comes from a variant of the same Indo-European base, as may *winter*; and *wet* is closely related.

Taylor Creek, Banff National Park.

Rocky Mountains are among the most poetic and richly self-affirming of all the words that exist in the language of Canadian water.

Mountains are monuments to what water can make. Dissolved in rain, worn away by the mechanical action of running water and blown apart by the alternate freezing and thawing of frost and ice, the Rockies rose hip-deep in their own debris. This process happens everywhere that tectonic forces have pushed rock high up into the winds of the Earth's spinning. If there is one single statement that puts the relationship between water and the world into proper perspective it is this: the summit of Mount Everest is marine limestone. The highest mountain on the terrestrial globe is this planet's tallest monument to what water is and what water does to our world.

Mountains are found on every continent. Occupying about one-fifth of the land surface, mountains provide direct life support for 10 per cent of all human beings on Earth. More important than the area they provide for human habitation, however, is the fact that, excluding the two polar icecaps, mountains provide more than half of the world's freshwater.

One of the most common words water uses in mountains is rain. Rain is born when warm, moist air rises up the steep slopes of mountains and cools, condensing first into cloud and then into rain. While this process is active everywhere the sun heats the surface of the Earth, it is most active in and around mountains, where steep terrain forces moving air rapidly upward into generally colder reaches of the atmosphere. This particular pattern of wringing moisture out of the sky is often greatly assisted by wind.

Many of the mountain ranges of western Canada are in the direct path of moisture-laden winds blowing inland from the Pacific. Each successive inland range of mountains wrings yet more moisture from the ocean air until, crossing the front ranges of the Rockies, these winds have little or no moisture left to give to the Great Plains.

The rainiest place in Canada, at least at the moment, appears to be Ocean Falls, on the central coast of British Columbia. In this lovely seaside community it rains on average some 4390 millimetres each year. That's about 14 feet of rain every 12 months. Precipitation decreases with each range of mountains that stand in the way of the inland advance of moisture-laden Pacific clouds. In Hope, where the Cascade Mountains begin, precipitation averages 2000 millimetres a year. At Revelstoke, where the Selkirks begin, annual precipitation averages just under 1000 millimetres. At Banff, on the eastern slopes of the Rockies, annual precipitation is just less than 500 millimetres. By the time Pacific winds reach the sun-hot prairies they are able to contribute little moisture. Average precipitation on the Great Plains of Canada, that other great continental sedimentary landform, is, in some places, less than 200 millimetres a year, a tenth of what it is on the coast. And in drought years rainfall on the plains can be even less.

The place in Canada where the least precipitation falls is Ellesmere Island in Nunavut. The lonely weather station of Eureka sees an average of only 71 millimetres in any given year. That works out to about 1.5 to 1.6 per cent of the precipitation at Ocean Falls. Ocean Falls is a temperate rainforest. Eureka is an Arctic desert. It is a measure of just how unevenly distributed precipitation is in Canada that such a range of rainfall exists in only a single, albeit very large, country. It is also a measure of how differently people think about water depending upon where they live in this country. You can tell a great deal about a person by knowing how much precipitation falls where they live.

What rain says to the forest

The language of water is well understood by trees. When rain falls on terrain that is forested, the canopy breaks the fall of the raindrops. When rain does hit the ground its fall is absorbed by a ground mat composed of fallen leaves or needles, twigs, moss and decaying plant matter. The irregular nature of this surface keeps the drops from splashing. As the rain is allowed to stay suspended on the surface, much of it goes directly back into the air through evaporation.

Once water seeps beneath the vegetative mat that covers the soil, it comes under the influence of plants. Plants, and particularly trees, absorb enormous quantities of water and transport it upward. The absorption of water by the roots of a tree is not accomplished independently. Water and nutrient transfer from the soil is facilitated by an extensive network of branching subsurface fungus strands in contact with the roots of the tree. The little understood partnership between fungus and root is yet another one of the life-creating wonders we can attribute to the exotic nature of water as a liquid. Without the close symbiotic relationship between water, tree roots and fungus, trees could not exist. This partnership is so central to the life processes of the tree that the combination is usually considered a single organ known as the fungus-

root, or mycorrhiza. Recent studies suggest that mycorrhizal fungi appear to collect nutrients very selectively as if the tree were able to communicate its needs to the roots.

Once water has entered the root system, it carries nutrients upward and imparts turgor to living cells. Water accounts for more than half of the live weight of most trees. Although some of the water drawn upward is used by plants in building their own tissues, a much larger proportion is passed right through the plant and "exhaled," or "transpired," as water vapour through billions of microscopic pores on the leaf surfaces, called stomata.

The volume of water that can be transpired by big plants like trees can be substantial. A single large Douglas fir, for example, can transpire 100 litres of water through its needles in a single day. When the sun comes out after a spring rainstorm, evaporation from the forest canopy will briefly surpass the amount of moisture released into the atmosphere by transpiration. But as soon as the surface moisture has evaporated, transpiration resumes generating more moisture than evaporation does. In a single hour following a heavy rainstorm, ten metric tonnes of water vapour can rise from every single hectare of evergreen forest upon which rain has fallen.

For the purposes of calculating the total volume and rate of water loss to the atmosphere from vegetated ground, evaporation and transpiration are generally lumped together and called evapotranspiration. The volume of water given back to the atmosphere through evapotranspiration can be substantial. An evergreen forest can easily give up 50 metric tonnes of water per hectare on any given day. This is a lot of water. Consider, for example, that if even half of the 50,142 hectare Peter Lougheed

Provincial Park in the Kananaskis region of the Canadian Rockies is below treeline, the trees in that park will give up 1,253,550 metric tonnes of water every day of the growing season. Forests evapotranspire enough water to form their own clouds. They can even create their own rain.

Over half the rain that falls in a forest returns to the atmosphere by way of this evapotranspiration. In so doing it creates the moist microclimate one feels the moment they enter a forest. With enough rain, big enough trees and a deep enough ground mat, you will produce a temperate rainforest in which the microclimate creates its own ecosystem.

The types of ecosystems water creates in the microclimates of rain forests are like no other on Earth. It is not just in the rainforests of Central and South America that researchers have discovered canopy ecosystems of unexpected complexity and diversity. It is well known that redwood trees filter fog through their needles. The form of absorption has a huge impact on the amount of water available in the area around the tree. A rain gauge on the ground under a healthy redwood can measure between 100 and 170 centimetres of precipitation a year. Lacking the absorptive contribution of the mature redwood, clearcuts in same area will record between 50 and 65 centimetres a year, less than half of what would fall to the ground in presence of these great trees.

The moist microclimate created by a single coastal old-growth giant can support a thousand strains of a single species of fungus. Hundreds of hitherto undiscovered species of insects live in close association with the mats of moss and lichen that festoon the upper third of the canopy in the coastal rainforests of the Pacific Northwest. This is

an ecosystem that includes birds, bats, flying squirrels and red tree voles that never leave the canopy.

It is now generally believed that lichens hanging from rainforest trees can provide up to three-quarters of the nutrients necessary to support an old-growth giant. Lichens metabolize nutrients they filter from the mist and fog that linger after heavy rains. They collect and store many of the nutrients that in drier climes would be blown away by the wind or washed into the soil in runoff.

Many lichens only exist in ancient forests. It is now known that many of them do not even begin to appear until the trees are at least 400 years old. It appears these lichens start developing only during the middle age of the tree. Scientists have discovered that some fungus species that arrive as part of this arboreal mid-life crisis kill insects that would normally eat the tree. As Alice Outwater explains in her book *Water: A Natural History*, the point here is not to create a campaign to "Save the Lichens." The point is that we do not know how to grow big trees. We don't even know how big trees grow. Only water knows and it is a secret it keeps with the trees.

Of water and watersheds

Even in the deepest forests, rain will slowly percolate down through the soil to become groundwater that will sometimes re-emerge as springs. Pursued relentlessly by gravity, some of the water will run over the surface of the ground mat and over top of the soil to join existing waterways. Just as leaves on a tree connect with a stem, the stems to larger branches, the branches to the trunk, and the trunk to the ground, runoff collects into tiny rivulets that join streams that become part of tributaries that join the main stem of great rivers until everything ultimately pours into the sea. The branch-like pattern by which water accumulates from rivulets to rivers defines the water catchment system of a given region. The catchment network in any given area is also called a river basin or, simply, a watershed. "Watershed" is an important word in the vocabulary of Canadian water.

The extent and nature of a watershed is defined by the decisions water makes in response to hard choices gravity offers in any given landscape. In much of Canada, the landforms over which water moves were created by earlier geological action of water. In addition to being made by water, these landscapes will also have been shaped by the influence of water in all its remarkable forms right up to the moment when running water makes its decision on how it will define a watershed. The conversation between water and landforms never seems to end. It is for this reason that watersheds never cease in their changing.

A watershed is not just a network of streams and rivers. It is a dynamic nutrient flow system around which entire ecosystems evolve. Rainwater runoff universally picks up and carries away sediment from the surface. Tiny rock particles less than 0.06 millimetre, 1/400th inch, in diameter, are fine enough to become suspended in runoff as it makes its way downhill into ever larger tributaries that eventually join the main stem of a watershed-defining river. Along the way, suspended organic material piles up against trees and branches in the streambed or accumulates in beaver dams. Suspended sediments and decomposing organic materials are also held back by natural dams as well as by other landscape features such as oxbows, outwash plains,

wetlands and lakes. All these are important words in the language of water. As Alice Outwater points out in *Water: A Natural History*, somewhere between 65 and 82 per cent of the organic debris that falls into any given small stream each year stays in the streambed. The rest is carried downstream. The implications of this organic nutrient retention are nothing less than life-giving.

In natural circumstances, most of the nutrients that contribute to a developing stream ecosystem come from the leaves, limbs and trunks of trees that fall into the water from its banks. Aquatic plants and animals have evolved with these inputs in mind. The breakdown of tree parts creates a nutrient base that supports a microbial ecosystem upon which larger organisms can eventually support themselves. The recipe is simple. You start with fresh water. Add a little broth in the form of decomposing leaves. Let nutrients swirl and collect in hollows and against fallen trees. Bake in the sun until the bacteria and algae show up. Sprinkle in a few invertebrates like snails and freshwater shrimp. Add a variety of insect types. Then sit back and watch the miracle of a trout come into existence in response to the conditions you have created.

Rain is both a noun and a verb in the language of water. Its children include the all the verbs of change inherent in the flow and life of the river. Water is, of itself, the agent that brings down trees and fills streams with nutrients. In concert with wind, branches and entire trees can be brought down by the weight of snow or ice. Driftwood can be carried into streams by torrents created by heavy rainfall, mudslides or avalanches. Visit a forest after a heavy rainfall and witness water's incredible power. Where flooding has carved away the riverbank, dozens of trees may have fallen in the water. The water has changed colour, and provided there is not too much mud for too long, everything you need to support an aquatic ecosystem will be suspended in it.

The language of water also embraces the manner in which water flows, like a corkscrew twisting in upon itself as it moves downstream. This manner of movement has a huge impact on the rivers as geological features and on the character and concentration of aquatic ecosystems. In a river, water flows faster at the surface than it does on the bottom, where it is slowed by friction as it moves over obstructions on the riverbed. Where the river bends, the faster flow of the surface pushes against the bend's outer bank like a race car pushing against a banked turn on an oval track. The pressure of the river's flow erodes the outer bank while the slower, siltier water at the bottom gravitates to the inner bank, where it drops some of its load of sand or gravel. This is how meanders are made along maturing lowland rivers. It is also creates the circumstances that allow life to establish itself along the entire course of the river.

The difference in flow rates, combined with the river's influence on the outer part of a bend, allows the water to carve out pools at the outside edge of each curve and deposit a bar of silt on the inner edge. Every fisherman knows that pools and riffles are distinct habitats, each having its own characteristic life community. The organisms that live in riffles at the inside edge of a river's turn are adapted to swifter, shallower water. Most of the creatures that live in riffle habitats are small enough to hide between the rocks or are adapted to clinging to their surfaces. A great number of fish species seek the relative protection of the gravel beds in which to lay their eggs.

The deeper pools at the outside edge of a river's curve offer completely different habitat possibilities. Because they are deep and because organic materials can fall to the bottom, these pools can support the whole bestiary that inhabits the water column. It is in these pools that the bottom dwellers can be found and where the biggest fish pause to rest and feed. Every imaginable expression of life in between these extremes shares this habitat. These deeps are the cities of the river.

The river likes sunlight. The light and warmth naturally stimulate algal growth that in turn supports more zooplankton. The temperature of the water determines the number and nature of the creatures at the base of the food chain. This in turn determines the potential diversity of the life that exists in, along and on the river. The river does not just carry water. It is an open vessel carrying blood to the skin of the Earth. Just like the blood in our bodies, the blood that is the river is an ecosystem in its own right. In fine balance with its surroundings, it teems with living nutrients which only water can deliver.

To appreciate the importance of rivers to terrestrial ecosystems, it may be useful to describe the combined influence that tributaries, streams and rivers can have on large land masses like continents.

Of countries and their rivers

Because so much precipitation falls on the windward slopes of uplands, it is in the mountains that many of the planet's greatest rivers have their origins. The longest river in the world is the Amazon. Born in the high Andes, the Amazon drains an astounding 6.15 million square kilo-

Giant steps, Banff National Park.

metres. It flows west to east across most of the vast South American continent, defining the boundaries and identities of seven countries. As of its most recent measurement, it is estimated to be some 6300 kilometres in length. But it is not just the length of this river that is so amazing. The runoff from the Amazon basin is a mind-boggling 6591 cubic kilometres. To get some idea of just how much freshwater this is, it is instructive to think about the Amazon's contribution to the Atlantic Ocean. Even though it is

a smaller ocean, six times more freshwater flows into the Atlantic than into the Pacific. The great Mississippi, with its 3.27 million square kilometre drainage system, contributes 4 per cent of that flow. The entire North Sea basin contributes another 3 per cent. The Amazon, though, contributes fully 50 per cent of all the freshwater that flows into the Atlantic, and 20 per cent of all river flows into the global ocean.

The next two largest rivers in the world are in North America. Though they are both enormous geological features, they barely hold a candle to the Amazon, especially in terms of the volume of freshwater and sediments they discharge. Measured in 1989, the Missouri–Mississippi river system is estimated to be 6260 kilometres in length. The Mississippi discharges some 580 cubic kilometres of freshwater and 210-million metric tonnes of sediment each year into the Atlantic by way of the Gulf of Mexico. That is a lot of water and a lot of sediment. It is hardly any wonder that the Missouri and the Mississippi figure prominently in American history and folklore. The next biggest rivers in the world are in Canada.

Great Canadian rivers

There are many, many big rivers in Canada. In fact, Canada has 9 per cent of the world's freshwater on only 7 per cent of the Earth's landmass. To appreciate just how important rivers are to this country, it is helpful to look at a map of Canada that illustrates its main watersheds. An excellent source of such maps is the National Atlas of Canada, 6th edition (1999–2009), published by Natural Resources Canada and available for free at the GeoGratis webpage nrcan.gc.ca/earth-sciences/geography/atlas-canada/map-archives/16868. For anyone who loves geography, the streamflow map from the Atlas's 5th edition (1995) is a joy to behold. It illustrates something that many Canadians tend to forget, that the rivers of Canada flow into five major ocean drainage basins: the Pacific, the Arctic and Atlantic oceans, Hudson Bay and the Gulf of Mexico. This map tells it all in bold colour. The watershed of the Pacific-bound coastal rivers of the northwest is depicted in green. They include the Yukon, Taku, Stikine, Nass, Skeena, Fraser and Columbia rivers.

Butting up against the evergreen of the coast is a great, wheat-coloured fist reaching in from the southern plains that extends to the east to join a great yellow horseshoe around Hudson Bay. This is the former boundary of Rupert's Land, that mythical and once unmapped region of Canada granted in monopoly to the Hudson's Bay Company in 1670. This great basin straddles parts of Alberta, Saskatchewan, Northwest Territories, Nunavut, Manitoba, Ontario and Quebec. Surrounding and flowing into Hudson Bay are too many fabled rivers to name. These include all the rivers that flow into Foxe Basin from the southern slopes of Baffin Island. Among the northernmost of the mainland rivers are the Thelon, Seal, Hayes, Albany and Moose and the myriad canoe routes of Northern Ontario and Quebec. Among these too is the great river system of the Canadian plains, the Saskatchewan.

Interestingly, there is also island-like, khaki-coloured swath labelled "Churchill," for a river which, at Southern Indian Lake, appears to get diverted somewhat away from its course toward James Bay by doubling back southward and then back around northeastward to join the Nelson.

At the bottom of the map there is a small swatch of

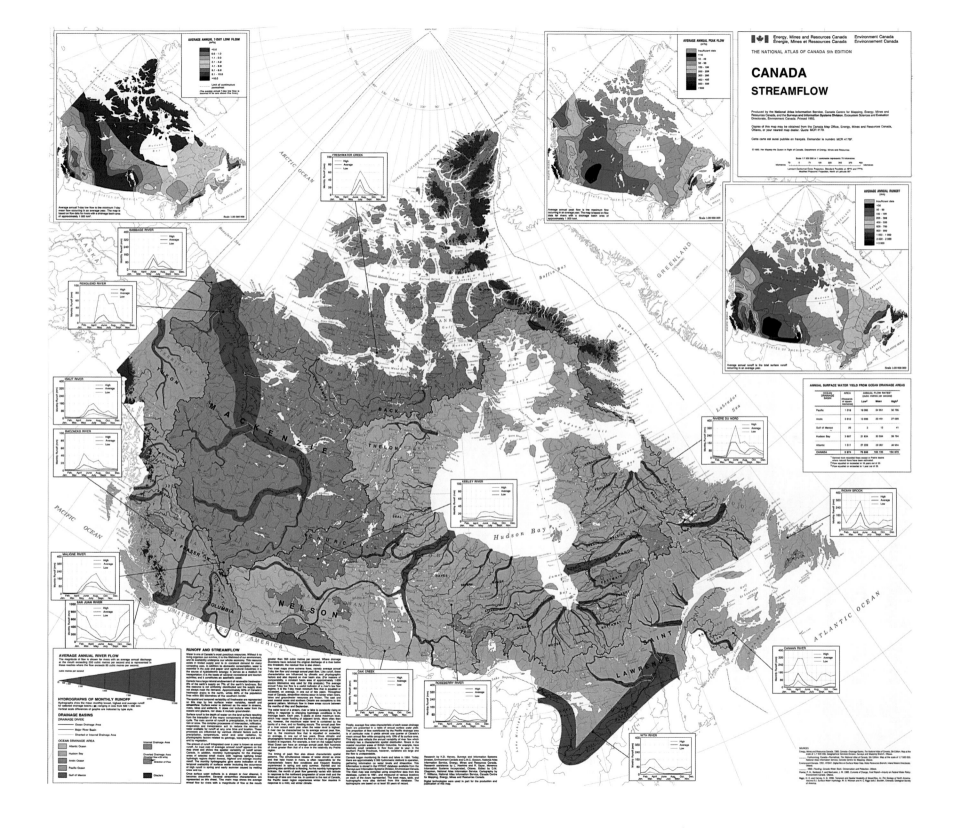

purple creeping upward into the yellow as though some-one spilled wine on the table where this great map is spread. This grape stain delineates that small but significant part of Canada in which the waters flow south into the United States to join the Missouri and Mississippi. The watercourses in this region include the north and south branches of the Milk River system.

The St. Lawrence

To the east of the waters that flow into Hudson Bay is a large deep-blue boot that looks rather like Italy fallen on hard times. But at roughly four and a half times the size of Italy, this boot is more mukluk than high fashion. If you thought of the Maritimes as tassels you could see it as a great blue moccasin worn by a giant voyageur. Or, if you tilted it slightly, it might seem like a ski boot with with Point Pelee sticking out of the sole. Whatever you choose to make of it, this is the drainage domain of Canada's best known and most heavily travelled river, the beloved St. Lawrence.

The story of the St. Lawrence is essentially the story of early Canada. Though hundreds of generations of native peoples knew of or lived along the river before his arrival, the European most associated with the St. Lawrence was the French navigator Jacques Cartier, who sailed up the river in 1534. Under orders from King Francis I of France, Cartier was directed to explore ways to compete with Spain in the search for a northwest passage to India. En route Cartier was ordered to establish French claims to lands where it was hoped gold might be found.

Cartier sailed up the St. Lawrence and over time met thousands of natives. He also encountered a "land cul-tivated and beautiful, large fields full of corn of the country." In other words, he encountered another civilization. Though he found no immediate evidence of gold, it was the river that impressed Cartier most. Though he could have hardly guessed it at the time, the St. Lawrence drained more than a million square kilometres of a land Cartier described using the term "kanata," a word used by Iroquois Chief Donnaconna which in his language meant "village." From its farthest headwaters the St. Lawrence is 3058 kilometres long and, depending on the year, can carry between three and four million tons of Canadian earth into the Atlantic every year. Cartier was sensitive to the fact that this was no ordinary stream. The French have two words for river. *Rivière* describes the small rivers that flow through most of hometown Canada. Then there is *fleuve*. What's that, you ask? Well, the town of Tadoussac is located on the north bank of the St. Lawrence at a spot where the river has widened to some ten kilometres across. Visiting there one December, I asked a local exactly what *fleuve* meant in French. He noted my accent and smiled. "I want to translate as exactly as I can into language a Western Canadian like you will understand," he teased. "Think of a *fleuve* as a bejeesus big river; think of it as the mother of rivers; think of it as the foremost of all flow." Clearly, the St. Lawrence isn't a river, it's a *fleuve*.

Though it is immense, the St. Lawrence is not the only *fleuve* in Canada. If we return to our streamflow map of Canada, we see to the northwest, depicted in mauve, the huge drainage region that flows into the Arctic Ocean. This watershed looks like it covers at least a quarter of the entire country. Within this immense region we find small but very historic rivers like the Back and the Coppermine.

We also find the greatest river of them all in both length and discharge, the mighty Mackenzie.

The Mackenzie

In 1778 Peter Pond was the first to connect the fur trade routes radiating outward from Hudson Bay with the Mackenzie Basin. This immense river is named for Alexander Mackenzie, one of this country's greatest explorers, who followed the full length of the river to its mouth in 1789. The Mackenzie is the 13th-longest river system in the world and the longest in Canada. If its upstream tributaries are counted, it is 4241 kilometres in length, nearly half as long as Canada is wide. By virtue of its length and the volume of water it carries, the Mackenzie is the longest navigable river system in Canada. Its drainage area is an immense 1.8 million, square kilometres, an area that represents about 20 per cent of Canada's 9.98 million square kilometre land mass. It is a complex watershed composed of huge tributaries and spectacularly large lakes. Its tributaries include the Peace, Smoky, Athabasca, Pembina, Liard, South Nahanni, Fort Nelson, Petitot, Hay, Peel, Arctic Red and Slave rivers.

Though its runoff, depending upon the year, may not be as high as the St. Lawrence's, the Mackenzie manages to contribute a stunning 325 cubic kilometres of freshwater to the Arctic Ocean each year. Its sediment discharge is huge: 100-million tonnes each year, which is 15 times the volume carried by the St. Lawrence. Though the Mackenzie is arguably the most remarkable natural feature in this country, few Canadians have ever seen it.

Lakes

Water also plays a central role in the second mechanism by which landforms are shaped: the creation of lakes. Most of the lakes that presently exist in the world were a result of the last ice age. It has been estimated there may be as many as two million lakes and ponds in Canada. They cover no less than 9 per cent of the nation's landmass and discharge. They are everywhere, but only 31,754 are bigger than a pond. The Atlantic provinces possess 1,792 freshwater lakes larger than three square kilometres in area. Quebec has a staggering 8,275, more than twice as many as Ontario's 3,899. Though many Canadians will find this unimaginable, the prairie provinces together have 5,382 lakes bigger than three square kilometres. British Columbia, for all its fame as a land of lakes, has only 861. The real freshwater, however, is not in the south. The Yukon, Nunavut and the Northwest Territories are the ultimate lakeland. Together they possess 11,545 lakes larger than three square kilometres.

Most of Canada's lakes are found in the higher latitudes, created after glacial ice scoured the surface of North America. The majority of these lakes are in the northern geological province of hard rock called the Canadian Shield. Five of the largest, however, form an imperfect boundary between Canada and the United States. It is widely held that the Great Lakes constitute the largest freshwater system on Earth. Some estimates offer that these five lakes – Superior, Michigan, Huron, Erie and Ontario – contain roughly 18 per cent of this planet's liquid freshwater resource.

We have so many lakes in Canada that we have run

out of names for them. There are 204 Long Lakes in Canada. Lac Long appears in 152 different places on our map, proving once again that we are fully bilingual even in our redundancy. Lac Rond appears 132 times, exactly 25 more times than Round Lake. In looking at the names of Canadian lakes it would be easy to get the impression that fishing is very good here. There is no other way to explain why Lac à la Truite might appear 109 times on the map. Either we have very little imagination or we just have a lot of lakes. How else to account for the patterns in our lake names? There are 182 registered bodies of water called Mud Lake, 101 called Little Lake and 100 called Moose Lake. The fact that Lac Perdu appears 101 times on the map suggests that even when we get lost we are never far from a lake. We live lake on lake upon lake. No wonder Canadians spend so much time on water; there is no place else to go.

Jacques Cartier was wrong when he assumed there was no wealth in Canada. While Canada's mineral assets may not have been immediately obvious, the territory was rich in wildlife, which turned out to be a valuable resource in its own right. Cartier observed that the Indigenous peoples who welcomed him possessed valuable furs and foresaw the beginning of substantial trade. But it would not be Cartier who would establish the mutually respectful relationships with native peoples that would form the foundation of trade. That wise and far-seeing man was Samuel de Champlain.

The canoe frontier

After establishing Quebec in 1608, Champlain set out to expand and profit from the St. Lawrence fur trade. To do this he needed to establish excellent working relations with the native peoples. He also needed to ensure that the French mastered the use of the canoe. The success of the French endeavour on both counts can be measured by the extent of their explorations on the river highways of the interior. It was considered an everyday event to travel a thousand kilometres by canoe from Quebec City or Montreal to Sault Ste. Marie. It was not the least uncommon for voyageurs to travel 2000 kilometres to Lake of the Woods. Though such trips were unprecedented in the history of the exploration of this continent, the French undertook even longer canoe journeys to extend their influence and trade into the Canadian West.

At the height of French influence in Canada, the canoe frontier extended from the Maritimes to Saskatchewan and south along the west slopes of the Appalachian Mountains all the way to Louisiana. Were it not for an unexpected British victory on the Plains of Abraham near Quebec City in 1759 and the later recognition of the independence of former British colonies following the American Revolutionary War, the French would have controlled much of the fur trade that existed at the time in Canada and almost all the territory in the Mississippi basin, where the canoe was the established mode of travel.

The fur trade did not decline with the rise of British influence in Canada. Nor did canoe use. The great inland waterways continued to be the only effective way to travel. As beaver hats grew ever more popular in fashionable circles in London and Paris, the beaver and other fur-bearers were trapped out in the St. Lawrence and Great Lakes areas. Fur-trade enterprises such as the Hudson's Bay Company and later the rival Northwest and XY companies competed fiercely to open up trade in increasingly

remote places. By 1793 Alexander Mackenzie had expanded the European canoe frontier to the shores of the Arctic and Pacific oceans, creating a British fur trade empire that extended from sea to sea to sea. Later canoe expeditions by Simon Fraser and David Thompson defined the final unexplored regions of the continent, extending the fur trade to the upper reaches of the Fraser and to the great interior valley created by the Columbia River. Even after an exhausted and nearly bankrupt North West Company was absorbed by its bitter river the Hudson's Bay Company in 1821, the only change made to the canoe was to make it bigger so that it could carry more. The famous Montreal canoe, built in Trois Rivières, was often more than 12 metres long. It could carry 3500 kilograms of freight and eight to twelve paddlers. In their day these "stretched limo" versions of the classic birchbark canoe turned a lot of heads. Over time they spread an entire European material culture westward and on their return carried back to England the bounty of the nation's wildlands in neatly tied 90-pound bundles. When the canoes left Montreal they were filled to the gunwales with trade beads, knives, pots, guns and, later, rotgut whisky. When they came back from the north and the west they were filled with beaver, bear and marten pelts and legends of a land immense beyond imagining.

How do you put such bounty into words? Water is our nation's wealth. For the first two centuries after European contact, Canada was a water world. European trader–explorers followed the waterways in every direction, seeking out native peoples to trade with. Canadians, native and European alike, travelled on rivers in the summer and on the ice that formed over them in winter. In the practical

Ponder a single grain of sand and perceive a tool, at once cut, cutting and smothering its own work. A rain of grains is the sediment filling our sea.

And we, we are castaways, cast downward instead of outward. Ten miles of air, five miles of water – a difference of substance but not dimension.

We know of flying fish and diving birds, but really, all birds are fish and all fish fly. —Peter McGuire, 1974

Trilobite fossil, Yoho National Park

language of the river, Canada meant water, and it was on water that our nation's first economy floated. The connection between the canoe and Canadian culture made this country unique. Water still resides deeply in the collective consciousness of Canadians. A stream flows through the innermost recesses of our minds and sliding silently over the riffles that form our deepest memory is a bark canoe.

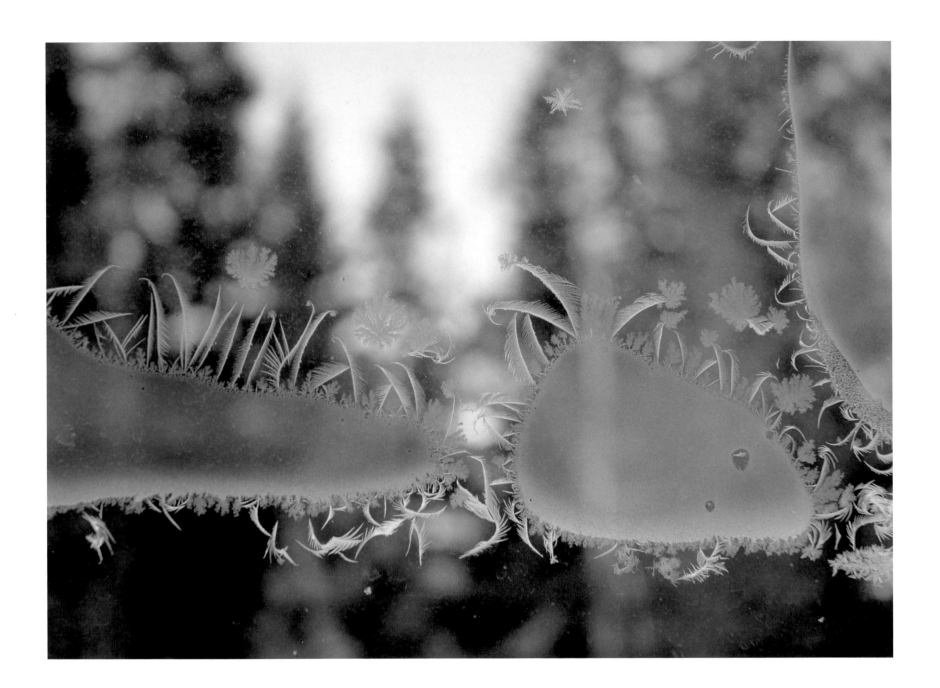

As the planet passes through its orbit, we get less sunlight.

Less sunlight makes us a lot colder. It cools the air and brings us winter.

What before was water freezes in ponds and lakes and rivers and becomes

ice; what before was rain freezes in clouds and becomes snow.

And that, very simply, is that.

—ADAM GOPNIK, *WINTER: FIVE WINDOWS ON THE SEASON*

TWO: What Winter Does to Water

WHILE THE CANOE IS AN IMPORTANT ELEMENT of Canadian identity, it is what winter does to water that is the essence of what the world imagines when they think of Canada. Our success in triumphing over the challenges of the long Canadian winter are largely attributable to the ways we employ the unearthly qualities of water as expressed in its solid as well as its liquid form. But despite all the ways it influences our identity, few Canadians truly understand the amazing processes by which water actually becomes ice and snow. Even fewer appreciate the wide-ranging ecological and cultural implications of the eccentric characteristics that emerge in these common substances as they form. In many ways it is the wonder of water in winter that makes us Canadian.

Given its uniqueness even in its liquid state, it should come as no surprise that when water takes the form of ice or snow it brings along with it all its unworldly qualities as a substance. Under extreme temperatures and pressures in laboratory circumstances, frozen water has been observed to take on at least a dozen different forms. This, apparently, is a record number of states in which a solid can exist. The basis of all these kinds of ice, however, is Ice 1, which is the kind of ice you can create in a refrigerator or that forms naturally in your backyard or near the surface of a forming glacier by simply cooling water below its freezing point.

This basic form of ice has fundamental qualities that become exaggerated in the other, more extreme forms of ice, many of which are uncommon or non-existent in nature, at least on Earth. When simple water freezes, whether in a refrigerator, a lake or ocean or a water droplet in the atmosphere, each water molecule is joined by hydrogen bonds to four others. The result is rather like what

Ice crystals.

might happen if everyone in a milling crowd suddenly decided to organize themselves in a series of dance squares. Just as in the dancing crowd, the resulting network of joined molecules in freezing water forms a crystal that expands outward to create a great deal of empty space within. It is the expansion of the crystal outward and the creation of the empty space inside the forming crystal lattice that gives ice a density that is less than liquid water. It also gives ice its tremendous expansive power.

The crystal structure of frozen water

The crystal lattice that is formed as water freezes has six identical sides. Though it is not known why, the lattice is also flat. This symmetry, which is established at the atomic scale, exerts an astonishing influence on the range of six-sided shapes these crystals can assume. The molecular lattice is a crystal around which a seemingly infinite variety of flat hexagonal arrangements can be created. This appears to be particularly true in the case of snowflakes.

Snowflakes form in the atmosphere when water vapour freezes out on a "seed particle." A lot of different materials can perform this function. Snow crystals can form around motes of dust from a construction site, particles of stone sheared by the wind off the Great Wall of China, pollen carried into the wind from a farmer's field or specks of ash blasted into the high atmosphere from a distant volcano. Snowflakes also form around particles released into the air in automotive exhaust, salt spray from oceans, broken bits of ice or even around micro-organisms floating in the atmosphere. When you taste snow you taste the dust around which it formed. Though it is a classic

Canadianism, the expression "pure as the driven snow" is an oxymoron. It is, however, an oxymoron with interesting philosophical connotations. At the heart of even the most perfect white there is likely a speck of black.

Snowflakes are almost always hexagonal, but the exact nature of each crystal appears to be uniquely defined by a range of micro-environmental circumstances that exist at the time of its formation. It is something that has fascinated humans for probably as long as we have experienced snow. The first recorded observations of how the shapes of snowflakes changed with prevailing meteorological conditions were made in 1675. It was not until the invention of photography in the early 19th century, however, that the truly amazing manner in which snow creates infinite variation on its own hexagonal theme began to be fully explored, recorded and widely shared.

Because of their flatness, snow crystals were relatively easy to photograph, even with primitive microscopes and cameras. While many dabbled temporarily in such photography, at least one amateur found snow beautiful enough to take a serious interest in snowflake photography. Over a period of fifty years, American farmer and photographer Wilson Bentley and his assistant W.J. Humphreys created more than 5,000 photomicrographs of snowflakes. No two were the same. A summary of his lifetime of observations, Bentley's 1931 book, *Snow Crystals*, remains a scientific classic even today. He was a man who loved snow.

The "no two flakes the same" myth created by Bentley and others persists today. Despite the popular assumption that every snowflake ever to form is unique, there is nothing in nature that suggests that this has to be so. An American meteorologist named Vincent Schaefer once

calculated that it took more than one million snow crystals to blanket two square feet to a depth of ten inches. That would suggest that about 13.9 trillion snowflakes per square mile, or about 5.38 trillion per square kilometre, could fall in any given winter storm. It is estimated that, due to the current concentration of continents in the northern hemisphere, snow falls at some time each year over about a quarter of the Earth's terrestrial surface of 148 million square kilometres (57 million square miles). In all those trillions upon countless trillions of snowflakes it seems impossible that no two could be alike. But when you look at the odds, perhaps it is not out of the question. It is estimated that there may be as many as 10,000,000,000,000,000,000 (10^{18}, or ten quintillion) water molecules in a typical snow crystal. The possible arrangements among these molecules is almost infinite. David Phillips, a popular senior climatologist with Environment Canada, has estimated that the number of snowflakes that have fallen on Earth over the course of time is 10 followed by 34 zeros. That is a lot of snowflakes. While experts can't say for sure, there is general agreement among scientists that the likelihood of two being identical is next to impossible.

While we may never know if two can ever be exactly the same, we do know the kinds of conditions that create various kinds of snowflakes. In distinguishing such conditions it is important to note the difference between snow crystals and snowflakes. A snowflake is a conglomeration of individual snow crystals. Both whole and broken, these crystals come together to form a snowflake as they fall through the atmosphere. As any Canadian will tell you, snowflakes, depending on temperature and humidity, can

be as tiny as pinheads or as big as two-dollar coins. They can be feathery light or almost as heavy as water. They can be almost as dry as dust or wet as rain. Thanks to a Japanese scientist named Ukichiro Nakaya, we now know the conditions in which a number of basic types of snow crystals are formed.

The many faces of snow

The characteristic hexagonal shape of snowflakes is prevalent, but not at all temperatures. Between 0 and -3°C, for example, snowflakes form as flat plates with hexagonal shapes. These are the shapes we know best, for this is the snow that falls at cool but still pleasant temperatures. This is Christmas card snow, the snow we remember playing in as children.

Between -3 and -7°C, snowflakes assume needle-like shapes. Cross-country skiers often experience the difference between snow in the form of plate crystals and snow as needles when they climb from the valley floor into cooler temperatures and the wind brings the snow sharply into their faces. As the temperature drops to between -22 and -25°C, humidity begins to play a role in determining the shape of snow crystals. If the humidity is low, plates are formed. If the humidity is high, snowflakes assume the shape of dendritic stars. Below -25°C, snow assumes the form of prismatic crystals. Canadians know this snow. This is the snow of the deep Canadian winter, of prairie blizzards and Arctic night.

In 1951 the scientific community and the International Commission on Snow and Ice agreed on seven basic forms of falling snow crystals. These include star, plate, needle,

column, column with endcaps, spatial dendrite and the catch-all classification of irregular flakes. In addition to these seven categories the commission also identified three other classifications of falling frozen water that did not assume crystalline shapes. These include ice pellets, hail, and crystals heavily coated with rime that are known as graupel. What is interesting about living in Canada is that in many places in the spring you can often observe at least two or three different kinds of snow crystals, as well as ice pellets and graupel, all within a couple of hours. Canada is the kind of place where there is a reason to get positively excited about snow. Here, snow is a dialect of water everyone speaks – in both official languages. In a song he wrote in 1964 for a National Film Board production called *La neige a fondu sur la Manicouagan*, Gilles Vigneault got it right with his opening line: "Mon pays, ce n'est pas un pays, c'est l'hiver" ("My country is not a country, it's winter").

As anyone who has experienced winter knows, snow changes as it forms and falls and continues to change after it hits the ground. The progression of these changes is part of the wonder of water and part of what makes Canada such an interesting place to live, especially in winter. Though snow expresses itself in a wide range of impacts on the winter landscape, the one most directly experienced by Canadians is the influence of accumulating snow on our roads and highways.

Our slippery roads …

Though snow and ice are both technically solids they have one quality that most solids don't possess: they are slippery. In most circumstances in the natural world, the sliding of one solid over another is inhibited to a greater or lesser extent by friction. Ice is utterly remarkable in all of nature in that it offers, depending on temperature, 20 to 30 times less frictional resistance to motion than almost all other solids. The everyday implication of this fact of physics dogs Canadians all winter. Ice's reduced frictional resistance makes roads treacherous. We respond to this in a number of ways. We spend millions clearing roads of snow and millions more applying abrasives so as to increase the frictional response of the road surface to the tires on our cars. Though this practice is in decline because of its effect on surrounding watercourses in the spring, we also apply thousands of tonnes of salt to our roads to depress the melting temperature of the surface ice so that it can be channelled through the treads of the specially designed tires we put on our cars in northerly latitudes.

Over the four generations since the automobile came into common use, Canadians have become for the most part masterful at adapting to the reduced frictional resistance of ice on their roads. Until recently, Canadians needed only a snowstorm or two to adjust fully to safe winter driving attitudes and practices. Developing automotive technology and the increased popularity of the four-wheel drive sport utility vehicle, however, have illustrated that even intelligent, road-experienced Canadians can be seduced by advertising imagery. In a triumph of marketing over common sense, many Canadians now trust that their four-wheel-drives can violate the laws of physics. Each winter the physical nature of water when it freezes flips that kind of thinking on its roof.

The reason so many four-by-fours end up in Canadian ditches is that their drivers have bought into a myth of

frictional resistance that has no basis in nature. While four-wheel-drive vehicles do have a decided traction advantage in snow, this advantage can become a disadvantage at high speeds on ice. At low speeds in snow, additional driving wheels double the surface area that comes under traction. When this traction is coordinated by an on-board computer, the vehicle automatically makes small, continuous adjustments to the slipperiness of the road surface and, rather like a rocket constantly correcting its course in space, makes its way in a more or less straight line in the direction it is steered. At appropriate speeds the tires are able to compress the snow, melt it under pressure and channel it through the treads to momentarily create a passable road surface under the wheels. Most fail to realize

that this little trick would be completely impossible were it not for the amazing nature of water as a solid.

Drivers of ditched vehicles almost always blame the roads. It is not the roads that are to blame so much as the fact that they have forgotten Canadian winters demand special judgment. The imagery of television advertising notwithstanding, Canada remains Canada after all. Water wouldn't have it any other way.

... and our slippery slopes

The same self-lubricating characteristics of solid water under pressure that make roads so perilous also make the object of so many of our winter trips enjoyable and memorable. The fact that pressure evenly applied to the surface of snow will create a thin, lubricating film of liquid water is the basis for one of the most popular recreations in Canada. Yet another in an endless series of boons it offers humankind, water is proud to sponsor the sport of skiing. Water is the sole and utter reason an entire industry can exist to encourage you and your friends to slap boards on your feet and giddily launch yourself down a mountain slope at a hundred kilometres an hour and live through it. All the fun and wonder of skiing are owed once again to the wonder of water.

More than 150 years ago, the British chemist James Thomson, the brother of Sir William Thomson (Lord Kelvin), was drawn to the crystalline properties of snow and to the remarkable sticky nature that ice exhibited near the freezing point. Thomson noted that yet another common but amazing quality of water as a solid resided in the fact that two pieces of ice can be made to stick to one another. This, Thomson observed, doesn't happen with other solids or crystals. Thomson surmised that snow and ice could be made to stick together because the act of pushing them together created enough pressure to lower ice's melting point. But this is only part of the wonder of water as snow. It sticks to itself but not to everything else.

It was not until 1901 that a British engineer named Osborne Reynolds was able to explain why a ski passing over snow didn't stick to it. Reynolds was the first to scientifically observe what skiers had been using to their travel advantage since the Vikings first slapped on the boards a thousand years before. Under even temporary pressure, snow melts to form a thin, slippery film of liquid water. If this thin film was a hazard if you were driving a car, it was an absolute delight to someone standing on a mountain or ridge contemplating a thousand-metre slope covered with a metre freshly fallen powder. As any skier will tell you, however, the self-lubricating capacity of snow is very much a function of temperature. Skis are now designed around this fact.

While certain kinds of wood have long been known to slide over snow easily, it was not until two Cambridge University researchers studied the relationship between temperature and pressure on the snow's surface that modern ski technology began to develop. In 1939, two British scientists, F.P. Bowden and T.P. Hughes, performed a series of ingenious experiments to explore how effectively skis made of different materials created frictional heating as they moved over a snow surface. Bowden and Hughes discovered that because heat was conducted so quickly through metals such as brass, skis made from

Blowing snow survey, Marmot Creek Research Basin, Alberta. Photograph courtesy of the Global Water Futures Program

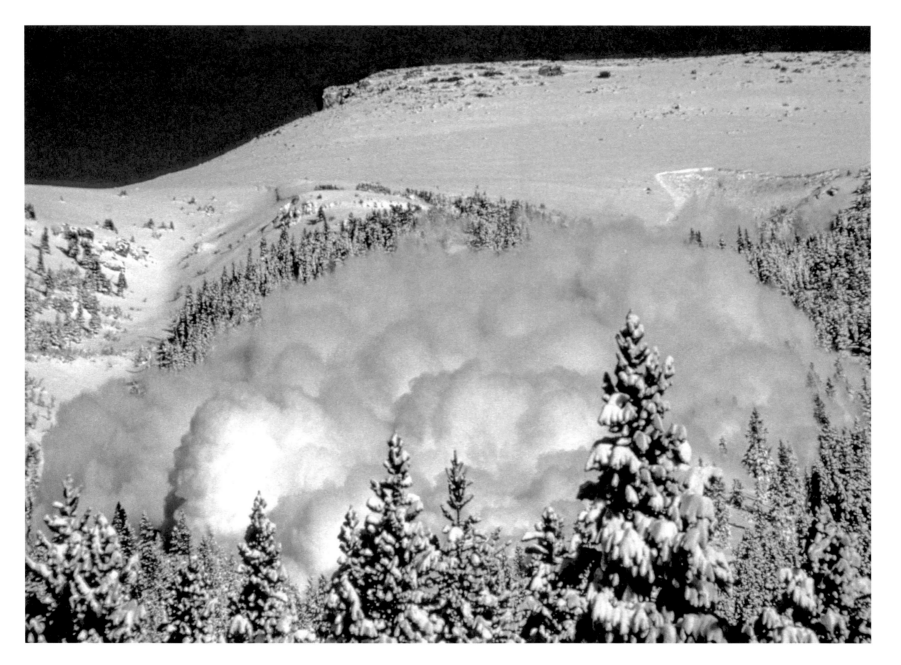

these materials produced less fictional melting than skis made of a hard plastic like ebonite. This preliminary research became the basis of the development of the sophisticated high-tech materials that go into today's ski equipment.

The research into the remarkable nature of snow, combined with enthusiastic support for the sport by early Swiss and Austrian mountain guides, is the basis of the popularity of skiing in Canada today. It was skiing that made the Canadian winter ours. It is with great pride that we promote our winter all over the world. It should never be forgotten, though, that it is the physics of snow and the abundance of water in winter that makes Canada a world ski destination.

The settling snowpack

As snow falls it does not create a solid blanket on the ground. What essentially comes into existence is an unstable conglomeration of air and crumbling snowflakes. Newly fallen snow is more of a cold froth than a solid. The larger the accumulating flakes, the bigger the air pockets that are created between them. The more intricately branched the flakes, the more rapidly they undergo metamorphosis.

As soon as snow begins to accumulate, the snowflakes that compose it begin to sublimate away from the points in the stars. The hollows of each snow crystal begin to fill in at the expense of the points and edges. The intricate original patterns and surface details decompose. Small crystals lose their molecules to larger crystals, which, as the process continues, eventually become small, round grains.

As the snow ages this process continues until the snow settles and becomes denser. In time, further sublimation creates what is called hoar snow. When this happens the weight of the snowpack often causes it to settle on its own. Every Canadian has experienced this. Walking or skiing across an expanse of snow there is suddenly a "whumpff" and you find yourself closer to the ground with the rest of the settled snowpack.

In steep terrain, ball-bearing-shaped hoar crystals forming at the bottom of a snowpack can cause real trouble. As the weight of accumulating snow grows over the course of the winter, instability deep in the snowpack, resulting from the formation of hoar crystals at the base of the snow load, causes avalanches. Depending on the steepness of the slope, avalanches can cause tremendous damage. If a snowpack releases and then falls over a vertical mountain wall, the descending mass will displace the air below it, generating winds that in some cases can be as high as 500 kilometres an hour. Even though the snow that generated these winds doesn't always make it to the valley floor, avalanche storms of this magnitude have completely splintered forests though which these winds pass.

Water in the form of avalanching snow can entomb people unfortunate enough to be trapped within. Though roughly twenty Canadians a year die in avalanches, this number is expected to rise as more people explore steep winter slopes on snowmobiles, skis and snowshoes and as snow conditions become more variable as a consequence of changing winter temperature regimes.

Powder avalanche near the Columbia Icefield. Photograph by Frances Klatzel

An overhanging carapace of ice, hollowed underneath by melting,

forms a dome illuminated from above by the sun. Freya hacks steps to it, and Hal follows.

They stand together, watching as capillaries of water run and swirl along the

translucent ceiling of the dome. In places the thin trails flow together, swirl and let fall a spray

of glittering droplets. They can see a whole labyrinthine network of interlacing rivulets,

lit by the sun, threading among the rounded crystals of the deliquescing ice.

Freya sets up her camera and squints into the viewfinder, then turns to Hal.

"I sometimes have the feeling the ice is alive."

—THOMAS WHARTON, *ICEFIELDS*

THREE: *Ecology as Defined by Winter Water*

CANADA WOULD HARDLY BE THE SAME PLACE without snow and ice. Far more important than the mere fact of their existence is the role they play in the creation and maintenance of winter ecosystems, not just in Canada but everywhere in the winter world. As life is largely water-based, all terrestrial ecologies are essentially defined by the physical properties of water at various temperatures. It is for this reason that the modern temperature scale is defined, not by what heat or the lack of it does to us, but by what it does to water.

The bulk of the life processes we rely on for our survival take place between the temperature at which water freezes and the temperature at which it boils. If life were confined to what water does at these temperatures, much of it could not exist in winter nor would the diversity of life survive the cold. Fortunately, however, living things have been working on the problem of preventing or slowing the crystallization of water at its freezing point within their systems for a very long time. Adaptive mechanisms have evolved to allow life to sometimes circumvent the physiological problems that occur as a result of water freezing within living cells. What becomes physiologically possible

Bow River in Winter.

at the cellular level ultimately expresses itself both morphologically and ultimately as behaviour at the species level. These manifold influences merge at the ecological level until what you end up with is not just the survival of life in winter but its perennial triumph over it.

Snow as a landscape in its own right

To elucidate the role of snow as both a landscape in its own right and as an agent that dramatically shapes ecosystems and the behaviour of the living things that populate them, it is important to first dispel two popular misconceptions about the Canadian winter. The first is that snow in Canada is white. The second is that there is no such thing as an iceworm.

At the heart of each crystal there exists a mote of dust or organic debris. As the crystal assumes varying shapes at different temperatures, snow is only very rarely pure white. Like water in its liquid form, snow is also highly reflective of the circumstances in which it is viewed. On overcast days it can seem grey. As Ruth Kirk reported in her classic book *Snow*, it can be shadowed and textured or reflect the tints of the sky. In certain kinds of light snow can appear blue or even violet. In bright sunshine it can glitter like sequins on a snow queen's dress. Under moonlight snow can glow. Ask any artist and they will tell you that the really difficult landscapes to paint are those in which water exists in the form of snow. In an essay entitled "The Colour of January" illustrator Jocey Asnong observed that "the colour of early twilight in winter looks more like lavender than blue against the brilliant white of the snow…" She noted she had been working unsuccessfully for more than 20 years to mix colours on her palette that perfectly matched the blue of deep cold and suspended ice crystals as the last light of the day pauses on the peaks.

Organisms within can also affect the colour of snow. While northern native peoples undoubtedly observed curiously tinted snow for thousands of years, the first scientific observations of this phenomenon were not made until British expeditions began to explore the Canadian Arctic in search of a northwest passage to the Pacific. During the high Arctic summer of 1818, Captain John Ross observed and collected late-lying snow that had developed surface red patches and long pink streaks. Back home in England, scientists couldn't agree on what caused the snow to colour in this way. It took decades of advancing science before "pink snow" was identified as one of a hundred different species of microscopic algae that actually flourish in, among other places, spring snow.

Algae that turns snow pink is commonly found in the mountains of the Canadian West, where it was first identified by a University of Toronto geologist named Arthur Philemon Coleman during a mountaineering expedition to the Clemenceau area, near Jasper, in 1892. On his descent from a remote summit, Coleman described "beds of snow red with *Protococcus nivalis*, and saw black glacier fleas all alive in the sunshine." This is the first popular reference to "pink snow," or snow algae, in the literature of the Canadian alpine. It is also the first reference in popular culture to other creatures that live out their life cycles in the subnivean, or "under snow," environments of Canada's western mountains.

Snow algae and snowfleas are both common elements of the Canadian winter. So are iceworms. Relatives of the

earthworm, all of the iceworms known today belong to a single genus, *Mesenchytraeus*. Most species are no more than two centimetres in length and very thin. Iceworms can sometimes be seen in the thousands writhing in packed masses at the surface of spring snow. They appear to feed on algae and to move upward in the snow mass by absorbing the heat of the sun. Snowfleas and stonefly larvae are also common on and near the surface of spring snow, as are microscopic rotifers and single-celled protozoans.

Snow as ecosystem and habitat

Recent studies indicate that snow is in fact an ecosystem in its own right, possessing bacterial and fungal chains that decompose the bodies of creatures that live within. Even predators exist in the ecology of cold. Spiders hunt the fauna of the snows and birds haunt the snows seeking spiders. Under careful examination, two popular misconceptions collapse simultaneously. Snow is seldom white and seldom "pure."

We now know that if it persists long enough, snow cover becomes a habitat in itself and an ecosystem separate from the landscapes upon which it has fallen. Snow is a unique environment with its own remarkable hydrological conditions. All organisms living in or under a given snow ecosystem must contend with these conditions in order to survive and take advantage of them if they are to enhance their adaptive capacity through natural selection. Some of the most remarkable adaptations in all of nature occur in snow ecosystems.

If you live in or regularly visit the Rocky Mountains you have likely seen clear evidence of the existence of some

Pink snow. Photograph courtesy of Scientific American blogs

of these adaptations. The cold-hardy species most people are likely know best are the *Collembola*, or what are commonly called springtails or snowfleas. Some 28 species have been identified in polar and high mountainous regions around the world. Three species have been identified in Canada. An outlier of Mount Allen in the Kananaskis Range near Canmore is called Mount Collembola. Historian Ruthie Oltmann tells us the mountain was so named after a researcher named Jan Sharp found *Collembola* at altitudes of between 2600 metres and 2800 metres on the upper slopes of its main ridge in the early 1970s.

Because they have internal as opposed to external mouthparts, the *Collembola* are not true insects. They are a group of winter-active hexapods that thrive in subnivean habitat at temperatures down to -7.8°C. As with mites, *Collembola* are most likely to be seen in late February or March, as this coincides with greater light penetration through the denser snow cover. They are not called springtails for nothing. Some species are known to travel 200 to 300 metres a day, or as much as or two to three kilometres in 10 days of fair weather. Collembolans that live in snow at high altitudes have pigment granules in their epidermal cells as protection against strong solar radiation. They can also occur in large populations on melting snow. Depending on the colour of the aggregating species, they can turn the surface of the snow a sooty colour or red or even gold.

Creatures that thrive at or below the freezing point of water are known as cryophiles. They like the cold. There are a lot more of these than anyone suspected. A 1968 study reported the presence of 466 species of micro-organisms found in snow, of which 77 were fungi and 35 were bacteria. The remainder were algae.

The best known cryophiles found in the Rocky Mountains are of the same genus of red algae Coleman collected near Jasper in 1892. This algae is routinely found in snow in concentrations large enough to turn the spring and summer snowpack pink. Snow algae are what are known as "obligate cryophiles," in that their adaptation to cold is not merely a peripheral trait evolved to cope with occasional cold during their normal existence. "Obligate cryophiles" have no choice in where they live; they live in cold environments and nowhere else. Snow is their principal habitat. Conversely, cold-tolerant species that *can* live in environments other than snow, such as soils or water, are called non-obligate cryophiles.

The physical and chemical properties of snow and ice are such that microbiological activity can occur in what appear to be the most hostile of environmental circumstances. The range of conditions these organisms face is extraordinary indeed. They include extremes not just in temperature, but in acidity, radiation levels and nutrient availability. In some cases they also include conditions of extreme desiccation that occur when liquid water is no longer available.

Obligate cryophiles like snow algae are also called psychrophiles. Psychrophiles include some of the Earth's earliest life forms: anaerobic bacteria that adapted to extreme conditions – the extremophiles as they are sometimes called. Ah yes, you will say – the extremophiles – we can identify with those. It is widely held that the thermophiles – micro-organisms adapted to extremely hot temperatures associated with thermal vents in the oceans and with volcanic environments – emerged first. The mesophiles – adapted to more temperate circumstances – evolved next; and the psychrophiles – the cold dwellers – evolved last.

There is evidence that present-day populations of snow algae may be remnants of much larger populations that existed through previous ice ages. There is considerable scientific debate over whether these life forms were derived during the recent ice ages of if they go back to the glaciations of the Carboniferous or even earlier. Some researchers think the evolution of the psychrophiles that populate snowpacks in Canada today go back even earlier, to the very first glaciations known to have occurred on Earth.

The Lipalian, or Vendian, period of the Precambrian era was the time that immediately preceded the Cambrian explosion of life, the exuberance of which is so well represented in the Burgess Shale. It appears the Lipalian period was bracketed by the father and mother of all ice ages, two extreme glaciations that appear to have nearly blanketed the entire Earth. During these two glaciations, the mean atmospheric temperature of the Earth was about -50°c. Even at the equator temperatures evidently only averaged -20°c. These are the "Snowball Earth" conditions that are of such engaging interest to glaciologists, evolutionary biologists and climate scientists. These glaciations appeared to end abruptly when volcanic outgassing raised atmospheric carbon dioxide concentrations to about 350 times the amounts that exist in our atmosphere today.

The period between the two extreme glacial advances is marked by the appearance of an unusual and conspicuous marine biota call the *Ediacara*, which astoundingly appears to have characteristics inherited beneath the ice of the "Snowball Earth" episode. Evidence suggests that these cryophilic biota, which consist primarily of cyanobacteria and chrysophyte and cholophyte algae, may have played a central role in ending the second "Snowball Earth" episode, which marked the end of the Lipalian and the sudden appearance of abundant skeletized animals in the Cambrian. More than a half a billion years later this would lead to the life forms and self-regulating Earth system we have today. It appears that cryophilic microbiota have probably existed on Earth for more than 700 million years. They still exist today and can be found in close association with glaciers.

The psychrophiles are an amazing lot. For many of these organisms, optimal growth can only occur at temperatures below 10°c. In some strains of snow algae, particularly *Chlamydomonas nivalis*, which is most common here, optimal grown of motile vegetative cells occurs at temperatures between 1 and 5°c. The very upper limit of temperature at which growth can occur in many of these species is between 16 and 20°c. Minimal temperature for growth is 0°c or even lower. But it is the survivability of these algae in extreme cold that is truly spectacular. In laboratory tests, viable cells of snow algae have recovered from temperatures as low as -196°c.

Even the hardiest psychrophiles, however, need liquid water at some point in their life cycle to grow and reproduce. The life phases of snow algae correlate with physical and chemical factors that exist at the time of snowmelt.

Active metabolic phases occur in spring or summer, when melting snow produces liquid water, nutrients and gases are available and light penetrates through the snowpack. One study in Montana revealed that algal life phases advanced most quickly when water content in the snowpack was between 52 and 72 per cent. The process begins with germination of huge numbers of resting spores at the interface between snow and soil or between old snow and new on snowfields or glaciers.

The germination of the resting spores produces motile biflagellate zoospores. What follows is active zoospore migration through the snowpack. These cells swim in the meltwater surrounding the snow crystals toward the upper surface of the snowpack. In temperate regions the distribution of red, green and orange snow coloured by populations of algae is directly related to the amount of sunlight that falls on those populations. Their position in the snow column is determined by radiation levels and the spectral composition of the light that penetrates the snowpack. The amount of photosynthetically active radiation at a particular depth is therefore of critical importance to snow algae. For this reason, these algae are often found concentrated not on top of the snowpack, but in horizontal ice layers several centimetres beneath the surface.

The exact location of ideal positions in the snow column is influenced by a number of other factors as well, including meltwater flow and the presence of horizontal ice layers, and vertical ice fingers that may have formed over the course of the winter within the snowpack. The use of dyes to track meltwater flows has demonstrated that meltwater can travel laterally for several metres at rates of between 3 and 150 cm per hour in shallow snowpacks.

The maximum flow in these experiments was seen to occur during mid-afternoon, when air temperatures were highest, when there was direct sun exposure, and in snowbanks that were connected. Nutrient availability is also tied directly to meltwater flow.

Visible blooms of snow algae occur within a few days of germination. Populations of up to one million cells per millilitre are not uncommon. But algae don't exist alone. Wherever you find snow algae you also find psychrophilic bacteria. In red snow at one site, algal production was between 141 and 180 times greater than bacterial production, and it was suggested that the bacteria were utilizing organic matter produced photosynthetically by the algae. This of course suggests an important interrelationship between algae and bacteria in cold ecosystems.

Gravitating toward adequate light and water, however, are not the only challenges snow algae face during snowmelt. As the snow melts, concentrations of dissolved carbon dioxide and oxygen in the snow change and so does the acidity of the snowpack. Understanding all that lives within and all the life processes that go on in a melting snowpack dispels the myth that wholesomeness can be defined by the purity of the driven snow.

Everything that gets into air gets into snow and falls with it to become part of the snowpack. As a result of global atmospheric pollution, the acidity of snow can be very high. What I am talking about is acid snow. Observations of pH in snow ranged from 4.0 to 6.3 in western North America to as low (acidic) as 3.5 to 5.4 in central Ontario, with the lowest pH occurring during the initial stages of snowmelt.

Snowmelt and sublimation can actually concentrate sulphuric acid in meltwater. Some microbes respond to this by removing CO_2 and nutrients that help buffer acidic conditions in snow. The astonishing thing, however, is that snow algae also appear to secrete organic materials in the form of acids and polysaccharides that lower the pH of the snow around them by as much 0.4 to 0.7 pH units. Bioaccumulation of heavy metals also occurs in snow algae in concentrations that are thousands of times higher than in surrounding snows. This is certain the case in *Chlamydomonas nivalis*, the snow algae that is most common here.

The active period in the life cycle of snow algae is brief, a few weeks at most. The resting spores eventually adhere to the soil or to debris on the soil when the snowpack has melted. They also remain in old snow in persistent snowfields. From year to year, populations of snow algae stay in approximately the same locations except where resting spores have been transported by skiers or where such spores have become airborne and been transported by the wind into ideal habitat conditions elsewhere.

The resting spores remain dormant during the summer, are covered with new snow in fall, winter and spring; and do not germinate again until the conditions ideal for the activation of the spores repeat themselves. It is not known how long resting spores remain viable, but some retained in their original meltwater have held on for more than 25 years. Evidence of the existence and extent of the life forms and ecosystem function in the snowpack can be found widely once spring snow disappears. The snow fungus *Phacidium infestans* also grows throughout the melting snowpack. *Phacidium* grows during winter under heavy layers of snow over unfrozen soil in places of adequate humidity where temperatures remain near 0°c at the soil

surface. Where the fungus exists, it becomes a substrate to which snow algae passively adhere. When the snowpack finally melts, *Phacidium* and its adhering algae spores becomes a dry thread that can be found draped over rocks, shrubs and lower tree branches at and above timberline. Under certain circumstances, this fungal blight may parasitize coniferous seedlings in winter as it does during spring snowmelt.

But these are not the most surprising discoveries. What is amazing is that some of the oldest ecosystems on Earth are comprised of cryophiles. While they have likely existed for vast periods of geological time, these are among the ecosystems in the Rocky Mountains about which we know least. Some of the most threatened of these ancient life systems are the ecosystems that form in pockets of sun-warmed water on top of glacial ice. Studies have revealed that miniature ecosystems can arise deep inside these depressions in which red snow algae are soon joined by iron bacteria, blue-green algae and green algae which over time become food for nematodes, rotifers and, at the top of the food chain, what are known as "water bears" (*Diphascon recameri*). Well of course! Doesn't every mountain ecosystem have to include a bear?

So why is it important to know this? One very good reason is that cold-adapted micro-organisms have considerable potential in biotechnological applications as diverse as waste treatment at cold temperatures, enzymology, the food industry, medicine, environmental bioremediation and molecular biology as a whole. We are just discovering that such systems exist. But they may not exist for long. It appears that despite the presence of protective pigments in their cell walls, changes in ultraviolet radiation levels brought about at high altitudes by depletion of the ozone layer, particularly over the poles, are having lethal effects, including nuclear mutations in some strains of snow algae. The field of glacial ecology is still very much in its pioneering stage. The role of snow algae as potential ecological bio-indicators needs more attention. We could learn much from them. Once the glaciers go, watch for effects on snowpack and snow cover which will affect other cryophilic biota and ecosystems. In the absence of snow and the decline of winter, these ecosystems could disappear.

Surviving freezing

The problems faced by plants and animals are different than those that confront species that live on or in the snow. Overcoming or sidestepping serious problems created by the freezing of water in living cells must rank among the greatest advances in the evolution of life on this planet. As Philip Ball notes in *Life's Matrix,* you don't have to be an Arctic explorer to know that freezing is fatal. Most Canadians know this intuitively and many have tragic first-hand stories that confirm this fundamental biological truth. As Ball points out, ice kills in a number of ways. When the blood in the body or the fluid in an individual cell freezes, life processes are not simply suspended, they are profoundly disrupted. Frozen tissue is not simply "put on ice" and preserved perfectly until it thaws as we are so often led by Hollywood to believe. Cells are killed by freezing as a result of a whole range of what Ball describes as "irreversible disasters."

As water inside the cell begins to freeze, the carefully and elaborately folded proteins that orchestrate the cell's

biochemical processes unravel and cease to function. As freezing continues, cell walls and membranes are slashed apart from within by the knife-sharp edges of expanding ice crystals. As the ruptured walls and membranes begin to leak, a reversed osmotic pressure is created which actually sucks water out of cells, leaving them dehydrated. If the freezing continues, the cellular engine seizes up, organelles stop functioning and the cell dies. The water inside your body turns against you. Your cells slowly explode. When enough of your cells die, so do you.

In order to survive on a planet where a sizable portion of surface water turns to ice for at least for part of the year, living things had to find ways to prevent the water inside them from freezing. Those that were unable to do this did not survive the first frost. The first and most obvious way to prevent freezing is for an organism to create a physical environment that keeps freezing temperatures from happening. Humans are not the only – nor were they by any means the first – species to become masters of the creation of artificial environments.

How the birds and the bees do it

Colonial insects like honeybees are highly adapted to the creation of warm, artificial climates within their nests. Regardless of how cold it might become outside, temperatures at the centre of beehives have been found to be stable at within one or two degrees of 36°c. As this is so close to the normal human body temperature, the mechanism by which bees are able to regulate hive temperature is of real interest to scientists. The capacity to create and maintain a warm environment within the hive in winter appears to require a two-prong strategy. The first, not surprisingly, is

energy conservation. As the temperature drops, the bees move closer together to minimize heat loss. The second strategy involves an organized pattern of stopping up heat leaks and the generation of warmth within the cluster through communal shivering.

Communal thermal regulation is just one means of creating an artificial winter climate that will prevent water from freezing and killing. A variation on this theme is the strategy of maintaining a high metabolic rate and high body temperature to keep the cold at bay. This is what mammals and birds do, but it is a strategy that often requires a lot of activity and a lot of fuel.

One of the most remarkable things that both mammals and birds do if they stay active in winter is to allow foot and leg temperatures to stay low, sometimes just above freezing, so that the bulk of the heat generated by metabolism can be used to keep the main organs functioning normally. In mountain goats, caribou and over-wintering mammals and birds, only enough blood circulates through the legs and feet to keep the tissues alive. The development of dual heat exchange systems in animals is a remarkable evolutionary advance brought about by what is called anastomosis, or the interconnection of branches of blood vessels. Anastomosis requires physiological mechanisms that allow blood circulating through the legs and feet to be shunted directly from arteries to veins, bypassing the smaller and more sluggish capillary network. How the arterial and venous systems in these animals arrived at this solution, and how long that took to evolve, is a mystery.

That humans are incapable of anastomosis has made us highly vulnerable to winter cold. In deference perhaps

to our species' tropical origins, human skin appears to be designed primarily for getting rid of heat in a hurry. Water is an important agent in this process, in that heat loss occurs primarily through evaporative cooling by perspiration. We have so many sweat glands that our skin remains moist even when cold. Evaporative cooling is what causes hypothermia in humans and forces us to emulate the insulation strategies developed by mammals and birds that have already adapted to winter.

One of the primary adaptations overwintering creatures have developed to protect themselves from the cold is the thickening and lengthening of their coats or fluffing up their feathers so as to minimize the loss of body heat by radiation, convection and evaporative cooling. The smaller the animal, the more effective this strategy can be. The golden-crowned kinglet is a tiny bird found in coniferous forests across much of Canada. In experiments conducted by Bernd Heinrich, it was discovered that this species of kinglet, with a body temperature of 44°C, is so well insulated that at -34°C it can maintain an astounding 78°C difference between the internal temperature of its body and the air temperature outside. Heinrich calculated that in order to maintain such a huge difference between internal and external temperatures, the kinglet must expend 13 calories a minute to keep itself warm. To keep its tiny furnace operating the kinglet has to eat three times its body weight each day. Because of its tiny size, Heinrich estimated that if the kinglet lacked its insulating down and feathers, it would lose heat sixty times faster than a human being. But even with its splendid insulation, the kinglet will quickly perish if its furnace goes out. It must keep relentlessly eating or it will die.

The hibernation option

The remarkable physiological adaptations developed by winter-active mammals are advanced one big step further in hibernation. A number of North American mammals have evolved this strategy for dealing with not just what winter does to water, but also what it does to food supply and mobility. As the grizzly and the black bear illustrate, hibernation can be an effective method of cold avoidance. But it can also be a real bear in terms of the behavioural demands it makes on an animal and it can be risky physiologically.

There has been some question about whether or not it should be said that bears actually hibernate. According to the dictionary, hibernation means to pass the winter in a torpid or resting state. In the broadest sense, then, bears do hibernate. But the nature of their hibernation is very different from that of other mammals, in that the body temperature and heart rate of bears does not decline as dramatically as it does in species such as the hoary marmot. During hibernation the body temperature of the marmot can drop from around 40°C, or 104°F, to just a few degrees above the freezing temperature of water. Its heart and breath rates can drop to less than a dozen per minute. This is not just a resting state. This is true torpor. Bears, on the other hand, are more inclined to a resting state than torpor. When a creature like a marmot goes into hibernation, its heart rate and temperature will drop significantly. For this reason they are not easy to rouse during winter sleep. But because bears are hibernating at very close to their usual body temperature and heart rate, they can be roused very quickly in order to react to danger.

In black bears, body temperature will decline from a summer range of 102° to 106°F (39 to 41°C) to a lower range of 93° to 94°F (33.9 to 34.4°C). To maintain this relatively high average temperature, the black bear will require up to 4000 calories a day. At this rate an adult bear might lose 15 to 25 per cent of its pre-hibernation weight over the course of a long winter.

In the northern United States and in southern Canada, bears will hibernate from November until March or early April. Farther south in the US, bears may hibernate for a much shorter time, possibly only very briefly or even not at all, depending on the availability of food. It is interesting to note that problem grizzlies that have been removed from Canada's western mountain national parks and placed in zoos may not hibernate if they are fed regularly.

Neither black bears nor grizzlies eat, drink or defecate during hibernation. In the absence of food, drink or the capacity to eliminate metabolic wastes, regular metabolic processes would generate nitrogen-containing wastes like urea in the blood that would eventually poison the sleeping animal. In order to prevent this from happening, bears metabolize only fat reserves rather than protein during hibernation. The bear meets its critical need for water by breaking down fat into component water and carbon dioxide that are disposed of as the hibernating bear exhales. The small amount of urea that is created is broken down and recycled into protein. This slick mechanism allows the hibernating bear to emerge thinner in the spring but without any muscle deterioration or loss.

Most remarkable, however, is the bear's ability to recycle calcium so that bones build up during the winter rather than deteriorate. Researchers like Dr. Ralph Nelson at the University of Illinois College of Medicine, who study the physiology of bear hibernation, believe that further examination of these processes may lead to breakthroughs in the treatment of kidney disorders and bone diseases like osteoporosis in humans. It is also believed that the study of hibernation may one day lead to breakthroughs that will allow humans to survive extended space travel. Beyond the evolution of high metabolic rates, behavioural strategies that use insulating fur and other materials to create tolerable microclimates, and hibernation, living things have adopted two additional ways to avoid or survive freezing. The first involves lowering the freezing point of and supercooling the water in the cell. The second approach is to just give in to freezing but then manipulate its impact. Both of these strategies owe their success to the wonder of water and to life's uncanny ability to use the qualities water possesses to its own ends.

Freeze-point depression and supercooling

The primary mechanism life uses to prevent water from freezing within living cells is to fill them with dissolved substances that depress the freezing point of water. Millions of years before the invention of antifreeze for cars, living things were experimenting with solutes that prevent water from freezing until it is below (in some cases well below) 0°C. Insects in particular are masters in the use of solutes to prevent cellular freezing and rupturing.

Late in the summer, when diminishing daylight begins to signal oncoming winter, many insects begin to manufacture chemical compounds called cryoprotectants in their blood and in their cell fluids. Researchers have identified a number of natural cryoprotectants. These include

sugars such as fructose and a range of organic molecules called polyalcohols. The polyalcohol group includes substances such as glycerol and ethylene glycol. As every Canadian motorist knows, ethylene glycol is the active ingredient in the antifreeze we put in our radiators and the fluid we use to wash our windshields. It is a substance whose function and chemical composition were borrowed from nature.

By using high concentrations of ethylene glycol in our cars we can depress the freezing point of water well below -40°C. To achieve this effect, however, requires a ratio as high as one part ethylene glycol for each part of water. No living thing could tolerate that much solute in their blood, and that is why we don't experience a lot of insect activity in winter, though insects can tolerate surprisingly high concentrations of cryoprotectants in their systems. Cryoprotectants can compose up to one-fifth of the body weight of some of our best-known Canadian bugs. Putting this into human terms allows one to see just how extraordinary an evolutionary development freeze protection has become. Take a big man, a defenceman on a hockey team maybe, who weighs, say, 100 kilograms, about 220 pounds. Fill him with 20 kilograms, some 44 pounds, of ethylene glycol, and measure his ability to withstand cold. (Put aside for a moment the fact that ethylene glycol is even more poisonous than alcohol.) How well would our burly hockey player fare? How much cold could he endure?

The world record for low-temperature freeze avoidance appears to be presently held by a tiny insect that lives in galls on the leaves of Arctic willows. This insect is common in the high Arctic and alpine regions of many Canadian mountain ranges. It is known to be able to withstand -66°C, or about -87°C. No matter how much ethylene glycol you put into his system, no human could ever survive out in the open in such temperatures.

The reason why humans have adapted other strategies to avoid freezing is a function of body size. As author Philip Ball tells us, small size works to suppress ice formation even in the absence of cryoprotectants. There is less chance of an ice crystal forming in a small volume of water than there is in a large volume. There is also the matter of the permeability of our skins. Ice formation in our cells can be initiated through contact with frozen surfaces in our environment.

To avoid such problems, insects find dry places in which to hide themselves away from direct contact with the cold, and they rely on the impermeability of their waxy exoskeletons to reduce this hazard. They also stop eating so they can avoid ice crystals entering their bodies through food, bacteria in their digestive systems or as crystals they might accidentally ingest from the air. Insects survive winter through an elaborate and systematic process Ball calls "cold-hardening." For all its physiological sophistication, the strategy many insects use to survive what winter does to water is strikingly simple. They stop eating so there is nothing in them that cold might crystallize; they fill their bodies full of antifreeze and then a find a dry place to sleep it off.

Keeping dry in winter is an important adaptive strategy. It is an interesting winter irony that living things can survive cold water if it exists as snow but they die as soon as they get wet. Every Canadian knows that a tiny amount of moisture inside a boot, a mitten or a shirt can be far more dangerous than dry cold. Every child has been taught that

rain at near freezing can be lethal, while snow at -30°c can be completely survivable simply because it will not wet and destroy insulation. Humans know that, and so does every animal that relies on insulation to survive the Canadian winter. But what if you can't avoid getting cold and wet? What do fish do? What happens when frogs freeze?

Why fish don't freeze ...

With the coming of winter in the higher latitudes, fish face the problem of freezing in the water that is their habitat. Cold-water fish have been responding to this problem for millions of years and the solutions they have conceived are elegant indeed. The first and most obvious measure is simply to migrate to where winter conditions are less severe or non-existent. If you are a fish that lives in the sea you can go deeper to where higher pressure ensures there is no ice to trigger freezing in your supercooled body. If you are a freshwater fish, however, your options are more limited. Returning to the sea may not be possible without wholesale evolutionary adjustment. Salmon have been able to make this leap, though it demanded the development of tremendous physiological sophistication. They spawn inland in freshwater and return for most of their active life to the saltwater sea. But fish don't freeze, either in the ocean or in freshwater rivers and lakes. Why not?

Though no one knows how this evolutionary adaptation arose, or how long it took, cold-hardy fish have developed the capacity to manufacture protein molecules that suppress the formation of ice crystals in their blood. These substances, called glycoproteins, are amazing. The surfaces of these antifreeze proteins are studded with regularly spaced molecular groups that have the capacity to form hydrogen bonds. The position and spacing of these groups match up with water molecules as they arrange themselves on the surface of a developing ice crystal. The protein uses a hydrogen bond to lock on to the ice surface to prevent it from forming and spreading. The moment the tiniest ice crystal appears in the fish's bloodstream, these proteins quickly lock on to it to prevent it from crystallizing neighbouring water molecules. The presence of these substances in their systems allows fish to survive in a supercooled state. Though in nature, the supercooling effect has not been observed below -3°c, experimental evidence suggests that, in principle, glycoprotein function might be effective down to as low as -10°c.

Despite this remarkable adaptation to cold, winter remains an extraordinarily stressful time for northern freshwater fish. While glycoproteins may prevent them from freezing internally, these species have an external problem to deal with as well. The volume of water in many Canadian rivers drops to one-tenth or even one-twentieth of what it might be at high water during spring melt. Obviously this dramatically reduces effective fish habitat. And because most insects have filled themselves with antifreeze and gone into dry hiding, food supply for fish in both rivers and lakes is greatly reduced.

That rivers continue to flow at all seems miraculous, as if the landscape is creating something out of nothing. But enough of a time lag exists between when water becomes available as spring snowmelt or rain and when it finally makes its way through the soil and various earth-warmed subterranean channels to join a river, that water can be available year round, albeit in reduced volumes.

The fact that water absorbs so much heat also plays a

role in year-round water availability. It takes prolonged cold to freeze a deep lake or a body of moving, turbulent water like a river. Though the process is beautiful to watch, one might think fish must look upon it with trepidation. If indeed the wily trout is capable of such feelings, its thoughts might be shaped by an uneasiness concerning reliable oxygen supply. Most of the oxygen that fish absorb through their gills is dissolved in the water through mixing at the surface with air. When the surface of a river or a lake is frozen over, that exchange no longer occurs. It is like putting a lid on a bug jar without punching air holes in it. Everything appears all right for a while but soon whatever you have inside begins to slowly suffocate. Fish metabolism slows in winter to compensate. But if the winter ice stays on a lake or a river longer than normal, fish in the water beneath can die.

… but frogs do

The employment of cryoprotectants to depress the freezing point of water is only one evolutionary avenue that has been explored in response to the problem of water turning to ice in living tissue. Another strategy is to give in to the cold and let the body freeze. This, from the outset, has to be seen as a radical strategy. Given that death will ensue almost instantly if even the slightest thing goes wrong, this evolutionary adaptation involves the complexity and narrow margin of error of a space mission. When frogs freeze, they give themselves up to the cold of death and enter an outer space that exists at the inner heart of the winter world.

As Philip Ball explains in *Life's Matrix*, developing the ability to tolerate freezing demands extraordinary physi-

ological response to all the hazards that ice presents in living systems. Because cells cannot survive if their internal fluids turn to ice, the ice that freeze-tolerant species allow to form within their bodies must at all costs be kept outside the walls of living cells. This means freezing must be contained within the fluids that separate the cells. Semi-permeable cell membranes must also somehow be prevented from leaking, so that ice crystals cannot find their jagged and injurious way into the interior of the cell.

Though it sounds complicated, an even greater challenge is posed by the need to ensure that the concentration of solutes in the cell remains roughly equivalent to the concentration of solutes in the intercellular fluid. If solute concentration is dramatically higher in outside fluids, osmosis will trigger the extraction of water from the cell until a balance is restored. When water is withdrawn in this way, cells can become dehydrated and will die when the fluids that surround them freeze.

In order to overcome these manifold difficulties, freeze-tolerant animals such as land-hibernating frogs and other amphibians do something that seems almost unimaginable from an evolutionary point of view. They begin to manufacture proteins that actually induce the formation of ice in intercellular fluids. They *want* to freeze. At the same time, they generate glucose in quantities two hundred times normal and circulate it to living cells. Though this high a concentration of sugar in the bloodstream would induce diabetic shock in humans, in frogs it acts as a cryoprotectant which both protects the contents of cells from freezing and reduces osmotic pressure exerted by intercellular fluids.

How frogs learned how to do this is an utter mystery,

but they are able to trigger ice formation within their bodies as soon as the temperature drops below freezing in the fall. This freezing occurs between the cells before the water in the cells can supercool. Though the frog may appear to be frozen solid, the actual freezing only takes place in the 65 per cent of the body fluids that circulate around live cells. Locked up by proteins, the ice in the frog's fluids is confined to the spaces between cells, where it acts as the ultimate micro ice pack. In intimate contact with almost every cell in the body, this ice pack virtually ceases all cellular activity, stops the heart and induces a state of suspended animation. This little trick allows the frog to survive what winter does to the water that forms its habitat.

The lessons we learn from frog hibernation are both practical and symbolic. What the frog does is tantamount to going into outer space without any protection whatsoever and then turning your own body into a space suit that allows you to enter suspended animation until you reach a habitable planet six months later. To survive winter, turtles do something just as exotic, but it's not the same. They have a shell.

Plants, which have been around even longer than animals, have also developed a wide variety of adaptations to survive what winter does to water and other nutrients. Plants that cluster around hot springs or remain insulated under the snow can remain green all winter. Some plants that are exposed to the cold transport their nutrients deep into their roots. Some allow their surface parts to wither and die, to be replaced by stalks rising from protected roots when warmth returns. Others survive only as dormant seeds awaiting spring. Many plants produce a hormone called abscisic acid. This hormone forms what is called an abscission layer in the leaf stem which causes the leaf to fall when it freezes. In what Annie Dillard attributes to the fecundity of nature, big deciduous trees can produce six million leaves in the spring and then lose all of them in the fall. The leaves, having fulfilled their photosynthetic activities for the season, are released by the trees. The trees lose them to prevent what winter might do to the water in them.

For big plants like trees, the reaction to winter can take the form of a three-stage cold-hardening process. In the first stage, growth ceases and carbohydrates are moved from the stem to the roots of the plant. This mechanism alone can allow a plant to survive temperatures ranging down to -5 to -10°C. The second stage involves abscisic acid again and other chemicals that stimulate water to move out of living cells and into the intercellular spaces, where it can freeze without killing the plant. This is when dehydration of individual cells takes place. During this process the cell membrane pulls away from the cell wall, making it possible for small ice crystals forming outside to penetrate the cell wall without rupturing the cell membrane. This gives the plant further freeze-resistance down to -20 to -30°C, enough for most plants to survive the winter. As this final stage of winter protection demands elaborate chemical responses to freezing, not all plants are capable of it.

All cold-hardened northern plants seem to possess the capacity for stage-three defence. All have somehow evolved chemical cryoprotectants that modify the structure of ice as it forms in ways that alter natural patterns of crystallization. Through what is called vitrification, or glass formation, plants somehow create ice with smooth edges rather

than cell-rupturing sharp edges. Plants appear to create this vitrified or glass ice in three grades. Though vitrification does not begin to occur until at least -28°C, the first level of it will permit plants to survive freezing down to -45°C.

Standing in the deep cold of the forest at this temperature, you can tell which trees are capable of only the first level of vitrification. They are the spruce and the poplars that crack apart with a sound that resembles a rifle shot. At and below -45°C, bark explodes and trunks split vertically. At these low temperatures all but the best-insulated and -protected insects die. But, amazingly, plants survive at even colder temperatures. A second, discrete form of intercellular glass formation permits cold-hardened plant tissues to survive temperatures down to -70°C. A final and little understood mechanism of vitrification allows some northern trees, such as the alpine fir and the arctic willow, to survive temperatures down to -80°C. One shudders at what kind of Earthly evolutionary history demanded that plants adapt to such extraordinary extremes.

How humans have handled freezing

Compared to plants and animals, humans aren't very well adapted to winter. As big bags of walking water, people freeze easily. Their skins are moist and permeable. The only cryoprotectants humans possess are imperfect in their effectiveness and must be carried around in a flask or a bottle. Humans cannot evacuate water from their cells without risking immediate death and are unlikely candidates for hibernation in that they are incapable of sleeping more than a few hours without being wakened by the cold.

Being that keeping warm and dry is, and always has

Examining the nature of glacial ice on the surface of Athabasca Glacier.
Photograph courtesy of Athabasca Glacier Icewalks

been, essential to survival, humans took a completely different evolutionary approach to surviving what winter does to water. Instead of developing individual responses to survive deep cold, we worked collectively on the problem: instead of internal cryoprotectants, we created culture. Instead of living within winter, as much of the rest of nature does, we created a civilization that aims to triumph over it.

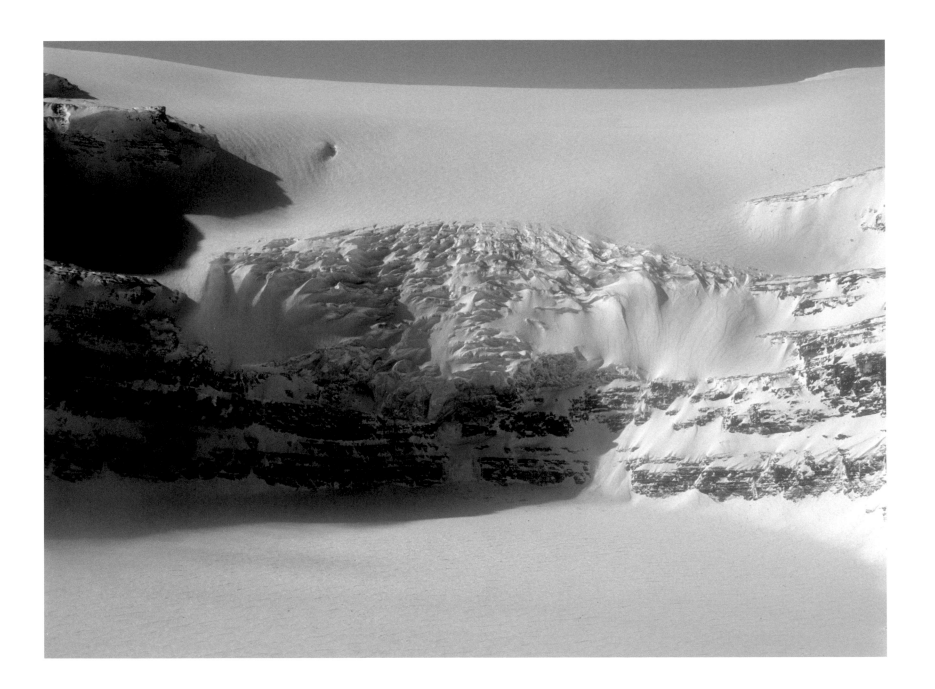

> [One] who keeps company with glaciers comes to feel
>
> tolerably insignificant by and by.
>
> —MARK TWAIN, *A TRAMP ABROAD*

FOUR: How Icefields and Glaciers Form

IN THE INTRODUCTION TO HIS 2012 BOOK *The Cryosphere,* University of Calgary glaciologist Shawn Marshall notes that surface temperatures on Earth are close to "the triple point" of water: the temperature at which water vapour, liquid water and ice coexist in thermodynamic equilibrium. Water, he observes, is the only substance on Earth that exists naturally in all three of these phases. Marshall goes on to point out that about 35 per cent of the world presently experiences temperatures colder than this triple point during at least part of the year, and that this portion of the planet includes fully half of the Earth's land mass. This vast frozen realm, which includes glaciers and ice sheets, sea ice, lake and river ice, permafrost, seasonal snowfall and ice crystals in the atmosphere, is known as the Earth's cryosphere.

Dr. Marshall writes that because temperatures oscillate around the freezing point of water over much of the Earth, the cryosphere is highly sensitive to changes in mean atmospheric temperatures. With only slight increases or decreases, water on the surface will quickly change state. This tight coupling between temperature and the state in which water exists in the cryosphere is one of the strongest and most immediate feedback systems in nature.

For the moment at least, nearly 70 per cent of the world's freshwater exists in the form of ice. While presently accounting for only 2 per cent of the total volume of water that exists on the surface of the Earth, freshwater represents the 2 per cent that means the most to us. This small fraction of the world's water frozen into the cryosphere happens to represent nearly three-quarters of all the freshwater that exists and is available for life on the planet.

The greatest concentrations of water in a frozen state are found in Antarctica and Greenland. There are, however,

Bow Glacier in winter.

still significant icefields and glaciers in Canada. Most of the larger masses are in the high Arctic, where ice more than 100,000 years old has been found at the base of many icecaps. Icefields and glaciers of substantial size are also found in the St. Elias Mountains in the Yukon, in the Coast Range along the Pacific Northwest and in the Selkirk Ranges of central British Columbia. Large subpolar accumulations of glacial ice are found along the spine of the Rocky Mountains between Alberta and British Columbia.

Frozen assets

How fortunate we are to live on a planet so appropriately composed of just the right substances, enveloped in just the right atmosphere and located just the right distance from the sun to permit an abundance of water on its surface. Water is not only the stuff that composes most of the living tissue of life, it is the universal solvent in which all life's nutrients dissolve and are distributed to even the most minute chains of being on Earth. Life is an intelligent idea carried around in the mind of water. Water could be viewed as life's way of getting itself around. Where water goes, life follows. Life is water, but so is the Earth. More than two-thirds of the Earth's surface is water. The Earth's atmosphere is an engine that circulates water. Not only does water define the boundaries of life on Earth, it also fashions the texture and nature of this planet's surface. Water is the Earth's most enduring agent of natural change. It is a mass transporter of elements that compose the Earth. The planet, at least as life views it, is almost entirely defined by the meanderings of rivers, by the reliability and distribution of annual rains and by the

frequency and duration of snowfall. This is water as liquid. The impact of water as snow and ice can also be immense. It is in these frozen forms that water is most visible and least subtle in its impact on the Earth's crust. It is with water as snow and ice that our inquiry into vanishing glaciers must begin.

Everywhere in the polar and temperate regions of the Earth, but also at high altitudes in the tropics, atmospheric water condenses and freezes into solid form. Sometimes the resulting water falls as hail or as small irregular globes called graupel. But most often, frozen atmospheric water falls as snow. Every child has marvelled at the lacy elegance inherent in the radial symmetry of the snowflake. Each flake is likely different, each practically unique, each perfect in its own way. When snow falls in the Rockies, individual flakes fall one upon the other, glistening and gradually deepening into the romantic image of the Canadian winter. As snow continues to fall and deepen, the sheer weight of accumulation changes the nature of the flakes. As pressure builds, the lovely radial arms, outstretched and intertwined, break off. Eventually the aging flakes devolve into a form of granular snow called hoar. In most places in the world, the life of hoar snow is terminated by the hot sun of springtime. The aging snow dies back into water as it melts. But at the poles, and in the high places of the Earth's mountains, the snow that falls in winter doesn't always melt. Some of it remains at the end of the summer, and at a given depth, perhaps 30 metres or so, the compressed snow slowly becomes ice.

This is not the thin, ephemeral ice we put in our drinks or worry about when driving, however. This is ice crystallized under the pressure of deep time. This is the ice of

Glaciers form in places where more snow accumulates annually than melts. The snow that accumulates rather than melts is known as firn snow. The density of the firn snow at the surface is around 350 kilograms per cubic metre. Over time the firn becomes compacted by the weight of the overlying layers and as a result of water vapour diffusion. From the surface down to a depth where the pack attains a density of about 550 kg/m³, the transformation of snow to ice is dominated by the firn grains rearranging themselves into a progressively denser pack. But deeper in the snowpack, simple reorientation of the grains does not lead to significant density increase. Rather, at these depths and densities, the most important transformational processes involve coalescence of the ice mass into a solid yet plastic condition. When the density of the pack approaches about 800 kg/m³, the open pores of air that remain in the compressing ice are gradually pinched off and form bubbles in the ice. This zone is called the firn–ice transition and it spans about the bottom 10 per cent of the total firn column. Depending on temperature and the amount of snowfall, the firn zone can be between 50 and 150 metres thick, and the age of the ice can range from a few hundred years as in southern Greenland to several thousand years as in central Antarctica.

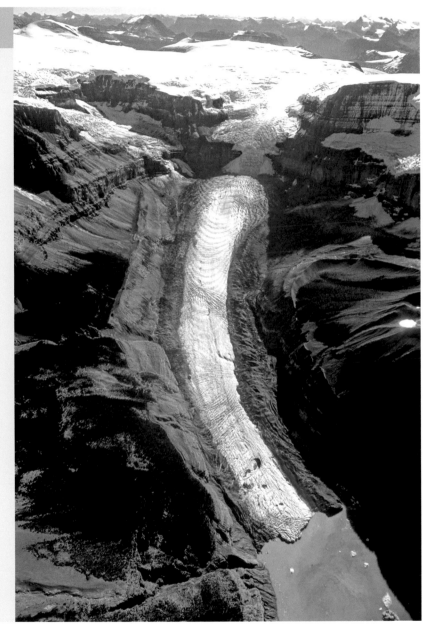

Columbia Glacier.

eternity. Under its own weight, and in response to dictates of its crystalline nature, this ice moves. This is the ice of the eons; this is glacier ice.

The snows of yesteryear: Snowball Earth

Glacier ice is a relatively recent phenomenon on Earth. Certainly ice could not have existed while hot swirls of cosmic gases were still condensing into the fiery turbulence of the forming Earth. Ice likely didn't exist while the still erupting surface of the Earth's crust was cooling into a shattered shell. Nor could it have appeared during the long, warm morning of the Earth's first oceans during which proto-continents began their tireless drift over the surface of the world. Ice likely couldn't have appeared until after a relatively stable atmosphere began to cling to a more slowly turning Earth, until the planet was protected sufficiently that it was no longer being scorched by the nuclear fires of the sun. Ice likely first appeared as soon as the aura of air around this blue globe at last glowed with enough gaseous substance to become effective as an atmosphere. Still, that was a long, long time ago.

The earliest evidence of the presence of glaciers in the world appears in the middle Precambrian amidst rock of an antiquity so distant in time that it is difficult for the mind to grasp its age. In North America, Africa and Australia, glacial deposits called tillites were laid down as early as 2.3 billion years ago, long before life rose from the warm broth of the sea to eventually conquer the land. One of the great unanswered questions in evolutionary biology is why complex life appeared at all on Earth and why it waited until the Cambrian explosion to make its grand debut. The answer to that question may reside in part in a glacial catastrophe during the early history of our planet which may have resulted in nearly all of Earth being covered by ice. Extensive research undertaken in Namibia by Dr. Paul Hoffman, a Canadian tectonic and sedimentary field geologist at Harvard University, has demonstrated that glacial ice entombed most of the planet hundreds of millions of years ago, and that complex animals such as we see in the Burgess Shale in Yoho National Park may have evolved in a greenhouse heat wave that followed the longest ice age in the history of the planet.

> Verily, glaciations of Precambrian time were probably the most severe in all earth history; in fact the world must have experienced its greatest Ice Age.
>
> —Douglas Mawson to the Royal Geological Society of Australia, 1948, quoted by Gabrielle Walker in *Snowball Earth*

Building on the earlier work of Antarctic explorer Douglas Mawson and Cambridge geologist Brian Harland, Hoffman and his colleagues put forward evidence that Neoproterozoic ice sheets may have extended to sea level near the equator for perhaps as long as ten million years as a result of planetary conditions that that created what he calls a "Snowball Earth." During this time, the Earth was little more than a frozen, white, largely lifeless ball. Hoffman has posited that a mostly ice-covered ocean would have become anoxic, slowing the advancement of life until photosynthesis emerged or glaciation ended. Hoffman's research also demonstrated that the end of this long glacial epoch may have been brought about by a gradual buildup of enough carbon dioxide in the atmosphere, as a result of millions of years of volcanic activity, to finally melt the Snowball.

While this theory may make readers wonder why volcanism doesn't generate the same result today, it actually makes a lot of sense. In geological epochs such as the one we are in now – and throughout most of the planet's long history – the world's oceans were largely free of ice. In such circumstances, carbon dioxide does not build up in the atmosphere except temporarily as a result of all but the most extreme volcanism. This is because the Earth has what could be described as a built-in thermostat, controlled by rainfall which entrains carbon dioxide and strips it out of the atmosphere. As rain descends it absorbs carbon dioxide and as a result becomes acidic. When this acidified rain reaches the ground, it reacts chemically with rock in a manner that results in the carbon dioxide being absorbed and later sequestered in sediments destined over time to become sedimentary rock. In this way the carbon dioxide produced by volcanic activity is literally scrubbed out of the atmosphere and locked away for eons in sedimentary basins in oceans. Though the process is imperfect, it has allowed the Earth's temperature to remain relative stable for millions of years, neither too hot nor too cold to sustain conditions conducive to life.

After the Snowball melted, glaciations came and went, largely in rhythm with longer periods defined by what are now known as Milankovitch cycles: fluctuations in Earth's orbit every 20,000, 40,000 and 100,000 years which bring about an ice age approximately every 100,000 years. In the upper Precambrian, there is glacial evidence at intervals of 900, 750 and 600 million years ago, the latter coinciding with some of the earliest preserved fossil life on the planet. Substantial evidence of glaciation presents itself again in the late Ordovician, during the age of the first fishes, and

again 300 million years ago, straddling the ages of the great coal-producing forests of the Permian and the Carboniferous. There is a long break in the glacial record during the Triassic, Jurassic and Cretaceous. And then there is the overwhelming evidence of the stupendous Cenozoic glaciations that shaped, and continue to shape, the world as we know it today.

Though much is known about the dynamics of glacier ice, there are few questions in all of modern geology as difficult to answer as those related to why ice ages occur on Earth. There are many theories. Many factors, individually or collectively, affect where snow falls, how long it accumulates, the size and nature of accumulated glacial masses, the ability of glaciers to sustain conditions that spawn them, and the changes in climate that bring ice ages to an end. Some of these theories, as already noted, imply the possibility of cosmic or galactic influences in the initiation of ice ages. Some theories speculate on wholesale changes in the orbit of the Earth and variations in the heat output of the sun. Others muse about planetary collisions with comet nuclei, the sun-screening effect of airborne, iridium-laced ash, or the presence of visiting suns. More earthbound theories include variations in the thermal characteristics of oceans, the effects of volcanism on the atmosphere, and changes in the heat reflectivity of the Earth's surface. One quite plausible theory offers that changes in the latitudes of the Earth's roving continents would induce glaciation.

One of the most clearly accepted theories of glacial origins is the observation that continental uplift resulting in mountain-building can elevate landmasses to the point where they force moisture-laden winds into the

thinner atmosphere and colder climes of the high peaks. Under cold conditions, high moisture condenses into high snowfall, which fails to melt during the brief high-altitude summers. These eternal snows linger in basins between the high peaks. Soon the accumulated snow is compressed by its own increasing weight into glacial ice. The ice, by its very nature, then begins to flow downhill, in the direction of least resistance, into neighbouring valleys. In the warmer climate of the lower valleys, the centuries-old ice then melts to form rivers.

Though other influences may combine to create larger continental glaciations, the glaciers in Canada's mountain West clearly owe their continued existence to the high-altitude mountains that surround many of them and to the moisture-rich winds that blow inland from the Pacific to dump snow on the high peaks of the coast and interior ranges of the mountain West. There are no other simple ways to explain the survival of so much glacial ice so far south at this particular time in the Earth's geological history.

The theory of mountain building as it relates to the glaciers along the cordillera of western Canada has another advantage. It may be the only way the astonishing fact of this stupendous sea of ice and snow can be compressed into a concept an overwhelmed witness can readily grasp.

Ice ages: The ice man cometh
Though it is a bold statement without complete evidence in support, it is generally assumed that as long as there has been ice in the polar regions of this continent, glaciers have likely existed in the mountains of the Canadian West. While local altitude and climatic conditions may have sup-ported glaciers for as long as three million years, ice movement here has also been linked to more widespread climatic coolings that have resulted in major glacial advances in these ranges. What may be the most extensive of all modern ice ages appears to have begun roughly 240,000 years ago. The Illinoian, or Great Glaciation, covered most of the northern regions of the Earth's upper hemisphere, fashioning much of the geography of North America as we know it today. The Great Glaciation was a spectacular geological event that lasted 100,000 years. Though the glaciers of the mountain West would have grown dramatically during this continental cooling, the dynamics of the major icefields in the region would have changed little. Warm, moist winds from the Pacific would deposit heavy snows in basins between the highest peaks; the snow would accumulate and compress into ice; and the ice would begin to flow down valleys already created by ancient rivers. The only difference would be that the major alpine glaciers could have been hundreds of kilometres long and as much as two kilometres deep as they left the Rockies and joined the even greater ice masses flowing southward across what are now the Canadian prairies from the direction of the pole.

Other notable but lesser glacial advances took place in the Rockies 75,000 and 20,000 years ago and did much to give these mountains the contours that make them so dramatic today. Another climatic cooling took place around 11,000 years ago and initiated what is called the Crowfoot Advance, a smaller but nevertheless measurable glacial growth period that is still represented today in the surface geology of the Columbia Icefield area. The last glacial advance to have taken place in the Canadian Rockies is so

recent that early travellers were able to document its close. The Cavell Advance likely began in about 1200 CE, roughly around the time King Richard the Lion Heart was killed in France and the Fourth Crusade was making life miserable in Constantinople. Three subsequent phases of the Cavell Advance were dated through tree-ring analysis conducted by Dr. Brian Luckman (see sidebar). The maximum glacier extent appears to have occurred in the mid-18th century. Research indicates that subsequent glacier surges occurred around 1800, 1816 and later in the 19th century. At the peak of the Cavell advance, in about 1750, Athabasca Glacier was two kilometres longer than it is now. Most of the other major glaciers that flow from the Columbia Icefield must have been much larger then too.

Early research in glaciology

As legendary Canadian glaciologist Dr. Garry Clarke pointed out in a journal article called "A Short History of Scientific Investigations on Glaciers," 18th and 19th century glacier research has a double legacy in that a growing Romantic appreciation for mountains attracted many to the science of glaciology while at the same time inspiring a wide audience for what science revealed about the nature, character and behaviour of glaciers. Clarke notes that the same love of mountain places that drew scientists of the calibre of Louis Agassiz, James Forbes and John Tyndall to the study of glaciers still attracts bright researchers with a passion for mountain places today. Clarke also observes that the principal interests of glaciologists working in mountain regions appear to have changed remarkably little since the pioneering work of

Because of the work of renowned scientists like Dr. Brian Luckman (see chapter 6) we have a foundation for understanding what is happening in our mountains. But even our best researchers would be the first to say we don't know enough. The Canadian Rockies have experienced a 1.5°C increase in mean annual temperature over the last 100 years. During this time, increases in winter temperatures have been more than twice as large as the increases during spring and summer. The annual temperature record in the Canadian Rockies is dominated by winter conditions, which show the largest inter-annual range, 12.7°C, and the greatest warming trend, 3.4°C, over the past century. In spring and summer, both numbers are more modest, with inter-annual variation of only 4 to 5°C and a warming trend of only 1.3°C over the century. From tree-ring chronologies for a site near Athabasca Glacier at the Columbia Icefield, Dr. Luckman was able to demonstrate that summer temperatures were below late-20th-century levels from about 1100 until 1800 CE, and that the coldest summer conditions occurred during the Cavell Advance in the 19th century, which averaged 1.05°C below the 1961–1990 mean. Over the past century, the area of glacial cover in the Rockies has decreased by at least 25 per cent and glaciers have receded in length to approximately where they likely were some 3,000 years ago, before the Cavell advance.

Dr. Brian Luckman.

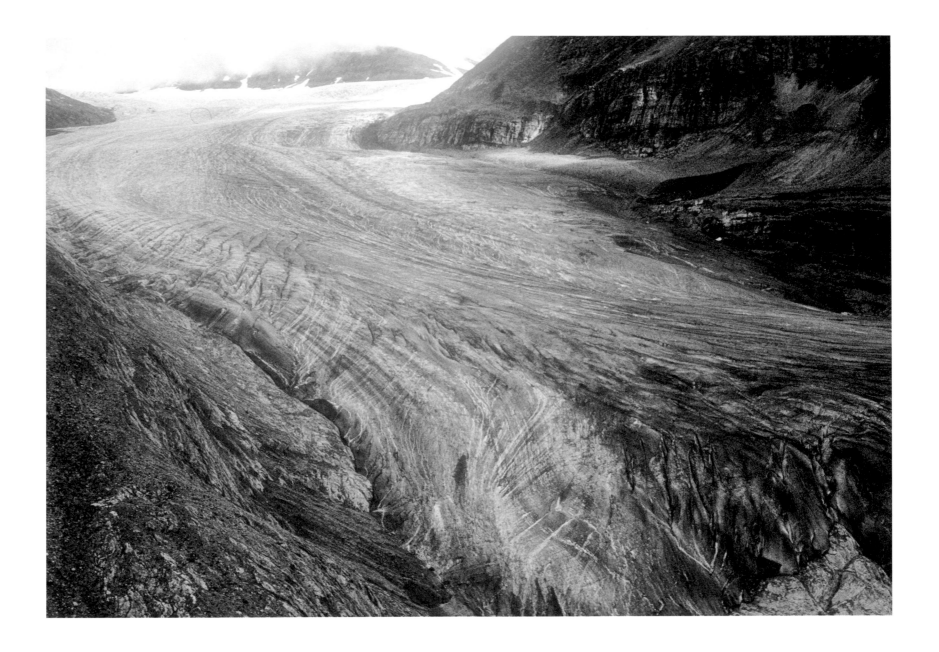

Louis Agassiz in the 1830s and '40s. Progress in the field during that time, Clarke notes, has not been driven by revolutions in thought so much as by technological advances in the speed and precision with which fundamental measurements of glacial dynamics can now be made.

Until the 18th century, the only people to venture much above timberline were hunters, prospectors and smugglers using the high passes to avoid customs officials. Even though the demons, dragons and other supernatural beings with which the early Catholic Church had populated every wilderness seemed close to extinction, other concerns prevented the average person from visiting European peaks. The climate in high mountains was comparatively brutal; high country offered little agricultural opportunity; the peaks interrupted communications and were seen to be dangerous because of avalanches, rockfalls and the preponderance of outlaws who were said to hide among them. The Romantic interest in the natural sciences, however, and a perhaps conflicting but growing sense of a sublime poetic presence in nature would gradually change the manner in which mountains were perceived. This emerging friction was well exemplified in the writings of John Tyndall, a physicist whose mountaineering interests extended to his research work when he began to focus on the "wondrous factory" that is the atmosphere. Tyndall, considered by many to be the patron saint of mountain science, was the first to discover the heat-absorbing qualities of both carbon dioxide and water vapour. In his book *Hours of Exercise in the Alps*, Tyndall explains the tension that existed in his time and in ours with respect to the glory of the high mountains and the desire to explore them scientifically:

Over the peaks and through the valleys the sunbeams poured, unimpeded save by the mountains themselves, which sent their shadows in bars of darkness through the illuminated air. I had never before witnessed a scene which affected me like this one. I opened my note-book to make a few observations, but soon relinquished the attempt. There was something incongruous, if not profane, in allowing the scientific faculty to interfere where silent worship seemed the "reasonable service" …

It is natural that the Alps became the cradle of both mountaineering and glaciology. The peaks were easily accessible to large populations, possessed unmatched charm and beauty and were so interesting that many priests that had interests in science were strongly drawn to them.

Oh, hail to noble glaciers that reach unto the skies,
We climb your lofty pinnacles with joyful hearts
 and eyes.
The snow is turning roseate; the air is pure and clear,
Let us seek the break of day on mountains far
 and near.

—old Swiss mountaineering song, translated by A.J. Kauffman
in *The Guiding Spirit*

One of the properties of glaciers that attracted the earliest scientific attention was that they flow. Evidence of glacier flow had been demonstrated by a number of Agassiz's predecessors, including Johann Jacob Scheuchzer, a leading authority on the Alps and a Fellow of the Royal Society who in 1708 classified "alpine dragons" with scientific care. Glacial flow was also observed by Horace

Yoho Glacier.

Benedict Saussure, an ambitious man of science who by marriage became known as the wealthiest man in Geneva. After a visit to Chamonix in 1760, Saussure offered an attractive prize to the local guide who could find a way to the summit of Mount Blanc. Actual measurements of the rate of glacial movement, however, were not made until Franz Josef Hugi, a professor of physics and natural history at Solothurn, established a field station beneath a large boulder on the medial moraine of Unteraargletscher, Switzerland, in 1827. Louis Agassiz, who at the time lived in nearby Neuchâtel, visited Unteraargletscher and in 1840 began historic research on the ice.

The following year, Agassiz met another giant of both glaciology and mountaineering, James D. Forbes, at a scientific conference in Glasgow. After a brief but failed collaboration, Forbes employed the drilling methods he saw Agassiz use on the Unteraargletscher in Switzerland to establish measurement points on the Mer de Glace on Mont Blanc in France. Achieving in a few days what Agassiz had waited a year to achieve, Forbes arrived at a number of conclusions that were to become fundamental to the emerging discipline of glaciology. First, Forbes confirmed that though often imperceptible, glaciers were indeed in constant motion. The rate of this motion, however, was not consistent from day to day or from week to week. Forbes also ascertained that different parts of a glacier move at different rates, faster at the centre of the ice stream than on the sides of it. Forbes also noted that the greatest distance he had witnessed the Mer de Glace advance in a day was 27.1 inches (68.8 cm). Forbes posited that the mechanism of glacial movement was viscous flow.

With this foundation the first debates in the discipline of glaciology began. The first matter of debate concerned the degree to which the glacier was sliding over the surface below versus the extent to which the ice possessed properties of viscosity as opposed to brittleness. Without rejecting any of Forbes's conclusions, Tyndall went on to propose a different law of glacier motion based among other factors on the effects pressure has on the melting point of ice. Tyndall believed glacial advance resulted from the formation of numerous small fractures in the ice that were subsequently healed by the ice melting under pressure and then refreezing. As Canadian glaciologist Stan Paterson wrote in his landmark *The Physics of Glaciers*, the ensuing debate generated enough heat, according to one observer at the time, to actually melt a glacier. Unfortunately, this famous controversy came to an end without conclusion when Tyndall's wife accidently killed him by unwittingly administering a lethal overdose of chloral hydrate in 1893. Nor did Tyndall's theory of "regelation" survive long after his death, for it was wrong. Advancements in science demonstrated that if it was "regelation" that allowed ice to deform, then glaciers in extremely cold regions would not flow. Despite this error, however, Tyndall's work nevertheless established a firm connection between glacier flow and fluid dynamics and thus did what good science does: enhance humanity's stock of verifiable knowledge.

Glaciology in Canada

In the early 20th century, researchers were able to demonstrate, with varying degrees of success, that the standard equations from fluid dynamics could be used to delin-

The rapid recession of glacial ice in the mountains of Canada was first studied by the celebrated Vaux (pronounced "vox") family of Philadelphia in the years following the completion of the Canadian Pacific Railway in 1885. The Vauxes' contribution to early glaciology and the natural history of Canada's western mountains was celebrated with an exhibition and the publication in 1983 of a landmark book by Edward Cavell entitled *Legacy in Ice,* featuring the photographs of George Vaux Jr., William S. Vaux and Mary M. Vaux. In 1997 Henry Vaux Jr. began taking duplicate photographs of the glaciers his grandfather, great-uncle and uncle captured on glass plates a century before. On the left is a photograph the Vauxes took of the Illecillewaet Glacier in 1902. On the right is one taken from exactly the same location almost exactly a hundred years later. If this rate of glacial recession continues, it could clearly have huge impacts within our lifetimes on the volume of water that flows from the mountain headwaters.

Henry Vaux Jr. went on in 2014 to write a book and curate an accompanying photographic exhibition entitled *Legacy in Time: Three Generations of Mountain Photography in the Canadian West*. Published by Rocky Mountain Books, the volume is already a classic, not just in glaciology but as an outstanding chronicle of the Vaux family's remarkable and continuing contribution to science and to the natural history of their beloved "Canadian Alps."

Photograph of the Illecillewaet Glacier in 1902 courtesy of the Whyte Museum of the Canadian Rockies; Illecillewaet Glacier in 2002 courtesy of Dr. Henry Vaux Jr.

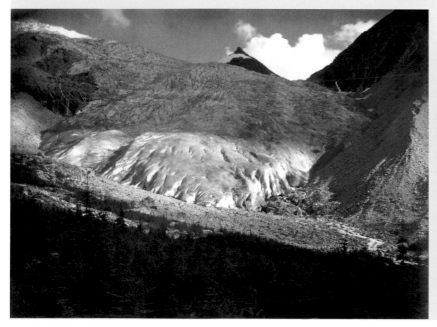
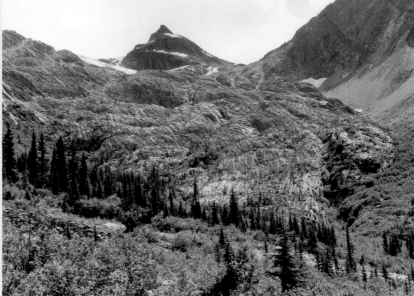

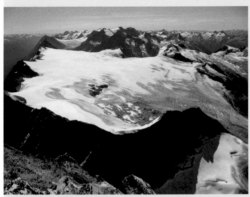

Jocelyn Hirose's research characterized the main meteorological parameters influencing glacier snow and ice melt and quantified the glacier contributions, including that of the Illecillewaet, to a sub-basin of the upper Columbia River in British Columbia. Her studies have advanced our understanding of climate sensitivity to the glacierized regions of the basin and its impact on streamflow, resulting in a more representative estimate of glacier contributions. This research helps to better estimate the timing and concentration of glacier runoff, which is essential for ecosystems, municipalities and hydroelectric generation. Hirose's work comes at a crucial time, as the Columbia Basin Treaty between the US and Canada is up for reconsideration.

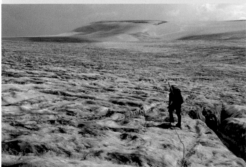

From top:
The Illecillewaet Icefield.

Finding an ice core site on Illecillewaet Glacier.

Jocelyn Hirose.

eate many aspects of glacier flow. The stage was set and the research agenda gradually established that would see glaciology become a mature discipline in the 20th century. Canada walked onto the world glaciology stage in 1926, the year that Arthur Philemon Coleman, a geology professor at the University of Toronto, published his landmark *Ice Ages Recent and Ancient*, a book that shaped understanding of glacial dynamics for a generation. Stan Paterson notes, however, that it wasn't until the mid-20th century that advancing concepts of solid-state physics and metallurgy could portray glacial ice as a crystalline solid that deforms like other crystalline solids such as metals at temperatures near their melting points. And as Shawn Marshall notes, it was not until the late 20th century that it was demonstrated how the thermal characteristics of snow and ice determine exchanges of energy between the cryosphere, the oceans and the atmosphere and thereby govern the sensitivity of the cryosphere to climate change and the multitude of cryospheric feedbacks to that change. Before these scientific discoveries were made, however, a long presence of local people in the mountain West had already been using glaciers as highways of trade and incorporating knowledge accumulated over generations of observations into their own Indigenous oral histories and cosmologies. The real extent of this Indigenous presence and the depth of their knowledge, as well as the consistency of it with what scientists have since discovered about glaciers, continues to emerge from the receding ice.

Indigenous traditional knowledge about glaciers

In her remarkable book *Do Glaciers Listen?*, Julie Cruikshank places Indigenous people's relationship to glaciers into the larger context of adventurism and settlement by Europeans in lands they little understood and for which, initially at least, they felt little sense of place. One of Cruikshank's central arguments is that colonialism began when 18th-century visitors arrived on our coasts excited by the Enlightenment notion that an inanimate nature could at last be brought under human control through empirical investigation and measurement. They were confident it would be only a matter of time before the scientific method and its instruments would separate nature from culture in the same way it had at last separated church from state. This northern European idea of a self-evident divide that would enable people to separate themselves from nature contrasted sharply, however, with the ways of living and the cosmologies of the well-developed Indigenous civilization that had evolved over thousands of years in the presence of some of the largest glaciers and icefields in North America. The oral traditions of these peoples stressed that glaciers were powerful elements of a natural world from which humans could never be separated.

Glaciers in these cultures were part of the larger social space that was nature, in which attitudes that influence human actions – casual hubris or arrogance in particular – could have unpleasant if not fatal consequences. This difference in world view has yet to be bridged. Even today, Cruikshank notes, citing anthropologist Paul Nadasdy, "A growing number of terms crucial to ongoing land claims negotiations, wildlife-management debates and environmental conflicts in northwestern Canada – terms like 'land,' 'hunting,' 'resources' and 'property' that may initially seem straightforward – are actually fundamentally contested." Opposing parties often mean very different things even when they are using exactly the same terms. This profound divide with respect to different approaches to knowledge is tellingly exemplified by difference in the way glaciers are viewed by Indigenous peoples as opposed to the Europeans that colonized the Pacific Northwest. A case in point is the remarkable phenomenon known as the "galloping glacier."

Of the nearly 4,000 glaciers in the northwest corner of North America, Cruikshank explains, approximately 200 periodically undergo dramatic surges in their movement. After remaining relatively dormant, often for 10 to as long as 200 years, they suddenly begin to advance, sometimes at rates as much as a hundred times faster than normal and over distances of several kilometres before suddenly terminating, often with a sometimes substantial discharge of stored water. For contemporary glaciologists, surging glaciers are merely one of the many puzzles of modern geophysics and much is being done to understand how the combined mechanics of low sun angle, marked seasonal differences in solar radiation, extreme ecological differences associated with topography and relief, and patterns of snowfall and ice-cover exacerbate and are exacerbated by the effects of a warming global atmosphere. By their own admission, scientists focus on "natural forcing mechanisms," as opposed to anthropogenic factors that are driving hydro-climatic disruption.

The impact of glaciers, Cruikshank suggests, may lie

not just in their immense physical presence, but also in their influence on collective local imagination. Athapaskan and Tlingit peoples attribute characteristics to glaciers not granted by western science. In the oral traditions of these peoples the glaciers over which they have travelled between the coast and the interior for hundreds of generations are characterized as sentient, often spectacularly aural and possessed of vision. As Cruikshank puts it, glaciers listen. They pay attention and they respond directly to human behaviour, and especially to indiscretion. Through long experience of place and paying close attention to the sentience of landscapes, the travel narratives of Indigenous peoples did not include terror as experienced by many of the Europeans they often guided. Indigenous guides held that the terrors "explorers" in their lands often reported were largely of their own making as a result often of incompetence but also as a consequence of the failure to respect ecological hazards or to travel with ritualized respect within well-established practices that assured great safety.

Having dealt with these matters, Cruikshank then makes an important claim. Noting that the cultural crevasses that separate Indigenous oral traditions from the narratives of the physical sciences appear so deep that it would seem the two cultures would never intersect, First Nations narratives are in fact consistent with and actually validate Little Ice Age glaciology. The two solitudes of traditional local knowledge versus western science may not be as separate from one another as we have historically maintained. Discourse between the two does not have to be a zero-sum game. Overlapping accounts from researchers and Tlingit and Athapaskan elders suggest there may

INTERPRETING AN INDIGENOUS WORLD-ORIGIN STORY OF HOW THE ICE AGE CAME TO AN END

At the beginning of time and before they acquired their respective forms, humans and animals shared a dark and exclusively winter world, perpetually freezing and helplessly watching their offspring die. Still more troubling, they knew that a parallel "summer world" existed adjacent to the one they inhabited, sealed off from them by the horizon. Eventually, these beings came together and resolved to rupture this boundary in order to steal summer and distribute it more equitably. They conscripted bloodsucker to make the initial puncture and wolverine to push through after the first small opening appeared. Then they dragged a moose hide behind them to enlarge the breach. Beyond this skyline, they were able to escape their perpetual misery by capturing summer in a gigantic bag, stealing it from the powerful but ungenerous controller of weather, and releasing it to establish a seasonal cycle that more fairly distributed access to warmth and vegetation. In this way, a "winter" world with its perpetual whiteness and a brighter "summer" world were brought into alternation by the efforts of humans and animals who jointly made the world as we know it now.

—Julie Cruikshank introducing a transcription of "How Animals Broke through the Sky" as told by Tagish elder Angela Sidney in *Do Glaciers Listen?*, 79–80

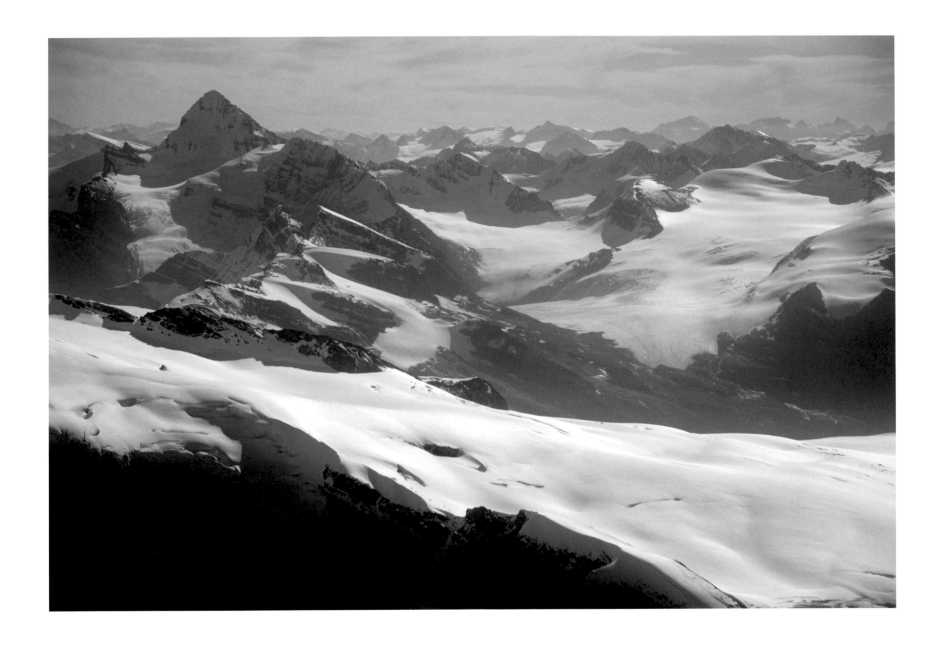

be ways in which we talk about global issues such as climate change that accord equivalent weight to cultural as well as scientific approaches to validating and acting upon human knowledge. That said, the huge question of which knowledge type should judge and inform at the expense of the other remains to be resolved. The common threat of glacial loss, however, could be a means to resolution. Cruikshank wonders whether, since glaciers globally seem to be melting rather than reproducing themselves, they aren't becoming "a new kind of endangered species, a cryospheric weather vane for potential natural and social upheaval."

The oral traditions of many Indigenous peoples hold that the world is constituted by human and non-human forces collectively and that ideas have material consequences. Traditions of Pacific Northwest peoples depict advancing and receding glaciers as shape-shifters that respond directly to failures of human respect and intention. Do glaciers listen, then? As Julie Cruikshank brilliantly observes, glaciers are metaphors that tell us to listen *for* and not just *to* stories. If you consider the question of whether glaciers listen to be a metaphor – as part of a story – then the answer has to be yes, glaciers do listen. They speak too, and they will have a lot more to say about ice, about people and about history as they continue to melt.

Neither scientists nor elders disagree that glaciers are archives of endangered memory. In Indigenous oral traditions glaciers are seen as sentient beings capable of moral judgment. Glaciers are "listening" to us but appear now to be withdrawing rapidly from the one-sided conversation. Taking its cue from this Indigenous narrative, *Do Glaciers Listen?* argues that if we want to avoid alarming repercussions resulting from arrogance in the face of non-human others, we need to explosively transcend contemporary conventional wisdom to create a new water and climate ethic in Canada and globally within a scaffolding of much older narratives. Western science, the book concludes, may benefit from learning how to conduct its research in places considered sentient by others.

Mount Forbes and surrounding glaciers in Banff National Park.

The lakes of the region owe their origin mainly to former glacial action, consisting either of rock-basins or of depressions in the glacial or fluvio-glacial deposits. Certain ones have been dammed back by morainic material deposited either beneath or at the extremities of glaciers of greater extent than at present. Those lakes which receive glacial sediment, or which are shallow, have a greenish cast, while those free from sediment and of moderate to considerable depth are rich blue.

—WILLIAM HITTELL SHERZER, *GLACIERS OF THE CANADIAN ROCKIES AND SELKIRKS*

FIVE: Canada's Most Accessible Glaciers: The Icefields Parkway, Athabasca Glacier and the Columbia Icefield

Early European contact with the Columbia Icefield

A century ago the Canadian Rockies were as remote and unknown as any landscape on Earth. Beyond the thin steel line of the national railway, the limitless wilderness of the mountain West spread to every horizon. If anyone had seen western Canada's great interior icefields, they had left no records. The locations and heights of the country's most spectacular peaks were still unknown.

It was a most unlikely group of people who undertook the first explorations of the great stone divide that formed the spine of the continent in Canada. Though some, like J. Norman Collie, were scientists, while others, such as James Monroe Thorington, were medical doctors, only one was a glaciologist. For the most part they were essentially tourists. Though they were serious in their ambitions, pioneer climbers and adventurers such as geologist Arthur Philemon Coleman and photographer Walter Wilcox did not derive their livelihoods from exploration. They took the train west on their holidays and explored the country as time and money permitted. While they were competent

Norman Collie (facing right) and the members of the 1897 Mount Lefroy expedition at Lake Louise.
Photograph courtesy of the Whyte Museum of the Canadian Rockies

and inspired, it was their wealth and leisure that granted them the opportunity to do what locals could not do, given the demands of a pioneer culture which required that the most practical things be done first because they were linked to survival.

The three adventurers most closely associated with the discovery of the Columbia Icefield were Hugh Stutfield, Herman Woolley and J. Norman Collie. Hugh Edward Millington Stutfield was a wealthy British stockbroker who through careful and considered investment was able to retire early from the London Stock Exchange and pursue his interest in travel. Stutfield was also a crack shot with a rifle and shotgun, a talent that later allowed him to save his fellow climbers from a difficult predicament in Canada with respect to food supply. It was this same talent, however, that induced him to be hunting instead of climbing when the Columbia Icefield was discovered in 1898.

Herman Woolley was a pharmaceutical chemist and the head of a large Manchester drug firm. He also was an amateur boxer of note and a strong climber. John Norman Collie was best known as a scientist, though he also had a fine reputation as a climber in England and Europe. During his active life Collie made a total 77 first ascents in Skye, the Scottish mainland, the Lake District, the Himalaya and the Canadian Rockies. It is perhaps only coincidental that this total is exactly equivalent to the number of scientific papers he published on subjects ranging from the action of haloid compounds on sodium phosphide to notes on krypton, xenon, neon and other noble gases. Collie's association with the Nobel laureate and ground-breaking chemist William Ramsay is now legendary. Collie's scientific reputation would, in itself, grant him a place in posterity.

Fortunately for us, however, Collie was as good a geographer as he was a chemist. During four visits to the Canadian Rockies between 1897 and 1902, Norman Collie mapped more than 3,000 square miles of Canada's mountain West. He was also a climber of note in the Rockies a decade before mountaineering became popular in the region. While Hugh Stutfield and Herman Woolley deserve to be remembered for the parts they played in finding the Columbia Icefield, a hundred years after this historic discovery it is Collie we remember best.

Collie first heard about the Canadian Rockies as a result of an accident at Lake Louise. In August of 1896 a Boston lawyer, Philip Stanley Abbot, lost his life on Mount Lefroy. When the small but enthusiastic North American mountaineering community found itself the object of sharp criticism over the needless death, the Appalachian Mountain Club rallied support for an expedition to the mountain on the anniversary of the accident. Charles Fay, who was with Abbot when he died on Mount Lefroy, did not want to rely on inexperienced climbers to make the 1897 ascent.

Before Philip Abbot's fatal expedition to the Rockies, he had climbed in Switzerland with Harold Baily Dixon, who, like Collie, was a Fellow of the Royal Society and an elected member of the Alpine Club. It had been Abbot's hope that Dixon would join his 1896 party, but this had not been possible. At the insistence of Philip Abbot's father, who was anxious to prove that the mountain upon which his son had died could be climbed, Dixon agreed to join the 1897 attempt on Mount Lefroy. Dixon invited a few of his friends. Among them were George Percival Baker and Norman Collie. Collie was looking for new challenges and

gladly accepted the offer. The three British climbers then invited Swiss guide Peter Sarbach to join them. It is worth noting that Sarbach, who had climbed with Abbot in the Alps, was not invited as a guide but simply as a means for strengthening the climbing team.

Dixon and Sarbach arrived at Glacier House at the summit of Rogers Pass in July of 1897 followed by Collie a few days later. After training in the Selkirks, the nine-member Anglo-American team made the first ascent of Mount Lefroy on August 3. Two days later Collie and Sarbach made the first ascent of Mount Victoria with Charles Fay and Arthur Michael. The climbers then went to the Bow Lake area where, on August 11, they made the first ascent of Mount Gordon, where they were likely the first to see the great white expanses of the Wapta Icefield. With three new ascents to celebrate, the Americans had run out of time and had to go home.

After Dixon headed east to attend a meeting of the British Association in Toronto, Collie, Baker and Sarbach planned to visit Mount Assiniboine, which had acquired the reputation of being the Matterhorn of the Rockies. Collie changed these plans, however, on the basis of something he had seen to the north from the summit of Mount Gordon: a fine, doubled-headed snow peak with large glaciers pouring down its east face. They named the peak Mount Mummery in honour of Collie's friend who died in the Himalaya in 1895. They also looked upon a giant that loomed cold and sharp in the clear August skies farther north. This peak, they surmised, was Mount Forbes, which they guessed to be somewhere near 14,000 feet in height. The sight of this mountain triggered something in Collie that would change his plans for the remainder of

the summer of 1897 and bring him back the following year.

The image of Mount Forbes brought an old legend to life in Collie's mind. It was a legend that grew from the journals of David Douglas who, in 1827, had been the first man to climb a major mountain in North America. Douglas had told the story of two giants that guarded Athabasca Pass in what is now Jasper National Park. These stone monsters, which Douglas had named Mount Hooker and Mount Brown, were said to be as high as 18,000 feet. The Himalayan-sized peaks were said to lay to the north, beyond Mount Forbes. Collie decided to find and then climb them. During the winter of 1897–98, Collie could not get the Hooker–Brown problem out of his mind. Through careful research, Collie learned that many competent explorers had already applied themselves to the mystery of the two mountains and had published excellent accounts of their findings.

The entire issue surrounding the legendary heights of Hooker and Brown began with the explorer and mapmaker David Thompson, who was the first European to traverse Athabasca Pass in 1811. Thompson, perhaps from an incorrect boiling-point determination, estimated the 5,735-foot summit of the pass to be about 11,000 feet. Ross Cox and Thomas Drummond, who crossed the pass in 1814, compounded Thompson's mistake by calculating that if the pass was about 11,000 feet, then the summits of the two major peaks in the area of the pass must be 16,000 and 18,000 feet. When botanist David Douglas crossed the pass in 1827, he recorded in his journal that he wished to climb one of the two peaks at the crest of the pass, and set out to ascend the one on the left, or west, side, which appeared to be the taller. Douglas's journals did not identify any peak

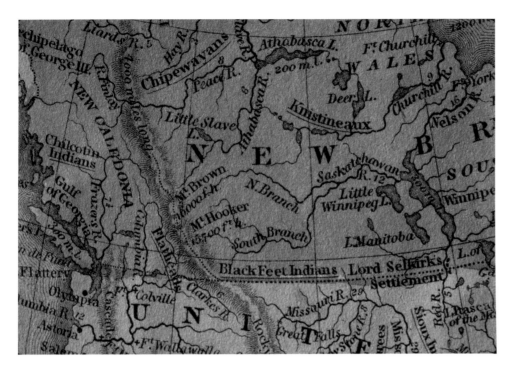

Map of mounts
Hooker and Brown.

the famous fur trade route first crossed by David Thompson in 1811. He claimed the mountain to be 17,000 feet instead of his original estimate of 18,000 and for some unknown reason claimed this peak to be "the highest yet known in the Northern Continent of America". He then named the two Athabasca Pass mountains for botanist colleagues William Hooker and Robert Brown. With a few strokes of a pen, Douglas sent three generations of geographers and mountaineers on a wild goose chase searching for these two fabled peaks.

By 1890 most explorers had given up on finding the Douglas giants. In 1893, however, a Canadian-born geology professor and mountaineer named Arthur Philemon Coleman undertook to resolve the Hooker–Brown mystery for good. Coleman was obsessed with the problem of two huge mountains existing on a map but not existing in fact. In 1893 he made his way to the summit of Athabasca Pass. Members of his party climbed the highest peak on the north side of the pass and found it not to be thousands of feet lower than Douglas had claimed. This information, however, did not dissuade Collie from coming to Canada to see for himself if the Hooker–Brown legend was true.

On July 31, 1898, Collie, along with his friends Hugh Stutfield and Herman Woolley, left Laggan with a large pack string organized by Bill Peyto, after whom the Peyto Glacier is named. Peyto had also hired two wranglers for the long expedition, Nigel Vavasour and Roy Douglas. (Nigel Pass, on the Banff side of the Divide, below Mount Athabasca, would later be named for Vavasour.) Bill Byers had hired on as camp cook. The expedition decided to follow Peyto's 1897 suggestion of reaching the drainage

by name or elevation. Neither did he claim the peak he had climbed was the tallest in North America. Quite contrary to what he claimed when he got home, his journals clearly admit there were many other mountains in the area of the pass that were higher than the one he climbed.

Douglas returned to England in 1828 and began the transcription of his journal notes into an account he hoped to present before the Royal Horticultural Society. It is at this point that the account begins to diverge from his notes and from fact. His published transcriptions argue that instead of climbing the mountain on the left, west, side of the pass, he climbed the one on the left, north, side of Committee Punch Bowl, the small lake at the summit of

of the Saskatchewan by way of the Pipestone and Siffleur valleys, which permitted them to avoid the timber jams and bogs of the lower Bow Valley. The route also afforded them an opportunity to test the validity of another mountain myth, this one concerning Mount Murchison. James Hector of the Palliser Expedition had named the mountain and guessed its altitude at 15,789 feet. Collie proved that the mountain did indeed exist but that Hector had been wrong about its height.

On August 17, their 19th day out from Laggan, the expedition was camped on the divide that separates the Saskatchewan and Athabasca rivers. Opposite their camp, a huge glacier-clad peak beckoned to them. Late in the morning on August 18, Collie and Woolley started for the summit of Mount Athabasca. Valuable time had been wasted in killing of two ptarmigan near timberline, for the deed had to be done with stones. Soon, however, they were on the east side of the peak and climbing. The ridge gave them little trouble until it gave way to rotten, eroded rock. They took to the glacier and made their way up to a large basin just below the summit. Then they cut steps for two hours along a line that was so steep they couldn't change places to relieve the tedium of step cutting. Finally, they arrived at a small platform just below the summit, where a chimney led them to a very trying pitch that allowed them access to the summit ridge. The peak itself would have been reward enough, but the view slowed their minds. Collie later described what he saw:

> The view that lay before us in the evening light was one that does not often fall to the lot of modern mountaineers. A new world was spread at our feet; to the westward stretched a vast ice-field probably never before seen by the human eye, and surrounded by entirely unknown, unnamed, and unclimbed peaks. From its vast expanse of snows the Saskatchewan glacier takes its rise, and it also supplies the headwaters of the Athabasca; while far away to the west, bending over in those unknown valleys glowing with the evening light, the level snows stretched, to finally melt and flow down more than one channel into the Columbia River and thence to the Pacific Ocean. Beyond the Saskatchewan glacier to the south-east, a high peak (which we have named Mount Saskatchewan) lay between this glacier and the west branch of the North Fork, flat-topped and covered with snow, on its eastern face a precipitous wall of rock. Mount Lyell and Mount Forbes could be seen far off in the haze. But it was towards the west and north-west that the chief interest lay. From this great snow-field rose solemnly, like "lonely sea-stacks in mid-ocean," two magnificent peaks, which we imagined to be about 13,000 or 14,000 feet high, keeping guard over those unknown western fields of ice. One of these, which reminded us of the Finsteraarhorn, we have ventured to name after the Right Hon. James Bryce, the then President of the Alpine Club. A little to the north of this peak, and directly to the westward of Peak Athabasca, rose probably the highest summit in this region of the Rocky Mountains. Chisel-shaped at the head, covered with glaciers and snow, it also stood alone, and I at once recognised the great peak I was in search of; moreover, a short distance to the north-east of this

Arthur Philemon Coleman.

Photograph courtesy of the Alpine Club of Canada

81

mountain, another, almost as high, also flat-topped, but ringed round with sheer precipices, reared its head into the sky above all its fellows.

At once I concluded that these might be the two lost mountains, Brown and Hooker. As rapidly as I could I drew lines in all directions on my plane-table survey towards these peaks, and put up my mercurial barometer; but, hurry as fast as I could, it was 6:30 p.m. before we started down from the summit. Woolley's patience must have been sorely taxed, but he endured the waiting and the cold with characteristic fortitude.

Having conquered the difficult north face, the tired climbers opted for an easier way down. Following the summit ridge to an adjacent horn they descended what is now the classic route up this popular mountain.

On August 20, two days after the first ascent of Mount Athabasca, Collie, Woolley and Stutfield camped on Athabasca Glacier just below the last of its three great icefalls. At 3:00 a.m. the following day they used headlamps to make their way up through the deep crevasses and jumbled séracs to become the first to stand on the icefield proper. They were heading for Mount Columbia, the wedge-peaked giant Collie had seen from the summit of Athabasca. As the day warmed and the snow on the icefield began to thaw, they realized that Mount Columbia was too far away to reach in a day. Instead they climbed a great arc of snow on the edge of the icefield which they called the Dome. Back in England it would occur to Collie that on the top of what is now called Snow Dome, they were standing on the only peak in North America where the snows, when melted, find their way into three different oceans. This peak is a triple divide, the apex between the drainages of the Columbia River, which flows into the Pacific; the Saskatchewan, which drains to the Atlantic at Hudson Bay; and the Athabasca, which makes its gradual way north to empty into the Arctic Ocean.

Collie surmised correctly that the chisel-headed summit they had named Columbia, and the neighbouring flat-topped giant which they named Alberta, could not be the legendary Hooker and Brown. Though Collie went on looking, he never found Douglas's fabled giants. In all his adventures, which included six expeditions and more than 20 first ascents in Canada, he never found anything that rivalled the grandeur or the geographical significance of the Columbia Icefield.

Filling in the map: Completing the exploration of the icefield

Norman Collie's 1898 exploration of the Columbia Icefield area raised more questions than it answered. Collie and Stutfield had been greatly impressed with the size and nature of the Icefield giants and had first-ascent designs on mounts Columbia, Bryce and Alberta. Unfortunately, the distance from any base camp in the Saskatchewan or Athabasca river valleys made these mountains simply too distant for a practical one-day attempt. The climbers acknowledged that Mount Columbia might be possible if an easier route through the triple icefall on Athabasca Glacier could be found. Stutfield, however, offered that the entire Columbia Icefield group of mountains might be far more accessible from the western side, where massive gla-

ciers and the névé of the Columbia Icefield did not make it impossible to bring horse camps closer to the peaks they wanted to climb. So it was that in 1900 Stutfield and Collie planned a third expedition to the Rockies with the aim of exploring the remote mountains between the main ranges of the Rockies and the Columbia River. The expedition proved to be a disaster, however. The climbers did not take into account that the forests on the wet side of the Great Divide would be dense and impenetrable. The party spent a month beating their way up the Bush River only to find themselves 15 miles away from the Columbia Icefield.

Disappointed by their failure to climb even one decent mountain during the summer of 1900, Collie gave the Rockies a miss in 1901 and went instead to climb in the Lofoten Islands in Norway. In the meantime, however, the Canadian Pacific Railway advanced their plans to turn the Canadian Rockies into the Canadian Alps. Following the death of Philip Abbot at Lake Louise in 1896, the railway hired professional mountain guides from Switzerland to take hotel guests up mountains at Lake Louise and at Glacier House at the summit of Rogers Pass. In 1901 the railway brought Edward Whymper, the conqueror of the Matterhorn, to the Rockies to promote mountaineering in Canada. This angered Collie, who wrote to Charles Thompson to complain that Whymper was going to hog all the first ascents.

Collie adamantly disliked Whymper because he had done his level best to denigrate Albert Mummery's mountaineering accomplishments by blackballing Mummery's application to join the exclusive Alpine Club in Britain. But Collie need not have worried about Whymper. At 62 years of age, Whymper was haunted still by the deaths of four companions on his ascent of the Matterhorn and had taken to drink. In the entire time Whymper was in the Rockies, he was never more than two days away from the railway tracks. Though the "Lion of the Matterhorn" proved no threat to Collie's Columbia Icefield ambitions, Whymper did make the first ascent of Mount Collie, adding, in Collie's mind, insult to injury with respect to his relationship with the most famous mountaineer of his time.

Though Whymper did not prove a threat to Collie's first-ascent plans in the Columbia Icefield area, another British climber did. After teaming up with Whymper briefly, James Outram made headlines in Canada and abroad with the first ascent of Mount Assiniboine in September of 1901. Collie resented Outram as much as he did Whymper, if only because Outram had played no role in the exhausting early exploration of the Rockies but was managing simply to make first ascents of mountains found and mapped by others. When Collie returned to the Rockies in 1902, he was no longer interested in exploration. He wanted to make first ascents in the icefield he had discovered. Competition between these two climbers would lead to full exploration of the Columbia Icefield and first ascents of many of its most prominent peaks.

In the summer of 1902, Outram got into the field two weeks before Collie. Realizing he had only a short time before Collie arrived, Outram advanced immediately up the main branch of the Saskatchewan to the Alexandra Valley with the intent of stealing the first ascent of Mount Columbia, the giant of the Columbia Icefield. Near the base of Mount Alexandra, which dominates the head of the valley, Outram and his guide, Christian Kaufmann, ascended a high ridge to survey the surrounding peaks.

There they saw before them the edge of the great icefield discovered by Collie and Woolley four years before. They saw also the narrow, three-pointed ridge of Mount Bryce and, as the clouds parted, the exquisite summit of Mount Columbia. They saw too that they were still a difficult and trying distance away from both.

On July 19, 1902, Outram and Kaufmann set out from their camp at 2:20 a.m. in just enough light to see the shadows of the trees in the valley. In an hour they felt the coldness of the glacial ice. At 5:00 a.m. they roped together to thread their way through the maze of crevasses and soon looked out over the eternity of ice and snow that forms the windswept névé of the icefield. The mountain looked no closer than it had from the valley floor. It took the climbers nearly four hours of continuous walking to reach the bergschrund out of which the peak of Mount Columbia rose into the cold, indifferent sky. They made their gradual way up the arête to a sheer and icy escarpment that was the last obstacle to the summit. At just after 2:00 p.m., Outram "planted the Union Jack on the broad, white platform that crowns the summit, the highest point in Canada from which the British flag has ever floated." Then they faced the careful descent and the long slog back over the ice to camp. Just after midnight, after 22 hours of strenuous walking and climbing, they at last stumbled into their tents.

Outram and Kaufmann went on to do other first ascents before joining Collie, Woolley and Stutfield at Glacier Lake. It appears that Outram's success on Mount Columbia may have stifled Collie's interest in the Columbia Icefield. He never climbed there again. Whatever misgivings Collie may have had over Outram's theft of his Columbia dream, he appears to have stifled them. The amalgamation of the two climbing parties generated historic results. They climbed together for 11 days. During this time, they made first ascents of Mount Freshfield and Mount Forbes. After these successful landmark climbs Collie went south to tackle the imposing tower on Howse Peak. Outram went north again, toward Collie's icefield, to make the first perilous ascent of awesome Mount Bryce.

Outram's account of the first ascent of this great peak offers important insights into the early history of mountaineering in Canada. History, it appears, is recorded by those who can write. A disproportionate share of the glory goes to those who document their climbing stories. Though clients were often competent and courageous, more is generally owed to the guides who accompanied them than is usually acknowledged. Outram was an ambitious, able climber, but without Christian Kaufmann he would never have succeeded as he did. For his day Outram was a climber at the extreme, and were it not for the balancing influence of a good guide, Outram's body might still be resting on some lofty but lonely Canadian peak. It can be argued, however, that this is the role of the professional guide: to make mountain travel safe and impart to clients a wholesome appreciation of all things alpine. It was generally held that guides were supposed to leave the storytelling to those who hire them, hoping that a little credit might come their way. Certainly it did in 1902, Outram's most spectacular season and a banner year for mountaineering in the Columbia Icefield.

Between 1902 and 1919, there was virtually no exploration done in the area of the Columbia Icefield. During that time, the efforts of mountaineers were concentrated farther south, at Lake Louise and beyond. While a

few expeditions made their way north from Lake Louise to Jasper, they avoided the difficult Columbia Icefield section. In time, however, civilization began to catch up with the remoteness of the West. In 1913 a survey to delineate the boundary between Alberta and British Columbia was undertaken by the Office of the Surveyor General in Ottawa. During the first three years, the survey concentrated on the southern Rockies between Akamina Pass and Mount Assiniboine. By 1918 the survey had advanced past Thompson Pass to within sight of the Columbia Icefield. The next year, the survey took up where it left off at Thompson Pass. In July of 1919 a climbing party ascended to the Columbia Icefield and began to survey a line across it to Mount Columbia. The survey was undertaken by R.W. Cautley of the Alberta Land Survey and Arthur Oliver Wheeler of the British Columbia Land Survey. Wheeler was already famous as a mountaineer and co-founder of the Alpine Club of Canada. His landmark survey of the Great Divide would lead to the first widely available maps of the Columbia Icefield and to a new focus on the area as a centre for mountaineering and high alpine adventure.

The first major expedition to the Columbia Icefield was led by a prominent American ophthalmologist named James Monroe Thorington and his friend W.S. Ladd. Their guide was a famous Austrian named Conrad Kain, who had worked with Wheeler on the boundary survey in the Columbia Icefield area. Kain would later lead the first ascent of Mount Robson, the highest peak in the Canadian Rockies.

A 1922 expedition to the Freshfields had whetted James Thorington's appetite for the northlands. Throughout the following winter Thorington and Dr. William Ladd spent hours poring over the few available maps and photographs of the region they called the "Alexandra Angle." This country, which they considered "a land lost behind the ranges," included the peaks along the Continental Divide between Howse Pass and Mount Columbia all of which were encompassed by the uppermost drainages at the headwaters of the North Saskatchewan River. Though some of the earliest expeditions, including those of James Hector, Norman Collie, Walter Wilcox, Jean Habel, James Outram and Mary Schäffer had made brief incursions into this blank space on the map, it was still, to a very large extent, unexplored. Since the early expeditions, the Boundary Survey had made preliminary maps of the region. But one could still very easily get lost amid this ordered absence of human presence.

In fact, the expedition of 1923 would prove more exotic than anything any of them ever could have planned. It would be a journey that would connect James Thorington with Conrad Kain for the rest of both of their lives – and it would make for enduring history in the annals of exploration in the Canadian Rockies.

Plans for the expedition were finalized in the spring. The outfitter for the expedition was to be none other than Jimmy Simpson. Simpson wrote to Thorington to say that Tommy Frayne, who was cook for the 1922 Freshfields endeavour, would return to cook the meals and run the camp. He added also that Ulysses LaCasse would be the expedition's wrangler. While tourists who had stopped at the train station at Laggan watched, their long pack string departed from Lake Louise on June 27, 1923. The next day they reached Bow Lake. By the first of July they had crossed the forks of the Saskatchewan and had camped on

Graveyard Flats below Mount Coleman. The next day they were at "Last Grass Camp" at the head of the Alexandra River. The idea of visiting the Columbia Icefield filled every Thorington thought. Every landmark, every old camp they passed gave dimension to his waking dream of first ascents of peaks surrounding that great mass of ice.

After visiting the east and west Alexandra glaciers and the north basin of Mount Lyell, the expedition reached Castleguard camp on July 5. The next day, the entire expedition, including Jimmy Simpson, Tommy Frayne and Ulysses LaCasse climbed Mount Castleguard.

On July 9, while William Ladd unsuccessfully tried his luck fishing in the Castleguard River, Conrad Kain and James Thorington made the first ascent of Terrace Mountain. The following day they were ready for their first big ascent. At 3:20 a.m. they set out for North Twin. As Thorington later explained, they came to know the scale of the Columbia Icefield on that day. At 6:00 a.m. the climbers were at last able to leave the shoulder of Mount Castleguard at the head of Saskatchewan Glacier and begin their long tramp over the icefield proper. Though it looked only half that distance to the Thorington party, North Twin is a full 12 air miles from the shoulder of Castleguard. It took them several hours just to reach the head of Athabasca Glacier and the base of Snow Dome. They were still only halfway to North Twin. After circling widely to avoid crevasses at the head of Columbia Glacier, Thorington began to see things that weren't there:

> Fatigue mirages – momentary illusions – began to appear; for an instant I was convinced that the dark line of a distant crevasse was a staff planted on the summit of

North Twin; and I berated Conrad for bringing us so far only to let us be cheated of a first ascent.

Thorington's observations of mirages on the immense plateau were confirmed the following year by the Osgood Field expedition and from time to time have been reported by climbers right up to the present. Bushes and trees constantly seem to present themselves at various places all over the icefield as climbers painfully observe their own slow progress over the eternal snows.

Only after the party stopped for lunch at 2:00 p.m., after nearly 11 hours of walking across the ice, had they reached their mountain. Before them was a stunning scene. Framed by North Twin and ice-deep summit bulges of Mount Stutfield, the climbers peered in silent awe at the unclimbed, cliff-walled summit of giant Mount Alberta. They reached the top of North Twin at about 4:20 p.m. As too often happens in mountaineering, the climbers had reached the summit only to be greeted by dense cloud. Robbed of the view, the party had to be satisfied with the first ascent of North Twin, the last of the unclimbed 12,000-foot peaks in the Columbia Icefield area, and with the first traverse of the Columbia Icefield from the Castleguard valley to the head of Habel Creek. As any climber will tell you, the summit is only halfway to the goal. Underscoring the scale of the Columbia Icefield and the great peaks that surround and cradle it, the arduous return journey from North Twin is one of the epics of early mountaineering in Canada. Thorington described it as if it were a dream:

> Someone, following in our track, may one day understand that journey back across the icefield's

vastness. For an analytical mind, it will at least afford insight of the psychology of fatigue: the half-hour in a blizzard, obscuring the trail and exhausting us; the clearing at sunset, with crimson and orange light banded against masses of lead-blue storm clouds behind The Twins; mist and snow-banners wreathed about and trailing from Columbia and catching up the light – we three mortals in the middle of the field, in all its immensity, struggling on in insufficiently crusted snow until the light failed.

Twenty-three hours after leaving camp, the climbers fell on the grass beside the campfire and ate breakfast as the sun rose on the peaks surrounding Castleguard Meadows. This had been the longest mountaineering ordeal to date in the Canadian Rockies.

By July 12 Ladd and Thorington had recovered enough to follow Kain up the low saddle that connects the head of Castleguard with the Terrace Valley. Soon the climbers were in the shadow of Mount Saskatchewan, which, from that north-facing angle, reminded them of the Matterhorn as seen from Zermatt. Making their way up a series of chimneys and up the broken cliffs on the north side of the peak, they overcame the last steep pitches of snow to gain the arête. The summit required careful negotiation of several long cornices overhanging on the north. By about 3:00 p.m. they were constructing their summit cairn.

Two days later Thorington and his friends were off to Mount Columbia. Though the snow conditions were better than when they had made their way across the icefield to climb North Twin, it was still a long way to Mount Columbia. Not until 1:30 p.m. did they finally reached the top. Though it was cold, they stayed on the summit for 40 minutes making photographs and trying to find words for the complex geography they were seeing.

With the ascent of Columbia, time ran out for the Thorington–Ladd expedition of 1923, but their adventure was not over. Though they climbed no more mountains on this trip, they did do something that had never been done before in the Canadian Rockies. Jimmy Simpson had observed that Saskatchewan Glacier could be accessed from Castleguard Meadows by way of a low pass which he called Castleguard Pass. The glacier could then be approached by way of a relatively flat moraine. Simpson had also observed that the glacier advanced at a gentle angle down to the outwash plain at its snout. Though he was unsure of the conditions at the toe of the glacier, Simpson was confident that with a little assistance from Ulysses LaCasse and the climbers, they could use the glacier as a descent route back into the Saskatchewan River valley. Thus did the Thorington party become the first to cross a part of the Columbia Icefield by horse.

The next year, 1924, was also a highlight for Canadian mountaineering. A number of important and very long expeditions were undertaken into the least known parts of the Rockies. One of these expeditions, led by prominent American glaciologist William Osgood Field, would discover a remarkable geological feature at the edge of the Columbia Icefield that would become a major exploration challenge to scientists and speleologists for the next 50 years.

The Columbia Icefield is an enormous topographic feature. The great peaks that circle this huge mass of ice are

The glaciers of the Canadian Rockies have been under the study of the scientists of the Smithsonian Institution, according to the announcement of Dr. J. Monroe Thorington of the Smithsonian staff, and it is declared that the retreat of the glacial tongues is apparently more pronounced during the past few years than previously. Then the astounding statement is made that this is due to the fact that mild weather and decreased snowfall at the ice fields which feed the glaciers, 150 years ago, is the cause.

It is not a matter, according to the scientists, of warmth or deficient snowfall nowadays, but because a century and a half ago such had occurred, that the glacier tongues of the Canadian mountains are rapidly receding. It is explained that the flow of the glaciers is at the rate of 100 feet per year and for the ice of the upper fields to reach the tongues, a distance of three miles, it would take a century and a half. In other words the deficiency of ice that formed 150 years ago would now demonstrate itself through a lessened flow today.

There could be an analogy between an occurrence in nature and an act in the life of humanity. Words spoken generations ago have exerted a tremendous influence upon mankind through all the years and affect human relations and human conduct today as greatly as they did when first spoken. Acts doubtless designed to meet some specific emergency ages ago, still have an important bearing upon humanity. A new thought given to the world might well influence human conduct and human faith generations after the brain which conceived it had been forgotten.

It may not properly be said that the happenings of today are ephemeral, meeting conditions of the present only to be forgotten – inert and dead. The seed hidden away in the ground may well germinate long after it had passed from sight. The action of today may bear long after present generations have passed from the scene. It has well been said that nothing in nature is ever lost.

— Helena, Montana, *Daily Independent*, Saturday, April 30, 1927

often a considerable distance from one another. Without camping on the icefield itself, it takes climbers a long time to reach the peaks that offer the greatest altitude challenges and the grandest views of the ocean of ice. In 1923 Thorington had in effect thrown down a gauntlet to other climbers by announcing that Conrad Kain, W.S. Ladd and he had set a "new long-distance and altitude record in Canadian mountaineering." Their claim rested on having first travelled from Laggan to the Columbia Icefield, then climbed, on five consecutive days, North Twin (first ascent and a journey of 54 kilometres, more than 30 miles), Mount Saskatchewan (also a first ascent, with a trek of 27 kilometres, nearly 17 miles) and Mount Columbia (second ascent and 42 kilometres, or 26 miles). The longest of these expeditions, North Twin, had taken 23 hours. There exists in the climbing tradition a myth that mountaineering is not supposed to be a competitive sport. Not everyone subscribes to that idea.

The 1924 Field expedition was composed of Harvard glaciologist William Field, whom his friends called "Oz"; Field's brother Fred; guide Edward Feuz, who had been hired on at Lake Louise; Lement Upham Harris; and Joseph Biner, a Swiss guide from Valais who had climbed with Harris in the Alps. The party had come to the Rockies because of a talk James Thorington had given at the American Alpine Club in Boston about his 1923 Columbia Icefield expedition. They were very anxious to make the first ascent of South Twin.

Feuz led them first to Castleguard Meadows, where they camped. As South Twin was a good 25 kilometres, about 15 miles, away, Feuz instructed the party to leave at 8:00 p.m. one evening and to walk across the icefield by

moonlight to the base of the 11,700-foot peak. It was only lunchtime when the team of very strong climbers made their way to the summit. Relishing the stimulating physical exercise and grand views, William Field proposed that the party climb North Twin while they were in the vicinity. Feuz agreed, suggesting that since they were going to be late getting back to camp anyway, they might as well make a full day of it. Fred Field complained he'd already had enough, but he was overruled. William and Edward had their way.

The return trip from North Twin was something of an exercise in masochism. As had happened to the Thorington party the year before, the climbers had to return over the icefield during the hot part of the summer day. Mirages began to appear, just as they had to the eyes of Thorington and his party. Harris saw bushes and trees growing out of the ice and claims to have seen groups of people watching their "piteously slow progress on that interminable march." In just over 24 hours the climbers had walked 58 kilometres, some 36 miles, and climbed two of the highest peaks in the Columbia Icefield group.

The party took a day off and then climbed Mount Castleguard. By this time, the Fields and Lem Harris began to get fidgety and decided on another adventure. Feuz suggested the party climb Mount Columbia the next day. As the ascent of Columbia was thought to be long but technically easy, their plan quickly expanded to include not just the members of the climbing team but outfitter Max Brooks and wranglers Ernie Stenton and old Soapy Smith as well.

The Castleguard caves

The day after the Columbia climb, while Feuz was discussing the types of crumbling rock in the Canadian Rockies and how they compared with the much harder rock of the Selkirks to the west, Lem Harris spotted a large string of pack horses coming up the valley from the south. It was a party led by none other than Sir James Outram. This was to be Outram's last visit to the mountains he so loved. Along with him was Henry Hall, an American climber who, with his wife Lydia and friend Henry Schwab, was en route to the Alpine Club of Canada camp at Mount Robson by way of the Columbia Icefield. Hall brought news of a big fire at Chateau Lake Louise.

At the age of 29, Henry Hall was already a very successful investment broker and an established mountaineer. A competent administrator as well, Hall would ultimately serve as a councillor, director and officer of the American Alpine Club. He understood that expedition climbing was about to become a major thrust in American mountaineering and he did much to encourage outbound expeditions to the Himalayas and elsewhere. Hall's name would also become inextricably tied to successful expedition-style climbs in the St. Elias Range, for which this journey to the Columbia Icefield was but a training exercise.

Though many other outfits had camped in the Castleguard area and observed how meltwater disappeared through cracks and fissures in the bedrock of the meadows, none had hitherto discovered where that water went. Exploring the timbered slope below their camp late one afternoon, two members of the Field party heard a rumbling underneath the ground. Before they could

ascertain what was happening, a river burst forth from the side of the mountain below them. Further exploration revealed a substantial cave mouth out of which the water was flowing in torrents. Two days later the water subsided, at least for a time, and the party was able to explore the cave for some 200 metres to where the cave floor dropped into an abyss. The mystery of the Castleguard cave system would haunt scientists and cave explorers for more than 50 years until research initiated by McMaster University geologist and caver Derek Ford led to the realization that the 12-kilometre-long cave system ended under the Columbia Icefield itself. Today the cave system is closed to the public for reasons of safety. Even the entrance to it can only be accessed by experienced and well-equipped mountaineers. Travelling in the cave system can be extraordinarily dangerous, as flooding is common and unpredictable. The Castleguard caves remain one of these places we are happy to know exists and pleased to have protected as part of a World Heritage Site, but it is not a place that will ever be visited by many people.

A few days later, the Field party moved back down the Saskatchewan River valley towards Banff and up the Mistaya River to near Mistaya Lake. On the way they had made first ascents of Mount Outram, Epaulette Mountain and an unnamed peak near the twin Kaufmann Towers. It was there that yet another long string of pack horses made their appearance. A party of nearly 20 young American women from a girls school in New Jersey made their dreamlike appearance, led by Caroline Hinman, known to the outfitters as "Timberline Kate." The girls had had a rough river crossing and were soaked when they made camp. A great party ensued, prompted by a three-foot-long bannock baked by Max Brooks and Hinman's packer Jim Boyce.

Following this meeting, Lem Harris and Joseph Biner departed for Lake Louise and their return to New York and preparations for a climbing trip to the Alps. The Field expedition concluded on July 30 at Lake Louise, where they were able to look upon the charred ruins of Chateau Lake Louise.

Perhaps because the Field party had been so successful and did much to advertise their success, they advanced the tradition of masochistic multi-peak forays into the Columbia Icefield area. Not to be outdone by Field and his crew, Alfred J. Ostheimer, the Harvard geographer who had accompanied James Monroe Thorington on his 1924 trip to Athabasca Pass, returned to Jasper with two of his students in the summer of 1927. Their two-month expedition visited the Columbia and Clemenceau icefields with Swiss guide Hans Fuhrer. In one 36-hour orgy of peakbagging, their party put up a new route on North Twin, made first ascents of Stutfield Peak and Mount Kitchener and completed the first traverse of Snow Dome. They were on their way to Mount Columbia to add this to their triumphs when bad weather forced them to end their spree. The Ostheimer expedition was in the field for 63 days. During that time they travelled more than a thousand kilometres, some 600 miles, and climbed 36 major peaks. Twenty-seven of these ascents had never been made before.

The legend of Byron Harmon

It was during the 1920s that photography really began to define how locals and visitors alike perceived the land-

scape of the imagination that was the Canadian Rockies. During the 40 years he lived in Banff, photographer Byron Harmon probably did more than any other photographer in the area's history to capture what it was like to travel in the early days in what is now the expanded area encompassed by the Canadian Rocky Mountain Parks World Heritage Site. Though he figured significantly in the 1911 Yellowhead Pass scientific expedition, Harmon's major claim to enduring fame may be his involvement in Lewis Freeman's Roof of the Rockies expedition in 1924.

Byron Hill Harmon was born near Tacoma, Washington, on February 9, 1876. One of three children of Hill and Clara Smith Harmon, Byron grew up amidst a pioneer atmosphere given over to self-reliance, resourcefulness and a great respect for nature. As a child, young Byron was regularly plagued by serious health problems. He twice contracted typhoid and suffered almost continuously from asthma. In his teen years, Harmon exhibited two skills that he would cultivate to his advantage throughout the rest of his life: a remarkable ability to design and build useful objects from simple materials at hand; and an interest, eventually quite a serious interest, in photography. Both of these talents would come into spectacular play during the Roof of the Rockies junket, the longest and most difficult of his many expeditions in the mountains.

As a teenager, Harmon began to take pictures at a turning point in the evolution of photographic technology. By the 1880s Kodak had begun to market its first roll films. Using the slogan "You push the button, we do the rest," Kodak was able to spread photography beyond a technical or scientific elite and put a camera in the hands of anybody who could afford one. Harmon overcame this

A.O. WHEELER AND THE GREAT MAPPING

For a hundred years the image of Arthur Oliver Wheeler has towered over the history and legend of Canada's western mountains like a colossus. Here is a man who appears to have been everywhere, known everyone and done everything at the most important junctures not only in the development of mountaineering but in the history of Canada.

Before Arthur Wheeler was 20 he fell in love with the notion of the "great lone land" that was the West. He became of surveyor at just the moment in history when cartography was being revolutionized by photography. He fought, and was wounded, in the North-West Rebellion. He followed the tracks of the newly completed Canadian Pacific Railway west. He mapped the Selkirk Ranges and then wrote the first book published by a Canadian on the history and character of our mountains. Wheeler co-founded the Alpine Club of Canada and established it as the leading institution for alpine science and exploration in its day. He mapped huge sections of British Columbia and southern Alberta. He was a commissioner of the boundary survey which mapped and named the mountains, icefields and glaciers along the 750-mile Continental Divide separating Alberta and British Columbia. Wheeler contributed to the creation of Canada's renowned mountain national and provincial park system and then created a national organization dedicated to its protection and expansion.

A.O. Wheeler became known around the world as a champion of Canadian mountaineering. It can be argued that he almost single-handedly drew together the people and resources that made Canada into an alpine nation. A.O.'s achievements are commemorated for all time by a National Historic Sites plaque at the Columbia Icefield visitor centre.

latter problem of affordability by simply constructing his own. His first lensless pinhole camera was a crude affair but it still took pictures, at least well enough to allow the young Harmon to remain enthusiastic about his progress in the photographic craft. After a brief stint working in a lumber mill proved aggravating to his asthma and he found himself without a job, he made photography his central interest and profession.

It is not known exactly when Harmon started taking pictures for a living. We do know he opened a small portrait studio in Tacoma sometime in the mid-1890s. In Bart Robinson's biography of the famous photographer, aptly titled *Great Days in the Rockies*, we learn of a marvellous anecdote about those early portrait years, a story Harmon himself apparently liked to tell after he moved to Banff. It seems that after buying all the necessary equipment and renting studio space, young Harmon did not have any film with which to begin his business career. As he was out of cash and well beyond his credit limit, he had to take a risk to get his life started on the photographic path. After welcoming his first client, Harmon took a portrait without any film in the camera in order to obtain payment for the resulting print in advance. When the client returned to claim the portrait, Harmon announced himself unsatisfied with the quality of the image and asked his client to repeat the sitting in order to gain the desired results. Such was the ingenuity of this young photographer that his career was launched without so much as a roll of film to his name.

By the end of the 1890s, Harmon found the moist Tacoma air was still aggravating his asthma. He also found that his photography needed a change of scenery to fulfill itself as an art form. Reducing all his photographic equipment to what he could pack and carry with him, Harmon became an itinerant photographer bound to see the world. He travelled throughout the American southwest. He went to the eastern seaboard. He worked in New York. Finally, he began his gradual return west by travelling across Canada. Although of very short duration, Harmon's first visit to Banff was an important one. Visiting the hot springs, as almost every visitor did, he met a local who told the young photographer that, despite almost unlimited photographic opportunities in the national park, there was no permanent photographer or studio in the town of Banff. Pondering the potential positive effects of the high, dry mountain climate on his asthma and somewhat weary of his constant travels, Harmon gave serious consideration to moving to "that part of Canada which stands on end," as he liked to call it. Harmon returned to Canada the next year and began working in High River, where he had been at the time he made his first visit to Banff and its famous hot springs the year before. Auspiciously, he began almost immediately to make a national name for himself. It all started with a gunfighter he met in the streets. Don't all great western stories start this way?

It appears that a notorious American gunfighter had moseyed into High River one day, obviously on the lam from the law in the States. The law-abiding townsfolk were terrified by the appearance of this mean, gun-toting dude on their quiet streets. Hiding out behind a big chimney on a main-street roof, Harmon was able to get a good clear picture of the outlaw without being noticed. He sent prints to eastern newspapers hungry for any hint of wild news from the West. Widely published, the picture brought Harmon his first taste of national recognition.

In the summer of 1903, Harmon moved to Banff. He was 27 years old. Though he continued his portrait trade as a way of establishing himself in town, he also began selling a variety of "mountain views" to tourists brought to Banff by the Canadian Pacific Railway. By 1907 he had expanded his line to more than a hundred images and was able to advertise the largest postcard collection in existence ("over 100 assorted views").

As Harmon's health improved, his portrait business came to mean less and less to him. The country captivated him. He took up hiking, riding and climbing in an ambitious way, carrying his heavy, large-format cameras and big tripods to the most unlikely places. He became an ardent mountaineer. When the Alpine Club of Canada was formed in 1906 and its offices located in Banff, Harmon became one of its charter members and its official photographer. The club also afforded Harmon regular opportunities to meet some of the most important climbers of his day. He was in regular contact with the irascible Arthur Oliver Wheeler, president of the ACC, as well as with other members of the Dominion Land Survey who made the first complete maps of the Great Divide boundary between Alberta and British Columbia. It had been Wheeler who had asked Harmon to accompany him and Tom Longstaff on their 1910 expedition to the Purcell Range, where they visited the famous Bugaboos. Until its toponym was later changed by the Geographical Names Board, Bugaboo Glacier had been called Harmon Glacier to honour the great early photographer. This extended journey was the longest undertaken by Harmon until his 1924 expedition to the Columbia Icefield with Lewis Freeman. But there were other long trips in the interim. Harmon was

with Wheeler's Yellowhead Expedition in 1911, and in 1913 he made the first ascent of Mount Resplendent near Mt. Robson with Conrad Kain. Later, Harmon became as involved in making motion pictures of the Rockies as he was in the production of postcards.

In the spring of 1920, Harmon represented the federal government and the Alpine Club of Canada at the International Congress of Alpinism in Monaco. His movies received rave reviews and were the toast of the entire congress.

Despite his growing international reputation and a barrage of European contract offers, Harmon still believed he had a lot of work left to do in the Rockies. His most ambitious project was to photograph every major peak and glacier in the region.

It is to Byron Harmon's incredible images that we must look to find out how big the glaciers were and what the country and the people who travelled through it with him were like. Some of Harmon's most enduring images were made on a remarkable expedition mounted by a visiting American during the autumn of 1924 which spent a lot of time on or near glacial ice.

On the Roof of the Rockies, 1924

Lewis Freeman's account of the Roof of the Rockies expedition draws continual attention to the fact that he had been travelling all over the world in his pursuit of adventure. Early in the account we learn that the 1924 expedition with Harmon was delayed into the late summer because Freeman had already planned "a jaunt of his own" that took up July and most of August in that fourth summer of the Roaring Twenties. Absurd as it may appear today,

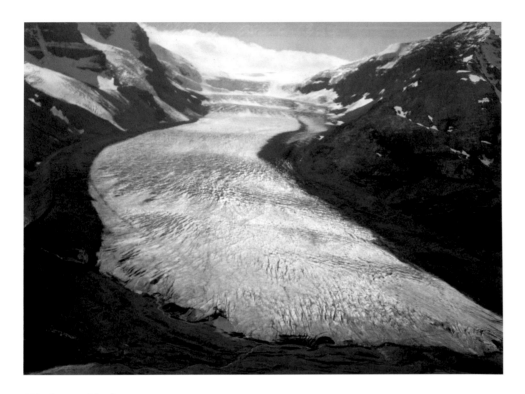

Athabasca Glacier as photographed by Byron Harmon in 1917. Photograph courtesy of the Whyte Museum of the Canadian Rockies

Freeman goes out of his way to tell us that "by hard and steady pushing through the stormiest early summer the Great Lakes have known in many years," he was able to complete a motorboat trip from Chicago to New York in time to make his rendezvous with Harmon in Banff on August 15. It is difficult to see how two such expeditions could even compare. In reading between the lines, we can tell early in the narrative that although Freeman is financing part of this expedition, he is really only along for the ride. It is Harmon who knows the route, and the hazards, and he has hired the very best horsemen to undertake this very problematic late-season journey into the high country. Harmon had daring plans. The party would follow the Bow River to Bow Lake, cross Bow Pass into the drainage of the North Saskatchewan and follow the Saskatchewan to the Columbia Icefield by way of the headwaters of the Castleguard River. After crossing Saskatchewan Glacier by horse, the party would then round the icefield by way of Parker Ridge and Sunwapta Pass and camp for a time at the snout of Athabasca Glacier before tracing a route down the Sunwapta River and up the Athabasca to its source near the north face of Mount Columbia. The party would then travel to Jasper for supplies and begin the 200-mile horse journey back to Banff. The winter conditions they would encounter on the return would be the subject of "snow films" produced by Harmon. Freeman pondered what he considered the two biggest challenges of the expedition. First, he did not believe that horses could be used to cross any part of the Columbia Icefield. Though Jimmy Simpson had engineered this feat for the Thorington expedition the previous year, their party had made their crossing of Saskatchewan Glacier earlier in the season. The second challenge, the lateness in the season, bothered Freeman for other reasons. As much of an adventurer as he thought himself to be, he did not look forward to crossing the high passes of the Rockies in mid-October, even if he was accompanied by Herbert A. "Soapy" Smith, one of the best packers that ever lived in the Rockies.

It was clear from the outset that Freeman the journalist would have a story even if the expedition failed. The real pressure to make it a success fell upon the packer, the cook and on Byron Harmon, who would be subjecting hundreds of pounds of photographic equipment and supplies to the rigours of long-distance horse travel in rugged

country virtually devoid of anything that looked like a normal horse trail.

Harmon added some interesting twists to the trip. As if carrying regular packs through the dense bush and deep water of the eastern side of the Great Divide were not difficult enough, Harmon also brought homing pigeons along as a means of getting word out about the progress of their long expedition. The pigeons were also to be used as part of another experiment. As well, the party brought a radio set. Not only would this supposedly bring much-needed entertainment into the expedition's camps at night, but it would also be used to see if, by way of pigeons, messages could be forwarded to major North American radio stations about the progress of the party. One pigeon did arrive at Harmon's house in Banff with a message that was forwarded to a powerful American station. The station broadcast Freeman's editorial remarks for a book he had just completed about a Grand Canyon trip he had made in 1923. The expedition heard the broadcast one lonely night on the trail. Freeman had used the pigeons to draw attention to himself rather than to the expedition.

Lewis Freeman was often self-centred in this way, and his record of Harmon's Roof of the Rockies expedition is no different. But he was nevertheless a very vivid writer, and nowhere is this more obvious than in his description of the owner of the outfit and head packer Herbert Alonzo "Soapy" Smith. In characterizing Smith, Freeman had a lot to work with. While he did not know about Smith's dry sense of humour, Freeman could see that Soapy could swear with real authority. For some reason this really impressed Freeman:

An irate packer telling the world and a considerable portion of the adjacent solar system just what he thinks of the ancestry of his strayed cayuses is not exactly at his best, from a polite and refined standpoint, that is. And yet my first impression of our head packer was unmixedly favourable. Spectacled and with the long, drooping moustaches of a moving-picture sheriff, one of his friends had described old "Soapy" to me as a cross between Theodore Roosevelt and a bull walrus. It was my instinctive feeling that the man who was to guide our material destinies for the next three months combined many of the best elements of both of these virile prototypes that inclined me instantly in his favor. Too, I liked the technique of his profanity – words winged with fire but flowing with the easy, effortless inevitability of the spinning of a turbine of an ocean liner. Free, natural swearing meant a well-driven, well-treated pack train. One of Nature's own swearers is also one of Nature's own gentlemen. That truth had been driven home to me through years of experience. I have never known a packer who swore freely and naturally to beat a horse cruelly. Yes, I took to old "Soapy" Smith at once, even though his name had been borrowed bodily from a notorious gambler and confidence man who had won what was pretty nearly my last dollar on the "pea-and-walnut" trick in Skagway the week before he was shot by a Klondiker from whom he had lifted a cool ten thousand.

Such are the people that were attracted to early expeditions to the big icefields of Canada's mountain West.

As he had just returned from the Columbia Icefield and an ascent of Mount Columbia with the Field expedition, Smith was in an excellent situation to conduct the Roof of the Rockies expedition to its end. And Soapy did not disappoint during the 70 days the expedition was in the remote wilderness of the Canadian Rockies. His persistence and wry wit, combined with an innate sense of how far to push his pack string, resulted, more than any other factor, in the success of the trip. The Roof of the Rockies expedition added dozens more stories to the legend of Soapy Smith, one of the best being a note he left for one of his partners after the entire pack string took a thorough dousing in the deep fords near the headwaters of the North Saskatchewan:

> If you need any sugar or salt, dip it out of the Saskatch. Nine-tenths of ours is already in the drink and the rest most likely goes tomorrow. If you see any horseshoes floating down stream, look under them for my cayuses. Deep water navigation by pack train ain't what it's cracked up to be.

To fully appreciate how difficult mountain travel was in 1924, it is useful to examine the account of the Roof of the Rockies expedition in terms of the difficulties Soapy Smith had to overcome in getting his client Byron Harmon into position for the photographs and movies he shot.

After great difficulty in bringing his pack string through the high water of the upper Alexandra River, Soapy Smith allowed his animals to fatten up in Castleguard Meadows while the party did its climbing in the Columbia Icefield. The next challenge would be to take his horses down Saskatchewan Glacier, and Smith wanted to make sure they were in good shape for the trip. The appointed day arrived and it was perfect for travel. As Freeman points out:

> There was a clear vault of indigo sky overhead, with the west banked full of rolling cumulus clouds which gave all the effect of an approaching storm with none of the threat.
>
> The rims of the hanging glaciers high up on the mountains to the left and right were scintillant with reflected sunlight while on all sides of us the broken surface of the icefield threw tremulous shadows like those of the waves of a rough, choppy sea.
>
> The pictorial possibilities of the traverse so smote upon the artistic spirit of Harmon as to leave him for the moment gasping like a child set down in a candy shop and told to help himself.

LaCasse and Smith moved the horses slowly toward the great lateral moraine that snakes down the side of the glacier. They observed, as had Jimmy Simpson the year before, that though the surface of the ice was rough and in places slippery, the horses found the footing underneath unexpectedly firm. So the expedition continued down the glacier, wandering two or three miles back and forth across the ice for every mile they advanced down it. About a mile from the snout, the party ran into trouble. As so often happens, the nature of the glacier's surface had changed since the year before. As the crevasses grew in size and frequency, it was decided to move the pack train off the glacier and onto the broken rock of the lower shoulders of the Athabasca massif to the north. The only place this could be done, however, was by way of a narrow tongue of

ice and gravel running down the rock between two very deep crevasses. This "runway" was about 20 feet wide and 80 feet long but so steep that the only way it could be done was by unpacking the horses, tying their legs and lowering them down the slopes on their sides. The great fear was that the horses would panic and perhaps fall into one of the crevasses on either side. As this plan appeared too time-consuming, the wranglers tried another method. They led each horse in turn to the edge of the ramp and started him down, head first, by a rope pulled from below. Trusting each horse to its instincts and allowing it to sit low on its haunches and slide down the slope, the cowboys were able to get the pack string past this obstacle. But their travails were not yet over. Below the ramp they encountered extensive broken rock with footing so treacherous that even the cowboys were reluctant to walk there, let alone take the horses. The horse carrying the radio stepped on a couple of tilted rock chunks, each larger than himself. Instantly the two huge pieces closed up around him and the horse suddenly found himself in a stone vise. Fearing extensive injury and a stampede of the other terrified horses, Rob Baptie and Ulysses LaCasse immediately set about to free the troubled animal without encouraging a further slide of rocks from the slope above. By the time the pack string was safely off the ice, the horses had left behind a trail of blood from their badly rasped hooves.

The next day, they led the pack string up the steep slope to the top of Parker Ridge and down toward Sunwapta Pass and Athabasca Glacier. A few days later, after the horses had been allowed to feed and heal, the wranglers investigated the icefalls of upper Athabasca Glacier to determine whether or not a horse route might exist from the icefield proper directly down the glacier into the Sunwapta Valley. Though it shows the confidence the wranglers had in their animals and in their own skills, the idea of bringing a horse down the entire length of Athabasca Glacier proved to be unpromising to say the least. Good horsemen though they may have been, this would be tantamount to trying to teach a horse to ice-climb. Still, Freeman, at least for the purposes on his account of the expedition, gave it real consideration:

> Our conclusion was that, while there was a bare chance that the traverse by this route might be possible, the odds against it were far too great to justify the risk. The penalty of failing to find a way over the broken ice at the head of Athabasca Glacier would inevitably mean a night on the main icefield with exhausted and unfed horses. Most of these could probably be taken back to Castleguard Valley the following day – if no accident occurred. I can hardly conceive, however, that a pack train could be disentangled from the mazes of up-tossed ice on upper Athabasca Glacier without serious losses.

It is an easy bet that Soapy Smith, Rob Baptie and Ulysses LaCasse were grateful for this final, very practical assessment of the possibility of taking horses up into the deep and brutal snows of yesteryear. Still, had they been asked, they may well have tried it.

After a long wait to photograph Mount Columbia the Roof of the Rockies expedition followed the Sunwapta River downstream to Sunwapta Falls.

The party refitted in Jasper and arrived back in Banff on October 24, 1924, ending their ten-week journey into

the wilderness and one of the most difficult horse trips undertaken in this century. Freeman ends his account humbly with this final understated remark: "It was a notable achievement for our packers."

Indeed.

It was also a notable achievement for photography, for it provided some of the best baseline images of what the icefields and glaciers were like a century ago, at least along the roof of the world in Canada.

Headwaters the early climbers saw

The great days of trail-blazing mountaineering expeditions are over. To create the West we want, we have to see with fresh eyes the West we already have. While they discovered much else as well, what the early explorers and mountaineers essentially discovered was the birthplace of Western rivers. The organizing principle of the Canadian Rocky Mountain Parks World Heritage Site is watershed. The spine of the Rockies is the birthplace of western rivers. Every aspect of the mountain landscape encompassed within the World Heritage Site is an expression of what ice and water do on the landscape. All of the rest of the wonders – the shapes of the peaks, the colour of the lakes, the rich forest and alpine ecosystems – all flow from this basic fact of abundant water. To see the World Heritage Site in this context is to understand its significance not just to the West but to the world.

Before it is anything else, the spine of the Rockies is a hydrological feature of continental importance. Before we perceive it as home or as a tourist attraction it should be viewed first as a region of annually generated snowpack and rainfall that provides water to almost the entire West.

Everything starts at the apex of the world, which in the Rockies means the Columbia Icefield. It is from this high basin of stone and snow that the plenty that is the West flows downstream to enrich the rest of the continent. If we truly want to understand this place we have to realize that, at their very foundation, the Rockies are all about slopes and divides. They are all about water. With this in mind, one way to recontextualize the Canadian Rocky Mountain Parks World Heritage Site as a biophysical and cultural unit is to examine the seven magnificent parks that comprise it in the context of watershed. In this light, the Magnificent Seven, so to speak, can be reordered into three regions: the North Slope, from which waters flow into the Arctic Ocean; the West Slope, whose flow ultimately pours into the Pacific; and the East Slope, down which water splashes into rivers that reach the Atlantic Ocean at Hudson Bay. This ordering has the advantage of perfectly mirroring the substantial differences that happen to exist between the ecosystems on each of these three slopes. It also enables us to return to perceptions of the mountain West that existed before our direct physical experience of the landscape was interrupted by new forms of straight-line travel like the train, the car and later the airplane.

PHOTOGRAPHER HARRY ROWED

"We can't afford another cub reporter right now," the editor told Harry Rowed. It was the early 1930s in Saskatchewan and money was tight.

"But we can pay you $5 per week if you do both the writing and photography. Learn how to use a camera."

Within a few years Harry became a well-known photojournalist and was selected to cover the 1936 Olympics in Berlin, where he captured haunting images of the rise of the Nazis. Following the Olympics he vagabonded and photographed through Germany, Austria, France and England before returning to Canada to become the director of photo services for the National Film Board. During the war his assignments took him to the Rockies, both summer and winter, covering Lovat Scout and Canadian mountain troop training at the Columbia Icefield. This experience confirmed for him a love for the mountains, and shortly after the war Rowed moved to Jasper with his wife, Genevieve, and daughter, Daphne. After his death in 1987, his son Scott catalogued tens of thousands of his father's mostly medium- and large-format negatives and transparencies, which chronicle a remarkable period in the history of Jasper National Park. These photographs feature the glacier as it was in 1939, the year the "Wonder Road" between Lake Louise and Jasper was completed, and the Lovat Scouts training in the area during World War II. Photographs courtesy of Scott Rowed (scott.rowed@gmail.com)

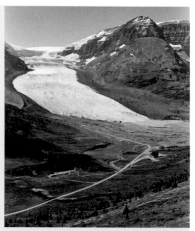
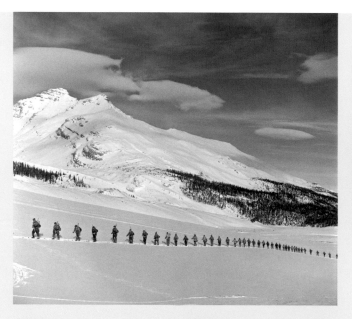
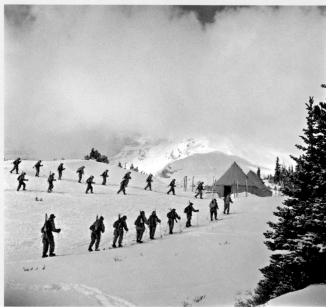

Below: The Greenland Ice Sheet.

Right: Ice streams flowing through the southern part of the Greenland ice sheet.

The World Glacier Monitoring Service estimates there are approximately 160,000 glaciers in the world covering an estimated 650,000 square kilometres. Depending upon latitude, altitude, topography, climate and orientation to the sun, glaciers will take a number of different forms.

Ice sheets

A body of glacial ice is considered to be an ice sheet if it assumes continental dimensions. That is, it has to be larger than 50,000 square kilometres (19,305 square miles) in area. While the northern hemisphere was once covered by them, true ice sheets are now found only Antarctica and Greenland.

Ice streams

Ice streams are long, ribbon-like glaciers that flow within the confines of an ice sheet. Bordered by slower-moving ice rather than by mountains, these huge glacial masses can be very sensitive to the rate of loss at their terminus, especially if they terminate in the ocean.

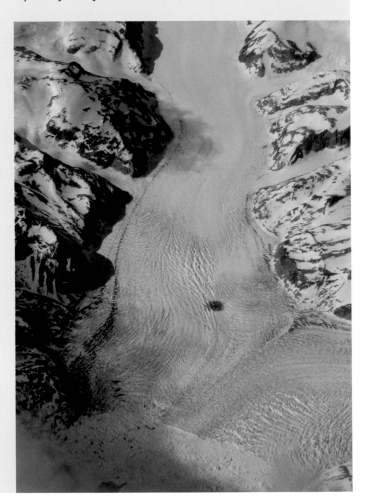

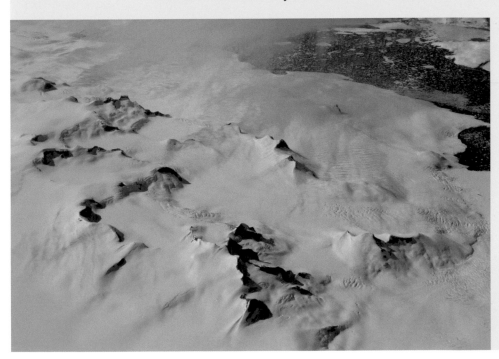

Ice caps

Ice caps are smaller versions of ice sheets. Covering less than 50,000 square kilometres, ice caps form primarily in polar and subpolar regions that are relatively flat. Ice caps are found in northern Canada and throughout the circumpolar north.

Icefields

Icefields are similar to ice caps, except that their flow is influenced by the underlying topography. Icefields are also generally smaller than icecaps.

Below left: Sölheimajökell Glacier flowing from the Mýrdalsjökull Ice Cap in Iceland.

Below right: The degree of influence of the underlying topography is clearly apparent in this photograph of the Eyjafjallajökull Icefield in Iceland.

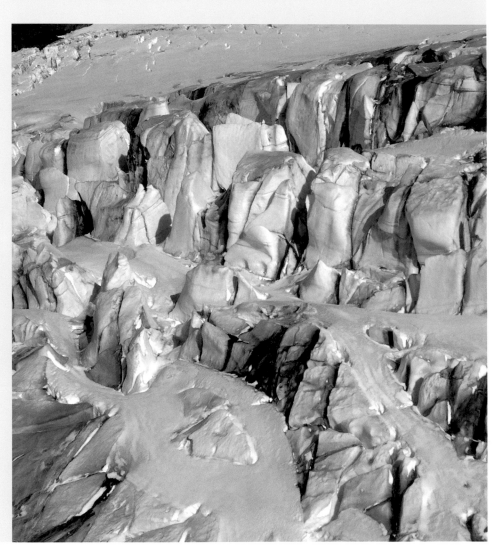

Mountain glaciers

A mountain glacier is a body of ice that flows out of an icefield that spans several peaks. Like other large icefields in the mountain West, the Columbia Icefield is the source of three large mountain glaciers and many smaller ones.

Valley glaciers

Commonly originating from icefields in mountainous regions, valley glaciers form long tongues of ice that flow downvalley, often beyond the summer snowline, where they are subject to annual melt.

Tidewater glaciers

Tidewater glaciers are valley glaciers that terminate in the ocean. Instead of melting as they might do on land, tidewater glaciers calve into icebergs which, if they float into shipping lanes, can create serious hazards.

While tidewater glaciers exist in Antarctica and Greenland, some of the most spectacular and accessible examples are found along the coast of Alaska.

Our understanding of why glaciers advance and retreat is largely informed by the predictable behaviour of glaciers in the European Alps. Renowned American glaciologist Tad Pfeffer, however, will tell you that coastal glaciers, in Alaska, are very different. There, an advancing glacier

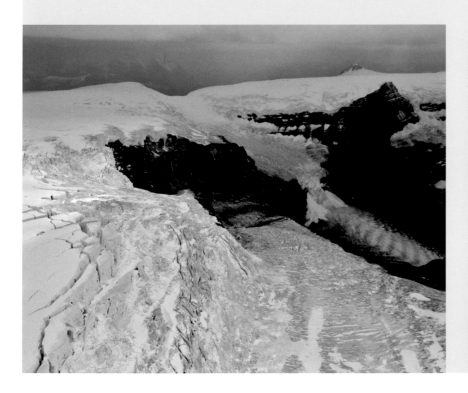

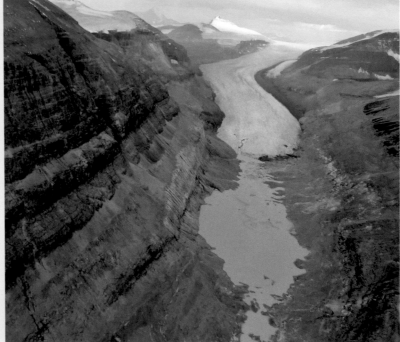

can be located right next to a retreating one, even though both share a more or less similar climatic environment. The glacier advances slowly until it becomes thin and extended. Then suddenly there is a rapid, irreversible retreat, whereupon a new cycle of slow advance commences. From this we see that it is not always climate that causes dramatic glacial recession. The behaviour of tidewater glaciers can be as much influenced by conditions at their termini and by the sub-surface topography of the ocean into which they pour as by climate warming.

So why does this matter? It matters because if you can't clearly establish the relation between glaciers and oceans, you won't be able to determine how warming will affect glacial melt and its influence on sea-level rise. This relation remains unresolved to this day and is the greatest unknown variable facing scientists working to prepare forecasts of sea-level rise in the face of global warming.

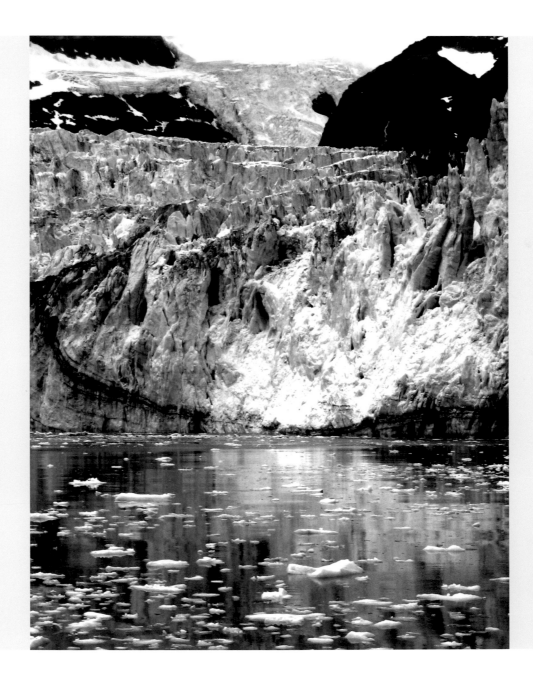

Hanging glaciers

Angel Glacier.

As valley glaciers thin and recede, their remnants are sometimes left in small, high valleys above the main valley into which the glacier once flowed. These glacial remnants are called hanging glaciers. When hanging glaciers disappear the valleys they leave behind are called hanging valleys.

Angel Glacier, on Mount Edith Cavell north of the Columbia Icefield in Jasper National Park, is often mistakenly held to be a classic, accessible example of a hanging glacier. There is no question that as it recedes it will become a hanging glacier, but technically it essentially is still an icefall delivering ice from the Upper Cavell glacier to the Lower Cavell one, to which it is no longer connected.

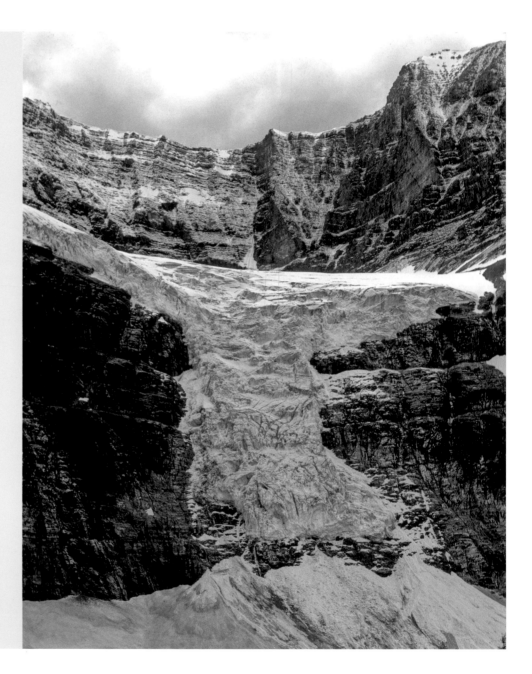

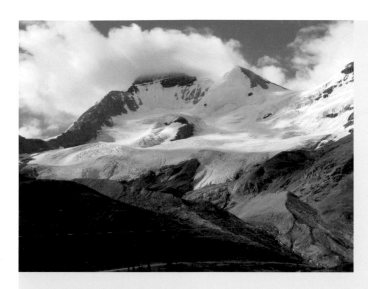

Cirque glaciers

Cirques are bowls carved out of the sides of mountains by the action of glacial ice. Glaciers that create and occupy these bowls are called cirque glaciers. Such glaciers persist because they are found most commonly on high, north-facing mountainsides and thus are protected from summer heat. It is anticipated that if current warming trends continue, cirque glaciers may be among the last to survive in the Canadian Rocky Mountains.

Rock glaciers

When frost-shattered rock accumulates in cold conditions, melted snow and rain can freeze beneath the rubble and lubricate the movement of such slopes in a way that very much resembles the movement of glacial ice itself.

Though most visitors fail to see what it is because of its enormous scale, there is a classic example of a rock glacier that is very visible from the Icefields Parkway, on one of the outliers of Mount Athabasca near Parker Ridge just south of the Columbia Icefield.

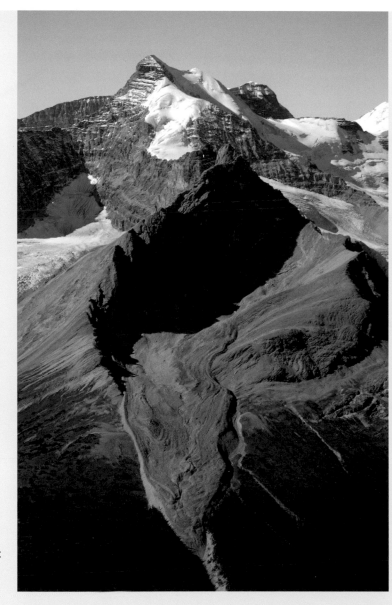

Cirque glaciers on the front side of Mount Athabasca.

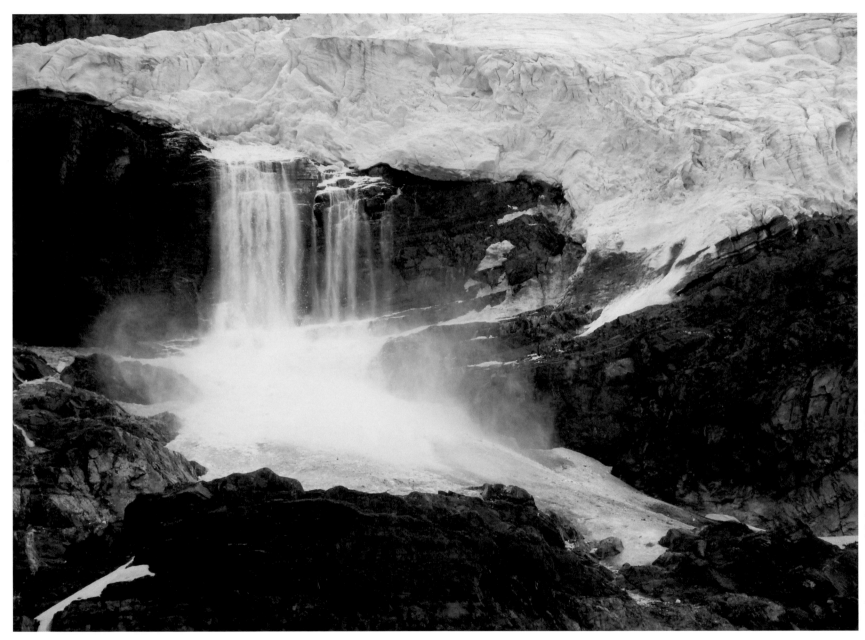

> We may not be coming to the end of the planet, but we may truly be coming —
> and sooner than we might expect — to the end of winter as we have known it.
>
> —ADAM GOPNIK, *WINTER: FIVE WINDOWS ON THE SEASON*

SIX: The Death of Peyto Glacier: A Case for More Comprehensive Hydro-Meteorological Monitoring in the Canadian Rockies

ANYONE WHO HAS STRUGGLED SUCCESSFULLY to understand the mechanics of global climate change will appreciate the complexity of our Earthly life-support systems. To suddenly be able to visualize the fragile, highly interactive and instantly responsive glory of the atmosphere on one's own terms can be a life-altering experience. The first true glimpse of just how sensitive our planet's atmosphere is to orbital eccentricities, material inputs, minor shocks and human influences can take your breath away. It is one thing to learn about this from others and quite another to discover it for yourself. The moment one can see in their mind's eye how additions and subtractions of heat or small amounts of various gases or aerosols can change the seasons or bring on or delay ice ages, the world is no longer the same. The ability to comprehend and model such a hugely diverse universe of cosmic, atmospheric, terrestrial, marine and hydrological variables and interactions is one of our most recent and greatest human intellectual achievements.

It should come as no surprise that a good number of those few people in the world who are capable of mastering such complicated, interrelated intellectual and scientific domains and revealing them to others are Canadians. It

Meltwaters flowing from the Peyto Glacier.

Photographs courtesy of the USGS

Up until recently North American attention has been focused on the rapid loss of glacier ice in Glacier National Park in the United States: 113 of the 150 glaciers that existed in the park in 1860 have since vanished.

1932

2005

will also be a revelation to some that, of this country's foremost climate scientists, many have undertaken elements of their most important work at the same glacier in the Canadian Rockies. In 2006 a group of these researchers published a book celebrating a century of scientific exploration in and around the beloved object of their research, Peyto Glacier in Banff National Park.

Published by the National Water Research Institute, *Peyto Glacier: One Century of Science* was edited by three of the most respected glaciologists and climate scientists in the country.

Mike Demuth was with Natural Resources Canada at the time, where he was responsible for Canada's Glacier-Climate Observing System. Co-editor Scott Munro had undertaken micrometeorological instrumentation work on Peyto Glacier as early as 1969, when he was a professor of geography at the University of Toronto, and he has been involved in glacial research in the western mountains ever since, even in retirement. The editorial selections made by Demuth and Munro were vetted by none other than Gordon J. Young, a pioneering legend in hydrological studies, not just in Canada but around the world. Dr. Young's early work on the mass balance of Peyto Glacier is widely regarded as the foundation of modern glacial research in the Rockies.

The book is comprised of nine scientific papers that summarize findings from studies done on Peyto Glacier since it – and the remarkable icefield that creates it – entered the European imagination more than a century ago. These papers, written by the most respected experts in the field, represent landmarks in our understanding of dynamics of glacial ice as defined by climate in the Rockies over the past 10,000 years.

As climate change concerns become top of mind in our society, the authors of this book are likely to be further recognized for the important contribution they have made to Canadian science. One of the reasons for this is that glaciologists in general, and these in particular, subscribe to the theory that you can't manage or even understand what you can't measure.

If the reader so chose, it would also be possible to see lurking behind every one of these important scientific papers the spectre of longer prairie droughts. The book could also be read as a plea for more resources to collect information so as to be able to predict when our glaciers might be gone and what that might mean in concert with other climate change impacts to the way we live in the mountain West.

Early studies of the Peyto

In the first paper, "The History of Scientific Studies at Peyto Glacier," Dr. Gunnar Østrem sets the scene for the research done to date. It is a scene that will be familiar to many who live in or around Banff National Park. Østrem explains that before being named by mountaineering legend Norman Collie for packer, guide and outfitter Bill Peyto in 1897, the famous turquoise body of sparkling water that derives from the glacier was known as Dog Head Lake. This historical revelation should provide comfort to the millions of people who have since stood at the viewpoint above this stunning feature and marvelled at the spectacular scene of the lake nestled in the Mistaya Valley and then left with a nagging sense that the shape of Peyto Lake reminded them of something familiar they were unable to name. (One could think of it as the shape of a coyote's head – the trickster himself, laughing – but that is a whole other story.)

Østrem also tells us that Peyto Glacier was first photographed, in July of 1896, by the American climber Walter Wilcox, who went on to make the Canadian Rockies famous through the publication of numerous well-written, beautifully illustrated books. While Wilcox did not linger to study the glacier, his photographs have remained the foundation of all later comparative analysis of changes in the extent, length and depth of the ice. Important photographs of the glacier were also taken from the Wilcox vantage on Bow Summit by the Vaux family of Philadelphia in 1902 and, as noted earlier, by one of their descendants a century later. Also photographing there was climber and alpine scholar James Monroe Thorington in

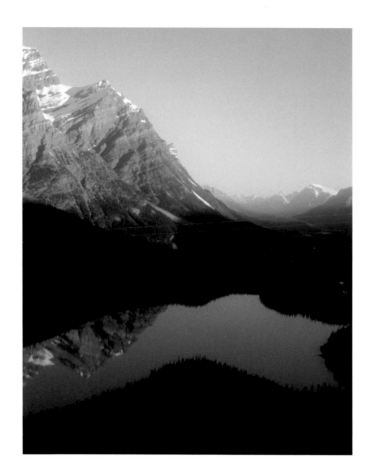

Peyto Lake.

1923. All these photographs are still used today in comparative analysis of the glacier's mass and movement.

The first actual research on the flow and character of the glacier was not undertaken until 1933, when it became the object of the tireless scientific attention of A.O. Wheeler, a co-founder and the first president of the Alpine Club of Canada. Wheeler believed fiercely that it was the responsibility of Canada's national mountaineering

organization not just to introduce Canadians to their own mountains, but to ensure they fully understood the geological processes that created them. His pioneering scientific efforts were continued after his death by two further generations of ACC members and faithfully published in the club's official record, the *Canadian Alpine Journal*. While able to undertake preliminary measurements and observations, ACC volunteers did not have the means to acquire and employ the highly specialized technology that would be later needed to achieve further understanding of glacial flow and discharge dynamics. By the early 1960s it became apparent that only a well-organized, multi-year research initiative would unlock the many climate secrets of the rapidly disappearing glacial ice of the Rocky Mountains. Such an extended, multi-jurisdictional effort could only be undertaken by a consortium of well-funded government agencies.

In 1963 it was decided that Canada's contribution to the International Hydrological Decade, which was organized to orchestrate water research around the world between 1965 and 1974, would include mass-balance and other studies on selected glaciers in western Canada and the Arctic. A Glaciology Section was created in the Geographical Branch of the federal Department of Mines and Technical Surveys to undertake this research. Mass-balance studies are fundamental to the understanding of glacial dynamics. The net mass balance of a glacier is defined as an idealized sum of how much mass it gains in winter from snowfall and avalanches, less the mass it loses in summer from melting and sublimation. Reduced to the simplest terms, mass balance describes whether and at what rate a glacier may be growing or receding.

Besides a long list of glaciers to be studied in the Arctic, some 30 glaciers were initially put on a list as candidates for mass-balance studies. Of these, six were selected. These included the Sentinel and Place glaciers in the Coast Range, Woolsey Glacier in the Selkirks in central British Columbia, Ram River and Peyto glaciers in the Rockies and Decade Glacier on Baffin Island. As Gunnar Østrem notes, neither the Ram River nor the Woolsey glaciers could be easily reached except by helicopter. Thus the cost of maintaining research capability on these two glaciers soon became prohibitive and both sites were later abandoned as financial resources became more limited. Østrem also points out why the Peyto is such a desirable location for glacial research. Not only is it accessible, but at the time, it was a glacier of a manageable size that existed in a well-defined basin with a single meltwater channel. Its surface is not so heavily crevassed as to make travel on it unduly dangerous and, finally, because of its location in a famous and historically significant national park, there exists an excellent multi-generational photographic record of changes in its size and surroundings in recent time.

As Gunnar Østrem notes in the conclusion of his chapter in *Peyto Glacier,* the choice of Peyto Glacier as a study site during the International Hydrological Year has proved an important turning point in the history of glacial research in western Canada. The more than 30 years of annual mass-balance measurements taken at the Peyto form the longest-running series of measurements for western Canada that exists today. This long-established record of reliable monitoring data makes Peyto Glacier a key location for glacial research on this continent.

Peyto Glacier as laboratory and library

Intensive graduate study on this glacier employing this 30-year corpus of mass-balance data has also served to develop Canadian expertise in glaciology and mountain hydrology. The rest of the papers presented in the book are testimony to how many competent people have graduated to an important understanding of how water works in western Canada and the world as a result of what they learned from monitoring conditions of ice and weather on Peyto Glacier.

Brian Luckman first saw Peyto Glacier in 1968. Since then he has become one of this country's leading experts on how the study of changes in the form of the Earth's surface and analysis of growth rings in trees can help us reconstruct past climate variability in the Rocky Mountains. In his contribution to the book, "The Neoglacial History of Peyto Glacier," Dr. Luckman explains what his research has revealed about past glacial advances and retreats in the Peyto Valley, which in his estimation at the time provided the most complete record of such fluctuations at a single site in the Canadian Rockies.

Among the many findings reported in the paper are several demonstrating the importance of tree-ring studies to our understanding of the changing climate of the region over the past centuries. Tree-ring studies in the Peyto Glacier area were among the first to be undertaken in the Canadian Rocky Mountains. Since those pioneering studies were begun, Luckman and others have expanded the network of tree-ring chronologies to over 50 treeline sites in the Rockies. All of these sites, which rely on cores from Engelmann spruce, Lyall's larch and whitebark pine, have generated chronologies from living trees that exceed 300 years in duration. It has been possible to extend this chronological record to more than a thousand years by employing ring analysis from living trees of 500 to 880 years old and supplementing those measurements with tree-ring series derived from dead trees that have been found on the surface of glaciers or that have been recovered beneath glacial deposits recently exposed by recession of the ice.

From this careful study, Luckman determined that the glacial advance that took place in the 1840s, known as the Little Ice Age, resulted in the most extensive glacial cover in the Peyto Valley in the last 11,000 years. Dr. Luckman also points out that Peyto Glacier is presently the only known site in the Canadian Rockies where three separate glacial events can be demonstrated prior to the Little Ice Age maximum. Luckman further explains that the data he has collected indicates that treeline in this area of the Rockies was at or higher than its present elevation 3,000 years ago. He also points to evidence that suggests that Peyto Glacier overrode the forest that was growing at the site of the glacier's present terminus roughly between 2,800 and 3,000 years ago.

Dr. Luckman has been able to tie this to similar evidence that suggests that the same circumstances prevailed at that time at the snouts of the nearby Yoho, Saskatchewan and Robson glaciers. This regional glacial advance has been designated as the Peyto Advance, which is now recognized as an important period in the recent geological history of this part of the Rockies. Based on this record, Luckman is able to offer with confidence that "the climate warming of the last 150 years heralds a change in glacier mass balances that is unprecedented in the latter half of the Holocene."

The more than 30 years of annual mass-balance measurements taken at the Peyto Glacier form the longest-running series of glacial measurements that exists today in Western Canada.

Unfortunately the history of glacier fluctuations presents an incomplete and selective picture of environmental change. There are long gaps in this record and only limited information is available for intervening periods of glacier recession. In the European Alps historical data can be used to address some of these questions and to document, in a few cases, whether the recession of the last 100 years is truly exceptional in the context of the last millennium. Such options are not available in the Canadian mountains and it is important to develop other records of environmental change that are continuous, have higher temporal resolution and reflect a wider range of environmental conditions. In this regard the situation at Peyto offers considerable promise.

—Brian Luckman, "The Neoglacial History of Peyto Glacier"

The Holocene is the geological epoch in which we presently live. It began in these mountains 10,000 years ago at the end of the last Ice Age. What Dr. Luckman is saying is that the glaciers in the Rockies have been changing in size faster in the last 150 years than they have since our current geological epoch began.

At the conclusion of his paper, Luckman establishes what the reader may find as a unifying theme that binds this collection of scientific papers together with respect to the direction in which a century of research at the Peyto points now and will direct us in the future. That direction is toward the need for more comprehensive monitoring and data sharing and interpretation that will allow us to do more with the baseline knowledge established over the last 30 years in particular at the Peyto Glacier site.

Luckman is very clear in explaining that the history of fluctuation in glacier extent presents an incomplete and selective picture of the kinds of changes that have taken place at the landscape level in the past. He identifies long gaps in the record and places where only limited information is available, which makes it difficult to determine whether the recession of our glaciers over the last 100 years is truly exceptional in the context of the last millennium. Luckman argues the importance of exploring other ways of validating the geological record. To this end he points to varves, layered sedimentary deposits on lake bottoms that, in association with tree-ring records, could assist in bringing past changes in climate into sharper focus. Here again, Luckman points out, the Peyto Valley and Peyto Lake offer a superior laboratory for exploring new ways of understanding more about what has shaped the climate of the Rockies in the past so we can understand what our climate might be like in the future.

Dr. Luckman characterizes current difficulties associated with the practical and useful collection of data as the "Least Publishable Increment Problem." One factor contributing to this problem is the fact that a great deal of research evidence is collected in piecemeal increments. The overall picture of what the data means, however, can usually only be developed cumulatively over many years of observation. Many individuals may observe, collect and date materials at the same site, but the gathering of such results seldom justifies publication of such small amounts of new information. This data will sometimes survive as potentially useful but unutilized "snippets" that suffer from inadequate documentation or connection to other data already collected. More often it will simply be lost.

Another factor that contributes to the failure of the full value of data to be fully realized is that researchers – sometimes even at the same institution – are so busy with their own projects that they are unaware of what other scientists

are doing and discovering. Luckman argues that the best way to overcome this is through what he calls "contagious collaboration" between independent projects can work to ensure both validation and useful application of data. Luckman offered that rare sites like Peyto Glacier provide an opportunity for comprehensive data collection and vetting over extended periods of time in formats that build an accessible body of knowledge upon which others can, after vetting, reliably base further research and analysis.

Luckman suggests that science has only begun to explore what these sites can offer. He predicts that in time exciting new sites will become exposed in the Peyto Valley and elsewhere and that it will be important to report and document these finds to the broader scientific and resource management community in a coordinated way. Dr. Luckman goes on in his chapter to propose a common archive that would preserve and share such information. But he says this need not be a new or independent institution. Instead, he proposes that ongoing inventory databases be established for certain classes of information. Such archiving, Luckman argues, would reduce duplication and the cost of undertaking research, especially in projects that rely on carbon dating and other expensive analyses to validate data. Dr. Luckman's message is not only that we need to know more, but also that we need to do more to take advantage of the hard-won knowledge we already possess.

The importance of long-term data

Additional chapters in the *Peyto Glacier* anthology have more to say about long-term data collection and what it can tell us about glacier retreat. In "Radar Measurements of Ice Thickness on Peyto Glacier," Gerald Holdsworth, Mike Demuth and Tim Beck explain how geophysical measurements were made on the glacier over time and what those measurements tell us about changes in the nature and extent of the glacier. From this article we learn that between 1966 and 1984, Peyto Glacier lost at least 18 per cent of its 1966 volume.

In "An assessment of the mass balance of Peyto Glacier (1966–1995) and its relation to recent and past-century climatic variability," Demuth and his colleague Ray Keller tell us that while the Peyto currently covers about 12 square kilometres, it has lost 70 per cent of its volume in the last 100 years and that winter snow depth and duration of cover have been declining since the 1970s. Demuth and Keller also observe that when mass-balance research was terminated at Ram River and Woolsey glaciers because of funding cuts in the early 1970s, broader regional investigation into what was being learned at the Peyto was greatly diminished for want of comparative analysis. Only one site has existed over the long term, and that is Peyto Glacier.

The constraint imposed by our limited number of comprehensive data collection sites has become obvious as the connections between weather cycles in the mountain West are gradually linked to better understanding of snow-bearing weather patterns such as the Aleutian Low and to conditions related to El Niño phases of Pacific Ocean decadal oscillations and to longer-term changes in these established patterns.

Demuth and Keller were very clear on the need for more comprehensive hydro-meteorological data collection and interpretation. In order to manage climate change impacts effectively in the Canadian West, we need to be

able to predict the time when our glacial masses will be gone. To do that, we need to better understand the nature of present climate fluctuations and their influence on water resources in the context of the variability in temperatures and conditions that have existed in the past.

A further suggestion of Demuth and Keller is that fuller exploration of the dynamics of Peyto Glacier in terms of what it tells us about historical variability will advance our knowledge of how our climate changed in the past. This knowledge, they argue, would help detect predicted human-caused stresses and allow us to forecast their impacts on water resources and aquatic ecosystems against the practical backdrop of natural variability. It would help us decide how to act most effectively in response to the

changes in the amount of water we can expect to flow from the Rockies as a result of a changing western Canadian climate.

In a chapter called "Linking the Weather to Glacier Hydrology and Mass Balance at Peyto Glacier," Scott Munro explains how much heat Peyto Glacier receives. We know this, Munro offers, as a result of careful analysis of hourly measurements of solar radiation, air temperature, atmospheric humidity, windspeed and precipitation, all of which are now recorded throughout the year on the Peyto. From this paper we learn that solar energy has more influence on glacial melt than air temperature does. Munro shows how sensitive our atmosphere is to natural changes in the sun's energy output and other cycles. He offers an astonishing statistic to press this point home. "There is," Munro explains, "almost a 20 per cent snow area increase suggested for only a 1 per cent fall in the value of the solar constant."

Munro explained how the broadening of comprehensive data collection and interpretation, using sites like Peyto Glacier as a foundation, could advance contemporary weather modelling technology from the level of a diagnostic exercise and transform it into a powerful forecasting tool that would be useful in anticipating not just natural climate variation but also anthropogenic influences on existing patterns of climate function.

In conclusion, Munro points out that at the time the automatic weather station record from Peyto Glacier has produced ten years of continuous data. This is a long enough duration to allow researchers to consider this data in comparative climatology studies with other stations in the region. To Scott Munro, the success of the

Dr. Scott Munro.

There is currently the great advantage that field studies can be placed in the context of the automatic weather station record. That record is now approaching one decade in length, a sufficiently long period of time to consider a comparative climatology with other stations in the area, perhaps to sharpen our knowledge of what has been gained from synoptic and statistical analysis of glacier response to climatic variation. The existence of the station also means that prospects for modelling an energy balance climatology of the basin to use for interpretation of mass-balance variations, and their impacts on local water supply, are currently stronger than ever before. The key to realizing these prospects is to employ knowledge of the surface energy exchange processes which are at work to effectively model the link between weather variations and glacier mass-balance fluctuations.

— Scott Munro, "Linking the Weather to Glacier Hydrology and Mass Balance at Peyto Glacier"

Peyto Glacier station means that prospects for modelling an energy-balance climatology for the basin that could be used to interpret glacial mass-balance variations and their impacts on local water supply are stronger than ever before. The key to realizing these prospects, Munro noted, is to collect information on energy exchange processes on the surface of the glacier and use that data to model the link between weather variations and fluctuations in glacier mass balance.

The benefit to be derived from more-comprehensive and higher-quality data was also a theme in Dr. Elizabeth Morris's chapter in the *Peyto Glacier* anthology, "Techniques for Predicting runoff from Glacierized Areas." Morris, who at the time was working with the British Antarctic Survey, investigated how data quality relates to improved climate modelling. The paper begins by explaining how the development of hydrological modelling in the past three decades has been made possible to a large extent by an ever-increasing volume of comprehensive hydro-meteorological data from river basins. Morris points out that when only time-series data relating to rainfall and runoff are available, the modeller is restricted to developing what is called a statistical "black box": at best a simplistic conceptual model comprised of parameters that have to be derived from surrogate data collected in other basins. With a broader range of reliable measurements from a specific basin, however, it becomes possible to create far more useful models. With better information, statistics-based models suddenly make way for physics-based models. The advantage here is that physics-based models have parameters that can be defined a priori so that predictions can be made about how a given river basin will respond to

The physics-based, distributed models which have been developed over the last fifteen years could not have been validated without extensive date from experimental basins. Theoretically it is possible to extend these models so that they can be used for simulation of hydrological processes in glacierized catchments. However, an intensive field campaign will be required to collect sufficient data from key glaciers to test the new models.

—Dr. Elizabeth M. Morris, "Techniques for Predicting Runoff from Glacierized Areas"

changes in any of its constituent characteristics. This means you can predict, for example, what a change in headwater forest composition might do to the hydrology of the basin. You can also forecast what climate change might do to that same hydrology.

Dr. Morris goes on to show that snow cover in a basin very much complicates such modelling, and that the presence of glaciers makes it even more complex. She concludes by explaining that it is possible to extend the capacity of current models to make them useful in simulating hydrological processes in glacierized catchments. But this can only be done if sufficient data from representative glaciers becomes available to test new models. Peyto Glacier, Dr. Morris submits, was an obvious candidate for such study, which would logically build on the impressive record of research that has already been conducted there. Once again the message is clear: if we want models that are more useful, we need to collect better data.

For the lay person, the most immediately accessible chapter in the *Peyto Glacier* anthology may be Corinne Schuster's and Gordon Young's "The Derivation of Runoff from the Peyto Glacier Catchment." The authors describe

in very clear language such technical matters as water release time lags, the dynamics of snowmelt on the surface of ice, and the warming effect of surrounding terrain on glacier ice. Schuster and Young explain that Peyto Glacier represents more than 50 per cent of the ice remaining in the larger Mistaya Valley basin and that glacial melt contributes some 6 per cent on average to the mean annual runoff of the Mistaya River. They note also that because this is the only site in the Rockies that has been extensively monitored, its data records are used as surrogate information to predict glacial runoff in the headwaters of the adjacent Bow River basin.

Schuster and Young further show that while records of glacial shrinkage and the changing relative importance of glacial melt contribution to mountain streamflow are being extrapolated with good success to adjacent basins such as the Bow, such analyses of glacial contribution to the water resources of the prairies would have been impossible without the very detailed records provided by three decades of careful data collection on Peyto Glacier. From this the reader could surmise that better future modelling in the increasingly water-scarce Bow River valley and other adjacent basins can only be possible through the development

of similar hydro-meteorological data collection at and below the headwaters of that basin. This at least was what glaciologists thought in 2006, when *Peyto Glacier: One Century of Science* was published. But then Peyto Glacier stopped acting like a glacier and began to disappear.

Ecohydrology and the future

The final chapter of the book, contributed by Geoff Petts, Angela Gurnell and Alexander Milner, introduces a new and very promising dimension of contemporary water resources research. In "Ecohydrology: New Opportunities for Research on Glacier-fed Rivers" the reader is spirited away to the next frontier of science that exists at the nexus of an ever-widening array of scientific disciplines. Here we learn about the link between water and life. We are invited to consider what kind of aquatic ecosystems might exist in the Rocky Mountain in the future if climate change continues to raise mean annual temperatures.

The arguments put forward in this paper invite the reader to imagine what kinds of aquatic ecosystems we might desire in the future and what kind of terrestrial ecosystems we will need to create to realize those desires. We are soon led to understand that the world created by tomorrow's climate will be defined directly by what happens to biotic conditions as glaciers shrink and by what impacts warmer water temperatures will have on nutrient availability, diatom complexes and microbiological production in mountain lakes and streams. A world of change will occur and that change will begin with water.

Like the other contributors to the *Peyto Glacier* anthology, Petts and company conclude their paper with a plea

for additional resources to develop new methods for describing physical characteristics that will help define the dynamics of broader environmental variables at the basin level. Their overall aim, they declare, is to develop predictive models of glacier river ecosystems that enable the influence of climate change and human impacts to be fully evaluated. Such evaluation, they argue, would require closer integration of glaciological, hydrological, geomorphological and ecological research. In the considered opinion of these scientists, a good place for this integration to begin is at Peyto Glacier, where much is already known.

In a quiet, subtle, scientific way, *Peyto Glacier* is a very important work. If we listen to what it tells us, it could change the way we think about where and how we live and the kind of presence the landscape will permit us to have on the eastern slopes of the Rockies in the next century. But because it took ten years to make the leap from manuscript to final form the book was already out of date when it was published. Many positive developments have occurred since. Monitoring at nearby Ram River Glacier was restored. The Peyto and Ram River monitoring stations became part of Canada's official Glacier–Climate Observing System, a network of 12 reference glaciers where seasonal and annual measurements are made continuously and augmented by remote sensing measurements that provide a broader regional context for determining climate change impacts on water and other resources.

This expansion of regional monitoring capacity spawned renewed hydro-meteorological research efforts such as those undertaken by Dr. Shawn Marshall at the University of Calgary who established what he called the "Eastern Slopes array," a vast network of new monitoring stations that produced more complete data that could be fed into ever-improving models. Additional projects were developed through a major five-year national research network called IP3, for "Improving Processes and Parameterization for Prediction in cold regions hydrology."

Research was also initiated into the sediment record provided by Peyto Lake, which will further assist in assessing the vulnerability of mountain water resources to further glacial recession and climate change. Efforts were also made to create a model hydro-meteorological observatory in the Rocky Mountains which can be used to demonstrate the permanent value of upland watershed monitoring as a mechanism for water resource management planning throughout western Canada. None of these programs, however, were guaranteed anything but short-term funding, which the federal government of the day systematically cut. But as troubling as those problems were, they were nothing compared to what was actually happening to Peyto Glacier itself.

The Peyto *in extremis*

By 2010 researchers were concerned that the glacier was breaking up and disappearing so quickly that it would soon no longer exhibit the flow dynamics that define it as a glacier. On September 3, 2016, Angus Duncan, a hydrology research technician working with Dr. John Pomeroy at the University of Saskatchewan's Centre for Hydrology, noticed that meltwater was undercutting the glacier so rapidly that it appeared that parts of the glacier's terminus would soon collapse. Duncan reported that the hydro-meteorological station at the toe of the glacier would soon

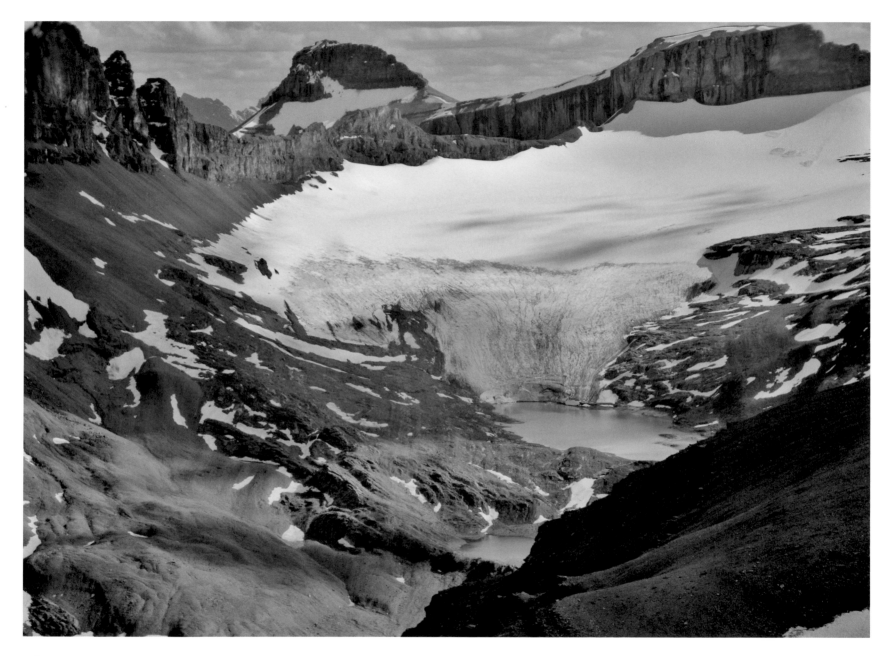

be underwater. Looking at the data from one of the monitoring stations on the glacier, Duncan noted that the snow left on top of the glacier from the previous winter appeared to have melted by about June 6. Between June 6 and July 21, however, the glacier itself had down-wasted an astonishing 2.25 metres, or more than seven feet. Duncan reported there was so much water pouring from the outlet channel that he didn't even try to get to the meteorological station at that location, but offered to collect data from there in the fall after flows declined. A proglacial lake has now appeared at the terminus of the melting ice. In honour of their esteemed colleague, glacial researchers are calling it Lake Munro.

In its disappearance, Peyto Glacier teaches us that surrogate data from monitoring sources from a single basin cannot be relied upon indefinitely to make water management planning decisions, especially when climate change may be altering the timing and nature of precipitation and snowpack dynamics and melt regimes. If we don't fully know what is going on in the upper basin, we can't properly predict what will happen downstream. Our aim should not be to just to capture better monitoring data but to go beyond data collection to the next levels of application. We need to make the full transition, from black-box modelling that serves only as diagnostic analysis, to physics-based modelling that allows us to predict how a given river basin will respond to changes in any of its constituent characteristics.

Though watershed protection was a fundamental ideal in the pioneering era in western Canadian history, this function was eclipsed for many decades by resource development pressures and tourism and recreation priorities.

Now, however, downstream population growth, increased agricultural and industrial water demands and climate change are putting the importance of upland watershed protection back into bold relief. The immediate need for additional monitoring and interpretation of expanded hydro-meteorological data; enhanced understanding of present and future surface and groundwater flow regimes; and support for aquatic ecosystem research have been identified as crucial to the development of better modelling techniques that will allow us to more effectively predict and act upon human use and climate change impacts on western water availability. Emerging principles of ecohydrological management of land and water resources will inform future integrated water management and land-use policy both within and outside our upland parks and protected areas. But these principles cannot come into play without expanded hydro-meteorological data collection and interpretation.

A hundred years of science at Peyto Glacier suggests that our goal now should be to elucidate the influence of disturbances of different types, frequencies and durations, not only in terms of the timing and extent of precipitation, but related also to glacial recession and these disturbances' impacts on biotic processes. The overriding aim should be to develop a predictive model of glacial, hydrological and river ecosystem dynamics that will enable the influence of human impacts and climate change to be more fully evaluated. This means the fuller integration of glaciological, hydrological, geomorphological and ecological research. Only through such integration and advancements in data collection will we be able to predict and act upon the serious threat of diminished water resources in

Ram Glacier.

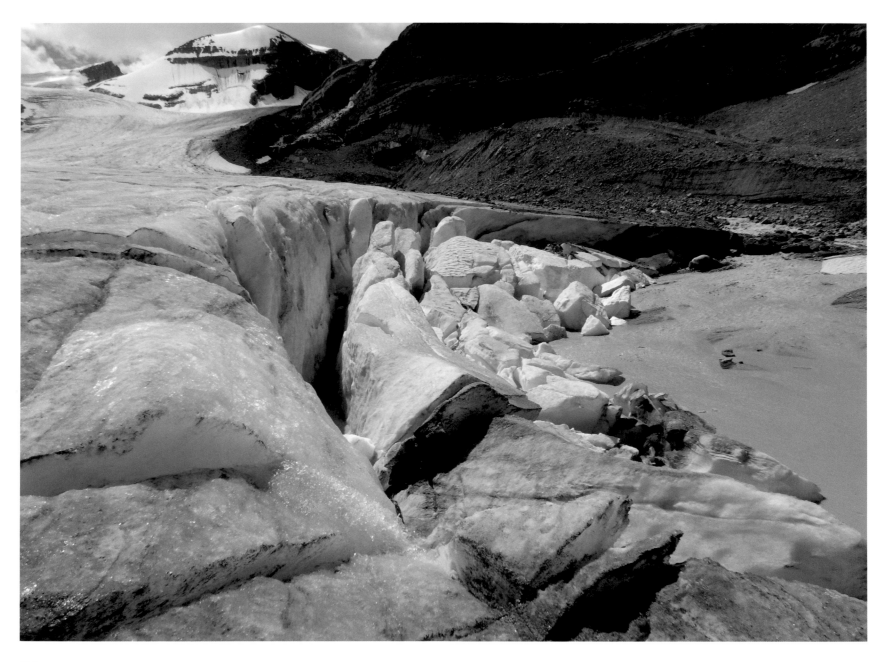

Alberta and deal with the spectre of prolonged drought in the Canadian West.

Rapidly liquidating assets

As Philip Ball has suggested, in his book *Life's Matrix*, there is good reason to consider the "white waters" of the atmosphere and the ice in mountains and at the poles as contiguous influences that water exerts on our planet. The sunlight that floods the Earth from space bounces off clouds the way hail bounces off a tin roof. Both clouds and ice play similar roles in determining the nature of the planet's climate. While it is difficult to predict the cumulative effects of a gradually warming atmosphere on the Earth's ultimate reflectivity, one thing is very clear. Continued climatic warming over the last century is reduc-

ing the size and volume of glacial ice masses in southern Canada. At current rates of recession, important glacial masses will melt away within decades. Communities that are planning residential or industrial expansion based on current volumetric flows of rivers that rely in part on late season glacial melt could find themselves in trouble. Water policy expert Dr. Henry Vaux Jr. pointed out the problem at the opening of an exhibition of his grandfather's glacier photographs in Banff during the United Nations International Year of Freshwater in 2003. "Building [policy] management systems based on water made available by unsustainable glacial melt," Vaux argued, "is no different than mining fossil ground water."

As one of America's most respected experts in this field, Vaux compared glacial recession in western Canada to the diminishment of the great aquifers of the American Southwest. Echoing the concerns of many Canadian scientists, Vaux cautioned Canadians to be careful not to write cheques the future might not be able to cash.

Calving at the rapidly retreating terminus of Peyto Glacier, 2016. Photographs courtesy of Angus Duncan, Centre for Hydrology, University of Saskatchewan

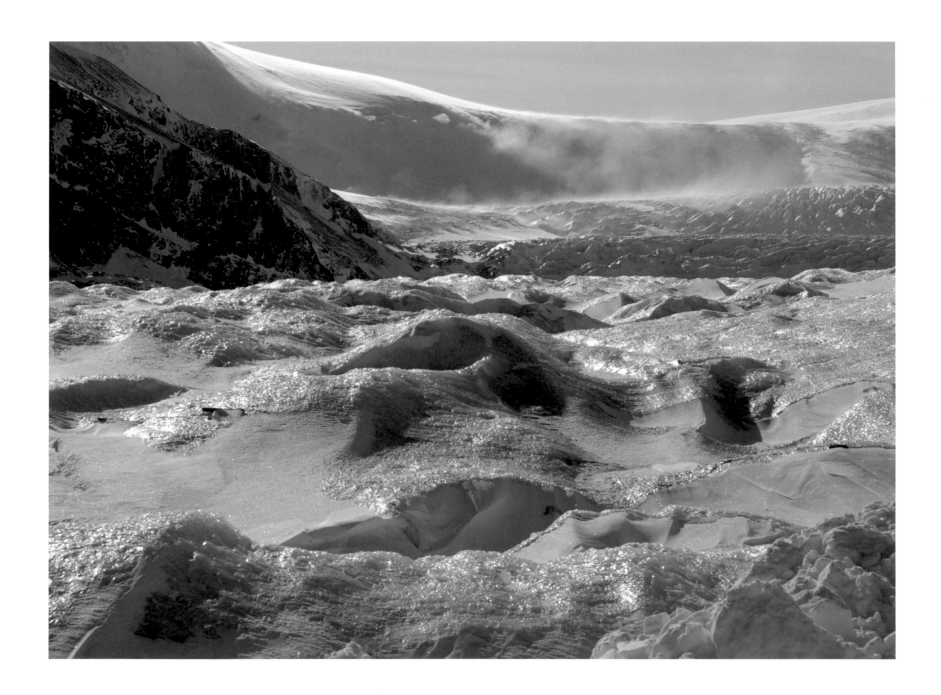

SEVEN: The Columbia Icefield Today

BY ANY STANDARD, the Columbia Icefield is a stunning geographical feature. It is a high basin of accumulated snow and ice that straddles some 220 square kilometres, roughly 85 square miles, of the Great Divide separating British Columbia from Alberta along the spine of the Rocky Mountains. Located at 52° north latitude and 117° west longitude, it has long been incorrectly touted locally as the largest concentration of glacial ice below the Arctic Circle in North America. What is true, however, is that the Columbia Icefield is the largest of the several icefields that straddle the Continental Divide of North America. It is one of the last places in southern Canada where weather and water still interact in exactly the same way they did during the last ice age. What makes this icefield truly unique, however, is its accessibility.

At Athabasca Glacier in Jasper National Park, you can literally get out of your car and in a few moments, walk directly into the Pleistocene, a colder epoch in the Earth's history when much of North America was buried beneath two kilometres of ice. One is immediately stood upright by the cold wind blowing off the thick ice. Melting at the glacier's snout is snow that fell and was compressed into ice 400 years ago. The towering black peaks seem to lean over you. The familiar sun is a cold and distant star.

There is a different sense of time here. Fleeting hours hardly matter. The day seems the smallest unit, the season next, then the year. Beyond the year there is only the timelessness of epochs, the incomprehensibly vast passing of the geological seasons, mountains rising and falling and the coming and going of entire rafts of planetary life. Confronted by eternity, we feel small in the face of the grumbling ice. Epiphany is possible here, a sense of aesthetic arrest. A shudder runs through your soul as you realize, suddenly, what an ice age really is.

Athabasca Glacier in October. The katabatic winds that spill down the glacier from the Columbia Icefield have removed all of the previous winter's snow and polished the ice.

123

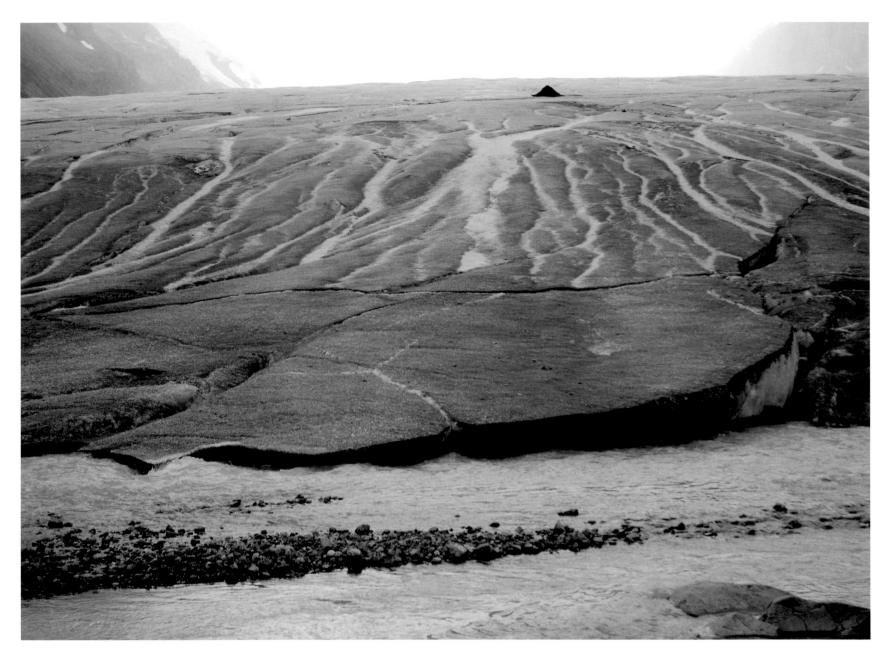

Few who visit the Columbia Icefield today fail to be impressed by the conditions that existed during the last ice age. It was a different and very dangerous world we emerged from. The ease of access is beguiling, however. To be at the terminus of Athabasca Glacier during peak melt is to understand the full extent to which glaciation reshaped the North American continent. If you give in to the mind-slowing scale of the high mountain landscape and wait long enough, the groaning and pinging of the advancing ice can actually be heard. This is not just the sound the glacier currently makes as it grumbles toward the valley floor; it is the sound this ice has made for the more than three million years glaciers have poured forth from the Columbia Icefield during the last lingering age of ice in the northern hemisphere. But there is far more to hear than just the echo of ice scraping across bedrock. There is the sound of water, too. On any given summer day, meltwater flows over almost the entire surface of the glacier. The water accumulates into surficial streams which plunge deep into the glacier by way of crevasses and mill-wells that channel the waters to the bottom on the glacier. Melt from the surface, in tandem with streams that flow out from under the snout of the glacier, collects briefly into a small lake before spilling out to become the headwaters of the Sunwapta River, a major tributary of the Athabasca River. What we witness at the terminus of Athabasca Glacier is nothing less than the birth of a life-giving watercourse that has flowed without interruption for more than 10,000 years. But this privileged access to timelessness and the primacy of the past is not without hazard. The terminus of Athabasca Glacier is a dynamic and treacherous place.

Life and death on the ice

Straddling Banff and Jasper national parks in the heart of the UNESCO Canadian Rocky Mountain Parks World Heritage Site, the icefield can be easily reached by way of excellent highways from any of western Canada's major cities. What is amazing about this easy access is that it makes it possible for the average interested person to simply open a door into a not so distant time in our Earth's history when our planet's climate was different; when it was colder and much of North America was covered by ice so deep it altered the landscapes over which it flowed. During this epoch there was so much ice on the land that sea levels were dramatically reduced globally. The resulting climate was such that it altered the evolutionary course of almost every species of life on Earth, including our own. But this is a climate to which we are no longer well adapted.

While it is easy to experience the awe, few of us have any idea of exact nature of the hazards until they are explained to us or we blunder into them accidentally. Because visitors are frequently not adequately equipped, do not heed warning signs and don't know how to identify hazards, accidents are not uncommon on Athabasca Glacier. Even experienced mountaineers are extremely careful on and around the snout of Athabasca Glacier. Nearly continuous rockfall caused by frost-shattering on steep mountain walls surrounding the ice is a serious hazard. It is not uncommon for head-sized rocks to come bouncing and whistling down the glacier, especially near the snout. There are also many tragic stories of people in street shoes who have slipped on the ice and fallen unroped into crevasses from which it was impossible to rescue

The Sunwapta River emerging from the snout of Athabasca Glacier.

them before they died right before the eyes of loved ones.

One such story is particularly horrendous. A family drove to the terminus of Athabasca Glacier and walked together up to the ice. Perhaps because of their awe, or because there were so many others doing the same, they walked past the signs posted by Parks Canada warning visitors of the hazards and went right onto the ice. Seeing others walking in the area above them, the father and son continued on. Suddenly the son disappeared. Quickly making his way to where the boy had vanished, the father found his son wedged below in a crevasse. Try as he might he could not reach the boy. He called a nearby mountain guide who was leading a group of sightseers kept tightly together on a climbing rope. The guide also tried to reach the boy but was unable to do so. The guide was able finally to get a rope around the child but was unable to gain the leverage necessary to pull him out of the crevasse. A national park rescue team was summoned.

It was an hour and a half before the body was finally pulled from the crevasse. By that time, however, contact with the ice has cooled the core temperature of the boy's body. He was already hypothermic and soon died. A legal battle ensued during which the aggrieved family sought to lay responsibility for the death of their son on Parks Canada. Parks Canada, however, was found not responsible. It was an unfortunate momentary lapse of human judgment, together with the blind coldness of the indifferent ice that killed the child. As this story demonstrates, anyone wishing to visit Athabasca Glacier should bring with them a profound respect for the ice, and be aware of its treacherousness at all times. They should also pay attention to warning signs.

SAFETY ADVICE FOR VISITORS

A qualified mountain guide takes a group on a tour of major surface features of Athabasca Glacier. Photograph courtesy of Athabasca Glacier Icewalks

While glaciers are always unpredictable, there are safe ways to travel on them. A modicum of caution and good sense can significantly reduce your chances of getting hurt in unfamiliar terrain and circumstances. Five things to consider include the following:

1. The most obvious and most often ignored safety tip is to stay off the ice, especially at the terminus of the glacier. Anyone who is not a mountaineer or experienced in glacier travel should not venture onto the ice without an expert guide. From April until well into July, most of the glacier and all of the icefield proper is covered with the previous winter's snow, which forms insubstantial bridges over crevasses. These bridges can be very difficult to detect, and they may collapse under a person's weight. When the winter snow is gone, the crevasses are easier to avoid, but the ice is extremely slippery in places and sharp in others. Injuries caused by simply falling and sliding on the ice are common and can be quite serious.

2. It is not just the ice that can be dangerous. Walking up moraines or debris slopes on the sides and at the terminus of the glacier can be like trying to walk on

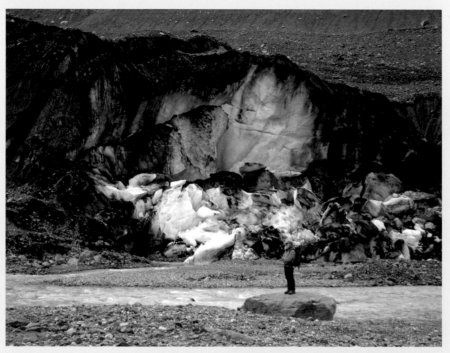

Left: So much sediment is carried off the glacier and out from under it that there are places at the terminus where quicksand becomes a problem for ill-prepared or inexperienced hikers.

Right: The margins of lateral moraines at the terminus of any big glacier can be particularly hazardous because of rockfall from above and unpredictable collapsing of unstable, debris-covered ice beneath the moraine. Legendary Columbia Icefield Icewalks guide Bernard Faure keeps even experienced climbers in his groups safely away from dangerous features such as collapsing moraines on Athabasca Glacier.

marbles that are rolling all over a rock surface. It is important to understand that the entire Columbia Icefield is in a state of constant flux and very little remains in anything close to a permanent geophysical state for long. Even the largest boulders sometimes move. Straying from trails is not advised.

3. Bring warm clothes and wear sturdy shoes or boots that provide good traction. Weather in the Columbia Icefield region is highly unpredictable and can change very rapidly. Be prepared for bitter cold at any time of year. Summer winds off the ice can be bone-chilling even if you are dressed for winter.

4. Keep children in sight and under control. While landscape experiences of the kind the Columbia Icefield offers can be transformative, especially for a child, Athabasca Glacier is not like your backyard or a playground. It is a dynamic part of the Earth system in which many of the most powerful forces of nature interact and must be respected as such.

5. To protect people you may not see below you, do not throw rocks or start them rolling down steep moraines. Once even small rocks hit the glacier surface they can begin bouncing down the ice, creating a potentially fatal hazard for others.

Peter Lemieux established Athabasca Glacier Icewalks in 1985. Photograph courtesy of Athabasca Glacier Icewalks

An Icewalks guide leads a group beneath the spectacular icefalls at the headwall of Athabasca Glacier. Photograph courtesy of Athabasca Glacier Icewalks

Guides from Athabasca Glacier Icewalks have been leading people across the glaciers of the Columbia Icefield since 1985. That was the year that a young assistant ski guide by the name of Peter Lemieux decided to offer people the opportunity to explore Athabasca Glacier on foot. Peter had worked as an interpreter for Parks Canada for a number of years and knew there was great interest from travellers. The Icewalk was born. Since that time, the company has led thousands of people safely across the Athabasca.

Athabasca Glacier Icewalks guides come from around the world: Canada, New Zealand, Iceland, all places with extensive glaciers. The guides are trained in glaciology, safe glacier travel and advanced first aid. They also know a great deal about the natural and human history of Athabasca Glacier and the Columbia Icefield. Their aim is to make your trip onto the glacier the safest, most enjoyable adventure possible and to share their passion for one of nature's great wonders. It's a perfect place to gain an in-depth understanding of active glaciation.

With the coming of the Great Depression in 1931, the Rocky Mountain national parks were chosen as sites for relief projects that offered unemployed men opportunities to work on construction projects financed by the federal government. The largest of these was the construction of the Jasper–Banff highway. When the gravel road along what had been called "this wonder trail" was finished in 1939, it was hailed as a modern engineering marvel. But it soon became clear that it wasn't the road itself that was the attraction. The landscape through which the "Highway in the Clouds" meandered was immediately recognized as some of the most spectacular in the country. According to many, the most amazing part of the highway was the slow climb up the steep slopes of Sunwapta Pass to the snout of Athabasca Glacier, the only major outflow of the Columbia Icefield that is accessible by road. In order to accommodate motorists travelling to the glacier and beyond, the government let a tender for the development of a small chalet overlooking the great expanse of slowly moving ice. The Columbia Icefield Chalet was built in 1939 by Brewster Transportation, a well-established Banff sightseeing company that would later take over the commercial tour operation on the glacier.

Prior to the completion of this gravel road, only hardened adventurers had ever seen Athabasca Glacier or the Columbia Icefield. After the highway officially opened, in 1940, the idea of mechanized public transport on readily accessible Athabasca Glacier began to gain traction.

In 1946 an army half-track left over from the Second World War made its appearance on the ice by way of the

A postcard featuring the first Icefield chalet, circa 1939, shows the extent of Athabasca Glacier at that time.

glacier's gently sloped terminus. In 1948 a man named Alex Watt began offering tours on the glacier using half-tracks, a project that succeeded well enough to draw the attention of Canada's National Parks Service, which later granted a licence for such an operation. Much to Watt's disappointment, a Jasper entrepreneur named Bill Ruddy was awarded the official government-authorized concession for the motorized Columbia Icefield attraction in 1952. It was Ruddy who introduced the famous six-passenger Bombardier snowmobile to the surface of the glacier and made the tour famous around the world.

By 1951 the toe of the glacier was becoming so steep that vehicles had trouble ascending it. By the mid-1950s, after lengthy negotiations, the federal government agreed to build a road along the south moraine of Athabasca Glacier. For years it was from this moraine that snow machines inched their way down onto the surface of the glacier. When the Banff–Jasper Highway was upgraded from oiled gravel to a modern paved highway in 1961, traffic up what by then was known as the "Wonder Road" increased dramatically. More and more visitors wanted to

Below right and opposite page, top left: A restored Bombardier snowmobile of the kind used for decades on Athabasca Glacier is on display outside the Columbia Icefield visitor centre. Its limitation was that it could only carry six to eight passengers.

Opposite page, top right and bottom left: The next iteration of Athabasca Glacier motorized transportation was a coach body on tracks. The "Shake and Bake" gave a rough ride and had no air conditioning, hence its nickname.

Opposite page, bottom right: Brewster's "Ice Explorers" at the turnaround midway up Athabasca Glacier.

visit Athabasca Glacier so they could touch the ice of the only road-accessible outflow of the famous Columbia Icefield.

By 1968 Ruddy had 20 snowmobiles on the ice and a summer staff of over a hundred at the Columbia Icefield. The Ruddys were one busy family. Too busy. In 1969 Bill Ruddy sold Snowmobile Tours Ltd. to Brewster Transportation, which already owned the Columbia Icefield Chalet.

In purchasing the Athabasca Glacier snowmobile operation, Brewster was immediately confronted with the challenge of developing more a reliable technology for transporting larger numbers of visitors onto the glacier in a safe and efficient manner. The Bombardier snow machines they purchased with the business were reaching the end of their practical life. Though the Bombardier was fun, it was noisy and rough-riding, not to mention expensive to maintain. Moreover, because it could carry only six to eight passengers, the snowmobile fleet could not keep up with the long lines of people who wanted to experience the surface of the ice.

Heavy visitation at the glacier and a new focus on group tours made larger vehicles a necessity. Brewster responded by experimenting with machines that featured bus bodies attached to track mechanisms that had been developed for Arctic exploration. Though these vehicles were crudely experimental, they provided the basis for further technological innovation. The next stage was a custom-made coach body attached to a much-improved track system.

The realization that even the best-designed tracked vehicles caused unacceptable disturbance to the surface of the glacier led to experimentation with all-terrain vehicles with large, low-pressure tires. This technology was tested first in the Arctic and found to be far more efficient and environmentally friendly than earlier track technology. The Foremost Terra Bus, or Snowcoach ("Snocoach" as the marketers spelled it), was developed jointly by Brewster and Canadian Foremost in Calgary, Alberta. Later models were renamed "Ice Explorers." Though very expensive, these remarkable 20-tonne, 56-passenger machines have proved to be ideal vehicles for glacier travel, especially when operated by well-trained driver-guides. It had taken 20 years for Brewster to perfect transportation technology that would work in this fragile and difficult terrain, but today the company's fleet of "Ice Explorers" take as many as half a million people a year onto the surface of Athabasca Glacier.

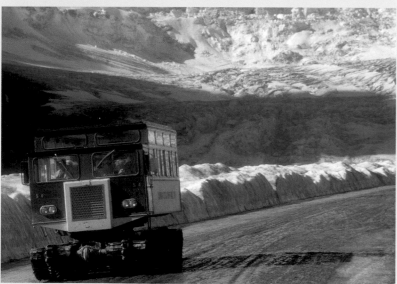

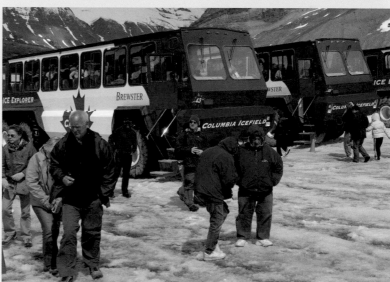

1. **Is it the Columbia Icefield or the Columbia Icefields?**
 Because the Columbia Icefield is a high-altitude basin in which snowfall collects and from which a number of glaciers flow, it is considered a single geological feature. Thus Columbia "Icefield" is a singular term, while "Icefields" Parkway is plural because more than one icefield can be viewed along its course.

2. **How big is the Columbia Icefield?**
 This is an interesting question. It was widely held for decades that the Columbia Icefield was about 325 square kilometres in area. The origins of this estimate appear to go back to a map in a 38-page publication entitled *Geology of the National Parks in the Rockies and Selkirks*, published by the Canadian Government Travel Bureau, Department of Resources and Development, in 1952. The map, albeit only a sketch, clearly depicts the inclusion of the Clemenceau and Chaba icefields but erroneously charts these as being part of the Columbia Icefield. What is interesting is that it was generally held in those days that, given the altitude of the icefield, its extent would not significantly change over time. Recent satellite analyses, however, indicate that what can properly be defined as the Columbia was approximately 223 square kilometres, or about 86 square miles, in 2005. The decade that followed was among the warmest on record, though, which means the Columbia Icefield would have shrunk even further at its margins and will likely continue to do so.

 For decades it was also maintained that the Columbia Icefield was the largest non-polar ice mass in North America. We now know this is not the case. The Andrei Icefield, north of Stewart, BC, is larger as is the Seward–Bering system in coastal Alaska. Several other fields in the Coast Mountains are also larger. The neighbouring "Clemenceau Icefield" could also be larger, though in fact glaciologists now view it as more of a group of glaciers with multiple ridgelines and flow divides than as a single icefield. The Columbia Icefield is hardly insubstantial, however. It is the largest of the multiple icefields that straddle the Continental Divide in North America.

3. **Are all the glaciers in the Canadian Rockies retreating?**

 While some tidewater glaciers in the higher latitudes of the northern hemisphere may grow in size if warming temperatures increase winter precipitation, almost all the glaciers in the Canadian Rockies appear to be in a prolonged period of recession. Recent research, in fact, suggests that as many as 300 glaciers disappeared along the Great Divide of the Canadian Rockies between 1920 and 2005. Only pocket glaciers high on north-facing walls of big mountains appear to be unaffected by warming valley temperatures.

4. **How deep is the ice?**
 According to the Geological Survey of Canada, the upper icefield – that is, the part of the icefield around the outlet valley glaciers – varies in depth from about 150 to 300 metres, with some limited regions too deep to measure using radar. From theoretical considerations, however, the maximum depth of the icefield may exceed 500 to 600 metres. The depth of Athabasca Glacier as measured in 1990 at its deepest point, which happens to be at the turnaround for the "Ice Explorers" touring its surface, was roughly 300 metres, or nearly 1000 feet. Downwasting of the glacier, however, has been almost continuous each summer since those measurements were taken. The ice cliffs that are visible on the eastern margins of Snow Dome and Mount Kitchener as you drive north from Athabasca Glacier toward Jasper are approximately 100 to 150 metres thick.

5. **What does "Athabasca" mean?**

 The word comes from the Indigenous Cree language and means "place where the reeds grow." The name refers to the Athabasca River in the area of Lake Athabasca in northeastern Alberta. Meltwater from Athabasca Glacier creates the Sunwapta River, which joins the Athabasca not far downstream. The Athabasca River too has its origins in the Columbia Icefield, but it originates from Columbia Glacier, which is not visible from the Icefields Parkway.

6. **Is it safe to go out on the ice?**

 Unless you are an experienced and well-equipped mountaineer, it is dangerous to go out onto the ice on your own. One of the reasons why the "Ice Explorer" excursion on Athabasca Glacier is so popular is that it ensures that everyone – no matter how inexperienced – can be safe while still having the opportunity to walk on the icy surface of a major glacier flowing down from the Columbia Icefield. For those who are more adventurous or desire a more prolonged ice age experience, private and regularly scheduled guided walks on the ice are offered all summer long by Athabasca Glacier Icewalks.

7. **Why is the ice blue?**

 Glacial ice is little more than compressed snow. At the centre of every snowflake is a nucleus of dust. Because of the size of the dust particles and the nature of the crystalline structures in which they are trapped, glacial ice reflects the shorter blue and green waves of the spectrum of visible sunlight.

8. **Does anything grow in or on the ice?**

 Yes, as noted in chapter 3, life can flourish but only on the snow that blankets the ice each winter. In spring and early summer, late-lying bands of winter snow often turn pink. Hikers walking on this snow often leave red footprints.

This coloration is caused by a blue-green algae of the species *Chlamydomonas nivalis*, which flourishes in high altitude snowpacks. The microscopic cells of this algae are encased in a red, gelatinous sheath which is capable of withstanding cold temperatures. This coating also protects the algae from the fierce radiation that falls on late-lying snow at altitude. Some say this snow, if eaten, has the faint taste of watermelon. Many insects can also be found living out various stages of their lives in or on the snow. Tiny iceworms are sometimes found in meltwater that pools in glacial depressions in some areas of the Rockies, but they are not common here.

9. **Can you drink the water?**

 The water created by the melting of glacier ice can be almost as pure as distilled water. The clear glacier water that flows over the surface of Athabasca Glacier is as fresh and clean and refreshing as any water on Earth. When glacial meltwater picks up a great deal of rock flour and other fine debris, as it does at the terminus of the glacier, its colour can change to grey or brown. Though the water is still fresh, these sediments can bother sensitive stomachs if the water is consumed in large quantities over a prolonged period of time.

10. **What is this area like in the winter?**

 Because of a gap in the mountain ranges to the west which separate the Rockies from the Pacific Coast, the Columbia Icefield receives a great deal more snow than any of the regions immediately around it. An average snow year would see 10 metres fall on Athabasca Glacier. It can also be windy and very cold in this part of Jasper National Park. While winter temperatures have moderated slightly in the Canadian Rockies in the early 21st century, winter temperatures of –40°C are still not uncommon.

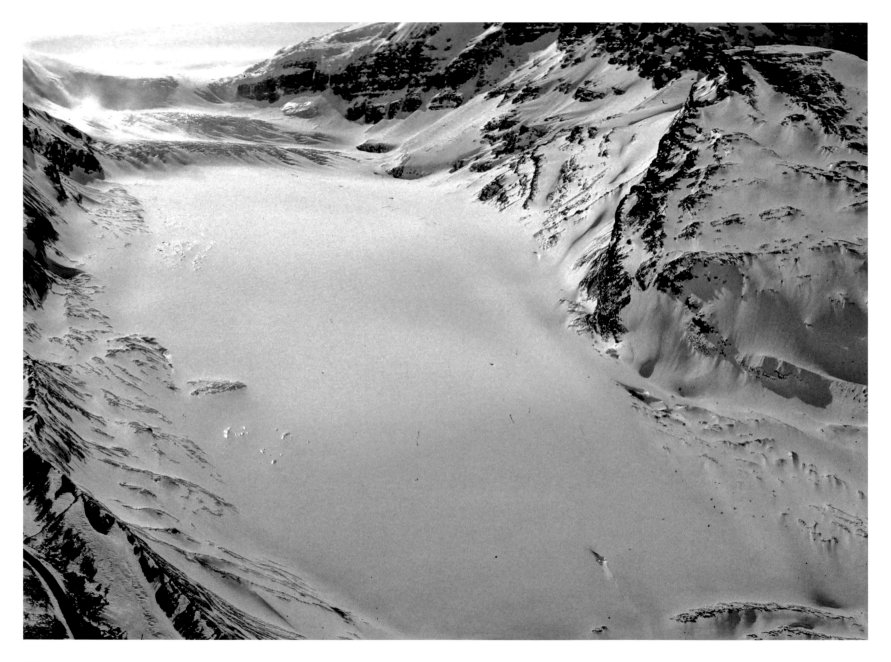

Canada's Rocky Mountain parks become a World Heritage Site

While circumstances are rapidly changing with respect to incorporating Indigenous and local culture into the design, management and function of our national parks, at the time the Canadian Rocky Mountain parks were first listed together as a World Heritage Site, their geographical boundaries were drawn as if local people didn't exist and never did. It was as if the history of previous human relationship to place, and all the stories giving life to place, were erased. As Julie Cruikshank would say, boundaries replaced stories. The World Heritage Site was instead largely designated on the strength of its truly spectacular and highly representative natural features. And those are among the most spectacular in the world.

It was immediately noted that the area that was to compose the World Heritage Site was located in the northern Rocky Mountains in what was defined as the Nearctic Biogeographical Province. This ecological province is distinguished by young mountains with high peaks and significant topographical relief and by extensive forests and diverse wildlife. The geological formations in the proposed World Heritage Site were identified as being primarily shale, dolomite, sandstone, limestone, quartzite and slate. It was also observed that this region offered easy access to classic representations of all the geological forces that create and then erode major mountain ranges.

One of the other reasons for the World Heritage Site designation was that the parks proposed for listing preserved all four northwest-to-southeast-trending geological sub-provinces that compose the Rocky Mountains. These sub-provinces include the Western Ranges, the Main Ranges, the Front Ranges and the Foothills. The Western Ranges, which are best exemplified in the southern part of Kootenay National Park, are composed of relatively soft shales that bent and twisted into elegant folds during the mountain-building process. The Main Ranges comprise the high mountains in the four national parks and form the Continental, or Great, Divide. Castle Mountain in Banff National Park and Mount Edith Cavell in Jasper National Park were cited in the application as dramatic examples of the many Main Range peaks readily visible to visitors. The Front Ranges, which are found only in Banff and Jasper parks, are composed principally of thick layers of limestone and shale. It is interested to note that these ranges are separated by a major fault zone that runs the entire length of both Banff and Jasper national parks. Characteristically, these mountains are tilted or tooth-like in appearance and, in places, exhibit dramatic folding. Mount Rundle above the Banff townsite and Roche Miette in Jasper National Park were offered as classic examples of Front Range mountains. The Foothills are the easternmost extension of the influences that created the Rockies. A small area along the Southesk River in southeastern Jasper National Park provides the only representation of the rounded, rolling hills of the Foothills geological sub-province to be found in any of the four mountain parks. (Protected areas in Alberta adjacent to the mountain national parks do, however, protect outstanding examples of this sub-province, and hopefully these will ultimately be considered an expanded designation of the region.)

Another important element of the World Heritage Site application was the extraordinary fossil record preserved

Athabasca Glacier is a cold and very windy place in winter.

in the largely sedimentary rock of these mountains. This record dates from the Precambrian to the recent. The rare and exquisitely preserved soft-bodied fossils found in the Burgess Shale layer of the Stephen Formation in the Cathedral Escarpment in Yoho National Park had already been designated as a World Heritage Site in 1980. The designation was founded upon the realization that the Burgess Shale contained not only some of the most significant fossils in the world but also offered a glimpse into evolution in action some 500 million years ago.

While earlier mountain-building and -shaping processes are well exhibited in the Rockies, their presence was not the only reason for the region's successful application for World Heritage Site status. While the last major glacial advance ended in this area some 11,000 years ago, there are still hundreds of active glaciers in and around the Rocky Mountain national parks. The designation of the Canadian Rocky Mountain Parks World Heritage Site was very much strengthened by strong reference to three spectacular features that continue to be shaped by the long presence of glacial ice in this region. The first of these features, the Columbia Icefield, ranks as the most accessible major glacial mass in the world. The second, the Castleguard Caves, is located under the Columbia Icefield. The final major feature that was put forward as evidence of this region's qualification as a World Heritage Site was the Maligne Valley in Jasper National Park. Like the Columbia Icefield, the Maligne Valley is so spectacular and so geologically interesting that it could have qualified for World Heritage Site designation in its own right. All three of these features can be appreciated within the context of the amazing natural history that composes the north and northwest slopes of the Canadian Rocky Mountain Parks World Heritage Site.

The organizing principle of the Canadian Rocky Mountain Parks World Heritage Site is watershed. The spine of the Rockies is the birthplace of western rivers. Every aspect of the mountain landscape encompassed within this World Heritage Site is an expression of what water is and does on the landscape. All of the rest of the wonder – the shapes of the peaks, the colour of the lakes, the rich forest and alpine ecosystems – all flow from the fact of abundant water. To see the World Heritage Site in this context is to understand its significance, not just to the Canadian West but to the world.

Before it is anything else, the spine of the Rockies is a hydrological feature of continental importance. Before we perceive it as home or as a tourism attraction it should be viewed first as a region of annually generated snowpack and rainfall that provides water to almost the entire West.

Everything starts at the apex of the world, which in the Canadian Rockies means the Columbia Icefield. It is from this high basin of stone and snow that the plenty that is the West flows downstream to enrich the rest of the continent. If we truly want to understand this place we have to realize that, at its very foundation, the Rockies are all about slopes and divides. The Rockies are all about water. With this in mind, one way to re-contextualize the Canadian Rocky Mountain Parks World Heritage Site as a biophysical and cultural unit is to examine the seven magnificent parks that comprise it in the context of watershed.

Snow Dome: A triple-triple divide

Beyond the experience of the utterly monumental in nature, even a brief visit to the Columbia Icefield teaches us that water is a central element in determining what the surface of the Earth was like at any given moment in its history. A change of only a few degrees in atmospheric temperature will govern what forms water will take and how it will act in shaping the world and the life forms that exist in it at any moment in Earth time. Of all the extraordinary glacial features at the Columbia Icefield offering testimony to the importance of water in the making of the world, Snow Dome is perhaps the most amazing, for it is a triple continental divide.

A divide is the boundary between the headwaters of two drainage basins. In lowlands – especially where the ground is marshy – drainage divides may be hard to discern. Lower drainage divides on valley floors are often defined by deposition or stream capture. In mountainous regions, divides usually lie along topographical ridges, which often take the form of a single range of hills or mountains. Since ridgelines are easy to see, drainage divides are natural borders that are often used to define political boundaries such as that between Alberta and British Columbia.

A continental divide is the boundary between watersheds that flow into different oceans. A triple continental divide is rare in nature. It is the uppermost point that separates water that flows in different directions across a continent to pour ultimately into not two but three separate oceans. The apex of the triple divide at the Columbia Icefield is the summit of Snow Dome, a 3510-metre peak that overlooks Athabasca Glacier from the north. Depending on where snow falls at the summit of this mountain, it can, upon melting, end up in any one of three major river systems, each bound for a different ocean. From the gently dipping northern shoulder of the mountain, melt joins the waters of the Athabasca River, which flow nearly 3000 kilometres northward through the massive Mackenzie River system to become part of the Arctic Ocean. Meltwaters from the mountain's western shoulder flow through the Bush and Wood rivers into the Columbia, which meanders 2000 kilometres southwestward to join the Pacific near Portland, Oregon. From Snow Dome's eastern shoulder, the flow is into the North Saskatchewan, the great river of the northern Canadian plains, coursing nearly 2000 kilometres to join Atlantic tidewater at Hudson Bay.

While Snow Dome was viewed initially as a worthy mountaineering objective and then as an interesting hydrological feature, it has come to stand for a great deal more as our scientific awareness has grown. We now understand the importance of the Columbia Icefield as a climatic thermostat and water tower for western North America. If you are among those who believe that life itself has the collective capacity to self-regulate the surface temperatures of Earth so as to maintain optimal conditions for sustained biodiversity, you will be interested to know the conditions on Snow Dome also represent "the triple point of water." The term refers to the temperature range at which all three phases of water – solid, liquid and vapour – coexist and interact. This range, between -40 and +40°C, is absolutely crucial to tolerable climate variability and to life processes, and at its centre is the freezing point of water. Looking up at the lip of ice visible from the Icefields

From the triple hydrological apex at the summit of Snow Dome, Jasper Park superintendent Ron Hooper, the author and Jasper mayor Dick Ireland ceremonially sent water to each of the great oceans to mark the United Nations International Year of Freshwater in 2003.
Photograph by Ward Cameron

Parkway, one gets a sense of what this means to the landscape and to those who live there. Our entire existence is clustered around the triple point of water.

The triple continental divide on Snow Dome is unique again in that it is so deeply blanketed in glacial ice. Over the last three decades the glaciers of the mountain West have been shrinking faster than at any other time in recorded history. If the world continues to warm and all this stored water disappears, the West, and our entire continent, will be a very different place.

In this larger context, Snow Dome could be seen as a *triple*-triple divide: it performs its basic function of separating mountain meltwaters destined for three different oceans; it reflects the atmospheric temperature balance that determines the proportion of water that exists on the planet in each of its various and highly active forms; and third, it serves as a baseline dividing past hydrological regimes from those of the present and those that will exist in the future, not just in the Rockies but in the entire West.

A counter-clockwise trip around the Columbia Icefield, starting at Athabasca Glacier, moving north over Dome Glacier to Snow Dome, Columbia Glacier and Mount Columbia and then south over Castleguard Glacier, the enormous Saskatchewan Glacier, up the Big Hill to Mount Athabasca and back to Athabasca Glacier and the Columbia Icefield Visitor Centre.

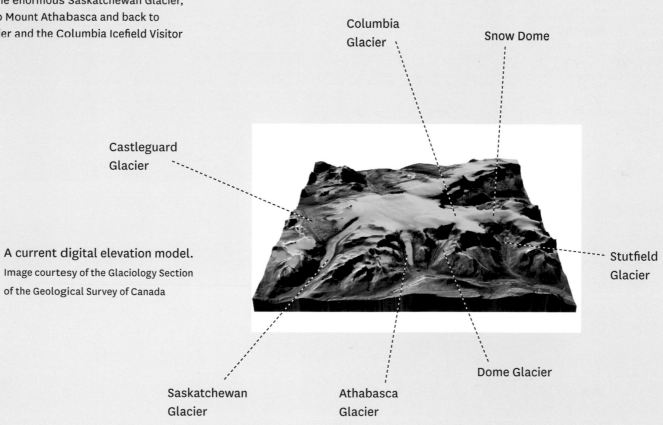

Columbia Glacier

Snow Dome

Castleguard Glacier

Stutfield Glacier

A current digital elevation model.
Image courtesy of the Glaciology Section of the Geological Survey of Canada

Saskatchewan Glacier

Athabasca Glacier

Dome Glacier

Top left: Stepping back from the terminus of Athabasca Glacier, it is possible to see its proximity to adjacent Dome Glacier, which pours down from the upper reaches of the Columbia Icefield.

Top right: Dome Glacier spilling down from the shoulders of Snow Dome. Much of its ice is covered by moraines.

Below left: Stutfield Glacier, named for Hugh Stutfield, the British mountaineer who accompanied Norman Collie on the 1898 expedition northward from Lake Louise which discovered the Columbia Icefield.

Below right: The triple continental divide on Snow Dome is a remarkable feature, one that would alone have qualified the Canadian Rocky Mountain Parks for consideration as a World Heritage Site.

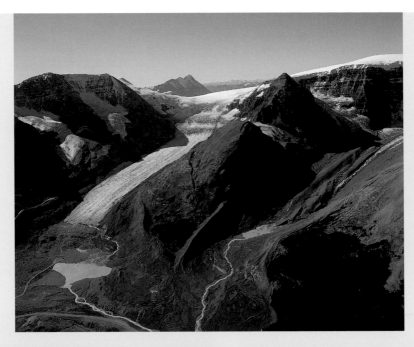

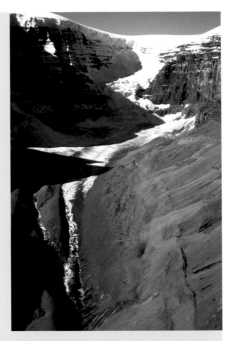

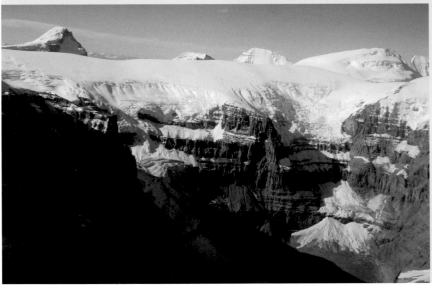

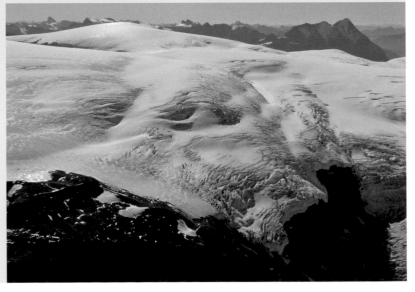

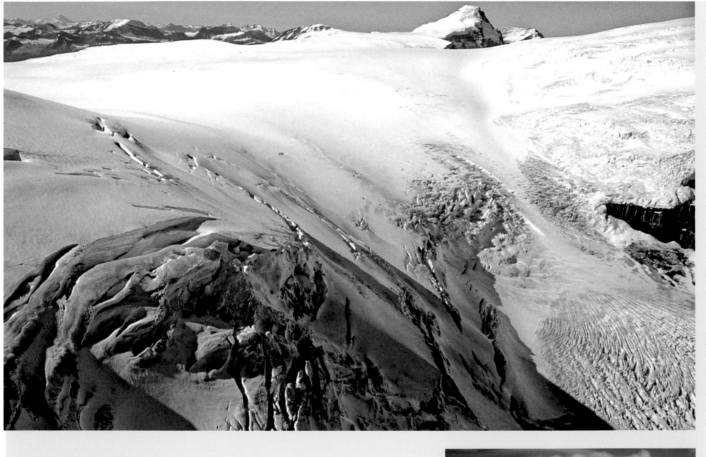

Top: Ice flows toward the surrounding valleys from the great bowl of snow that is the Columbia Icefield névé. The peak dominating the background skyline is Mount Columbia.

Below: The upper snows of the Columbia Icefield.

Right: Columbia Glacier, which flows from the northern rim of the Columbia Icefield, forms the headwaters of the Athabasca River, a major western Canadian watercourse.

Facing page: Mount Castleguard with Mount Columbia in the background.

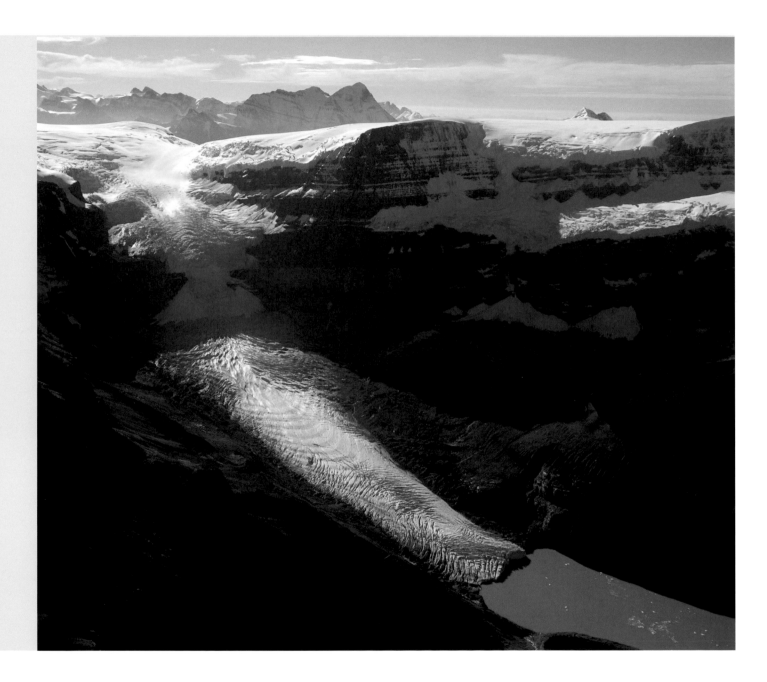

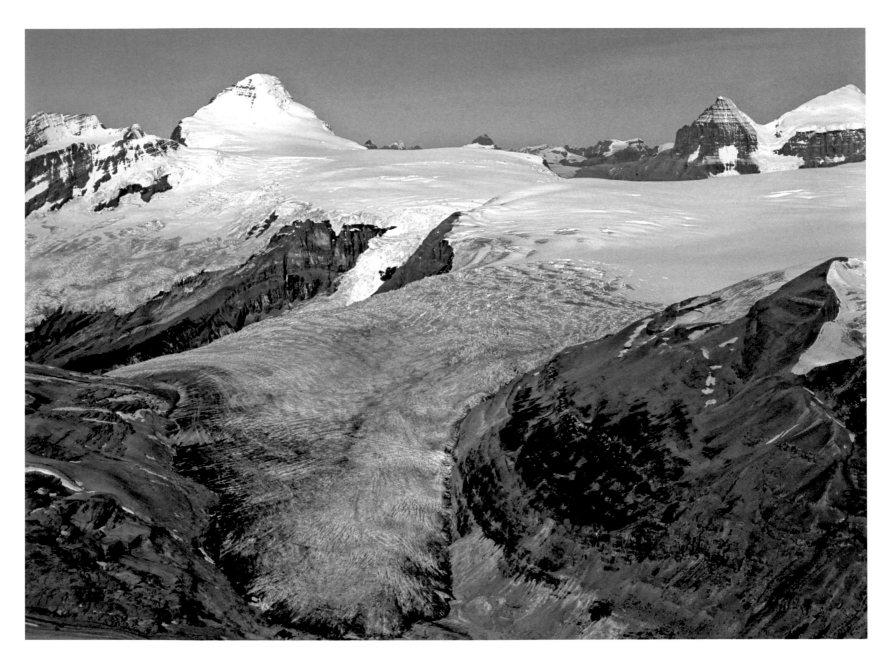

At 3747 metres, Mount Columbia is the highest mountain in the Columbia Icefield group and the highest point in Alberta.

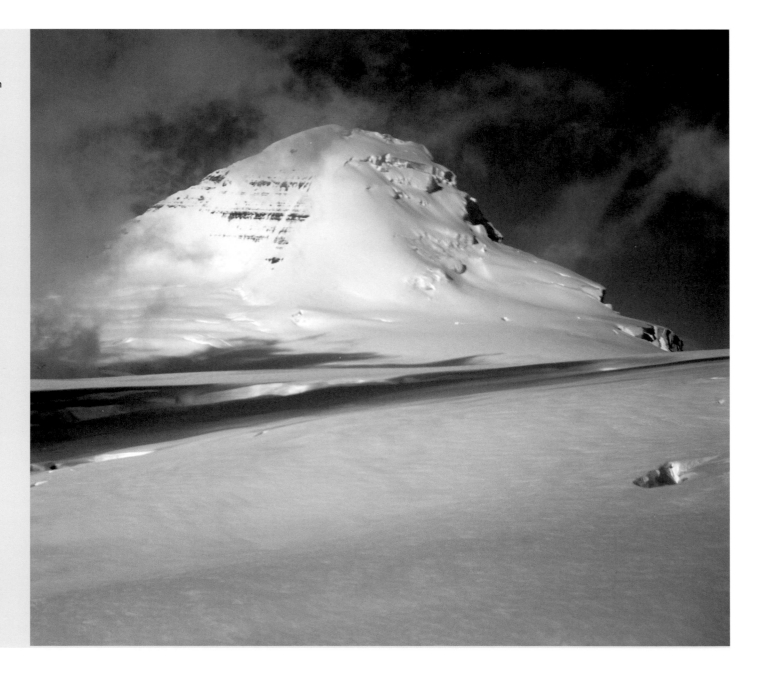

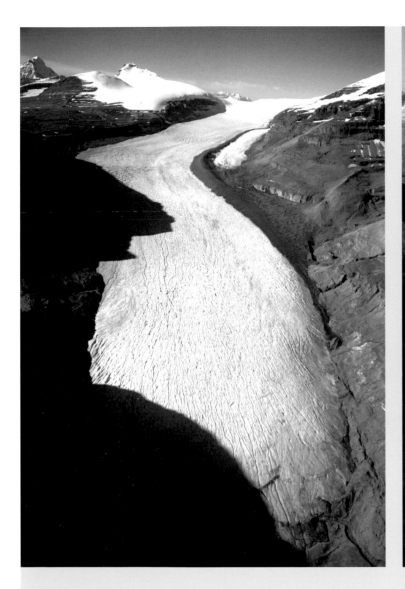

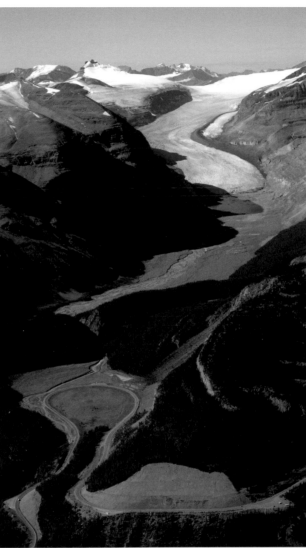

Left: Rivers of meltwater course down the Saskatchewan Glacier during peak summer melt.

Right: The Saskatchewan Glacier and the Big Loop on the Icefields Parkway just below the big hill up the south side of Sunwapta Pass.

The Saskatchewan Glacier is about six kilometres by extremely rough terrain from the Icefields Parkway. Because of the changing nature of the glacier's terminus, this route is recommended to experienced climbers only.

145

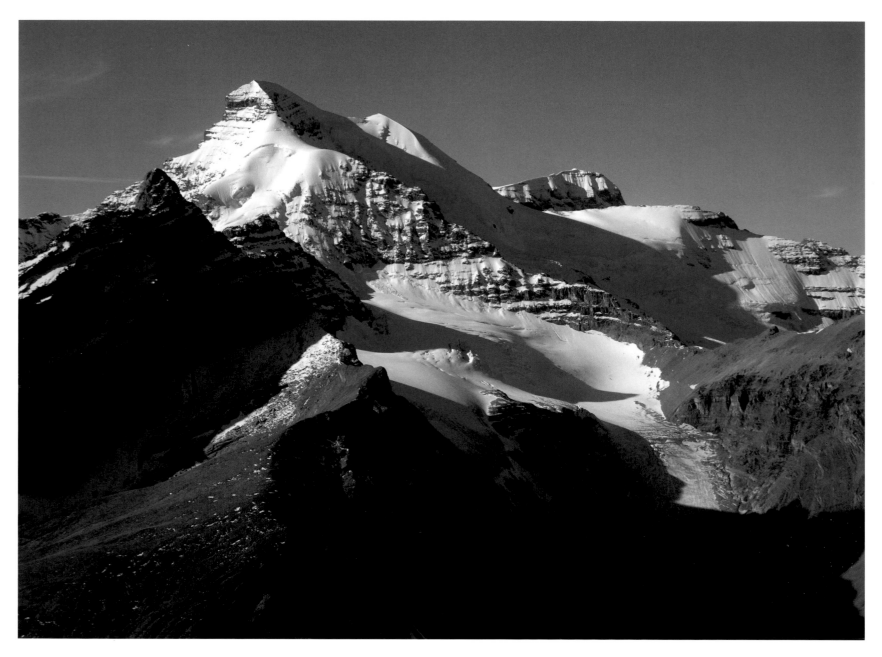

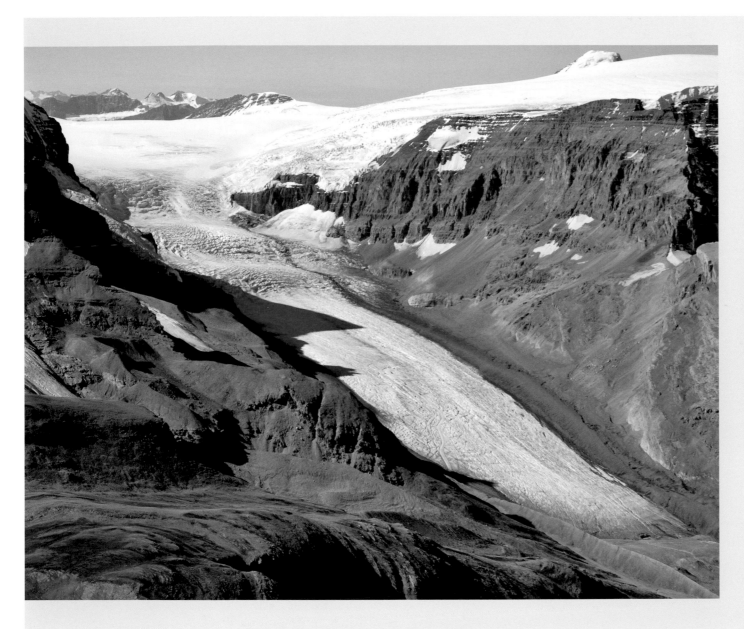

Facing page: Mount Athabasca is one of the principal geological features of the Columbia Icefield region. Besides cradling the Athabasca Glacier on its northern shoulder, this 3491 metre peak also has its own spectacular glaciers as shown in this photograph.

Left: The Athabasca Glacier in late summer when the past winter's snow has melted exposing the full grandeur of its three headwall icefalls and entire extent of ice not covered by lateral moraines.

It seems obvious that air is going to be cooled if it passes over a 220-square-kilometre block of snow-covered ice, but an icefield can affect more than just the air directly above it. If you visit the Columbia Icefield, you may notice a cold breeze coming from the direction of whatever glacier you are looking at. That breeze is caused by the same force of nature that makes rocks roll downhill – gravity. Cold air is denser than warm air, and thus heavier. As the air passing over the icefield cools, gravity pulls it downhill and you experience what is called a katabatic wind.

As the images demonstrate, glaciers, by their very presence, also have a direct and persistent refrigerating effect on immediate and surrounding landscapes. In the visible light images below we see the reflectivity of the ice at the terminus of Athabasca Glacier. The thermal image of the same terminus at exactly the same time demonstrates just how much colder the ice is compared to the surrounding landscape. The thermal image also shows just how warm the dark-coloured rocks that form the terminal moraines of Athabasca Glacier can become in mid-summer.

Because it takes 79 times more heat to raise the temperature of ice than it does to raise the temperature of liquid water, it has been estimated that the loss of northern sea ice will cause as much warming as can be attributed to 70 per cent of the CO_2 presently in the Earth's atmosphere.

These glaciers help refrigerate the world. A great many mountains that once were covered in snow and ice are already darkening and drying. Such mountains reflect less light and retain more heat. Often, as a consequence, the ice that is holding them together disappears. If our mountain glaciers disappear, the heat presently being withdrawn from the atmosphere to melt glacial ice will suddenly be available to further heat the atmosphere. The result will be greater instability. We are already observing this trend in many of the world's high mountain ranges.

In the autumn when the temperature gradient is highest between the icefield and the lower valleys, katabatic winds can be very strong. The winds are powerful enough to literally polish the surface of the glacier.

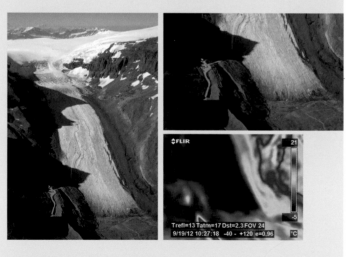

The visible-light photographs are by the author. The infrared image of the same glacier was made simultaneously by Dr. John Pomeroy of the Centre for Hydrology at the University of Saskatchewan.

The most telling characteristic of glacial ice is its plasticity under pressure. As snow falls and becomes ice in the icefield collecting basin a number of things happen to it. As the snowflakes are flattened they lose their characteristic crystalline shapes. Most of the air trapped between the flakes is driven out, and once this happens the resulting ice has greater density and a different crystal structure. This ice now is under great pressure. If it has somewhere to move in response to that pressure, it becomes a glacier.

While under pressure, glacier ice is neither a true fluid like water in its liquid form nor a true solid like stone in its cool state. Under extreme pressure, glacial ice acts the way a plastic might, in that its molecular structure allows it to flow over itself and over obstacles that stand in its way. A glacier, especially one like the Athabasca, is most plastic at its centre, where it is under the greatest pressure from its own weight and under the least influence of drag caused by the highly resistant bed over which the ice haltingly flows. This plasticity quite literally enables the glacier to stretch. This capacity is limited, however. If a glacier stretches too much, it dissipates the internal pressures that give the ice its plasticity. This often happens when the glacier flows over steep irregularities beneath its surface, and it gives rise to a number of beautiful but often very dangerous glacial features. When the glacier flows over particularly large irregularities, like the upper cliff that forms the headwall just below the top of Athabasca Glacier, the ice stretches to the point where its depth and plasticity are not enough to allow it to bridge the obstruction. The ice then fractures into towers of broken ice called séracs. As the glacier pushes each of these towers over the cliff edge, they collect at the bottom and immediately re-constitute themselves under the pressure of their own weight into plastic glacier ice that once again resumes its journey toward the toe. Where the irregularity over which the glacier flows is smaller in relation to the depth of the glacier, the stretching of the ice causes crevasses to form.

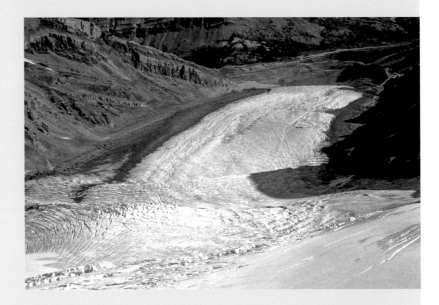

Athabasca Glacier from above the headwall, looking down toward the Icefields Visitor Centre.

The story is still told to disbelieving tourists. Imagine this. A man actually disappeared beneath the ice and was washed through the glacier to come out its snout. It sounds like just another bus-driver tall tale, but it is nevertheless true.

It all began innocently enough. After viewing a dizzying array of mountain-climbing photographs projected on the wall by a friend, I decided that I wanted to become a mountaineer. No point in half measures. The first backpacking trip I did in my entire life was across the Columbia Icefield. I only had two days off but that, in my opinion, ought to have been enough. After all, when you are twenty, how big can an icefield be?

The accident happened while we were descending the Saskatchewan Glacier on the afternoon of the second day. I was so tired that I had given up trying to avoid the big melt-water streams that coursed across the glacier's broken surface. I was cold and wet and worn out and all I wanted to do was get down. So I took a shortcut.

Unless you have travelled on the surface of a big glacier, it is hard to imagine how much melt can occur on a hot day. There are actually rivers on the surface of the ice. Seeking a direct line, I tried to cross one.

The power of the icy water lifted me up and carried me to the mouth of a huge crevasse. One moment I was looking at the sun-sparkle of splashing water; a moment later I was in the centre of a waterfall plunging into complete darkness beneath the ice. The waterfall cascaded down a

series of ice lips to join the river that flowed beneath the glacier. Never before or since have I heard, coming from everywhere around me, so many of the different sounds that water makes. Here I was, inside a planetary artery, examining first-hand what water does to the world. But then I had this little problem. Only a few inches separated the top of the water and the roof of the ice. In darkness, I kept smashing into boulders and scraping against the underside of the glacier. But, just as the shock and wonder were beginning to evaporate, just as calm was about to become sheer terror, the strangest thing happened. The ice above began to glow. At first it was a faint green. As the river swept me onward, the glow intensified. Green gradually merged into a pale blue. I noticed then that rocks were hanging down from a ceiling made entirely of light. Then I washed out of the glacier into sunshine and into the full flood of the North Saskatchewan River, where my problems really began.

The accident changed everything. My life flowed toward unexpected ends. I realize now that I have spent the rest of my life trying to prevent my own culture from carrying me permanently downstream and away from the luminous glory of that subglacial light. This book is a testament to how much that experience shaped my identity and how important the Columbia Icefield remains in the life and work of so many who care about the remarkable character of Canada's mountain West.

A popular way to explore the Columbia Icefield is to take the 3-kilometre trail up the rolling shoulders of Parker Ridge. This beautiful ridge is named for well-known American climber Herschel Parker, who visited the Columbia Icefield with Walter Wilcox in 1896. The wide trail up the ridge wanders through old firs and Engelmann spruce at the edge of timberline and into the open alpine. In summer it is a natural rock garden, resplendent with every imaginable colour of wildflower. Before cresting the ridge the trail also passes impressive fossil corals 350–400 million years old. Once the summit is reached, Saskatchewan Glacier and its outwash plain dominate the view. Nearly twice as long as Athabasca Glacier, the Saskatchewan flows gently from the high cold of the icefield into a deeply cut valley that falls steeply off from the viewpoint at the end of the trail.

Perhaps because it is one of the very best short hiking trails in all of the Canadian Rockies, it has been badly abused by inexperienced hikers who won't stay on the trails in springtime and by those who destroy the fragile tundra by shortcutting on their return trip down the gentle switchbacks. If you do not have footwear that will allow you to stay strictly on the trail, you really shouldn't attempt this walk. If you do have proper shoes, though, and you are prepared to make a few concessions to the fragility of alpine vegetation, a journey to the top of this ridge could be a turning point in your appreciation for the icefield.

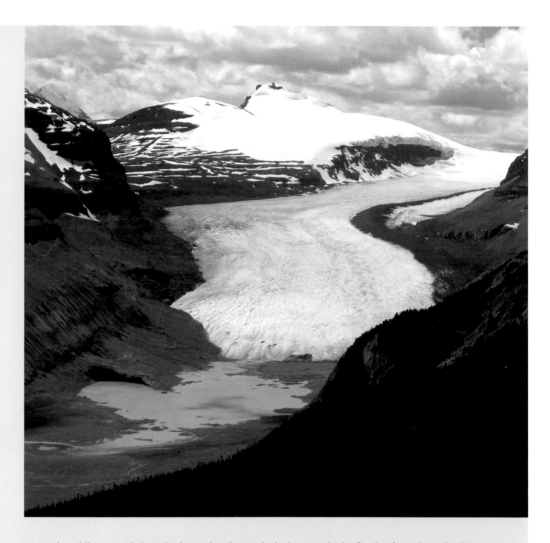

At nearly 10 kilometres in length, the Saskatchewan is the largest glacier flowing from the Columbia Icefield. It forms the headwaters of the North Saskatchewan River. The dark line down the right side of the glacier is a medial moraine, a common lateral moraine created when two glaciers meet and join. The slopes on the right are part of Parker Ridge, one of the best spots from which to observe the Saskatchewan Glacier.

151

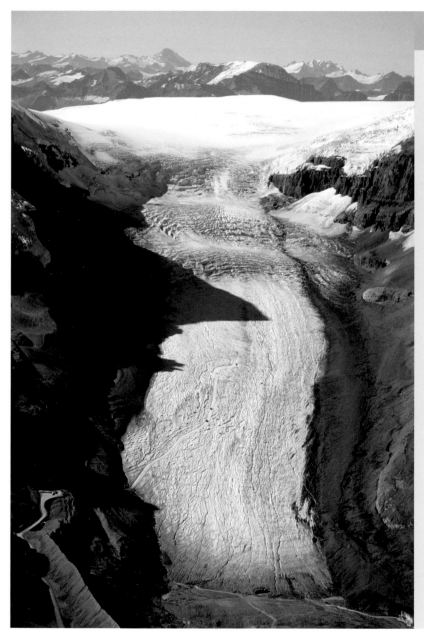

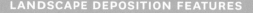

This aerial photograph of Athabasca Glacier dramatically reveals the effects that millions of tonnes of moving ice can have on the landscape beneath. The first thing that is obvious is the effect on the moving ice on the shape of the valley. Valleys carved by rivers are V-shaped, while valleys accentuated by the mass movement of glacial ice are U-shaped. This effect on the contours of mountain valleys can be observed all along the Icefields Parkway.

The next depositional features that are very obvious are the lateral moraines, the steep knife-shaped piles of broken rock that are pushed up by the moving ice on either side of the glacier. Some of these moraines are nearly a hundred metres high, evidence of the fact that the glacier was recently much longer and deeper that it is today. The knife-shape of these moraines

Left: The moraines of Athabasca Glacier as they looked in 2008.

Below: An Ice Explorer climbing the steep lateral moraine of Athabasca Glacier. The tour operator quite accurately explains that the road from the passenger transfer station onto the glacier is one of the steepest commercial roads in Canada, making access to the ice part of the thrill of the experience.

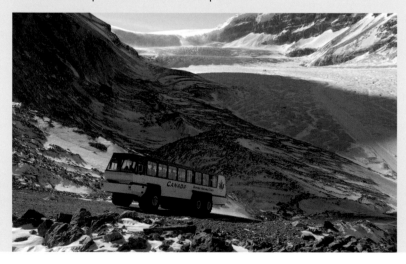

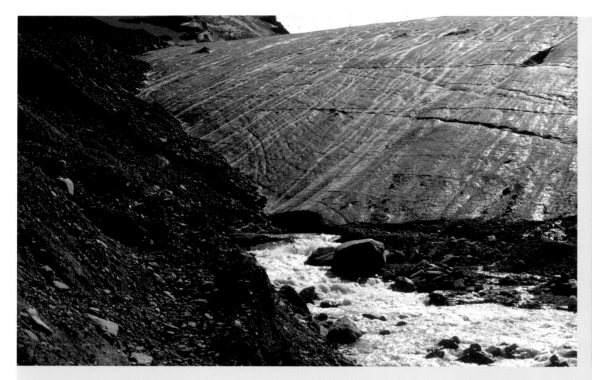

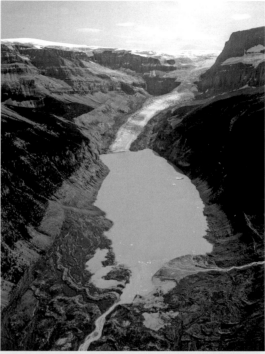

Left: Terminal moraines are another large-scale depositional feature that can readily be seen at Athabasca Glacier. These moraines are formed as the constantly moving ice deposits rocks, gravel and fine dust called rock flour at the snout of the glacier. Terminal moraines can become quite large if the glacier stays in the same place, which only happens when the amount of summer melt does not exceed winter advance. Athabasca Glacier, however, is retreating, which means the terminal moraine is receding along the margin of the ice. Right: Also typical of glacial landscapes are the proglacial lakes which form at the very terminus of a melting glacier. These are often impermanent features that come and go depending on the amount of debris deposited in them by meltwater. At the time of this writing there was a proglacial lake – Sunwapta Lake, locals called it – at the terminus of Athabasca Glacier. The best example of a proglacial lake in the Columbia Icefield region, however, is the as yet unnamed one shown here, which has formed at the terminus of Columbia Glacier.

is very clear at the bottom left of the photograph where we can see the road taken by buses to where the Ice Explorer tour began at the time this picture was taken. These lateral moraines collapse over the ice and may remain ice-cored long after the main body of the glacier has disappeared. In a warming climate, however, the ice buried beneath lateral moraines eventually melts, making such roads impossible to maintain for long, which is why the starting point of the Ice Explorer tour continually changes. The lateral moraines on the Athabasca have become so unstable that it may eventually be necessary for the Ice Explorer tour to get onto the ice by way of the toe of the glacier in the same way Alex Watt did when he began offering tours on the glacier using half-tracks in 1948.

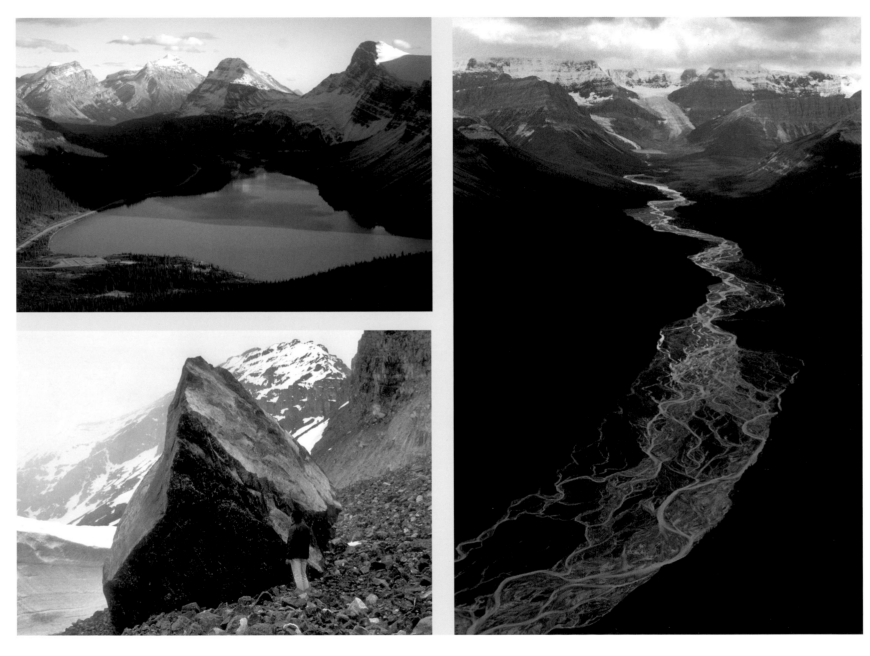

Opposite, clockwise from top left: In some places, proglacial lakes can become quite large and relatively permanent. In such circumstances much of the sediment deposited in the lake by the melting ice can settle, leaving only fine dust particles called rock flour suspended in the water. These particles are of just the right size to reflect the blue end of the sunlight spectrum, resulting in the spectacular turquoise colour of many of the famous lakes in the Canadian Rockies, including Lake Louise, Bow Lake (featured in this photograph) and Peyto Lake in Banff National Park and Maligne Lake in Jasper.

Glacier meltwaters carry huge loads of sediment great distances downstream. Where the landscape flattens out these sediments are deposited on what are called outwash plains. Braided streams are formed as the water finds its way around the sediments it has deposited. This is the outwash plain of the Alexandra River, just south of the Columbia Icefield. The Icefields Parkway skirts this outwash plain at a place called Graveyard Flats.

Above left: Glacial erratics are large boulders carried by advancing glacial ice that are deposited on the landscape as the glacier recedes. Erratics are known to have travelled hundreds of kilometres from where they were originally entrained by glacial ice. The one on the right originated in the Jasper area and came to rest in what is now a farmer's field south of Calgary.

Above right: Hoodoos are towers of relatively soft glacial debris called till capped by a boulder or glacial erratic composed of harder rock buried in the till. They are usually relatively impermanent, surviving only as long as the cap rock can protect the tower beneath it from erosion.

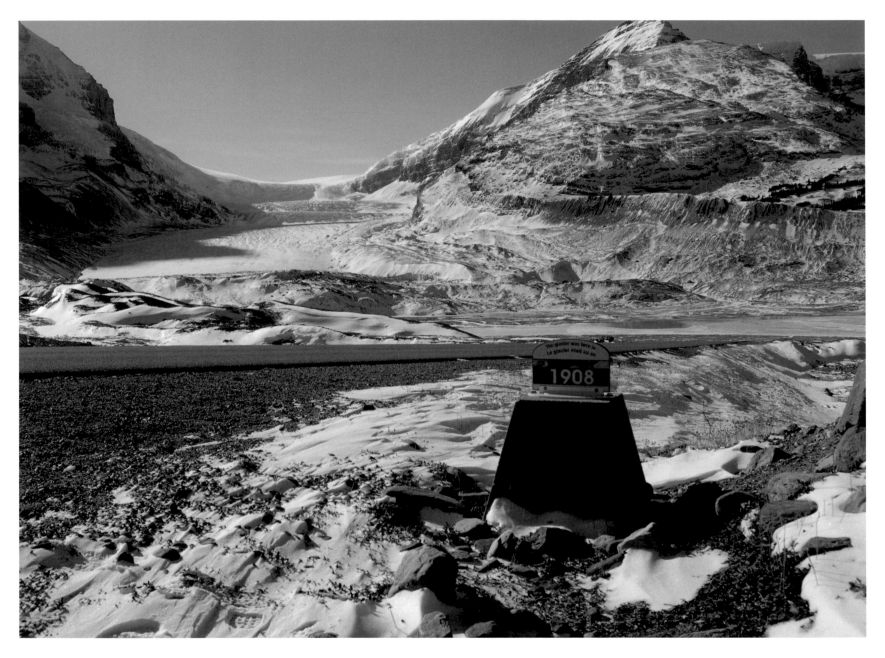

We live in a glass house warmed by an infinitesimal part of the energy

sent out by a furnace 92,000,000 miles away. All life of plant or animal depends on

the temperature of the surface of the earth and its envelopes. If we received a few degrees

less heat from the sun much of the world would be uninhabitable, and the same is true if our

atmosphere became a less efficient blanket against loss of heat by radiation into space.

On the other hand an important increase in the sun's radiation or of the power of the

atmosphere to retain it might blast all life by the rise in temperature. Comparatively

slight changes in the supply of heat would disarrange our whole economy if they

did not destroy life. It is evident that the question of the permanence or

variability of climate is a vital one.

—ARTHUR PHILEMON COLEMAN, *ICE AGES RECENT AND ANCIENT* (1926)

EIGHT: Glaciers in a Changing Climate

The five crucial functions of snow and ice

As already noted, what we are talking about when we talk about water in its frozen state is what scientists call the cryosphere: those portions of the Earth's surface where water exists the form of snow cover, glaciers, ice sheets and shelves, freshwater ice, sea ice, icebergs, permafrost and ground ice.

The cryosphere influences the global climate system in five significant ways. The first influence has to do with the extraordinary extent to which snow and ice reflect sun-light that falls on it back into the atmosphere. This high degree of reflectivity, called albedo, operates as a climate feedback mechanism.

The expansion of surface snow and ice cover increases the albedo of the Earth's surface, which lowers the temperature and thus enables ice and snow to spread even farther. On average, 23 per cent of the globe at any given time is covered by snow. The effect of snow cover is most pronounced where the land mass is as large as it is in Canada. Mean monthly air temperature can be moderated by as

Signposts on the road to the terminus of Athabasca Glacier illustrate the rapid rate of recession of this and other glaciers flowing from the Columbia Icefield during the past century.

much 5°c just because of the presence of snow. Over the past decade in particular, however, this effect has been working in the opposite direction. Snow and ice cover is shrinking, reducing reflectivity and increasing the absorption of solar radiation, which in turn increases temperatures and further reduces snow and ice cover.

The second major influence of the cryosphere is the thermal insulation of the land surface by snow cover and by lake and river ice. This blanketing effect greatly modifies the temperature regime on the underlying land or water. One of the qualities that makes snow such a central ecological influence is its capacity to shield living soil from the full effects of deep winter freezing. The temperature of the upper surface of a 10-centimetre-deep (4-inch) snowdrift may drop by more than 10°c overnight, but the underlying ground may cool by only 1°. The thermal conductivity of snow varies with its liquid water content, which is in turn affected by depth. In many circumstances the thermal conductivity of soil can be six times higher than that of the snow above it. This means that a layer of snow can insulate over six times more effectively than the equivalent depth of soil. By keeping the near surface of the Earth from cooling to the same temperature as the atmosphere, snow cover keeps the roots of trees and other plants warm enough to prevent the depth of freezing that would create fatal ice crystal formation in their cells. It is not just ecosystems that benefit from this effect. We humans do too. In many parts of Canada the presence of deep snow is what keeps the soil warm enough to grow grain crops like winter wheat.

A third way in which the cryosphere influences the global hydrological cycle is through the storage of water in snow, glaciers, ice caps and ice sheets, together with associated delays in freshwater runoff. The time scales related to such releases range from weeks to months in the case of snow cover, from decades to centuries for glaciers; and from tens of thousands to hundreds of thousands of years for ice sheets and permafrost.

Snow is a reservoir that stores water in precisely the way a dam does, for gradual release downstream over the course of the spring and, in many mountain ranges, long into the summer. There is not enough money in the world to build all the dams that would be required to store all the water that the winter snowpack does for later release into streams and rivers. Cold provides this invaluable service for free.

Snow is also a medium of water transport. As researchers such as the University of Saskatchewan's Dr. John Pomeroy have demonstrated, snow is widely relocated by wind and intercepted by vegetation. When that snow melts it provides crucially important water to the ecosystems where it has collected.

A fourth function of the cryosphere is paradoxical to the point of being other-worldly: snow acts as a heat savings bank – a kind of thermal battery – which stores energy and releases it slowly over time.

The reason why this occurs is that snow is stubborn and it takes a lot of heat to melt it. The amount of energy required to melt 1 kilogram of snow that is already at 0°c is equivalent to the energy it takes to raise the temperature of 1 kilogram of liquid water by 79°c. This is why snow is such an effective climatic refrigerant. It also takes a lot of heat to vaporize, or sublimate, snow. To turn 1 kilo of snow directly into vapour takes roughly the amount of energy needed to raise the temperature of 10 kilos of liquid water

by 67°c. You can see from this that having snow around keeps a lot of heat out of the atmosphere.

In the absence of snow the total amount of energy stored in the climate system at any given time will increase. Because snow normally blankets more than half of the land in the northern hemisphere each year, and possesses such important properties, seasonal snow cover is recognized as a defining ecological factor throughout the circumpolar world. The ongoing loss of snow's refrigerating feedback will cause land surfaces to warm and atmospheric temperatures to rise, with direct consequences for almost every ecosystem in this country.

The fifth major role the cryosphere plays in moderating the Earth's climate system is through modulation of carbon exchange with the atmosphere. Seasonally frozen ground and permafrost slow the release of stored carbon dioxide and methane into the atmosphere. Permafrost is particularly important in this process. Deep permafrost can take 100,000 years to form. Once formed, it can store or cap enormous volumes of carbon, preventing its escape into the atmosphere. Once permafrost thaws, however, the carbon dioxide and methane stored within and beneath it is quickly mobilized.

Snowcover, glacier loss and water supply

Almost all of Earth's snow and ice-covered land is located in the northern hemisphere. Snow cover in the northern hemisphere ranges from about 46 million square kilometres in January to about 3.8 million in August. Almost all of the 9.9 million square kilometre extent of Canada can be covered by snow in January.

Garry Clarke on Parker Ridge above Saskatchewan Glacier. Dr. Clarke is considered by many to be the dean of 21st century Canadian glaciologists. His careful analyses and outstanding visual interpretations of research findings have changed the way we think about the future of glaciers, not just in North America but around the world.

Photograph courtesy of the Western Canadian Cryospheric Network

But in terms of water and climate, snow is one thing, glacial ice quite another. The importance of glacial ice to who we are as Canadians is difficult to exaggerate. The glaciers of past ice ages have completely shaped Canada as we know it. The recession of glaciers created this country's unparalleled system of streams and rivers. It was the scouring action of glacier ice that created most of our two million lakes. The melting of glacier ice created the greatest freshwater feature on the entire planet – the Great Lakes. The rebounding of the continent from the great weight of the continental ice sheets continues to fashion our geography and the patterns of Canadian settlement. And perhaps most importantly, the remnants of the last ice age continue to shape our climate and our weather; they define our watersheds and contribute significantly to the flow of some of our most important rivers. Fossil water frozen in time in our remaining glaciers is water held for future generations of Canadians.

In most places where glaciers have been studied,

however, efforts have not been continuous, resulting in lengthy gaps in the data collected. Globally there are only 39 glaciers that have been studied for more than 30 years, and only 30 "reference" glaciers exist that have been subject to continuous measurement since 1976. Research conducted on these 30 reference glaciers indicates a cumulative global loss in glacial mass of 20 per cent in the 60 years between 1945 and 2005, which suggests that a great deal of the world's ice has already become water. Due to funding cuts to science, research in the high glaciated regions of the Rockies has been quite limited compared to what is being conducted in other mountainous places in the world. But what scientists are managing to observe in the Columbia Icefield region and throughout the mountains of the Canadian West appears to be consistent with global trends.

The first estimates of glacier change in terms of area and volume for the North and South Saskatchewan river basins and the Eastern Slopes of the Canadian Rockies were released in a report produced by Mike Demuth of the Geological Survey of Canada and Al Pietroniro of Environment Canada's National Water Research Institute in 2004. This work was advanced further in 2006, and additional research was done by David Sauchyn and others in 2008 to predict potential glacial recession. In 2009, Laura Comeau of University of Saskatchewan confirmed the degree of loss of glacial ice in the upper regions of the Saskatchewan system, which has its origins in the Columbia Icefield.

Between 1975 and 1998, glacier cover as measured by area decreased by approximately 22 per cent in the North Saskatchewan basin and by 36 per cent in the South Sas-

katchewan. Some three million people live in these two river basins. The ice volume wastage estimated for the North Saskatchewan, expressed as an annual average, is equivalent to the amount of water used by approximately 1.5 million people. When there is little or no ice left to become water, the growing needs of water-reliant populations, industries and agricultural sectors will exert ever-increasing pressure on water availability.

It has been calculated that the 1,300 glaciers on the eastern slopes of the Rockies alone supply approximately 7776 billion litres, or nearly 7.8 cubic kilometres, of water to rivers flowing through Alberta and beyond. Research on Canada's glaciers provides a clearer picture of what we can expect in terms of changing water supply as mean global temperatures continue to rise. All studies indicate that dangerously warm years like 2003 are likely to become more common. We know what extreme temperatures did to the Alps, which in places lost 10 per cent of their glacial mass in only one summer. We are only now beginning to understand the impacts here at home. In 2003 extreme minimum-temperature increases as reported from recording stations in the Rockies were in the range of 7° to 8°C above average. The fear, of course, is that extreme temperature events of this magnitude could push our climate system out of equilibrium. The problem, as climate scientists have already indicated, is that we are not ready for these kinds of changes, which appear to be accelerating.

Glaciers as climate research stations

Brian Menounos was the coordinator and a lead investigator of the Western Canadian Cryospheric Network,

or WC²N, a research project that involved scientists at six Canadian and two American universities between 2006 and 2010. Their objective was to clarify the fate of glaciers in Western Canada.

In the courses he teaches at the University of Northern British Columbia in Prince George, Dr. Menounos points out that glaciers are natural climate research stations. With funding from the Canadian Foundation for Climate and Atmospheric Sciences, the work done by Menounos and his WC²N team indicated the vulnerability of downstream ecosystems to changes in the balance between winter snow accumulation and summer melt of western Canada's remaining glaciers. This research underscored the fact that rising hydroelectricity demand in Western Canada may be on a collision course with decreasing stream discharge in some western rivers.

As a foundation for this work, researchers in the WC²N collaboration – ten undergraduate assistants, 18 master's students, nine PhD students and seven post-doctoral fellows – documented climate variability and changes in glacier extent in the North Pacific over the last 400 years. They also detailed meteorological processes and their links to the nourishment of glaciers as determined by mass balance, which is defined as the net annual gain or loss in the mass of a glacier when snowfall and refrozen rain are balanced against the wasting effects of melting and sublimation. The researchers then combined the information about historical loss of glacier extent with contemporary patterns of nourishment of glaciers, in order to project how glaciers may respond to projected climate conditions over the next 50 to 150 years.

Through patient analysis and careful consideration of all the analytical tools available to them, Dr. Menounos, Roger Wheate and their colleagues have been able to understand how climate affects glacial ice in the mountain West. In the face of limited support for hydrological and climate research, this team has been able figure out the best way to conduct scientific research on glaciers without having to rely on costly direct monitoring of what is actually happening to our country's ice. The principal tool they used to do this is a simple one. They compared what exists today as evidenced by satellite and aerial photographs to what earlier maps depicted in terms of glacial extent. Through these comparisons they were able to roughly determine how much the area covered by glaciers in the mountain West has changed over time.

Menounos and Wheate, along with their colleagues Matt Beedle and Tobias Bolch, compared glacier extents in the western cordilleran region between 1985 and 2005 as revealed by Landsat analysis. They divided the cordillera into nine regions: the St. Elias Mountains, the Northern, Central and Southern Coast ranges, the Northern and Southern Interior, and the Northern, Central and Southern Rockies. As one would expect given the vast differences in precipitation and latitude of the mountains in each of these nine regions, the rate of change in each differed dramatically.

With these analyses as a foundation, researchers then compared the number and area of the glaciers that existed in 2005 with similar satellite data and photographs taken from aircraft from 20 years before and with information derived from topographical maps created in the 1920s. Out of this research came some astounding discoveries.

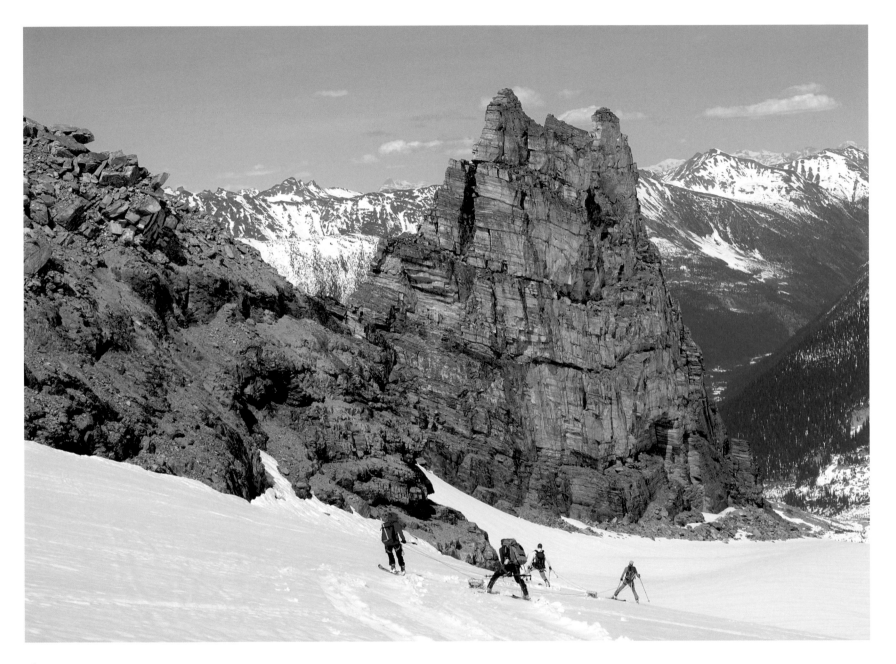

MEASURING GLACIERS USING RADAR

Glacier melt significantly contributes to the transboundary Columbia River, but little is known about the nearly 2,500 glaciers sourced in its headwaters. Dr. Brian Menounos and his team at the University of Northern British Columbia monitor rates of mass change for five glaciers in the Columbia Basin. Their data will update estimates of glacier runoff, which is substantial during the hottest, driest months, when water demand is highest and salmon runs occur. Pictured here, a team of researchers haul ground-penetrating radar (GPR) across Nordic Glacier in the Selkirks near Golden, BC. GPR measures ice thickness, a metric which is used to calculate glacier volume and determine how much ice exists in the basin. Calculating the current glacier volume and rate of mass change here will improve forecasts of regional glacier loss for the 21st century, enabling communities to better adapt to changing water resources in the Columbia Basin.

Monitoring ablation loss in the Columbia River Basin. Ski-travel photographs courtesy of Jill Pelto; photo of researcher Ben Pelto courtesy of Micah May, UNBC

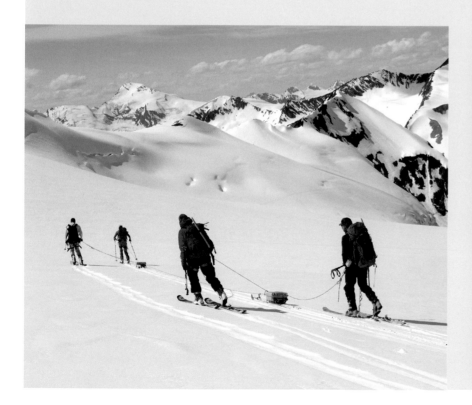

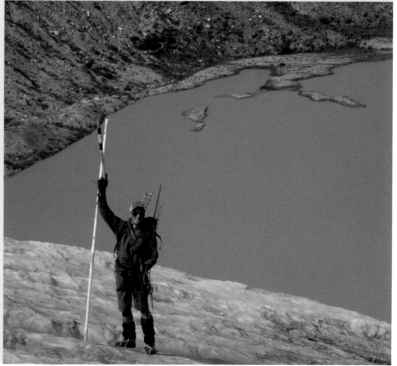

163

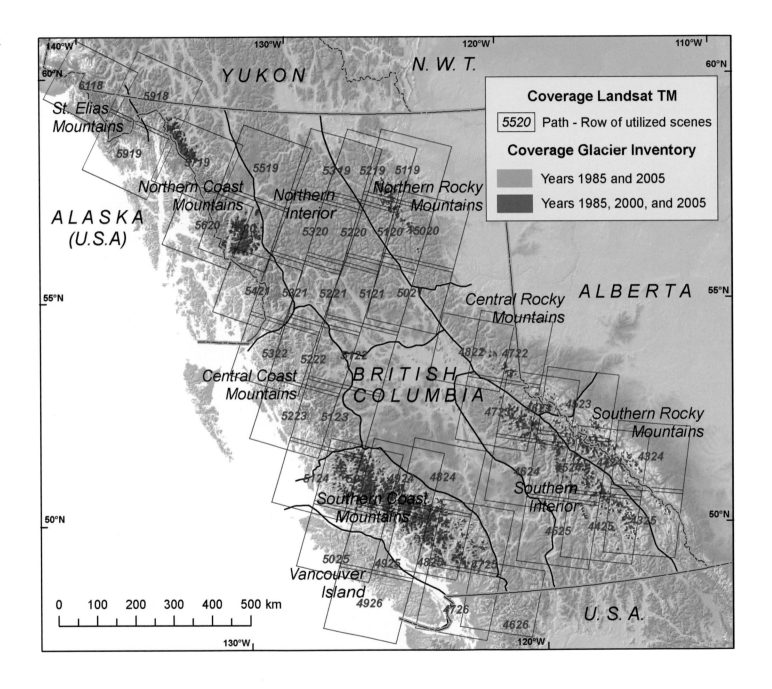

According to the WC²N glaciologists, Jasper National Park had 554 glaciers in 1985. Twenty years later, 135 of those had disappeared and the area of the park covered by glacial ice had diminished by 13 per cent. Also in 1985, the year Banff National Park celebrated its centennial, the park contained 365 glaciers covering a total of 625 square kilometres. Twenty years later 29 of those had disappeared and the area of the park covered by ice had shrunk by 19 per cent to just over 500 square kilometres.

The aggregate loss is almost staggering. In 1985 there were 1,155 glaciers in the Western mountain national parks. In 2005 there were only 1,006. In other words, 149 glaciers disappeared from our western mountain national parks in only 20 years. Up until now the world's attention has been focused on the rapid loss of ice in Glacier National Park in the United States, where 113 of the 150 glaciers that existed in 1860 have vanished. We now know that in Canada's mountain national parks alone, we have lost as many glaciers in only 20 years as existed a century ago in Glacier National Park. And the loss is even greater if you extend it over a longer period of time.

Through the efforts of research networks such as IP3 at the University of Saskatchewan and WC²N, we now know that we may have lost as many 300 glaciers in the Canadian Rockies between 1920 and 2005. Some 150 glaciers appear to have melted away in the 65 years between 1920 and 1985. Another 150 vanished into thin air in the 20 years between 1985 and 2005. Our losses appear to be accelerating.

In the western mountain national parks alone, the total area covered by glaciers diminished from 1870 square kilometres in 1985 to 1560 square kilometres in 2005. This means that the character of 310 square kilometres of

mountain landscape completely changed in only 20 years. What we see from this is that Alberta may have lost 25.4 per cent, a full quarter, of its glacier ice area in the 20 years between 1985 and 2005. The glaciers in BC are doing a little better but still losing ground. While big glaciers in coastal regions in the northwest of the province tend to skew the average, it appears that BC has lost only about 10 per cent of the area that was covered by glacier ice in 1985. The actual extent of newly de-glaciated landscape is quite large. It is important to note once again that glacial ice is not just water in storage for later. It is also a refrigerant that moderates climate and slows climate change effects. We are losing that refrigerant.

Glacier ice: Water in the bank

The realization that some 300 glaciers disappeared along the Great Divide of the Canadian Rockies between 1920 and 1985 did not come as a surprise to researchers. It is not their job to be surprised. Their immediate concern related to ensuring that the analyses were properly conducted and that the findings would stand up to further scrutiny. In the long-standing tradition of the scientific method, it was important that these findings became a sound foundation for further research. Dr. Shawn Marshall's work on the state and future of Alberta's glaciers demonstrates how science builds upon itself to address serious questions such as those related to the effect climate may have on future water supply in the Canadian West.

In many ways, the work of Dr. Marshall and his colleagues at the University of Calgary is a culmination of what had been collectively gained by linked research net-

Top: Dr. Joseph Shea launching a drone to collect glacier data in the Himalaya. Photo courtesy of Koji Fujita

Below: Debris-covered glacial ice in the Himalayas as revealed through data collected by a research drone. Orthomosaic courtesy of the Annals of Glaciology

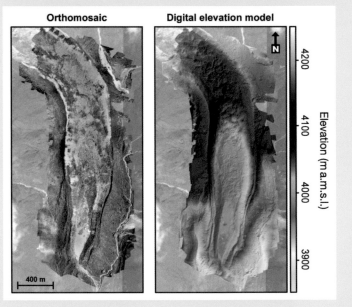

DRONE AIRCRAFT: A NEW WAY TO INVESTIGATE GLACIERS

Even in the highest mountains on the planet, glaciers are in decline. Hydrologist Joseph Shea saw the evidence first-hand during his four years in Kathmandu, Nepal, with the International Center for Integrated Mountain Development (ICIMOD). With colleagues from that organization and from Utrecht University, Shea conducted extensive high-altitude fieldwork, helped pioneer the use of unmanned air vehicles (UAVs), also known as drones, for monitoring changes in debris-covered glaciers, and collaborated on key glacier modelling and monitoring studies.

Large Himalayan glaciers are often covered with a layer of debris composed of rock, sand and silt. Since this material insulates the ice from melting, traditional glaciological measurements may not provide adequate data to give a clear picture of how glacial dynamics function. UAV surveys initiated in Nepal's Langtang Valley in 2013 and Khumbu Valley in 2015 have provided unprecedented detail on how the surfaces of these glaciers change and about the role of ice cliffs and ponds in promoting glacier melt. Dr. Shea has also led studies on simulated retreat of glaciers in the Everest region and on high-altitude meteorology.

Now based at the Centre for Hydrology at the University of Saskatchewan, Dr. Shea will be contributing to the Global Water Futures program in the very mountains where he first started his career. His work in western Canada will focus on mountain glaciers and snowpacks, the role of glaciers in local and regional hydrology, and the application of UAVs in a range of hydrological, ecological and glaciological studies.

works. Marshall's work builds on data already presented by Brian Menounos, Roger Wheate, Matt Beedle and Tobias Bolch, who compared glacial extent measurements in the western cordilleran region between 1985 and 2005 as revealed by Landsat analysis. Their work, in tandem with research by Mike Demuth of the Geological Survey of Canada and by Garry Clarke and Joe Shea at the University of British Columbia, indicated that the total area of glacier cover in the nine regions of the cordillera, including the wilderness areas outside the mountain national parks diminished by a total of 3057 square kilometres between 1985 and 2005.

RECALCULATING THE EXTENT OF THE COLUMBIA ICEFIELD

As part of joint research conducted by the Western Canadian Cryospheric Network, Dr. Shawn Marshall worked with Dr. Brian Menounos of the University of Northern British Columbia to accurately recalculate the current area of the Columbia Icefield. We don't yet know its volume, but that number too may soon be forthcoming.

Supervised by Dr. Menounos, Christina Tennant recalculated the area of the Columbia Icefield. Most of the contemporary literature had put the figure at around 325 square kilometres; Tennant estimated it to be about 223 as of 2005. Depending on exactly what ice masses are technically deemed to be included as part of the total, and the extent of detached ice not included in the estimates, the Columbia Icefield may be seen to have lost as much as a third of the area that had been ascribed to it in the 1990s. As this illustration shows, parts of the icefield have also diminished considerably in depth. Further research is presently being undertaken at the icefield to more accurately determine its area and volume.

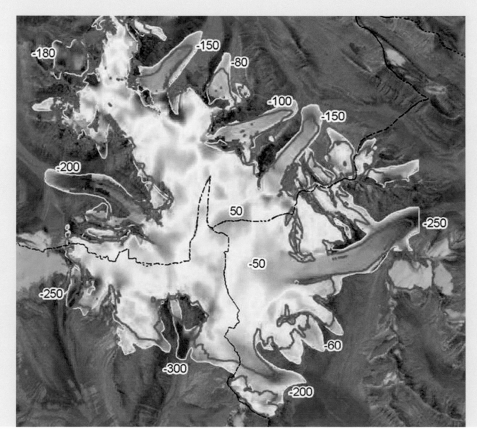

The Columbia Icefield 1920–2000, showing elevation changes in metres. Courtesy of Christina Tennant, WC²N

Yellow = 1920
Red = 2000
Black = water divide

Dr. Shawn Marshall of the University of Calgary established ongoing research on Haig Glacier in the Kananaskis Range of the Rockies in 2000. The project has accumulated the longest-running series of glacier weather station observations in North America. Haig Glacier has thinned by about 13 metres since 2000, and it has yet to experience a positive mass-balance year this century. Snow and ice chemistry and albedo data indicate that over the course of time the glacier has been observed, its surfaced has darkened, a significant positive feedback that accelerates melting. This is mostly associated with the accumulation of windblown dust and aerosols, which is particularly acute during large fire seasons in western Canada such as occurred in 2003 and 2015. The Haig completely lost its snowpack those two summers and crevasses opened up on the upper glacier that have yet to heal. Ice radar measurements indicate that the glacier is in an over-deepened valley and is just over 200 metres deep at its thickest point. A small consolation, then: despite the accelerated loss of mass, the glacier is expected to survive the century.

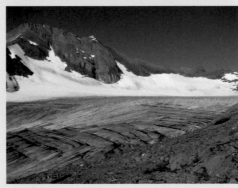

Top: Dr. Shawn Marshall.
Photograph courtesy of Dr. Marshall

Below: On the upper reaches of the Haig Glacier in late summer, all of the previous winter's snow has melted and the glacier is being wasted away by melt.
Photograph courtesy of Dr. Marshall

While glaciologists have yet to come out and say it, these findings are a major blow to the established myth of limitless abundance of water in Canada. We may have 20 per cent of the world's freshwater resources, but much of that is water left "on deposit in the bank" after the last ice age. That ice, as WC²N has clearly demonstrated, is disappearing quickly. Global warming is causing a cryospheric meltdown not dissimilar to an economic collapse. The amount of water that is left in our account in the glacier bank is much less than we expected. Unaccounted-for greenhouse gases are eroding the principal, interest rates are dropping and the balance is getting smaller all the time. The disappearance of the major glacial masses in the Canadian Rockies will mean there will be less water in our rivers in late summer throughout the West. What we do not know is how much ice is now buried under collapsed moraines or entrained under debris. This research does suggest, however, that these glaciers are on the way out and that the pulse of melt we expected as a result of rapid warming has already come and gone.

These projections offer important insight into what is happening to water we used to have in cold storage in the North and in the mountain West. As renowned hydrologist John Pomeroy has said, what is happening to our glaciers is of great importance to the future climate of the mountain West. While glaciers may no longer be as significant in terms of total water supply as they were when they were larger, what is currently happening to them may be a warning of other significant threats. We already know that long before global warming has finished reducing the length and depth of our glaciers it will already be after our mountain snowpacks and that could have a huge influence on our water supply.

It appears that climate warming will influence not just the volume of major rivers in Canada but perhaps even the direction of their flow. Evidence to that effect presented itself in the late summer of 2016 when researchers from the University of Washington in Tacoma observed that the massive Kaskawulsh Glacier in the Yukon had retreated so much that its meltwater outflows literally changed direction so dramatically that they are no longer part of the same watershed. In the first documented case of what is known as stream capture, the meltwater of the Kaskawulsh, which historically had flowed into the Slims River and on northward into the Bering Sea, suddenly changed course and now flows south toward the Kaskawulsh River, the Gulf of Alaska and the Pacific Ocean. In the geological record, changes in course of this magnitude are usually attributed to spectacular large-scale tectonic events such as major landslides or the bursting of glacial dams. In this case, however, these outflows changed course as a result of rapid glacial recession clearly attributable to climate warming.

Reduced or changed flows in western rivers will impact electricity generation and agricultural, industrial and municipal water security throughout the region. These flow reductions will also affect interprovincial water-sharing arrangements and transboundary agreements with the United States such as the Columbia River Treaty.

How much ice is left?

The next step in research aimed at assessing the future of Alberta's glaciers involved estimating the volume of the ice that still remains on the eastern side of the Rockies.

This is not an easy thing to do. Shawn Marshall and his University of Calgary colleague Eric White overcame the problem by employing a suite of algorithms, and the result was in a range between 30 and 115 cubic kilometres. For the purposes of their first-order assessment, they estimated an average of 42 cubic kilometres. This became the foundation for rough calculations of how long the remaining ice would last in each of Alberta's mountain river basins, based on climate warming trends witnessed over the past 40 years.

The foundation for these estimates was the mass-balance history of Peyto Glacier, which is the only glacier in the Rockies for which there is a data record of changes in volume in response to the rising temperatures of the past four decades. Mass balance, again, is defined as the difference between how much snow falls in the accumulation zone and the amount of ice that melts during the warm months in any given year.

While Peyto Glacier currently covers about 12 square kilometres, it has lost 70 per cent of its volume in the last 100 years. Winter snow depth and duration of cover have been declining since the 1970s.

Using a variety of modelling scenarios as a means of anticipating the future, Marshall and White projected the mass balance of Peyto Glacier forward to the end of the 21st century. The results revealed a dramatic decline in volume and runoff from the glacier over time.

After projecting the future of Peyto Glacier forward a century, Marshall then extrapolated the results onto surrounding glacier-fed river basins so as to predict changes in the volume of glaciers feeding the Bow, Red Deer, North Saskatchewan, Athabasca and Peace rivers. The results

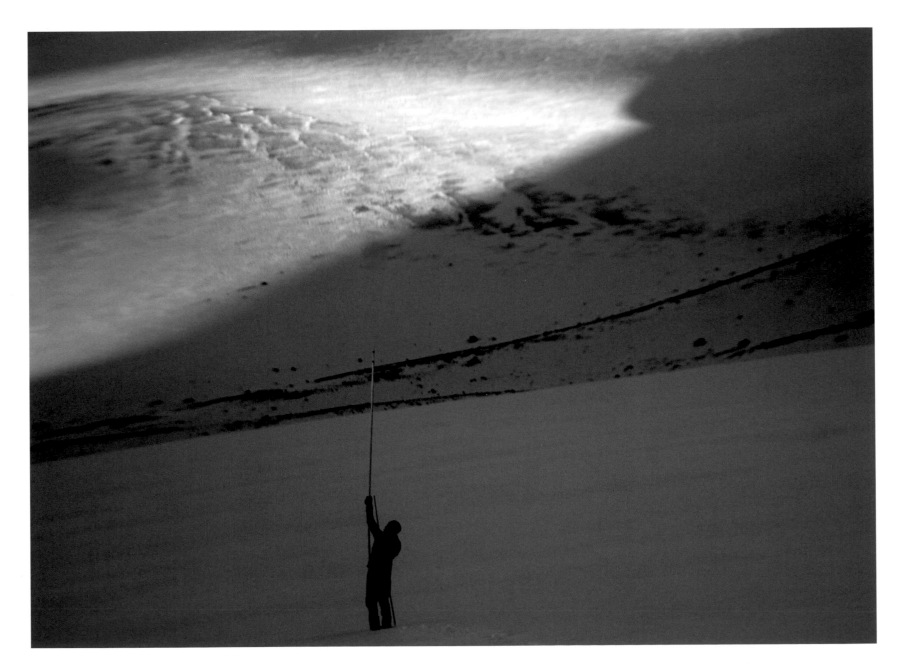

suggest dramatic loss of glacial ice at the headwaters of each of these systems.

Dr. Marshall went on to translate this loss of glacial mass into impacts on streamflow over the coming century. These calculations indicated a substantial negative effect on streamflows over time. Dr. Marshall noted that current glacial contribution to Alberta's mountain rivers was in the order of 1.2 cubic kilometres a year. He estimated that as the current century progresses this volume will diminish to as little as 0.66 cubic kilometres a year, or about half. This does not mean, however, that glaciers will lose their importance to the hydrology of the West. In parts of Alberta, existing water resources are fully allocated, if not over-allocated. Further reductions in flows as a result of loss of our mountain glaciers will be noticed by those whose reliable supply of water is suddenly no longer available.

But given current trends, even the 0.66 cubic kilometres contributed by much-diminished glaciers could ultimately be reduced to zero over time. Marshall reasoned that if in fact the volume of existing glaciers was around 45 cubic kilometres as estimated by his primitive methods – and if current temperature trends persisted – then Bow Glacier would completely disappear in 53 years, or somewhere around 2060. Similarly, the ice at the headwaters of the North Saskatchewan would disappear in 72 years, or around 2070, and the glacial sources of the Athabasca would be gone in 83 years, *circa* 2080. Only the glaciers at the headwaters of the Peace and the Red Deer would survive into the next century. Because they are located in high, north-facing cirques, the glaciers feeding the Peace might survive 97 years, and those in the high mountains at the headwaters of the Red Deer might last 132 years.

Marshall noted that the greatest uncertainty in these calculations is the accuracy of present-day ice-volume estimates. As mentioned earlier, his research team put the figure at somewhere between 30 and 110 cubic kilometres. Marshall is concerned that his average projection of between 40 and 50 cubic kilometres may be too low. He went on to say, however, that the volume of glacier ice in the Alberta Rockies was indeed 40 to 50 cubic kilometres at present and that his forecast is that only 5 to 10 cubic kilometres will exist by 2100. This would represent a 90 per cent loss of the volume of ice currently present in Alberta's Rockies.

Dr. Marshall made it very clear to his colleagues that these estimates were based only on "first-order" calculations that have not been verified by more accurate measures of the volume of ice that actually exists in Alberta's Rockies. Such more accurate numbers – including far better estimates of how much ice remained concealed under moraines or debris-covered surfaces – would be needed to test the validity of Marshall's projections of the future state of Alberta's glaciers. That work was undertaken by a team led by Mike Demuth of the Geological Survey of Canada.

The Columbia Icefield Research Initiative

As we have seen, the biggest challenge to properly assessing how much water is stored in the glaciers in the western and northern cordillera regions is the problem of accurately determining the volume of existing glacial masses. It is relatively easy to measure area. Volume is far more difficult because it is hard to know the nature of the landforms

A Geological Survey of Canada researcher checks snow depth on the Peyto in order to calculate the glacier's current mass balance, or the difference between how much snow has fallen in the accumulation zone versus how much has been lost due to melting during the warm months. A positive mass balance means the glacier will grow or at least stay the same size. A negative mass balance means the glacier is shrinking.

Projected declines in the flow of five major western Canadian rivers as a consequence of loss of glacial ice by the end of the 21st century.

Image courtesy of Dr. Shawn Marshall, University of Calgary

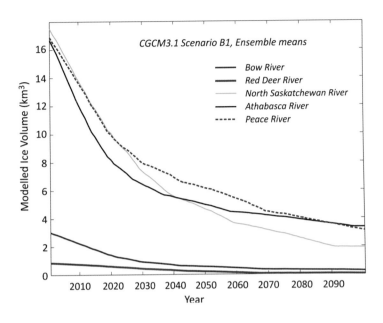

beneath the ice, and that is what determines the volume of ice that can exist in any given place. Because there is no simple and inexpensive way to do this, many of the projections regarding the state of Canada's remaining glaciers are only rough guesses based on the best information available about the general nature of the topography of Canada's mountain regions. This is why the Geological Survey, in association with Parks Canada, funded the necessary research to accurately determine the volume of ice contained within the largest glacial system in the Canadian Rockies – the Columbia Icefield.

The Columbia Icefield Research Initiative was established in 2010 as a multi-lateral program of observational and research science to measure the icefield's mass balance. One of its accomplishments has been to develop a monitoring site at the Columbia Icefield that will even-

tually replace the historically important site on the now rapidly disappearing Peyto Glacier. For the time being at least, the Peyto still flows down from the Wapta Icefield, but sooner or later its monitoring site will be left with little of importance to measure. Until then, the findings from these two sites together will assist in representing regional glacier changes as part of the Geological Survey's reference glacier and climate observing system and its contribution to the World Glacier Monitoring Service.

The initiative continues to this day with four active government and university research collaborations studying a variety of phenomena such as snow and ice accumulation and ablation at multiple scales, as well as developing techniques and placing instrumentation with which to measure, understand and predict the icefield's mass balance and volume changes – ultimately to better assess the water and ecological services it provides.

If this project is permitted to continue, the volume of the Columbia Icefield system will no longer be merely approximated, as it has been in the past, by estimating volume as a function of area. Instead the volume of ice will be calculated directly and exactly through the use of ground-penetrating radar surveys conducted on the surface of the icefield and through a remote sensing technology called LiDAR. LiDAR is short for "light detection and radar." Its operating principles are similar to those of its predecessor technology, RaDAR, which is short for radio detection and ranging (and which, through more than a half-century of use, has become a word familiar enough to be spelled lower-case). With LiDAR, however, the radio microwaves typical of radar are replaced by near-infrared pulses emitted by a laser. This laser energy interacts with

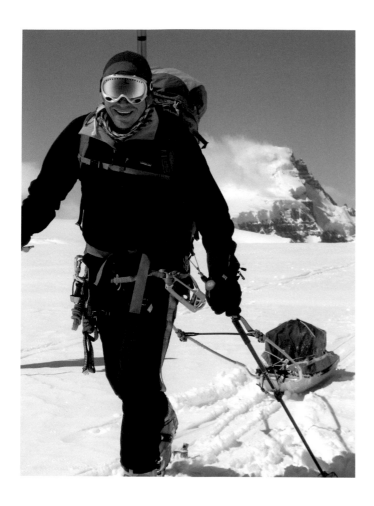

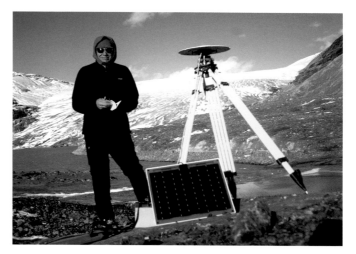

surface features, and upon scattering, returns to a detector. The range to the surface is a simple "time of flight" measurement, with the position of the survey aircraft accurately known using the Global Positioning System.

The aircraft carrying the LiDAR system flies over the study area, capturing information in swaths. Careful analysis of the data yields an illuminated relief map detailing all the features of the landscape and their exact distances from one another. The combination of LiDAR and ground-penetrating radar is expected to yield the first truly accurate measurement of the form and thickness of the Columbia Icefield and how much ice it contains, from which the water equivalent of that ice can be derived. Using these calculations it will then be possible to predict with a fair degree of accuracy how long individual glaciers and even the Columbia Icefield itself may last under a number of projected climate change scenarios.

Given the central position of the Columbia Icefield at the headwaters of three of the country's most important river systems, the Columbia Icefield Research Initiative could generate research outcomes that will be of great value in determining how much water will be available to those who live in the West in the future. The initiative has the potential be the most important scientific research project undertaken in a Canadian national park since the park

The camp of the Columbia Icefield Research Initiative is on a plateau at about 3200 m elevation, just below the summit of Snow Dome. The team's first significant discovery was clear evidence of substantial midwinter melt, probably from high temperatures experienced everywhere in the mountain West in 2010, the year the survey began. Winter melt at high altitude in the Rockies had been predicted by many climate models, and this confirmation of it is troubling because it suggests that ice masses and glaciers will be under attack not just from below by warming in the valleys, but also from above due to warmer winter air temperatures. This does not mean, however, that conditions on the Columbia Icefield are always pleasant. While the region around the Columbia may be warming, the high reaches of the icefield itself can still be a very cold and treacherous place. Researchers have been pinned down for days here by the very snowfall they were studying, and they are often unsure when the weather will clear enough to airlift their camp to the valley floor.

Image courtesy of Mike Demuth, Glaciology Section of the Geological Survey of Canada

system was created in 1885. A great deal of ice in the West is becoming water. By refining our understanding of the glacier ice at the hydrologic apex of western Canada, this research could very well define the state and fate of the entire West. Out of this research we might learn the hydrological limits of the dry West. We may be able to better understand what the western landscape can support, for it is water, not just natural resources, that ultimately constrains sustainability on the Great Plains. There is some urgency in doing so.

The latest science on deglaciation

In 2015 Dr. Garry Clarke and his colleagues Alexander Jarosch, Faron Anslow, Valentina Radić and Brian Menounos published a research paper in *Science*, one of the most prestigious scientific journals in the world, that employed much improved and far more accurate models to build on earlier estimations of projected deglaciation of western Canada in the 21st century. The results demonstrate that we can, on average, expect to lose about 70 per cent of the glacial ice that existed in Canada's western mountains in 2005 by 2100. The effects will be greatest in the Interior Ranges of British Columbia and in the Rocky Mountains. Less affected will be the coastal tidewater glaciers in northern British Columbia and Alaska. Coastal glaciers will likely diminish by 65 to 85 per cent, while glaciers in the Interior Ranges and the Rocky Mountains will suffer volume and area losses of up to 90 per cent or more in some cases. The main effects of deglaciation will be associated with changes in the hydrological cycle and consequent impacts on water availability, which will

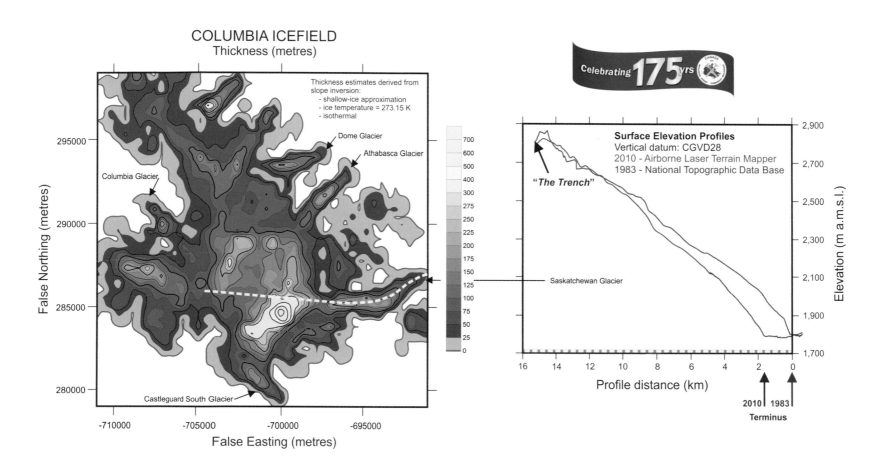

COLUMBIA ICEFIELD
Thickness (metres)

Thickness estimates derived from slope inversion:
- shallow-ice approximation
- ice temperature = 273.15 K
- isothermal

Dome Glacier

Athabasca Glacier

Columbia Glacier

False Northing (metres)

295000

290000

285000

280000

Castleguard South Glacier

-710000 -705000 -700000 -695000

False Easting (metres)

700
600
500
400
300
275
250
225
200
175
150
125
100
75
50
25
0

Celebrating **175** yrs

Surface Elevation Profiles
Vertical datum: CGVD28
2010 - Airborne Laser Terrain Mapper
1983 - National Topographic Data Base

"The Trench"

Saskatchewan Glacier

Elevation (m a.m.s.l.)

2,900
2,700
2,500
2,300
2,100
1,900
1,700

16 14 12 10 8 6 4 2 0

Profile distance (km)

2010 | 1983
Terminus

Left: Map of the estimated thickness distribution of the Columbia Icefield. For clarity, geo-radar thickness measurements are not shown.

Right: Surface elevation profiles of the Saskatchewan Glacier derived from topographic mapping data (1983) and Airborne Laser Terrain Mapping (2010) illustrating 27 years of cumulative terminus retreat and surface elevation change.

Courtesy Mike Demuth, Geological Survey of Canada (GSC) and University of Saskatchewan – Centre for Hydrology; Garry Clarke, University of British Columbia; Chris Hopkinson, Canadian Consortium for LiDAR Environmental Applications Research – as part of the GSC-Parks Canada initiative *Columbia Icefield – Water for Life*

175

impact hydroelectric power generation, recreation and tourism. If current trends persist, we can expect the Canadian West to be a different place by the end of the century.

Uncertainty resides in the fact that while we can project temperature increases fairly accurately, our knowledge is limited with respect to how warming will ultimately impact precipitation patterns over the long term. The risk here is real. Water security for the entire West may be altered by changes in the timing and nature of precipitation. Our models are having trouble keeping up with this. By mid-century the Canadian West could be as changed by this as it was by European settlement.

We have known for more than a century that for every degree Celsius of warming we can expect the atmosphere to carry 7 per cent more water vapour. If you increase the temperature of the atmosphere by 2°c, the atmosphere can carry as much as 14 per cent more water vapour. If you raise the temperature of the atmosphere by 4°c, it will carry 28 per cent more water vapour. This changes everything. The Clausius–Clapeyron relation is proving to be a critical driver in climate disruption in that the warmer the air is, the more water vapour it can carry. Storms are now occurring that feature higher relative humidity than ever experienced before. This in combination with rising sea surface temperatures allows for extreme cloud bursts and storms with greater power that last longer and carry more punch. It is important to note, however, that the amount of water vapour the atmosphere can carry increases in a non-linear manner, because with each degree rise in temperature the percentage increase is always added to a higher number. And that is why recently identified phenomena such as atmospheric rivers demand our full attention.

We are witnessing meteorological phenomena we either haven't seen or weren't able to recognize as such before. These include atmospheric rivers. Atmospheric rivers have likely existed for an eternity, but only now, thanks to satellite remote sensing, do we know of their existence and dynamics. These corridors of intense winds and moist air can be 400–500 kilometres across and thousands of kilometres long. They can carry the equivalent of 10 times the average daily discharge of the St. Lawrence. These huge rivers of water vapour aloft are carrying more water and causing flooding of magnitudes we have not witnessed before.

We have discovered that these atmospheric rivers – like the winds of the jet stream – derive their energy from temperature differences between the poles and the tropics. Their intensity also derives from the Clausius–Clapeyron relation in that the warmer the air is, the more water atmospheric rivers can carry. US president Trump's pre- and post-election rhetoric notwithstanding, there is nothing uncertain about the link between temperature and increased atmospheric transport of water. To claim this is a hoax is to ignore a fundamental law of atmospheric physics. It is tantamount to saying that apples don't fall from trees. The risk here is that until we stabilize the composition of the Earth's atmosphere, sustainability and adaptive resilience will forever remain a moving target.

Mid-latitude effects of glacier loss in the Canadian Arctic

While Antarctica and Greenland possess most of the freshwater in the world in the form of ice, Canada too has

a lot of frozen freshwater. Some 20 per cent of the world's remaining glaciers are found here. As a consequence of rapid melting of this ice, Canada is now the third-largest contributor to sea level rise. A study of glacial loss in the Queen Elizabeth Islands in the Canadian Arctic published in 2017 revealed that ten times more ice is melting annually due to rapidly warming Arctic temperatures. This research, undertaken by climate scientists at the University of California at Irvine, focused on data collected from 1991 to 2015 on the recession of glaciers in the highest reaches of the Canadian Arctic. The data showed that during that 24-year period, surface melt off the glaciers in this region increased by 900 per cent as a consequence of rising air temperatures. As has been clearly witnessed on the Peyto and other glaciers farther south, there are two ways in which glaciers can recede: through surface melt; and through calving, or the thinning and breakdown of the glacier's terminus. The University of California Irvine study observed that some 48 per cent of the glacier mass loss in the Queen Elizabeth Islands in 2005 was due to surface melt and 52 per cent from calving at the terminus. By 2015, however, surface loss accounted for 90 per cent of total glacial mass loss in the region. But perhaps the most astonishing finding of this research was that the glaciers of this region of the high Arctic had gone from shedding three billion tons of water annually to losing 30 billion tons a year, with accelerating effects on sea level rise globally.

What we appear to be seeing in Canada is that the loss of Arctic sea ice and the rapid reduction of the extent and duration of ice and snow cover in the northern hemisphere are reducing the temperature gradient between the pole and the tropics. It is this difference in temperature between the polar region and the warmer air to the south that largely defines the behaviour of the jet stream. The less ice there is in the Arctic, the slower and wavier the jet stream becomes and the more erratically it behaves. We see from the altered behaviour of the jet stream that warmer atmospheric temperatures do not automatically translate into warmer weather. In a uniformly warmer and therefore more turbulent atmosphere, both warm and cold fronts end up and persist in places in the mid-latitudes where they were not common in the past. There is a growing realization of the extent to which Arctic sea ice acts as a thermostat controlling climate right down to the mid-latitudes throughout the northern hemisphere.

On November 3, 2016, Arctic sea ice coverage was more than 600,000 square kilometres less than the previous record low and nearly 2.5 million less than the October average. The main reason for this was that October had been warmer than usual for the entire month. November was warm also. On November 17 the temperatures over the North Pole and much of the Arctic Ocean were 20°C above normal. These same temperature anomalies persisted through parts of the circumpolar Arctic through January and February of 2017.

Water temperatures are also rising. Instead of being 0°C, sea surface temperatures of 17°C have been recorded in the Arctic. Ocean waves, which in the absence of sea ice now have greater fetch, mix the water down to the bottom so that we now have for the first time in tens of thousands of years water that is above freezing affecting the seabed of the Arctic Ocean, where it encounters frozen sediments that are a seaward extension of permafrost on land. Embedded in these frozen sediments is methane in the

177

form of hydrates and clathrates which are now disintegrating as the sediments thaw, producing methane gas that has begun to rise to the surface in great bubble plumes. In deep water these plumes oxidize and disappear before they reach the surface, but at depths of less than 50 to 100 metres the methane does not have time to dissolve. Instead it emerges almost intact to enter the atmosphere, where in the immediate term it appears it may have a greenhouse effect that can be as much 100 to 200 times that of carbon dioxide.

What we are discovering is that if you change the composition of the Earth's atmosphere enough, you can warm the world without increasing emissions. All you have to do is reduce the reflectivity of ice and snow and the planet will warm. Alarmingly, we have found that the overall combination of ice and snow loss in the northern hemisphere may contribute an additional 50 per cent to the direct global heating effect caused by the addition of CO_2 to the atmosphere. The importance of this has yet to be generally realized. We are reaching the point where we should no longer simply say that adding carbon dioxide to the atmosphere by way of our emissions is warming our planet. Instead we have to say that the carbon dioxide *which we have added* to the atmosphere has *already* warmed our planet to the point where the feedback processes related to loss of reflectivity of ice and snow are themselves increasing the effect of those emissions by a further 50 per cent. *This means that carbon dioxide may not be the only driver of climate change.* What this suggests is that, as Peter Wadhams put it, we are not far from the stage when the feedbacks will themselves be driving the change – that is, we will not need to add any more carbon dioxide to the atmosphere at all, but will get warming anyway.

The destabilization of the Arctic climate system

Whether we want to admit it or not, Canada is the canary in the coal mine for climate change. The challenges are greatest in western and northern parts of the country. According to the Canadian Rockies Hydrological Observatory, we have lost two full months of annual snow cover in western Canada over the past 50 years. Winter temperatures in Alberta have risen 5.5°c on average since the 1960s. Then there is the Arctic, where the changes are even more dramatic. Arctic snow cover has been declining at a rate of 22 per cent per decade, sea ice at 12 per cent per decade. But now something else is happening as well: multi-year ice is disappearing and not as much sea ice is re-forming.

The increasingly rapid loss of sea ice in the Arctic is not yet a global political issue – that will come soon. But there is urgent concern among climate scientists, who worry that the accelerating rate of melt and thaw in the Arctic could destabilize global weather patterns. So what is actually going on?

Some very basic climate science is necessary to understand the problem. A positive feedback in the climate system, as opposed to a negative one, is a chain of cause and effect in which two or more circumstances begin to accelerate one another. A positive feedback loop enhances or amplifies changes which tend to move a climate system away from its equilibrium and make it more unstable. It appears that a positive feedback has been created between warming in the Arctic and the behaviour of the northern hemisphere jet stream – the westerly winds that are created as the world spins inside the ragged blanket of

its own atmosphere. To put it simply, the loss of northern snow cover and diminishment of Arctic sea ice is causing the jet stream to slow and become wavier. We see now that a wavier northern hemisphere jet stream brings warmer air to the Arctic more frequently. Temperature anomalies as high as 30°c above normal were recorded during the fall and throughout the winter of 2016 in the Arctic and parts of northern Canada. These warmer temperatures are leading to more sea ice loss, which in turn makes the jet stream even wavier, which brings even more warm air up from the south and into the Arctic. This in turn makes the jet stream even wavier still, which again results in even more warm air being transported into the Arctic, which of course causes further sea ice loss. As this feedback accelerates the Arctic Ocean absorbs more and more heat, affecting the behaviour of deep ocean currents. Increased natural methane releases from the warming land into the air and into inland and coastal waters are also being observed.

Sea ice, we have discovered, is a central element in the natural thermostat that regulates the temperature of the entire hemisphere, and once that thermostat is turned up, weather southward to the mid-latitudes and beyond quickly becomes more variable and erratic.

So why does this matter? The relationship between warming air and how much moisture that air can carry is critical. As mentioned earlier, one of the fundamental laws of atmospheric physics decrees that for every degree Celsius the atmosphere warms, it can carry 7 per cent more water vapour. Water vapour is a powerful greenhouse gas in its own right. Its increased presence in the atmosphere adds to the warming produced by the transport of warmer air northward. But according to climate scientist Jennifer Francis, that is not the only effect increased water vapour has had on the acceleration of Arctic temperatures. The more water vapour there is, the more clouds form. Cloud cover holds the heat in, which increases evaporation from the ocean, further accelerating warming. The Arctic is now warming five to eight times faster than the equatorial region. By breaking down the long-established temperature gradient between the poles and the tropics, these feedbacks are disrupting the entire weather system in the northern hemisphere. A slower, wavier jet stream is causing lock-ins of weather extremes that result in horrific rainfalls in some places and deep and persistent drought in others. What scientists fear is that the climate system in this part of the world is destabilizing. If this were happening to your business, you would call this degree of pending destabilization "hemorrhaging" and act immediately to stop it.

So what do we do? The first thing we should do is clearly recognize that climate change is not a hoax. Nor is it something we can wish away. The accelerating disruption in climate patterns in the northern hemisphere will continue until we stabilize the composition of the Earth's atmosphere and restore damaged elements of natural Earth system self-regulation. This requires reducing greenhouse emissions to zero, reversing ecosystem damage, halting species extinctions and ensuring that all development is not only sustainable but restorative.

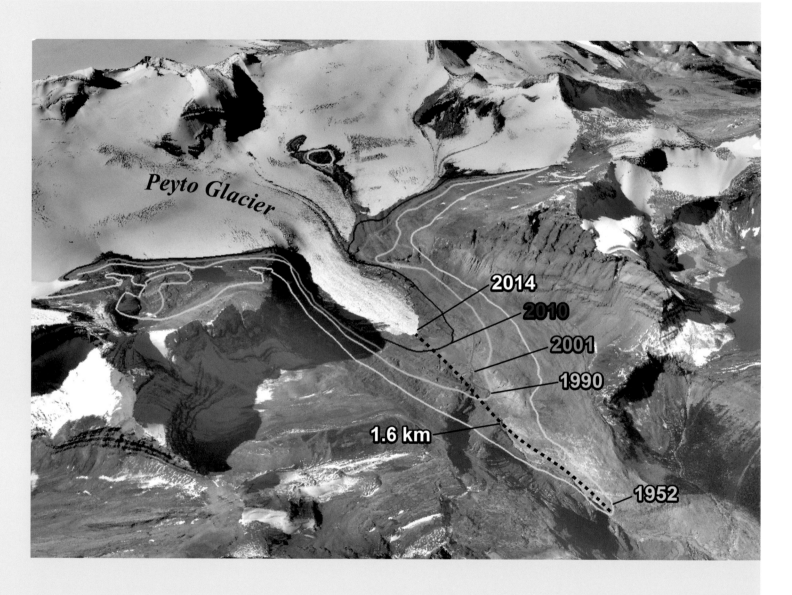

Recession of
Peyto Glacier.
Image courtesy
of the Changing
Cold Regions
Network

Dr. John Pomeroy holds a Canada Research Chair in Hydrology and Climate Change at the University of Saskatchewan but conducts much of his research on snow and glacier ice in the Canadian Rockies. He is also the associate director and a principal researcher in the Global Water Futures Program. Financed by a federal Canada First Research Excellence Fund grant of $78-million and an additional $65-million in support from 18 partner universities, this $143-million program involves 388 researchers in collaboration with eight federal government agencies, 28 provincial government departments, seven Indigenous communities and governments, 34 private sector collaborators, 45 international research institutions and three global water and climate programs. The Global Water Futures Program aims to simultaneously place Canada as a global leader in water science while at the same time addressing the strategic research needs of the country. These strategic needs include improving disaster warning, predicting

water futures and informing adaptation to change, all of which require a firm understanding of how much water will be available in the decades to come. Such understanding can only be gained through the study of the glaciers of Canada's mountain West.

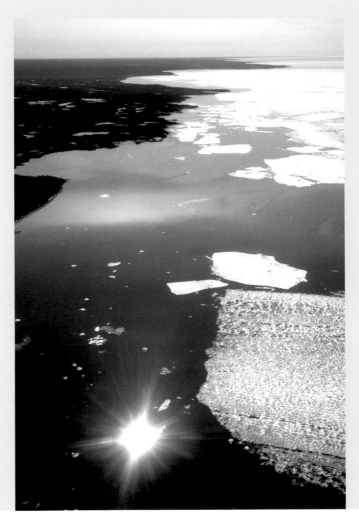

Far left:
Dr. John Pomeroy. Photograph by Marilyn Pomeroy

Left: Great Slave Lake at spring breakup.

We are not far from the moment when the feedbacks will themselves be

driving the change — that is, we will not need to add more CO2 to the atmosphere at all,

but will get the warming anyway. This is a stage called runaway warming, which is possibly what

led to the transformation of Venus into a hot, dry, dead world. When Jimi Hendrix played the

guitar he had the ability to play passages using feedback alone — his fingers didn't pluck

the strings but he manipulated electronic feedback to produce the sounds. We are fast

approaching the stage when climate change will be playing the tune for us while

we stand by and watch helplessly, with our reductions

in CO2 emissions having no effect.

—PETER WADHAMS, *A FAREWELL TO ICE*

NINE: What We Stand To Lose

Imagining a mountain West that has no more ice

The prospect of an absence of ice is daunting, to say the least, and the scientific outcomes of the IP3 and WC²N research networks put this into even more disturbing relief. Examining the time-lapse animations created by UBC's Dr. Garry Clarke and his colleagues in the Western Canadian Cryospheric Network, we can visualize what kind of West we may well have if the warming trends we have seen over the past 85 years persist. If the character-ization of the changes we might expect are even partially accurate, Banff and Jasper national parks are not going to even remotely resemble what they are now. If this is the case, one wonders what the rest of the West will be like.

Let's project the experience that would be available to a visitor to the landscape encompassed by Clarke's time-lapse map in 2100 and compare that to what exists now. Travelling by whatever means will be available 90 years hence, the experience would not resemble anything we would have had in 2002. Starting up the Icefields Parkway from just north of Lake Louise, the first thing a visitor

The Athabasca Glacier, by Banff artist Max Elliot.

183

would be grateful to notice is that there were still glaciers on the high peaks surrounding Moraine Lake and Lake Louise. North facing, high in altitude and in some cases protected by collapsing moraines, this ice had yet to be affected by dramatic warming in the valleys and longer summers. You do notice, however, there is no perfect reflection on Herbert Lake to mirror their glory. There is no reflection because there is no lake. There is no lake because there is no water. There is less water everywhere in the region because there is less snow and it melts earlier. A hundred of the 395 named lakes that existed a century ago are no longer there. A few new ones have formed as a result of the rapid decline of glacial ice. There is a lot less ice. You notice this because the lip of ice that marked the edge of the Waputik Icefield has receded beyond view and Crowfoot Glacier is gone, along with the icefield that formed it.

With photographs taken in 2002 as a reference for what existed before, you proceed north on the Icefields Parkway to Bow Lake. You notice the lake is a fraction of the size it was a century ago, but what really shocks you is that the glacier that supplied the water that formed the lake is gone. It has been gone for nearly 50 years. While the Bow River still flows out of Bow Lake, its volume is greatly reduced. While the river continues to run all year round at Calgary because so many tributaries supply meltwater and groundwater and dams control the flow, in the high mountains at its source the river dries in late summer. Like many waterfalls, it too has become just a freshet.

Even the icefield out of which Bow Glacier once flowed is gone. Most of the waterfalls in the Rockies, you discover, now exist only briefly during the intense melt of an earlier spring, as do many streams and even some rivers. Fewer people, you notice, live downstream now because there is less water than there used to be and flows are less reliable. Though you can see from the map that a tiny remnant of the Wapta Icefield still clings to the highest north-facing peaks, the glaciers that emerged from it are completely gone. This, you imagine, must have had devastating consequences on both sides of the Great Divide. You realize that on the west side of the Divide where the Wapta Icefield once draped over the eastern boundary of Yoho National Park, the effects have been catastrophic. Yoho Glacier has disappeared, as has des Poilus. Daly Glacier has also vanished and the loss of melt has turned Takakkaw Falls, once one of the great wonders of the world, into a spring freshet. There is no trace of ice anywhere on the Highline and Skyline trails. The age of ice appears to be in full retreat.

The full impact of what has happened, however, does not make itself evident until you visit Peyto Lake. The glacier is gone and only a thin stream of water pours down from the remnant icefield that once formed it. You can no longer hear the sound of mountain water rising and falling in the wind. The lake is smaller by half than it was a century before, but the difference that bothers you the most is that it has lost its amazing colour. The light that once was in it has gone out. It no longer glows a bright turquoise in contrast to the striking green of the surrounding forest. You realize that few glacial lakes remain that still carry within them the huge volumes of rock flour that gave them such ineffable colour. Their blue has become sedate. Everywhere, it seems, the Rocky Mountain lakes have lost their lustre. You find yourself speechless with a different kind of awe.

The big glaciers that clung to the Great Divide on the

WC²N estimation of icefields and glaciers in existence in the area of the Icefields Parkway in Banff and Jasper National Parks as of 2002.

2040 estimation.

2080 estimation.

WC²N estimation of the icefields and glaciers projected under a variety of climate change scenarios to still be in existence by 2100.

Dr. Clarke's time-lapse animations of what warmer temperatures could do to the remaining glaciers in the Canadian Rockies do not invite reverie. These images will be especially troubling to anyone who intimately knows the landscapes they portray.

Courtesy of Dr. Garry Clarke et al., Western Canadian Cryospheric Network

west side of the Mistaya Valley are all gone. Snowbird Glacier, once regarded as one of the most exquisite natural features in the Rockies, has disappeared. The lakes that once sparkled in this valley are diminished in size and depth or just gone. Though you can't see it because it is a range away, the map you have brought shows that a tiny spur of the Freshfield Icefield still survives, but the greatest of that icefield's glaciers, the Freshfield itself, has vanished into thin air.

At Saskatchewan River Crossing you look west in the hope that the Mons and Lyell icefields have survived.

The Mons, however, is completely gone. It is as if it was never there. Only fragments of the Lyell remain – high, distant patches with no glaciers at all. You discover that the Glacier River had ceased flowing 50 years ago. Permanently. Wilson Glacier above Saskatchewan Crossing has shrunk so much it is no longer visible. A few glacial remnants linger on Mount Amery and on the highest shoulders of Mount Saskatchewan, but the real shock doesn't hit until you reach the Columbia Icefield. There is no longer ice on the horizon at the loop below the Big Hill. Astonished by the late-summer heat, you stand on the crest of

Parker Ridge, only to discover that Saskatchewan Glacier no longer remotely resembles the ice age colossus that poured grandly out of the Columbia Icefield a century before. You realize that the Columbia could be as much as 200 square kilometres smaller than it was thought to be in 2002 and you suddenly dread what you are going to discover when you drive the eight kilometres between Parker Ridge and the once world-famous Athabasca Glacier.

All your fears are realized when you turn the corner at the site where the Icefield Centre once sat. The Columbia Icefield is no longer one of the last remaining places in southern Canada where cold, wind, weather and water still interact in exactly the same way they did during the last ice age. Where a century ago visitors marvelled at the accessibility of the five-kilometre-long glacier, what remains is almost impossible for any but a mountaineer to reach. Getting out of your electro-magnetic vehicle, you no longer walk back in the Pleistocene, that colder epoch when much of North America was buried beneath two kilometres of ice. You walked instead into a climate change nightmare. It is a nightmare that Garry Clarke and his colleagues fully visualized a century before.

A MOUNTAIN GUIDE REPORTS FROM THE FIELD

From: Public Mountain Conditions Report
Sent: Tuesday, July 23, 2013 8:57 AM
To: mcr@informalex.org
Subject: [MCR] Rockies, AA Col,
Mt Athabasca

I guided and instructed in the Columbia Icefield for the last three days. The firn line is migrating up the mountains. The Athabasca glacier is dry right up to the three steps and the Earth Gullies on Mt Andromeda (aka the Practice Gullies) are very icy, but with little cornicing left hanging above Middle Earth and Far Earth (the furthest-up glacier gullies of the 3).

Yesterday, July 22, my fellow guides Richard Howse, Deryl Kelly, Darek Glowacki and I guided an ascent of the AA Col route on Mt Athabasca. The erosion of the lateral moraine above the Brewster bus transfer site continues to be shocking. The trail moves uphill all the time and the big melting gullies in the moraine gobble it up as they cut upslope. Two small landslides (gravitational mass wasting) have slumped onto the trail above the big left-hand turn on the approach. Hard country to keep a trail in with so much change.

The glacier still has good snow coverage. Getting over the bergschrund required some compressing of snow into it and steps kicked in above. There is one tendril of snow leading to the saddle, or you can switchback up scree. The Silverhorn ridge is dry and in scrambling condition.

My first trip up Athabasca this year, good to be on the old hill, yet saddening to see it become more rocky and less glacier covered with each passing year. The quality of the route is on the decline.

Happy trails,
Barry Blanchard
Mountain Guide
www.barryblanchard.ca,www.yamnuska.com

GONE LIKE A GHOST

As valley glaciers thin and recede, their remnants are sometimes left in small, high valleys above the main valley into which the glacier once flowed. These remnants are called hanging glaciers, and when they too disappear the valleys they leave behind are hanging valleys. A classic example would be Ghost Glacier, located above Angel Glacier on the north face of Mount Edith Cavell, north of the Columbia Icefield in Jasper National Park.

Sometime during the night of August 9–10, 2012, some 60 per cent of Ghost Glacier let go from Mount Edith Cavell and fell 800 metres onto the surface of Lower Cavell Glacier. Thousands of tonnes of ice fell into the small tarn below, causing a huge displacement wave that over-topped the end moraine, eroding a new outflow channel which drained much of the lake. The wave instantly de-molished the day use area adjacent to the lake. Fortunately, no one was hurt.

Ghost Glacier. Photograph courtesy of Mike Demuth, Glaciology Section, Geological Survey of Canada

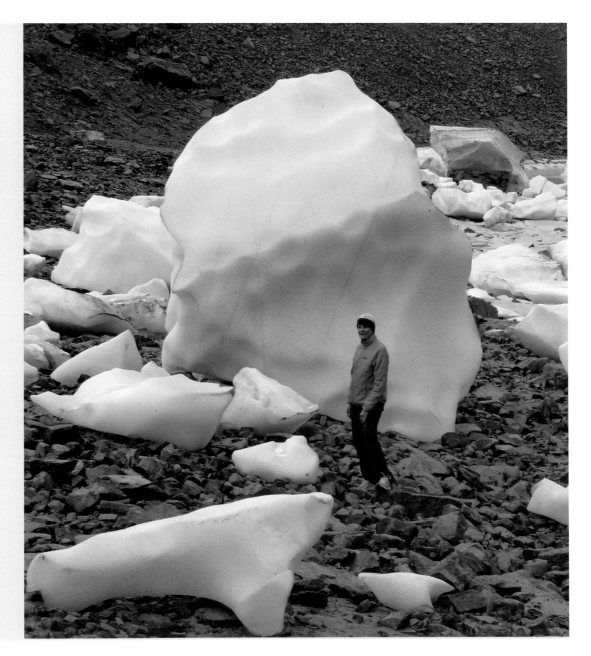

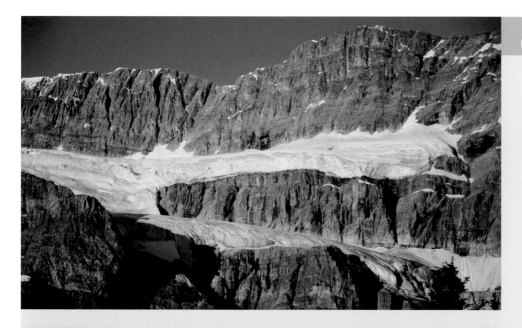

Crowfoot Glacier

Originating in a small icefield just above it, this hanging glacier just north of Lake Louise is highly visible from the Icefields Parkway. It is called Crowfoot because when it was first seen by explorers it had a third toe which extended to the valley floor. Over the last century the glacier has lost that lower toe and has thinned considerably.

Bow Glacier

Bow Glacier has its origins in the Wapta Icefield, which is only barely visible from the Icefields Parkway. Melt from Bow Glacier forms Bow Lake, which is the headwaters of the Bow River flowing past Banff, through Calgary and onward over the Great Plains. Once it leaves Banff National Park, the Bow is one of the most important and heavily used rivers in Alberta.

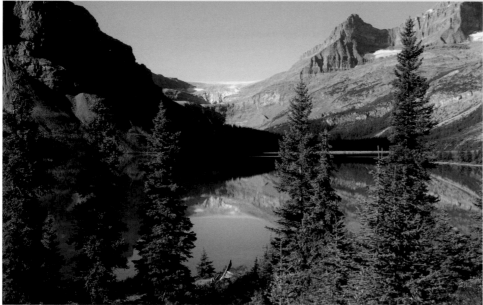

Peyto Glacier and Wapta Icefield

Peyto Glacier is the source of waters that pour into Peyto Lake, the headwaters of the Mistaya River, which in turn flows into the North Saskatchewan near Saskatchewan River Crossing on the Icefields Parkway. This glacier was the only one in the Canadian Rocky Mountain parks to be selected as a reference glacier by the World Glacier Monitoring Service. Though fed by the Wapta Icefield, Peyto Glacier has retreated to such an extent that glaciologists fear it will soon no longer exhibit the flow dynamics that define it as a glacier.

Wapta Icefield

Like the Columbia Icefield, the Wapta is a high, cold basin of eternal snows in which glacial ice is formed through the weight of accumulation and begins to flow in the direction of least resistance, which except in extraordinary circumstances is usually downhill. Also like the Columbia, the Wapta straddles the Great Divide – the high ridge of mountains that separates the waters that flow to the Pacific from those headed for the Atlantic, and which also marks the boundary between Alberta and British Columbia. A number of significant glaciers flow down both sides of the Great Divide from this icefield.

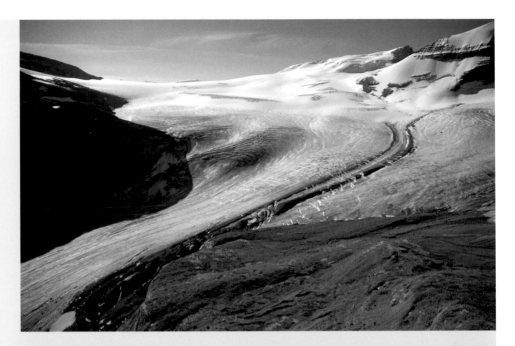

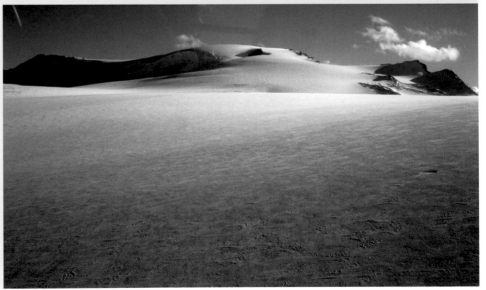

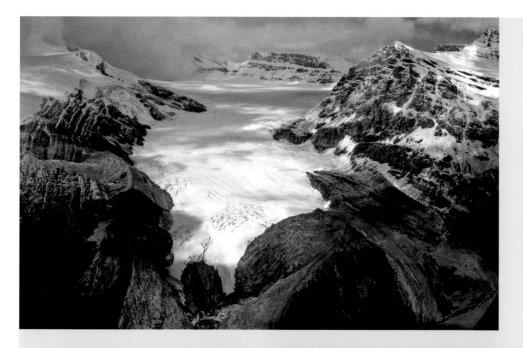

Wapta Icefield and Yoho glaciers

Yoho Glacier is one of several that flow down the west side of the Great Divide from the Wapta and Waputik icefields. It forms the headwaters of the Yoho River, which joins the Kicking Horse on its way into the Columbia River system and is one of the most spectacular features in Yoho National Park.

Daly Glacier and Takakkaw Falls

Many of the most spectacular waterfalls in the mountain West are fed by glacial meltwaters. As Daly Glacier melts away we can expect diminished flow volumes on Takakkaw Falls. In many places such falls will become ephemeral, active only during spring snowmelt.

Emerald Glacier

One of the glaciers that will be most missed in Yoho National Park is the Emerald. The famous Iceline trail skirts the terminus of this rapidly receding glacier.

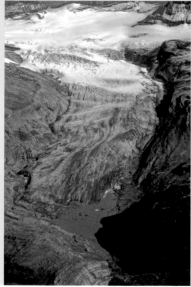

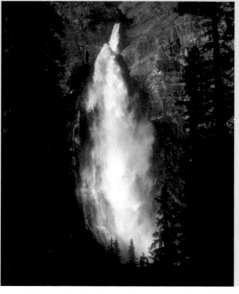

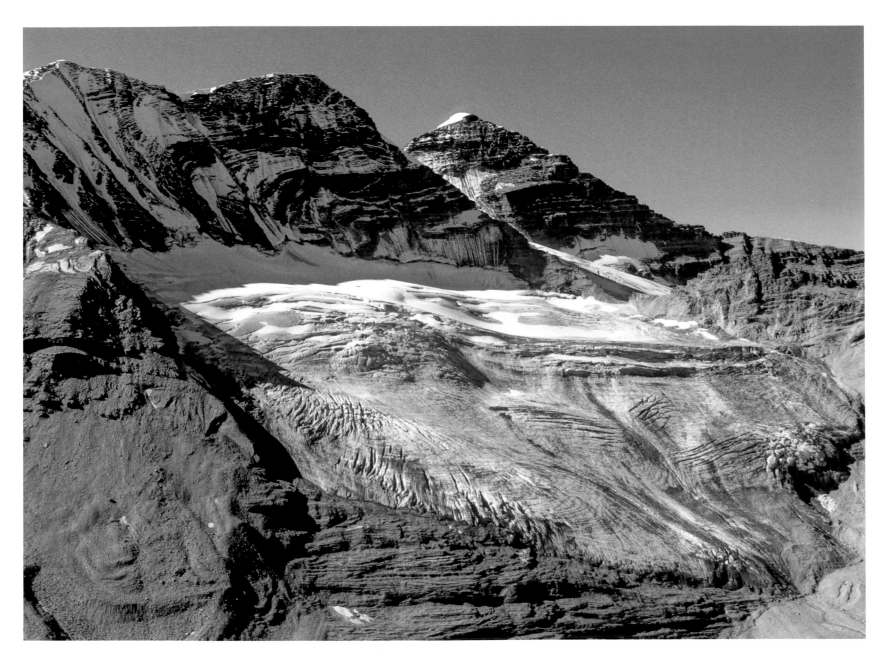

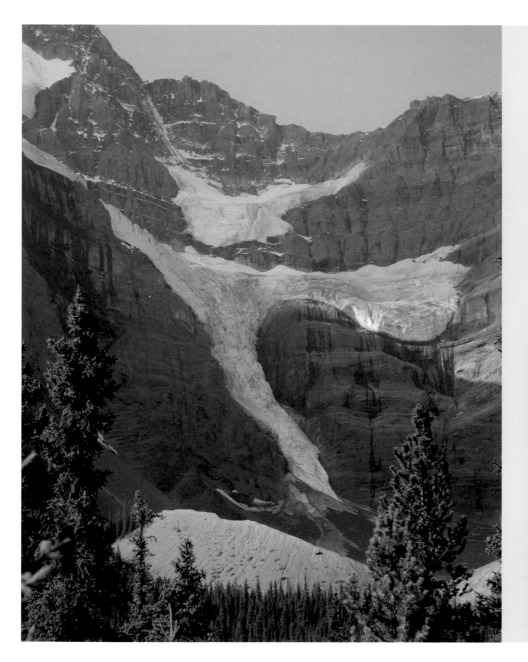

Snowbird Glacier

Snowbird Glacier, visible from the Icefields Parkway near Peyto Lake in Banff National Park, is an example of both a cirque glacier and a hanging glacier. The tail and the body and wings of the "snowbird" were connected until warming conditions in 2009 resulted in the glacier breaking into two sections.

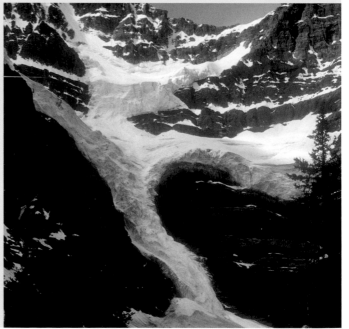

Freshfield Glacier

There are some very large glaciers in northern Banff National Park that cannot be seen from the Icefields Parkway. Among these is the spectacularly complex Freshfield Glacier, which flows from its own icefield. Freshfield releases its meltwaters into the Howse River below Howse Pass, on the fabled fur trade route established by mapmaker David Thompson in 1807.

Wilson Icefield

As temperatures continue to rise, we will lose glaciers that few ever see even though they are close to relatively heavily travelled places. The Wilson Icefield is invisible from the Icefields Parkway, as it is located on the back of Mount Wilson at Saskatchewan Crossing, between Lake Louise and the Columbia Icefield.

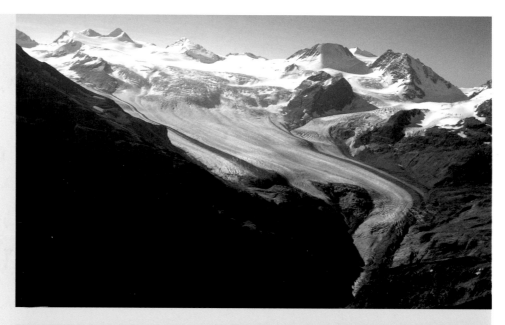

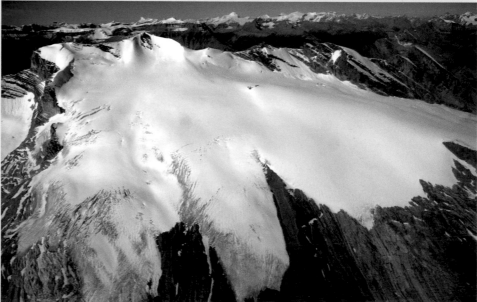

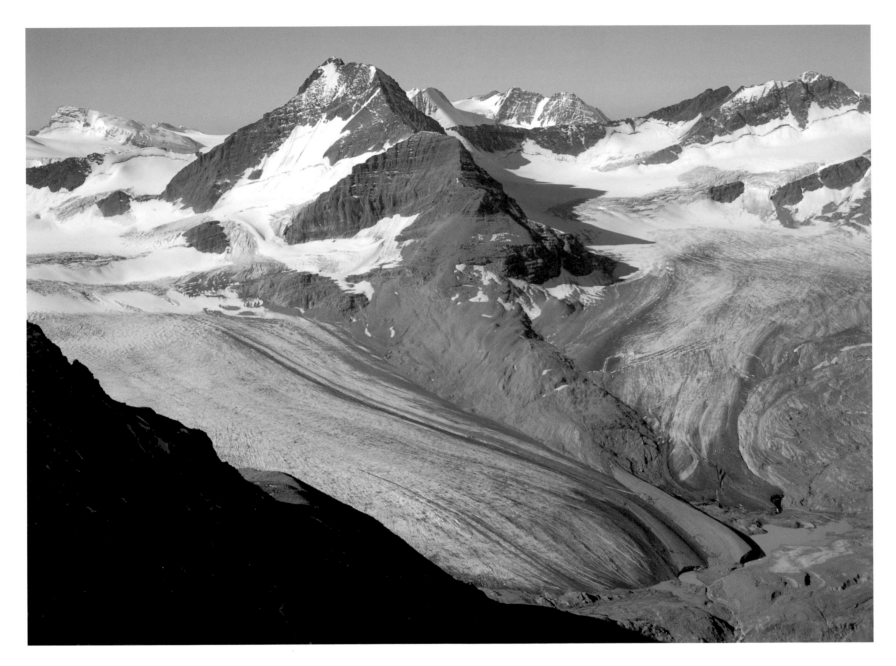

194

West and south glaciers of Mons Icefield

Left: Located in a remote and seldom travelled region north of Freshfield Glacier in Banff National Park, the Mons Icefield feeds a number of glaciers. These two were at one time a single glacier formed by the joining of two tongues separated by what is called a nunatak, or glacial island, which in this case is a mountain rising out of the surrounding ice. The glacier has since shrunk back into its sources and the two tongues no longer merge.

Mons Icefield and Mons Glacier

The Mons icefield (right) and glacier are located in the upper reaches of the Glacier River in northern Banff National Park. Note the very well-defined line between the surface of the glacier and where the snows from the previous winter remain unmelted. This is called the firn line, which in late summer delineates the glacier proper from the icefield that forms it.

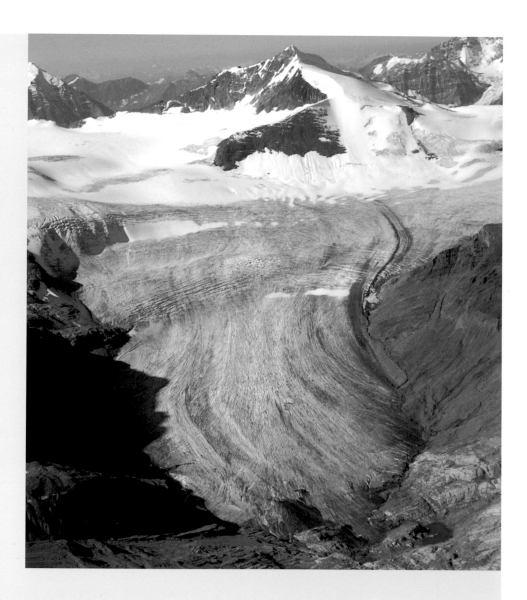

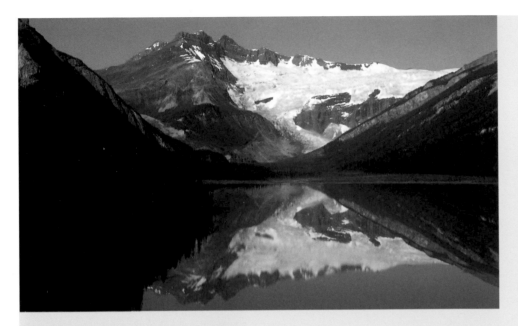

Glacier Lake and Lyell Icefield

Glacier Lake is fed by the meltwaters of the Lyell Icefield. As the icefield and its glaciers disappear the colour of the lake will change and its level may drop as a result of greater evaporation brought about by longer, hotter summers.

The Lyell Icefield and Southeast Lyell Glacier

The Lyell Icefield can be glimpsed in the distance from a viewpoint looking west toward the Howse River valley, near Saskatchewan River Crossing on the Icefields Parkway. Melt from the steep and torturously crevassed Southeast Lyell Glacier flows into Glacier Lake, a popular destination for hikers and backpackers.

Arctomys Lakes

(Facing page) One of the most notable changes that will be obvious in a deglaciated mountain landscape relates to the colour of the water in lakes. Once melting glaciers no longer contribute their "rockflour" sediments, many lakes will change colour from emerald to a deep blue.

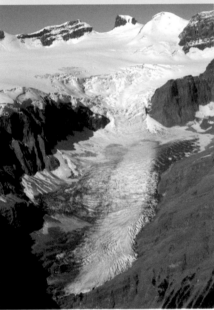

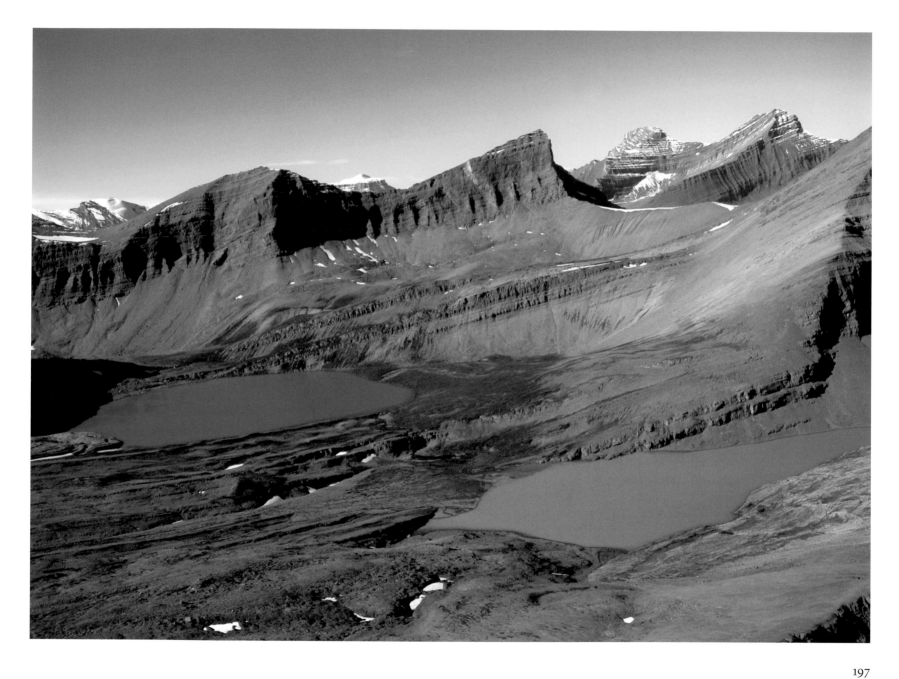

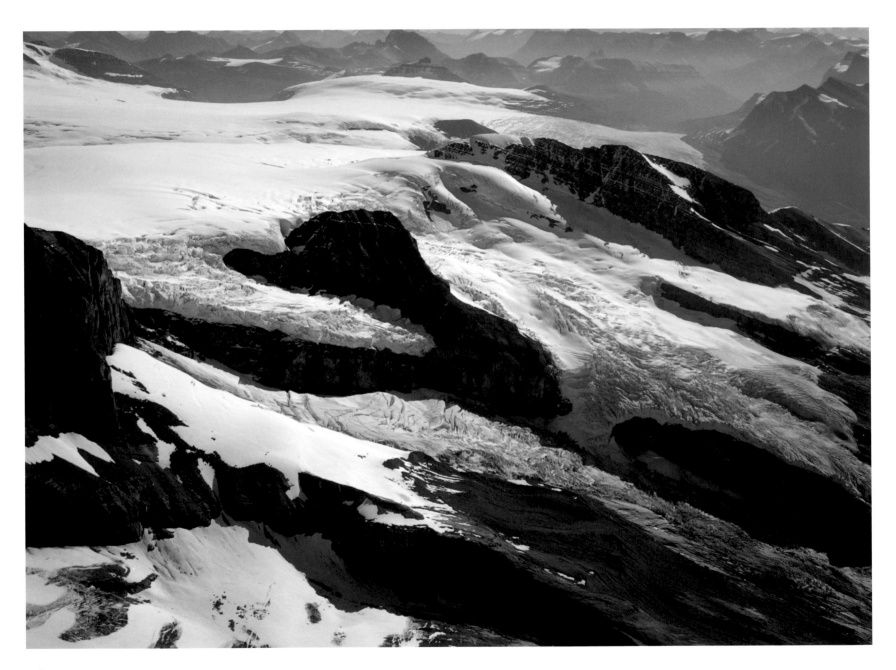

Glaciers on the west side of the Columbia Icefield

While the more accessible glaciers on the eastern slopes of the Great Divide receive most of the attention, a great number of the Columbia Icefield glaciers flow down the west side of the Divide into BC's Hamber Provincial Park, one of the least visited but most spectacular gems in the UNESCO Canadian Rocky Mountain Parks World Heritage Site.

Chisel Peak and the glaciers above Fortress Lake

(Facing page) The high alpine regions of Hamber Provincial Park are little better known today than when they were first mapped a century ago. By saving, protecting and reconnecting every possible piece, the Canadian Rocky Mountain Parks World Heritage Site has not only reintegrated a vast temperate mountain ecosystem, but also preserved icefields and glaciers that are now known to be a vital part of the natural thermostat that has regulated the climate of the northern hemisphere for millions of years.

Photograph courtesy of the University of Northern British Columbia

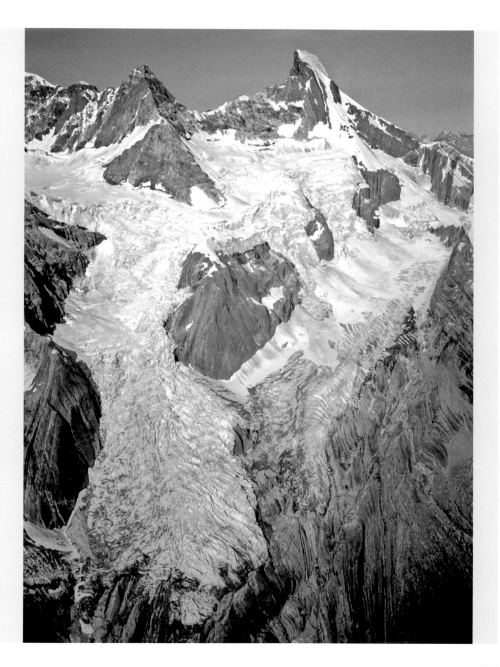

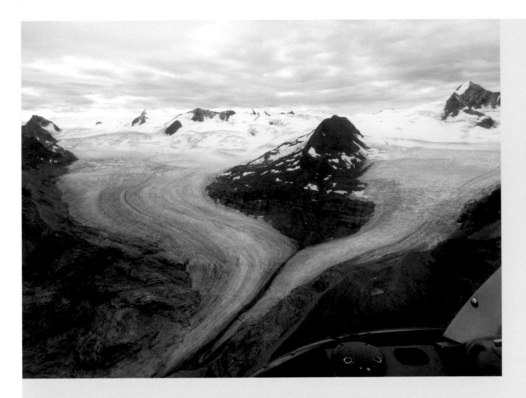

Conrad Glacier

The Conrad Icefield is at the northern edge of the Bugaboos in the Purcell Range of the Selkirk Mountains in southeast British Columbia. The icefield feeds Conrad and Malloy glaciers, each of which has two arms. In the case of Conrad Glacier the two arms still join above the terminus, while for Malloy there are now separate termini. Presently under observation by Dr. Brian Menounos and his team from the University of Northern British Columbia, this glacier is in rapid retreat and is likely to disappear by the end of the century if current warming trends persist.

Mountains everywhere are coming unglued

As pointed out by editors Ben Orlove, Ellen Wiegandt and Brian Luckman in *Darkening Peaks*, people who are active in the mountains do not have to be convinced that the climate is changing. Anyone who has spent any time outdoors will know that big changes have occurred in only one generation. Climbing routes are changing faster than guidebooks can keep up. The ice that held our mountains together is melting, and there has been a noticeable increase of superficial rockfall from deglaciated walls. Rockfall has become a particularly serious problem on north faces. In some regions whole walls are coming apart.

On December 14, 1991, a rock avalanche reduced the height of New Zealand's Mount Cook by some 20 metres when 14 million cubic metres of rock peeled off from the summit. When the avalanche struck the glacier below, it created its own earthquake of 3.9 on the Richter scale. But the mountain wasn't finished yet. The avalanche smashing into the glacier created a moving rock and ice mass of some 55 million cubic metres that travelled 7.4 kilometres downvalley at speeds up to 400 to 600 kilometres an hour.

These types of events are occurring elsewhere as well. On the evening of September 20, 2002, an ice and rock avalanche roared down the northern side of Kazbek Massif in the Russian Caucasus. Beginning as a slope failure below the summit, the slide slammed into Kolka Glacier, almost entirely entraining it. The rock and ice of the avalanche and the ice that composed the glacier created a debris flow of some 100 million cubic metres that blasted down the Genaldon Valley for 19 kilometres before being halted at the entrance of the Karmadon Gorge. A mudflow,

however, continued downvalley for another 15 kilometres, stopping only 4 kilometres from a nearby population centre. The combined impact of the rock and ice avalanche and the mud flow was devastating. About 140 people were killed and most of the region's roads, buildings and infrastructure were destroyed. But that wasn't the end. The ice dam created at Karmadon Gorge resulted in the creation of several new lakes, some up to 5 million cubic metres in volume, that remain an imminent threat to downstream areas.

In Europe, climate scientists are also anticipating increased rockfall associated with the accelerating advance of rock glaciers. It appears that 40 to 60 per cent of the ice in a rock glacier can be considered frozen fossil groundwater from the early Holocene or Pleistocene. These glaciers seem to be on the move. Accelerated rockfall is also being accompanied by increased debris flows on recently unfrozen slopes. Ice-cored moraines are becoming unstable. As we expect an increase in the frequency, intensity and duration of extreme weather events as a consequence of warming mean temperatures, we can also anticipate more intense and frequent debris flows after these storms.

At the same time, increased glacial melt is creating more glacial lakes and enlarging already existing ones. Small ice-contact lakes are also forming as a result of glacial recession within the confines of recessional moraines. Unfortunately more of these lakes are forming behind moraines that have melting ice cores, dramatically increasing the risk of massive outburst floods. These floods have become a real hazard in the Alps and the Himalayas.

In the Alps they can afford to pump water from these lakes to reduce the threat. In the Himalayas they cannot. There, people are forced to simply await the inevitable.

> Winter started as this thing we had to get through; it has ended as this time to hold on to.
>
> —ADAM GOPNIK, *WINTER: FIVE WINDOWS ON THE SEASON*

TEN: Water, Climate and the National Parks Ideal

The importance of cold

Many visitors to the Columbia Icefield ask why keeping this region cold even matters. If these glaciers are going to disappear anyway, what difference will further scientific research make? The answer is that we don't know enough about what is happening to ice and snow in the high Rockies to be able to predict the future. Because our temperature records are almost all from elevations between 640 and 1340 metres, scientists suspect that current extrapolations are probably underestimating warming at high altitudes.

It is at these higher elevations that climate change effects are expected to be felt first and to be most pronounced in terms of their impacts on water supply. At the moment, we simply don't know how much faster warming may be occurring at higher altitudes, because we have few measurements and no baseline for comparison. As noted, we don't know enough about what implications this may have for water supply for cities and farms that rely on rivers that originate in the Columbia Icefield and other icefields and glaciers in Canada's western mountains.

The long-term ecological effects of widespread glacial recession and diminution of snowpack and snow cover are also little known. We should expect, however, that the increase in non-reflective terrain in this region will have further warming effects on climate and that these effects will also cascade rapidly through both terrestrial and aquatic ecosystems. It is important to note that these systems took millions of years to evolve into what we experience of them today. Such biodiverse systems take time to respond to change. Ever since complex organ-

Night fires burning.

isms first appeared on Earth, the atmospheric temperature has varied within a range of only ±10°c. But over the past two centuries alone we have warmed the atmosphere half or more than the Earth's temperature has fluctuated over 600 million years. Biodiversity-based systems even in protected places are now under stress.

With the decrease in the extent and influence of glaciers, our rivers are already warming, which will affect every cold-sensitive species, from the smallest diatom and pathogen to every kind of fish. We have already seen what consistently warmer winters do in terms of insect infestations. Higher winter temperatures have aided the advance of forest pests like the pine bark beetle, which has now spread through about 10 million hectares of British Columbia forest. Some 411 million cubic feet of commercial wood has already been destroyed, which amounts to twice the annual harvest of all the logging operations in Canada.

With warmer temperatures and longer, hotter summers we will also have to pay more attention to water's diametric and symbolic opposite – fire. Dr. Mike Flannigan and his colleagues at Natural Resources Canada have been able to predict the effects that increased carbon dioxide concentrations will have on the length of the fire season in boreal forests. This important work suggests that the fire season will increase from 10 days to a whopping 50 days over much of the Canadian boreal by the end of the century. Based on carbon dioxide increases alone, Flannigan and his colleagues predict a 75 to 120 per cent increase in the area burned each year. Until very recently wildfires have largely been viewed as a local phenomenon tied to regional precipitation. Now, however, the increased threat of wildfire is being recognized as a new global normal controlled mostly by temperature and brought about in large measure by the combined and cumulative effects of the loss of seasonal snow, sea ice and glaciers on weather patterns.

We are already beginning to witness climate change impacts on vegetation and wildlife, especially in the alpine. For the last century, the alpine tundra zone has been defined as those places having a mean annual temperature of between 8 and 9.5°c during the warmest months of the year. The early 21st century has already seen temperatures rising above 10°c in large areas of the North American alpine tundra climate zone. By this measure it has been determined that 73 per cent of the alpine tundra in the western United States can no longer be classified as such. This means that since 1987 the continental US has lost three-quarters of its alpine regions to global warming. As we have seen, it is not unreasonable to anticipate that rising temperatures are having a similar effect on mountains in Canada. As the climate grows warmer a thermal sea will rise up the slopes of our national parks islands, separating each mountain range further from the next. This will aggravate precisely the two conditions that the theory of island biogeography suggests will deplete species diversity: species will become more isolated and their habitats will shrink.

Pika

The pika is actually a member of the rabbit family, but because it lives in a cold environment and remains active under the snow during winter, its ears are smaller and rounder than what we would expect of a rabbit. What researchers have discovered is that while the pika is a cold-hardy mountain species, it has limited tolerance for warming temperatures. The pika, or rock rabbit as it is sometimes known, is a species that lives only in the alpine regions of North America's western mountains. As ethologist Anthony Barnosky explains, pika tend to die of heat stress if they are caught outside in temperatures above 25.5°C for any length of time, which explains why they are generally found only near mountaintops. In the Colorado Rockies the temperature tends to cool by 2°C for every 300-metre gain in elevation. By going higher, pika avoid the high temperatures of the valley floor. Over the last 50 years, however, lethal temperatures have been moving upslope, pushing the pika ever upward. The problem for pika in Colorado is that they are now reaching the summits of mountains only to find out that rising temperatures make it impossible to survive even there. The higher latitudes and altitudes of the northern Rockies may be the last stand for this species. Photograph by Vi Sandford

Marmot

The hoary marmot can be found in the alpine regions below the Columbia Icefield. It is the largest member of the squirrel family and uniquely adapted to living at high altitudes within very narrow regimes of temperature. The marmot can hibernate up to nine months of the year, which makes it vulnerable to changing climatic conditions and plant availability when it comes out of hibernation.

The writing may also be on the wall for the marmot – at least in the southern Rockies. As naturalists in the Rockies have observed, marmots construct elaborate burrow systems into which, in the Colorado Rockies, they disappear whenever the outside temperature falls below 1°C or is hotter than 26°C. It is interesting to note that marmots have tolerance levels that embrace both ends of the temperature spectrum, which we now know is common to many alpine species. In a marmot burrow, the temperature stays between 8 and 10°C even though the outside temperature may be higher or lower. Marmots spend 60 per cent of their lives in hibernation. They emerge from hibernation sometime in the spring, just as the fat reserves they packed on during the previous summer are exhausted.

US researcher Anthony Barnosky found that, on average, marmots in Colorado were emerging from their burrows some 23 days – nearly a full month – earlier than they were in the 1970s. Barnosky also discovered that, in Colorado at least, more winter snow is falling each year and even increasing spring temperatures cannot melt it fast enough to permit plant growth to occur before the marmots end their annual hibernation. As Barnosky describes it, starving marmots in Colorado are coming out of hibernation to discover that the salad bar isn't open yet and won't be for some time – and then they are dying. The climate change circumstance marmots are presently facing is different from what has occurred in the past, at least in the southern Rockies. This may also be the case for other hibernating animals, including bears. Whether snowfall patterns as they are trending at the time of this writing will persist in a rapidly changing American Southwest remains to be seen, but what is already clear is that the future will be different than the present.

While mountain caribou are still seen occasionally in the Columbia Icefield area, their habitat has been diminishing throughout their North American range. While habitat disruption – by development in and around the very parks that were created specifically to protect such living wonders – has been a big factor in this species' decline, a changing climate is also adding to the stress. Photograph by Vi Sandford

Mountain caribou

While we may not be worried about pika or marmots in the Banff or Jasper parks at the moment, all the alarms are going off with respect to caribou survival. The mountain caribou has already been extirpated from Banff National Park and there are concerns about its survival throughout the Canadian Rocky Mountain Parks World Heritage Site. Ultimately, with no farther left to go, upwardly advancing cold-hardy refugees perish. Suddenly we see that our old land and wildlife management ideas no longer apply, because our fundamental conservation goals have been made self-contradictory by climate change.

Rocky Mountain bighorn sheep

Rocky Mountain bighorn sheep are common in the Columbia Icefield area, where they are often seen licking road salt off the pavement of the Icefields Parkway. Though both males and females have horns, the annual growth of rams' horns often determines social hierarchy in a species where horn size can play a big role in mating success.

What is to be done?

The first question, at least in terms of wildlife protection, becomes: How can we protect species whose last stronghold in protected areas is threatened by climate change? We might also ask: What is it we are trying to keep whole in ecologically protected areas?

The action plan that has to be on the ground where large, relatively intact natural systems still exist may boil down to three verbs: keep, connect and create. This, it appears, is as good a place as any for us to begin. We need to keep and protect what we have preserved in our parks and World Heritage sites. We need to connect what we have already protected to corridors and spaces outside of our national parks. And then we have to expand protection to those corridors to ensure that as many species as possible can move northward and upward along with the temperature regimes and ecosystems they rely on for their survival. But this cannot be done without an understanding of what is happening to the ice and snow that are central determinants of the character of ecosystems in cold regions.

We now know that snow cover, atmospheric circulation and temperature are interdependent and relate to one another as feedbacks. Water and temperature define climate, climate defines ecosystems, and ecosystems define us. In the absence of ice and snow we would be different people living in a different world. It appears that in the context of where and how we live in Canada, cold really does matter. And now we are beginning to understand why.

The mountain goat is a true alpine species. Often found on the steepest and highest of mountains, it can actually be seen looking down on the Columbia Icefield from vantages that people would find very difficult to reach. Like the Rocky Mountain bighorn sheep, however, the mountain goat lacks certain minerals and salts in its high-altitude diet and as a consequence can be found in the valley at natural salt licks along the Icefields Parkway.

It is not just animals that are affected by rapid changes in climate. Mountain forests are advancing to higher altitudes amid warming conditions, and alpine plant communities are being pushed upward ahead of the trees. In spectacular alpine meadows such as on Parker Ridge

Mountain goat.

Alpine buttercup.

and the slopes of Wilcox Pass it is possible to witness the extraordinary cold-hardiness of alpine flowering plants. The alpine buttercup, for example, often blooms right through the melting spring snow.

Wind from an enemy sky

When you think of climate change, think of where the dawn's light first strikes at the break of day. It of course illuminates the tops of mountains. And when you think of climate change, consider also where the sunlight touches the Earth most persistently, and that is where 24-hour light falls on the poles. Look to these places first for the impacts of change. A temperature increase in range of 1 to 6°C will cause dramatic changes in both these regions. We have already seen the kinds of changes that are happening in the Arctic. Similar changes are now happening widely in the Rockies. Vegetation zones in the mountain West are expected to shift upward by approximately 500 to 600 metres, or about 1,600 to 2,000 feet, the equivalent of one vegetation zone in any given mountainous region. Whole ecological systems are already advancing northward. Current ecological communities are fragmenting and regrouping into unpredictable new assemblages. The mountain West will be a different place by 2050.

The implications of these developments in the context of ecosystem protection are profound. For the last century the strategy for preserving global biodiversity has been to protect representative parcels of each important ecoregion. A 2000 joint study by Environment Canada and Parks Canada, *Climate Change and Canada's National Park System*, observed that many of our most treasured national

parks and reserves may no longer be located in the biogeographical regions they were created to represent. Currently we have no structures in place to help us manage such a development. Climate impacts may be the biggest challenge ever faced by Parks Canada.

Nor will it just be Canada that will face serious challenges in trying to protect remaining intact ecosystems. The fundamental assumption of the entire global protected places program, of which our own mountain national and provincial parks are an important part, is that these representative areas will remain biogeographically stable. But as an Alberta climate change vulnerability assessment published in 2014 pointed out, global climate change impacts are already invalidating this assumption. The maintenance of global biodiversity will require us to aim to protect what will effectively become, as University of Waterloo researchers Daniel Scott and Christopher Lemieux put it, "a moving target of ecological representativeness."

Protecting existing landscapes will require that disturbances be managed. New stresses will need to be controlled, and habitat modifications will likely be necessary to reconfigure protected areas so that they can survive emerging climate conditions. Biodiversity managers will have to figure out how to become restoration ecologists as they learn to adapt to change. Meanwhile, snow cover, which is expected to diminish by 40 per cent in the Rockies, is already coming later to ski areas; mountain ecosystems are moving upward; invasive species are already appearing; and the glaciers are disappearing right before our very eyes.

But the changing character of ecosystems is not the only danger to protected places. Threats exist that will challenge their very designation. As landscapes are diminished aesthetically as well as ecologically by climate-related hazards such as insect infestations and wildfire, and as other regions of the West become less habitable because of reduced water availability, upland regions are going to become ever more desirable places to live. People moving inland, uphill and toward water will not fail to see their growing value.

As it becomes clearer what precipitation will do and where the ground and surface water will go, we may well expect the greatest real estate play in the history of the West: the scramble to determine human settlement patterns in the face of growing climate-change impacts.

As the West is reordered economically around growing populations and intensifying climate, all protected-places bets could be off. If we want to keep what we have, we will have to find ways to ensure that protected and restored places take part in the creation of a future that is economic as well as ecologically sustainable .

The implications of these changes could dramatically alter our culture. As climate change impacts accelerate, as they almost certainly will, governments will have to do a great deal more to ensure reliable and predictable availability of the basic environmental goods and services that make our large cities and prosperous urban way of life possible.

A whole new global economy will emerge to provide the environmental services which nature at one time provided free on our behalf. The sheer scale and urgency of the project will require this to be so.

As greater climate variability and extreme weather events become more common, this will require huge

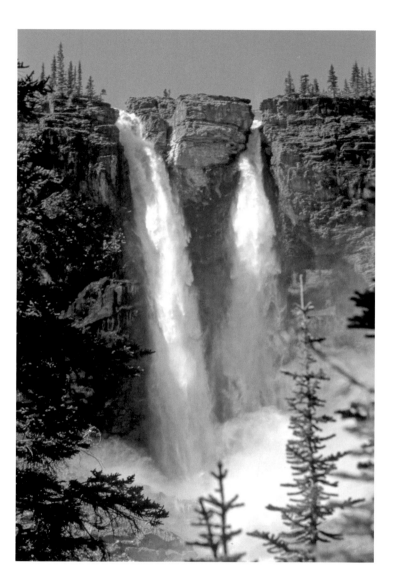

investments in infrastructure. Keeping things as they have been will become increasingly difficult. Managing our prosperity is going to take far more intensive intervention into ecosystem processes than ever before. More and more of our resources will have to be spent on managing and restoring natural, agricultural, forest and urban ecosystems so as to ensure the vitality of the basic processes that form the foundation of the environmental stability upon which our continued prosperity depends.

Imagine the directions we may be forced to take. These could include management of all wilderness areas toward defined goals of production of air, water and species diversity; complete management of both surface water and groundwater; integrated management of the energy, water and product inputs and outputs of agriculture and forestry; control of the composition, nature and behaviour of the Earth's atmosphere; and careful direction of global ecosystem change. The magnitude of the public policy changes that would be required in order to create the framework for such action on a global scale is more daunting than the challenge of creating a lasting international agreement on greenhouse gas reductions. Moreover, impacts are bound to accelerate.

We should expect further changes in the timing and nature of precipitation. We should expect shifts in agriclimatic zones and changes in the dynamics of our forests. We should expect an increase in the frequency and duration of violent storms. We should expect surprises and we should expect losses.

Though we are presently looking at an uncertain future, we have to see that there is a window of huge opportunity in this. Never before have we had a greater reason to create a vision of the West we want and to act on it. Never before

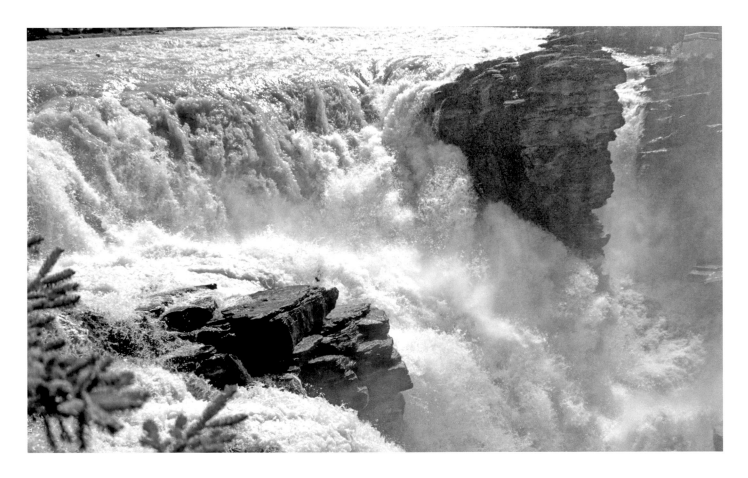

Athabasca Falls, downstream of the Columbia Icefield, in Jasper National Park, during the peak of the spring melt. The fact that the Columbia Icefield forms the headwaters of three of the great rivers of the Pacific Northwest has yet to be fully appreciated in the way we value our national parks. Once again, what we have protected may now protect us in a changing climate.

has there been greater urgency to get past the frontier free-for-all that once again defines our age to create a vision of what we want our West to be like at its future and ultimate best. "But it is impossible!" you will say, "to move against the current of established economics and political direction." You can say that all you want, but history disagrees. Our greatest cultural and public policy achievements belie this argument. Behold the central Rocky Mountain ecosystem.

Water, Climate and the National Parks Ideal

Changes in global hydro-climatic circumstances create an opportunity to rethink the value and mandate of our national parks and protected places. The Canadian Rockies World Heritage Site encompasses four national parks, three provincial parks, 13 national historic sites and four Canadian heritage rivers. Within this World Heritage Site

there are no fewer than 27 mountain ranges, 669 prominent peaks, 12 major icefields and some 384 glaciers.

These mountains are the water tower of the West. This combined reserve includes a total of 44 rivers and 164 named tributaries, only two of which are dammed. Four of the greatest rivers on the continent are born here. Within its boundaries are some 295 lakes and thousands of ponds, ephemeral pools and wetlands.

What has also become clear is that just curbing greenhouse gas emissions will not be enough to restore climatic stability. We can no longer ignore the local value of natural ecosystem processes. At the moment, it is still possible to hold the balance of positive effects, such as landscape protection, versus negative impacts to what it is today and then shift them in the direction of restoration that will lead back to relative hydro-climatic stability. It is not too late, and that is why there is hope. But in order to gain even partial rein over the hydrological cycle, we have to enlist all the help nature can provide us. We gain that help by protecting and restoring critical aquatic ecosystem function locally and by reversing land and soil degradation wherever we can.

No one knows better than those who manage our national parks that the watershed basin is the minimum unit at which water must managed. This fact in itself – that basin-scale water management is critical to social, economic and environmental resilience to changing hydro-climatic conditions – should inspire our actions.

We already changed the world once by doing the right thing in creating the protected-areas system we now have in Canada's western mountains. I believe we have it within us to do the right thing again by using this system as a foundation for the creation of a new water ethic in Canada and, through example, the world.

Through reaffirmation of the link between water and our national identity a second great public policy achievement in the West could be built upon the first. We saw to the creation of the Canadian Rocky Mountain Parks World Heritage Site and protected surrounding areas. Now let's use what we have done to demonstrate to the world how we can follow the water in our protected rivers and lakes back to the headwaters of our own history. From there we can identify that point in time when we made a wrong turn in terms of understanding the true value of our land and water resources. Correcting that mistake and starting again downstream towards meaningful sustainability demands that we decide what steady state we want for water and climate and then set self-regulation on the road to achieving that state.

Afterword: Rock, ice and art

The mountain West is a landscape of imagination and discovery. It seems that when you are not looking is when you find the most. If you have spent any time at all on the surface of a big glacier like the Athabasca, you may have noticed that melting surface water creates ice chimes. Ice chimes are somewhat like ocean surf in that over time a huge variety of sounds are created by water moving through delicate shards of ice that has frozen during the night. If you listen long enough you can hear words. You can think you are losing it, but in the midst of the chiming babble you hear something you think you understand. I have heard "rest" and "sugar" and "water."

The wind also does strange things on and to the ice. One day, coming onto the icefield from the Saskatchewan Glacier side, I heard a little gasp from my companion, but when I looked around he was gone. The wind had picked him up bodily and blown him away. I found him, looking incredulous, on an ice ledge below, where the wind had deposited him like tumbleweed.

Camping on the icefield is almost always a windy proposition. One night it howled to such an extent that it took all the moisture out of the snow wall we had built to protect the tent from the wind. What was once a wall was now a lattice fence. Suddenly, at 2:30 in the morning, the wind stopped and it grew warm. Everyone woke up. What was happening? Had the world stopped? Then we had it. The cold, heavy air above the icefield had descended into the valley, causing an inversion. We were now awash in air that smelled of clover and flowers from the valley floor.

Then there are the things the wind brings. One day we found the entire area around our camp covered in Ladybugs. *Ladybugs?!* Does this happen often? Are we to imagine Moth Mondays? Dragonfly Tuesdays? Watermelon Weekends in summer when whole regions of the icefield are pink with snow algae? Many of the icefields in the mountain West are so big they create their own weather, their own ecology. Places like the Columbia Icefield are self-willed and wild; they forcefully radiate a unique natural monumentality that is remarkable in all the world.

How do you portray such a place? Merely comprehending a landscape of this magnitude is difficult enough. Artists often suffer from a more profound aesthetic arrest than climbers do. From personal experience I can tell you that greater knowledge of place doesn't necessarily help. The more you know about the Rockies or the Selkirks or the Coast Ranges, the more overwhelming they seem to become.

Light radiates onto these landscapes from above in a manner difficult to capture on canvas. It bounces back and forth, creating lighting that resembles a movie set. Landforms glow. Then there is the matter of painting silver. There is a great deal of silver at altitude. Silver is reflected off the ice and wet rock, off the waxy surfaces of the willows, off the silver tips of grizzly hair and off the inner linings of the clouds.

The mountains here also have a bad habit of shrinking and growing. The high air acts as a lens that diminishes the apparent proximity of mountains when the air is warm and magnifies them when it's cold. Then there are the graduated blues and greens of the ice. There is also the problem of painting water. The mountain West is about what water is and what water does. Like history, and like our lives, the water that originates from this region has a direction and a flow.

Standing on the apex of the Columbia Icefield you can feel it. The great rivers that begin here are bringing life into the world. Good art does the same thing.

Our identity as Canadians is defined by the abundance of the water that flows from places like this. Visitors come from all over the world to experience the wonder of water through our eyes.

And yet, there has still been no singular great painter of Canadian glaciers. The one who got it all just right. But many have come very, very close.

The upper reaches of the spectacular Helen Creek catchment in Banff National Park are in the alpine.

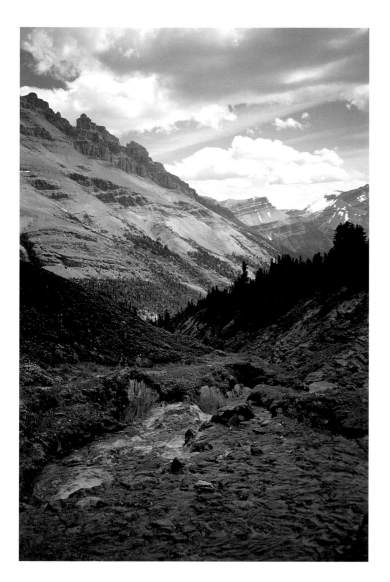

GLOSSARY

ablation: snow or ice removal through meltwater runoff, sublimation, wind scour, avalanching or glacial calving.

ablation zone: the area of a glacier where annual ablation exceeds annual accumulation, resulting in net loss of snow and ice.

accretion: increase in ice mass by freezing of basal water or surface water.

accumulation: snow or ice added to an ice mass by snowfall, frost deposition, rainfall that freezes on or in the ice mass, refrozen meltwater, windblown snow deposition or avalanching.

accumulation area ratio: the fractional area of a glacier represented by the accumulation zone at the end of the summer melt season.

accumulation zone: the area of a glacier where annual accumulation exceeds annual ablation, resulting in net accumulation.

active layer: the layer of seasonally frozen ground that is in contact with the atmosphere, usually with reference to permafrost terrain. Active layer depths vary from centimetres to several metres.

alpine: the life zone in mountainous regions that extends above treeline. In the Canadian Rockies treeline historically ranged, depending on slope and exposure, from about 2100 to 2250 metres, or roughly 6900–7400 feet, above sea level. But with warming conditions, treeline is slowly advancing northward and upward. Life does, however, extend above the tree, usually in the form of high meadows composed of interconnected, low-lying rafts of plant life. The alpine life zone in the Canadian Rockies is also referred to as alpine tundra, for conditions of life there are in many ways a southward extension, due to altitude, of the polar climate conditions that created the tundra of the Arctic.

alpine valley glacier: a small mountain glacier fed by accumulation of snow in the same trough in which it flows.

Anthropocene: the geological epoch many scientists believe we have entered as a consequence of the fact that human activities now rival the processes of nature itself. Unlike earlier epochs in the Earth's history, which were brought about by meteorite strikes and other geological events that resulted in mass extinctions, this epoch is marked by humans' overall impact on the Earth system. Climate disruption is only one of the Earth system boundaries that mark the safe zone we must stay within if we want a prosperous future. By virtue of our numbers and our activities we have altered global carbon, nitrogen and phosphorus cycles. We are causing changes in the chemistry, salinity and temperature of our oceans and the composition of our atmosphere. Changes in the composition of the atmosphere in tandem with land use changes and our growing water demands have also altered the global water cycle. The cumulative measure of the extent to which we have crossed these boundaries is the rate of biodiversity loss.

Bergeron process: the process by which ice crystals grow at the expense of cloud droplets in mixed clouds, through selective vapour deposition onto ice crystals. The phenomenon is driven by the lower saturation vapour pressure over ice crystals, relative to water droplets.

bergschrund: a large, semi-permanent crevasse at the head of a glacier which separates the moving ice from stagnant ice or from the adjacent rock surface.

Carboniferous: a period of the Palaeozoic Era in the Earth's history. It occurred between the end of the Devonian Period approximately 360 million years ago and the beginning of the Permian which began approximately 300 million years ago. During this period coal beds were laid down as central features of the stratigraphy of many parts of the northern hemisphere. The Carboniferous is often broken down into two geological periods in North America, the Mississippian followed by the Pennsylvanian.

Cenozoic: the most recent geological era in the Earth's history, extending from roughly 66 million years ago to the present (if recognized as such, the Anthropocene will be defined as an epoch, which is shorter than the era of which

it is but a part). This geological era includes the Quaternary period, representing the past 2.58 million years, which traditionally has been subdivided into the Pleistocene and Holocene epochs. Much of the glaciation that has shaped the Canadian Rockies as we know them today occurred during this era.

clathrate hydrate: gases (such as methane) trapped in an ice-crystal "shell" or "cage" found frozen in permafrost and in shallow seafloor sediments in, for example, cold continental-shelf environments.

Clausius–Clapeyron relation: the thermodynamic relationship between pressure and temperature which underlies both the pressure melting point depression in ice and the increase in saturation vapour pressure with temperature in the atmosphere.

continental divide: a divide is a height of land separating two different watersheds, and a continental divide separates watersheds that flow into different oceans. In the case of the Canadian Rockies, the Continental Divide, or Great Divide as it is often called, separates waters flowing to the Pacific Ocean from those that flow to the Atlantic. At the Columbia Icefield there is a rare triple continental divide: the high point on Snow Dome that separates waters flowing into the Atlantic, Pacific and Arctic oceans.

Cretaceous: a geological period in the history of the Earth that extended from roughly 145 to 66 million years ago, which is marked by the wholesale disappearance of many of the Earth's earlier life forms, including most dinosaurs.

crevasse: a crack or fissure in glacial ice. A crevasse is a break in ice, whereas a crevice is a narrow opening resulting from a split or crack in rock.

equilibrium line altitude: the elevation at which seasonal snow accumulation balances ablation on a glacier.

fast ice: sea ice that is frozen to the shore. Also called land-fast ice.

firn: multiyear snow that is in transition from meteoric snowfall to glacier ice. Firn densities typically range from 550 to 830 kilograms per cubic metre.

firn line: the often quite obvious boundary on the upper reaches of a glacier above which winter snow does not melt. The firn line distinguishes where a glacier ends and where the icefield that forms it begins.

floating ice: ice that is floating in water. Lake, river, and sea ice form from in situ freezing of water. Once initiated, meteoric precipitation (snow or frozen rainwater) adds to the ice mass. In contrast, floating glacier ice is transported to the water body from a terrestrial ice mass. Icebergs are fragments of glacier ice that have broken off and are now floating.

frazil ice: the early stages of the growth of small ice crystals in rivers, lakes and oceans when waters are supercooled and turbulent.

frost: deposition of ice on a surface, forming directly from water vapour.

general circulation model (GCM): three-dimensional model of atmosphere or ocean dynamics. Conveniently, GCM also stands for global climate model, and this initialism is now used interchangeably.

geology: the science that deals with the Earth's physical structure and substance, its history and the processes that act on it.

glacial erratic: large boulders carried by advancing glacial ice that are deposited on the landscape as the glacier recedes. Glacial erratics are known to have travelled hundreds of kilometres from the landscapes in which they were entrained by glacial ice.

glaciated: a region or landscape influenced by past glacial presence.

glacier: a body of permanent snow that has been compressed by its own weight into ice that has begun to move under the influence of gravity.

glacier ice: polycrystalline ice formed from snow metamorphism, with a density of 830 to 920 kilograms per cubic metre.

glacierized: a region or river basin where glaciers are currently present.

glacier mass balance: the overall gain or loss of mass for a glacier or ice sheet over a specified period, typically a year. This can be expressed as a rate of change in mass, expressed as kilograms per year; in ice volume, as cubic metres per year; or in water equivalent volume in cubic metres per year.

graupel: granular snow pellets, sometimes called soft hail.

Great Glaciation: a major glacial period that began in North America some 240,000 years ago and lasted approximately 100,000 years.

grounded ice: a glacier or ice sheet resting on bedrock or sediments. Such ice can be either above or below sea level.

ground ice: ice in permafrost of seasonally frozen ground. Also known as soil ice.

hoar: a sparkling, crystalline form of frost on, above or beneath the snow surface. Depth hoar is recrystallized snow found in the bottom layers of the snowpack. It is this recrystallization at the base of the snowpack that can make steep snow slopes unstable, triggering avalanches. Avalanches are very common in the Columbia Icefield area well into the spring.

hoodoo: towers of relatively soft glacial debris called till capped by a boulder or glacial erratic composed of harder rock buried in the till. Hoodoos are usually relatively impermanent features, surviving only as long as the cap rock can protect the tower beneath it from erosion.

hypothermia: the cooling of the core of the body to subnormal temperatures, a condition that can be fatal.

iceberg: a fragment of a glacier or ice shelf that has broken off from the main ice mass and is now floating in a lake or sea.

icecap: a glacial mass forming on an extensive area of relatively level land and flowing outward from its centre. A mountain icecap is a flat or gently sloping alpine upland buried in ice.

Ice Explorer: a 56-passenger motor vehicle, custom-built for travel on Athabasca Glacier at the Columbia Icefield, that is now being used in other glacial environments as well.

Originally called a "Snocoach" in marketing the Athabasca Glacier experience.

icefield: an area of permanent snow less than 50,000 square kilometres in size that is compressing itself under its own weight into ice which flows downhill as glaciers.

ice shelf: glacier ice that has flowed into an ocean or lake and is floating, no longer supported by the bed.

iceworm: small annelid worms of the genus *Mesenchytraeus* that have been found to spend their life cycles in or on glacial ice. First discovered in Alaska in 1887, they were made famous by a poem written by Robert Service entitled "The Ballad of the Iceworm Cocktail." Research indicates that these worms are among the most remarkably cold-hardy species in the world. But they can stand only cold, not heat: when iceworms are exposed to temperatures as high as 5°C (41°F), their membrane structures disassociate, causing the worm to liquefy or "melt." Though not common in the Rockies, iceworms are known to exist abundantly in some areas of the North Cascade Range in British Columbia and Washington.

katabatic wind: downslope wind resulting from gravitational drainage of cold air masses. These are common on valley glaciers and the flanks of ice caps and ice sheets.

lake ice: floating ice on a lake, initially formed by freezing of the lake water.

Last Glacial Maximum (LGM): period of maximum extent of the last Pleistocene glacial ice sheets, ca. 21,000 years ago.

Little Ice Age: a period of cooling that extended from about 1300 to about 1850 CE during which glaciers in the northern hemisphere, including those in the Canadian Rockies, appear to have advanced significantly.

Milankovitch cycles: variations in the Earth–Sun orbit on time scales of tens of thousands to hundreds of thousands of years which lead to changing seasonality and latitudinal distribution of insolation. These orbital variations drive the glacial–interglacial cycles of the Quaternary period.

millwell: a vertical hole through which surface water is carried down into a glacier. Some millwells are deep enough to carry meltwater right to the base of the ice. A millwell is the same as a moulin or a glacier mill.

mixed clouds: clouds from about 0°C to about -40°C, with a mixture of ice crystals, supercooled water droplets and water vapour.

moraine: a deposit of rock debris carried and shaped by glacial flow and erosion. Several types of moraines are found on and around Athabasca Glacier and in the Columbia Icefield region. These include lateral, terminal, medial and ablation moraines, each of which is formed by the dynamics of different kinds of glacial action.

moulin: *see* **millwell**.

névé: the accumulation area of an icefield, often associated with thick layers of *firn*.

ogives: a regular pattern of undulating bands of dark and light ice on the surface of a steeply descending glacier. These often evenly spaced bands bend down-glacier because the glacier moves faster at its centre than it does on its edges. The dark bands are composed of ice that moved over the icefall down which the glacier is pouring during the summer season. The light bands are composed of ice that moved over the icefall during the winter.

Ordovician: a geological period in the Earth's history extending from about 485 million years ago to about 445 million years ago. During this period, the continents of the southern hemisphere coalesced into a single landmass called Gondwana, which slowly began to drift toward the South Pole. During the same period, the continents Laurentia (present-day North America), Siberia and Baltica (present-day northern Europe) were still independent continents. Fossil fish have been discovered from this period and on land the preserved remains of mosses.

outlet valley glacier: a glacier, such as Athabasca, that flows out of a major icefield accumulation zone and into a neighbouring valley.

pack ice: drifting ice that is consolidated.

pancake ice: discrete, rounded pieces of sea or lake ice up to a few metres in diameter.

periglacial: terrestrial environments influenced by glacial or permafrost activity.

permafrost: perennially frozen ground, technically defined as ground that is at or below 0°C for at least two consecutive years.

pink snow: spring snow turned pink or red by the algae known as *Chlamydomonas nivalis* (see chapter 3 for details).

Pleistocene Ice Age: the last approximately 2.6 million years in Earth history, characterized by at least 40 advances and retreats of glacial ice over much of the world, in particular the northern hemisphere land mass. Also known as the Quaternary Age.

proglacial: the environment adjacent to a glacier, also referred to as the glacier forefield. For most contemporary glaciers, the proglacial environment is the recently deglaciated region where vegetation has yet to take hold.

river ice: floating ice on a river, initially formed by freezing of the river water.

rock flour: rock that has been ground into fine powder by glacial ice. This fine debris gives a milky colour to rivers and, depending on concentration, a brown cast to lakes fed by glaciers. The suspension of rock flour in many of the lakes in the Columbia Icefield area is of just the right concentration to make the water seem to glow turquoise. The dazzling blue of Peyto Lake and Lake Louise as seen from above is caused by suspended rock flour.

sea ice: floating ice formed by the freezing of sea water.

sérac: a standing tower of ice breaking off a glacier as it stretches downslope over an icefall.

snow: ice-crystal precipitation that accumulates on the surface.

Snowball Earth: episodes of complete global glacier and sea-ice cover in the Earth's distant past.

solar wind: the great storm of light and radioactive particles through which the Earth spins as it passes through the sun's glow.

Ice forming on the Bow River in Banff National Park.

I wish I had a river I could skate away on …

—JONI MITCHELL, "RIVER" (*BLUE*, 1971)

specific mass balance: the area-averaged mass-balance rate on a glacier expressed as kilograms per square metre per year, but often expressed at the rate of water-equivalent thinning or thickening as measured in cubic metres of water equivalent per year.

subglacial: the environment beneath a glacier, at the ice bed interface.

supraglacial: the environment on the surface of a glacier.

surface mass balance: the mass balance at the interface between atmosphere and glacier, associated with net snow accumulation minus surface ablation. This is often referred to as the glacier's mass balance, but strictly speaking, mass balance also includes the gain and loss of ice in englacial, subglacial and ice margin environments.

watermelon snow: *see* **pink snow**.

watershed: the area drained by a river system, or a ridge dividing areas drained by different river systems.

Historical accounts

The only surviving first-hand account of the discovery of the Columbia Icefield that is still in print was published in *Climbs and Explorations in the Canadian Rockies,* by J. Norman Collie and Hugh E.M. Stutfield. Published in 1903, copies of the original book are now rare. A modern paperback reprint of this classic, however, was published in 2008 by Rocky Mountain Books.

Two excellent biographies exist on Norman Collie. *The Snows of Yesteryear: J. Norman Collie, Mountaineer,* by William C. Taylor was published by Holt, Rinehart and Winston of Canada in 1973. Dr. Taylor shared material from his important work with Christine Mill for her biography *Norman Collie: A Life in Two Worlds, Mountain Explorer and Scientist, 1859–1942,* which was published by Aberdeen University Press in 1987.

A very interesting book has been published on the history of the Lovat Scouts which embraces the training they undertook in the Columbia Icefield area during World War II. *Highland Soldiers: The Story of a Mountain Regiment,* by William Taylor, was published by Coyote Books of Canmore, Alberta in 1994.

A thorough history of the discovery and later exploration of the Columbia Icefield area can also be found in *Ecology & Wonder in the Canadian Rocky Mountain Parks World Heritage Site,* which was written by this author and published by Athabasca University Press in 2010.

A vast range of historic materials concerning the Columbia Icefield area can be found in the archives of the Whyte Museum of the Canadian Rockies in Banff and in the Jasper–Yellowhead Museum in Jasper.

Historical fiction

Icefields is a work of historical fiction by Thomas Wharton that was published by Simon and Schuster in 1995. *Icefields* is spare and simple, like the glaciers and frozen peaks Wharton describes. The writing in this book mirrors the beauty of the high alpine landscape. Only the important features relating to the nature and character of place stand out. Wharton's characters are similarly constructed. They are reduced to the elemental spareness of the ice over which they wander, subject to only the most fundamental emotions. We see them come to grips with themselves by coming to grips with the ice and rock and pure light of the icefield where their remarkable story unfolds. It is not often that you come across a locally written classic. Not since Sid Marty's *Men for the Mountains* has the theme of Jasper mountains been handled with such clarity and eloquence.

Scientific literature and literary works

Ball, Philip. *Life's Matrix: A Biography of Water.* Berkeley: University of California Press, 2001.

Barnosky, Anthony D. *Heatstroke: Nature in an Age of Global Warming.* Washington, DC: Island Press, 2009.

Barnosky, Anthony D., and Elizabeth A. Hadly. *Tipping Point for Planet Earth: How Close Are We to the Edge?* NYC: Thomas Dunne Books, 2016.

Best, Cora Johnstone. "Horse Thief Creek and the Lake of the Hanging Glaciers." *Canadian Alpine Journal* 13 (1923): 229–41.

Cavell, Edward. *Legacy in Ice: The Vaux Family and the Canadian Alps.* Banff, Alta.: Peter and Catharine Whyte Foundation, 1983.

Childs, Craig. *The Secret Knowledge of Water.* Boston: Little, Brown, 2001.

Clarke, Garry K.C. "A short history of scientific investigations on glaciers." *Journal of Glaciology,* Special Issue Commemorating the Fiftieth Anniversary of the International Glaciological Society (January 1987): 4–24. Full text accessed 2017-03-05 (pdf) at researchgate.net/publication/262260534_A_short_history_of_scientific_investigations_on_glaciers.

Coleman, A.P. *Ice Ages Recent and Ancient.* NYC: Macmillan, 1926. Scanned original pages (pdf) accessed 2017-03-05 at is.gd/rREN1K.

Cruikshank, Julie. *Do Glaciers Listen? Local Knowledge, Colonial Encounters and Social Imagination.* Vancouver: University of British Columbia Press, 2005.

Cruikshank, Julie, Angela Sidney, Kitty Smith and Annie Ned. *Life Lived Like a Story: Life Stories of Three Yukon Native Elders.* Vancouver: University of British Columbia Press, 1990.

Demuth, Mike. *Becoming Water: Glaciers in a Warming World.* Calgary: Rocky Mountain Books, 2012.

Demuth, Michael N., and Ray Keller. "An assessment of the mass balance of Peyto Glacier (1966–1995) and its relation to recent and past-century climatic variability." In M.N.

Demuth, D.S. Munro and G.J. Young, eds. *Peyto Glacier: One Century of Science,* c. 4. Ottawa: Environment Canada National Hydrology Research Institute, Science Report 8 (January 2006). Accessed 2016-04-05 (pdf) at researchgate.net/publication/274069491_An_Assessment_of_the_Mass_Balance_of_Peyto_Glacier_1966-1995_and_its_Relation_to_Recent_and_Past-century_Climatic_Variability.

Demuth, M.N., D.S. Munro and G.J. Young, eds. *Peyto Glacier: One Century of Science.* Ottawa: Environment Canada National Hydrology Research Institute, Science Report 8 (January 2006).

Environment Canada and Parks Canada. *Climate Change and Canada's National Park System.* Edited by Daniel Scott and Roger Suffling. Ottawa: Environment Canada, Parks Canada, 2000. Accessed 2017-03-05 (pdf) at publications.gc.ca/collections/Collection/En56-155-2000E.pdf.

Freeman, Lewis R. *On the Roof of the Rockies.* Rocky Mountain Classics Collection. Calgary: Rocky Mountain Books, 2009. First published 1925 by Dodd, Mead, NYC.

Gopnik, Adam. *Winter: Five Windows on the Season.* CBC Massey Lectures. Toronto: Anansi, 2011.

Gosnell, Mariana. *Ice: The Nature, the History and the Uses of an Astonishing Substance.* Chicago: University of Chicago Press, 2007.

Government of Canada. *Atlas of Canada.* 6th ed. (online). Ottawa: Natural Resources Canada, 1999, 2002 and continuously updated since. Selected thematic maps accessed 2017-04-05 from nrcan.gc.ca/earth-sciences/geography/atlas-canada/selected-thematic-maps/16888. Edition history accessed 2017-04-05 at nrcan.gc.ca/earth-sciences/geography/atlas-canada/about-atlas-canada/16890.

———. *National Atlas of Canada.* 5th ed. Ottawa: Natural Resources Canada, 1993. Accessed 2017-03-05 from nrcan.gc.ca/earth-sciences/geography/atlas-canada/map-archives/16868.

Harmon, Don, and Bart Robinson. *Columbia Icefield: A Solitude of Ice.* Canmore, Alta.: Altitude, 1981.

Hart, E.J. (Ted). *Diamond Hitch: The Pioneer Guides and Outfitters of Banff and Jasper.* Banff: EJH Literary Enterprises, 2001. First published 1979 by Summerthought, Banff.

Holdsworth, G., M.N. Demuth and T.M.H. Beck. "Radar measurements of ice thickness on Peyto Glacier, Alberta: Geophysical and climatic implications." In M.N. Demuth, D.S. Munro and G.J. Young, eds. *Peyto Glacier: One Century of Science.* Ottawa: Environment Canada National Hydrology Research Institute, Science Report 8 (January 2006), 59–82.

Imbrie, John, and Katherine Palmer Imbrie. *Ice Ages: Solving the Mystery.* 2nd ed. Cambridge, Mass.: Harvard University Press, 1986.

Jones, H.G., J.W. Pomeroy, D.A. Walker and R.W. Hoham. *Snow Ecology: An Interdisciplinary Examination of Snow-Covered Ecosystems.* Cambridge, UK: Cambridge University Press, 2001, reprinted 2011.

Kauffman, Andrew J., and William L. Putnam. *The Guiding Spirit.* Revelstoke: Footprint Publishing, 1986.

Kirk, Ruth. *Snow.* New York: Morrow, 1978. Reissued with new preface, Seattle: U. of Washington Press, 1998.

Kucera, Richard E. *Exploring the Columbia Icefield.* Canmore, Alta.: High Country Press, 1981; rev. ed. 1990.

Leeson, Ted, *The Habits of Rivers.* NYC: Lyons Press, 1994.

Luckman, Brian. "The Little Ice Age in the Canadian Rockies." *Geomorphology* 32, no. 3 (March 2000): 357–384. Accessed 2017-03-05 (pdf) from researchgate.net/publication/244509414_The_Little_Ice_Age_in_the_Canadian_Rockies.

————. "The neoglacial history of Peyto Glacier" (2000). In M.N. Demuth, D.S. Munro and G.J. Young, eds. *Peyto Glacier: One Century of Science.* Ottawa: Environment Canada National Hydrology Research Institute Science Report 8 (2006), 25–57.

Luckman, Brian, and Trudy Kavanagh. "Impact of Climate Fluctuations on Mountain Environments in the Canadian Rockies." *Ambio* 29, no. 7 (November 2000): 371–380.

Marshall, Shawn. *The Cryosphere. Princeton Primers in Climate.* Princeton University Press, 2012.

Mill, Christine. *Norman Collie: A Life in Two Worlds: Mountain Explorer and Scientist, 1859–1942.* Aberdeen: University Press, 1987.

Millan, Romain, Jeremie Mouginot and Eric Rignot. "Mass budget of the glaciers and ice caps of the Queen Elizabeth Islands, Canada, from 1991 to 2015." *Environmental Research Letters* 12, no. 2 (2017): 024016. Accessed 2017-03-05 (pdf) at iopscience.iop.org/article/10.1088/1748-9326/aa5b04/pdf.

Morris, E.M. "Techniques for predicting runoff from glacierized areas" (2002). In M.N. Demuth, D.S. Munro and G.J. Young, eds. *Peyto Glacier: One Century of Science.* Ottawa: Environment Canada National Hydrology Research Institute, Science Report 8 (2006), 201–225.

Munro, D. Scott. "Linking the weather to glacier hydrology and mass balance at Peyto Glacier" (2006). In M.N. Demuth, D.S. Munro and G.J. Young, eds. Peyto Glacier: One Century of Science. Ottawa: Environment Canada National Hydrology Research Institute, Science Report 8 (2006), 135–176.

O'Riordan, Jon, and Robert William Sandford. *The Climate Nexus: Water, Food, Energy and Biodiversity in a Changing World.* Calgary: Rocky Mountain Books, 2015.

Orlove, Ben, Ellen Wiegandt and Brian H. Luckman. *Darkening Peaks: Glacier Retreat, Science and Society.* Berkeley: University of California Press, 2008.

Østrem, Gunnar. "Historical background of Peyto Glacier studies" (2002). In M.N. Demuth, D.S. Munro and G.J. Young, eds. *Peyto Glacier: One Century of Science*. Ottawa: Environment Canada National Hydrology Research Institute Science Report 8 (2006), 1–24.

Outwater, Alice. *Water: A Natural History*. New York: Basic Books, 1997.

Petts, G.E., A.M. Gurnell and A.M. Milner. "Ecohydrology: New opportunities for research on glacier-fed rivers" (2002). In M.N. Demuth, D.S. Munro and G.J. Young, eds. *Peyto Glacier: One Century of Science*. Ottawa: Environment Canada National Hydrology Research Institute Science Report 8 (2006), 255–278.

Paterson, W.S.B. *The Physics of Glaciers*. Oxford and New York: Pergamon Press, 1969.

Robinson, Bart, Byron Harmon, Carole Harmon and Jon Whyte. *Great Days in the Rockies: The Photographs of Byron Harmon, 1906–1934*. Toronto: Oxford University Press, 1978; Banff: Altitude Publishing, 1984.

Sandford, Robert William, *Cold Matters: The State and Fate of Canada's Fresh Water*. Calgary: Rocky Mountain Books, 2012.

————. *The Columbia Icefield*. Calgary: Rocky Mountain Books, 2016.

————. *Storm Warning: Water and Climate Security in a Changing World*. Calgary: Rocky Mountain Books, 2015.

Schuster, C.J., and G.J. Young. "The derivation of runoff from the Peyto Glacier catchment" (2002). In M.N. Demuth, D.S. Munro and G.J. Young, eds. *Peyto Glacier: One Century of Science*. Ottawa: Environment Canada National Hydrology Research Institute Science Report 8 (2006), 223–248.

Shank, Christopher C., and Amy Nixon. "Climate change vulnerability of Alberta's terrestrial biodiversity: A preliminary assessment." Edmonton: Alberta Biodiversity Monitoring Institute, 2014. Accessed 2017-03-05 (pdf) at is.gd/JtQsV1.

Sherzer, William Hittell. *Glaciers of the Canadian Rockies and Selkirks (Smithsonian Expedition of 1904)*. *Smithsonian Contributions to Knowledge* 34, no. 1692. Washington, DC: Smithsonian Institution, 1907. Scanned original pages accessed 2017-03-05 at archive.org/details/glaciersofcanadioosherrich.

Struzik, Ed. *The Big Thaw: Travels in the Melting North*. NYC: John Wiley & Sons, 2009.

Thorington, J. Monroe. *The Glittering Mountains of Canada: A Record of Exploration and Pioneer Ascents in the Canadian Rockies, 1914–1924*. Reprinted with a new foreword by Robert William Sandford. Rocky Mountain Classics Collection. Calgary: Rocky Mountain Books, 2012. Originally published 1925 by J.W. Lea, Philadelphia.

Tyndall, John. *Hours of Exercise in the Alps*. D. Appleton, 1896. Scanned original pages accessed 2017-03-05 at archive.org/details/hoursofexercisei96tynd.

Vaux, Henry Jr. *Legacy in Time: Three Generations of Mountain Photography in the Canadian West*. Calgary: Rocky Mountain Books, 2014.

Wadhams, Peter. *A Farewell to Ice: A Report from the Arctic*. London, UK: Allen Lane, 2016.

Walker, Gabrielle. *Snowball Earth: The Story of a Maverick Scientist and His Theory of the Global Catastrophe that Spawned Life as We Know It*. NYC: Three Rivers Press, 2003.

ACKNOWLEDGEMENTS

The author wishes to acknowledge the support of Dr. John Pomeroy, director of the Centre for Hydrology at the University of Saskatchewan, without whose generous sharing of knowledge and tireless commitment to increasing public awareness of ice, snow and climate-related water matters this book would not have been possible. The author would like to further acknowledge that this book would have had little if any substance without the cooperation of all the scientists who contributed. I am deeply honoured, and grateful for their support. Special recognition in this regard must go to Drs. Shawn Marshall, Garry Clarke, Brian Menounos, Al Pietroniro, David Sauchyn and Mike Demuth.

The author also particularly acknowledges the assistance of Peter Lemieux and his staff at Athabasca Glacier Icewalks for their productive, ongoing discussions about the condition of the Athabasca Glacier and for their always generous professional courtesy.

The project also benefited in its final stages from the support of the author's colleagues at the United Nations University Institute for Water, Environment and Health.

The author gratefully acknowledges the support and thoughtful assistance of Ralph Sliger, president and chief pilot of Rockies Heli Canada, who made a special effort on each of our annual aerial surveys to get us safely to where we needed to go in weather that allowed us to optimize our observations.

Ralph Sliger.

Special thanks are also due to Rocky Mountain Books and in particular to publisher Don Gorman for his commitment to books on water and climate; to editor Joe Wilderson for his diligence, intelligence, patience and good humour; and to Frances Hunter, whose mindful designs make books like this shine.

Finally, I must offer profound gratitude to my wife, Vi, without whose support and help in one of the most difficult times in our lives together this book would not have been written.

And of course it must be acknowledged that the author alone takes full responsibility for any errors, omissions, misperceptions or misunderstandings the book may contain. Understanding the state and fate of Canada's glaciers and predicting their future are not likely to get easier any time soon.

ABOUT THE AUTHOR

Bob Sandford is the EPCOR Chair for Water and Climate Security at the United Nations University Institute for Water, Environment and Health. In this capacity Bob was the co-author of the UN *Water in the World We Want* report on post-2015 global sustainable development goals relating to water.

In his work Bob is committed to translating scientific research outcomes into language decision-makers can use to craft timely and meaningful public policy, and to bringing international example to bear on local water issues. To this end, Bob is also senior adviser on water issues for the Interaction Council, a global public policy forum composed of more than 30 former heads of government, including Canada's Jean Chrétien, Bill Clinton of the US and Gro Harlem Brundtland of Norway.

Bob is also a Fellow of the Centre for Hydrology at the University of Saskatchewan and a Fellow of the Biogeoscience Institute at the University of Calgary. He is also a senior policy adviser for the Adaptation to Climate Change team at Simon Fraser University and a member of the Forum for Leadership on Water (FLOW), a national water policy research group centred in Toronto.

In addition to his many other books, Bob is also the author or co-author of a number of high-profile works on water, including *Cold Matters: The State and Fate of Canada's Fresh Water*; *Saving Lake Winnipeg*; *Flood Forecast:*

Climate Risk and Resiliency in Canada; and *The Columbia River Treaty: A Primer*, all published by Rocky Mountain Books. Later books include *The Climate Nexus: Water, Food, Energy and Biodiversity in a Changing World*, which he co-authored with former BC Deputy Minister of Environment Jon O'Riordan, and Bob's own *Storm Warning: Water and Climate Security in a Changing World*, both published in 2015 by Rocky Mountain Books. *The Columbia Icefield* and *North America in the Anthropocene* followed in 2016, also from Rocky Mountain Books.